Color:
How to Use It

Marcie Cooperman

PEARSON

Boston Columbus Indianapolis New York San Francisco Upper Saddle River
Amsterdam Cape Town Dubai London Madrid Milan Munich Paris Montreal Toronto
Delhi Mexico City São Paulo Sydney Hong Kong Seoul Singapore Taipei Tokyo

Editorial Director: Vernon R. Anthony
Acquisitions Editor: Sara Eilert
Editorial Assistant: Doug Greive
Director of Marketing: David Gesell
Executive Marketing Manager: Harper Coles
Senior Marketing Coordinator: Alicia Wozniak
Marketing Assistant: Les Roberts
Associate Managing Editor: Alexandrina Benedicto Wolf
Project Manager: Alicia Ritchey
Operations Specialist: Deidra Skahill

Cover Designer: Suzanne Duda
Cover Art: Front cover by Samantha Kelly Smith, back cover by Marcie Cooperman.
Lead Media Project Manager: Karen Bretz
Full-Service Project Management: S4Carlisle
Composition: S4Carlisle
Printer/Binder: Courier/Kendallville
Cover Printer: Lehigh-Phoenix Color
Text Font: Frutiger LT Std 45 Light 9/13

Credits and acknowledgments borrowed from other sources and reproduced, with permission, in this textbook appear on appropriate page within text.

10 9 8 7 6 5 4 3 2 1

ISBN 10: 0-13-512078-0
ISBN 13: 978-0-13-5120781

I dedicate Color: How to Use It to my mother, Shirley Cooperman—my primary and primal creative influence. When I was at the tender age of too-young-to-remember, my mother was the one who first fired up my passion for color and set me on the creative road that I still follow today at breakneck speed. She stimulated my sensitivity to color and design throughout my childhood by asking my opinion on so many things around us—the clothing she custom designed and sewed for me; the artwork, glass animals and the carpet and furniture that populated my childhood bedroom—all in the name of reconciling design and function with budget. My mother instigated my preoccupation with countless painting/sewing/embroidery/doll-making projects. Sadly for me, she passed away before she could see how much her inspiration has become part of the very fiber of my adult life and work.

CONTENTS

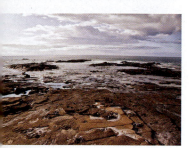

Marcie Cooperman is a Professor of Marketing at Parsons: The New School for Design in the Fashion Marketing Department. She has also been a professor at Pratt Institute of Design, where she has taught color theory classes for many years in the Industrial Design Department and Graduate Communications Design Department. *Color: How to Use It* is classroom-tested in these classes.

Marcie also conducts corporate presentations and educational seminars on color theory for industrial design companies and beauty companies such as L'Oreal, and has taught color theory, oil painting, watercolor, and trompe l'oeil painting at the Newark Museum since 1994. In addition, Marcie is a fine artist in oil and watercolor.

Color: How to Use It breaks new ground as the first in-depth color theory textbook to examine simultaneous **color interactions** and to explore **compositional influences** on the perception of color. It is not a simple process to create successful color interaction whether it be in a design or a painting; in consumer products, clothing, packaging, interior design, a website or an advertisement. Compositional elements and color relationships can completely change the colors we see and how we perceive them. *Color: How to Use It* takes these factors apart and examines them individually, then this book puts them back together for everything you need to know on how to use color.

Who Should Read This Book?

Color: How to Use It is a textbook about the study of color theory. It is directed to students in every art and design field—foundations, interior design, fashion design, merchandising, graphic and communications design, and design marketing. The 13 chapters cover the elements of composition with the depth and detail that a student needs for a full understanding of how and why color interactions occur. The book provides a solid foundation in the subject of color, so that students can make smart design choices based on an intimate understanding of how color works.

But artists and professional designers will enjoy using this book too, so that they can gain a thorough understanding of the elements of color and composition. When they read the discussions and apply their creativity to the rigorous fundamental exercises in each chapter, that will help make their work shine and increase their confidence.

Knowing How Colors Interact Gives Students Confidence

An understanding of how to use color is one of the most basic tools for designers and artists. Choosing colors based on the knowledge of how they influence each other is vital in helping designers create successful, balanced designs, drawings, advertisements, videos, and websites. With *Color: How to Use It,* students of design will understand what makes colors work well together and they will gain the knowledge of how to get more exciting results. This comprehensive guide to color interactions and the factors that influence them is an invaluable learning tool for every color theory student in every field of design. As students move into their careers, having this depth of knowledge of color theory will help them accept any design challenge with confidence.

What Are the Goals of *Color: How to Use It* ?

The goals of this textbook are to teach students the following:

- Learn to see:
 - Color and color relationships
 - The elements of two-dimensional (2-D) composition that affect how we perceive color

- Understand how altering even one of the colors, or one compositional element in a composition, will change the dynamics of the composition and affect all colors
- Gain skills in using the elements of color and composition in a 2-D composition

Organization of the Book Builds Skills Systematically

Color: How to Use It makes learning color theory easier than ever. Organized in a clear and concise fashion, this book explains color theory through a gradual process. It begins with basics such as the definitions of terms and explanations of color relationships, and it gradually introduces ever more complex interactions that come about from the elements of composition. Each chapter offers another piece of the compositional puzzle. Graphic illustrations, fine art, and photographs clarify how the chapter concepts affect color usage.

Each chapter builds upon the knowledge gained from the previous one. The goal is to solidify skills through these three steps:

1. Learning new skills
2. Practicing newly learned skills with focused exercises at the end of each chapter
3. Using learned skills as a basis for learning more complex skills in the next chapter

This process ensures that students will have a solid foundation built in an orderly manner, as well as a way to separate—and focus on—each of the compositional elements. In this way, the student can truly see how each element affects the composition.

Throughout each chapter, the concepts are illustrated with beautiful examples culled from classic and current works of art, design, and architecture as well as commercial uses of color. The current artworks are astounding, and especially useful as a window into the way that color is being used today.

Instructor Resources

All instructor resources can be downloaded from the Pearson Instructor Resources website at http://pearsonhighered.com/irc.

Acknowledgments

I would like to express my appreciation to the following good souls, without whom this book could not have been written:

Gusty Lange and Steve Ettlinger—for their sage advice and long experience in writing, teaching and publishing. I cherish their steadfast friendship.

Nancy Meckle—for her hard work in research and communications for the psychedelic posters.

My project manager at S4Carlisle, Jean Smith—for her kind heart, good humor, and high spirits, not to mention knowledge and skills.

The dedicated editorial team at Pearson—for their untiring shepherding of this textbook through the wild west of publication.

My Dad, Sam Cooperman—who set the example for me for self-reliance and public speaking.

My daughters Lindsay Brin and Sasha Nelson, and my husband Steve Bronstein—their unconditional support and pride in my work makes me happy.

My reviewers for their valuable feedback:

Linda Krueger, University of Minnesota

Patti Shanks, University of Missouri

Jeffrey Hicks, Savannah College of Art and Design

Marciann Patton, Missouri State University

Craig Lloyd, College of Mount St. Joseph

Anna Marie Bedsaul, IADT Orlando

and Tara Tokarski, International Academy of Design and Technology

My artists and photographers—for their kindness in allowing me to showcase their incredible contemporary works in this textbook:

Joel Schilling

Gary K. Meyer

Samantha Keely Smith

Cynthia Packard

Liz Carney

Catherine Kinkade

Janos Korodi

Alyce Gottesman

Liron Sissman

Pamela Farrell

Whitney Wood Bailey

Howard Ganz

Michael Price

Nina Baldwin

Julie Otto

Sasha Nelson

Lindsay Brin/Hano

Syed Asif Ahmed

Dodie Smith

Krista Svalbonas

Marsha Heller

Sarah Canfield

Mim Nelson-Gillett

Carla Horowitz

Ivan Valliela

Maryann Syrek

Nat Connacher/Samuel Owen Gallery

Mercedes Cordiero Drever

Shiri Cohen Karasikov

Annie Pires

William Watters

Suzanne Distefano

Elizabeth Motolese

Charlene Shih

Ross Connard

Paul Vanderberg

Color Theory History

Where does color come from?

What role does the human eye play in perceiving color?

What hues are primary, and cannot be created by mixing other hues?

As basic as these questions seem to us today, the answers remained unknown throughout much of history, although numerous hypotheses have been suggested. Chemists, physicists, teachers, and psychologists have offered explanations from their varied points of view, based on their specialties. Many of them contemplated the best way to illustrate the primary hues and their mixtures, coming up with different geometric shapes such as circles, triangles, and spheres.

And many thinkers formulated rules on choosing colors that work best together—a goal of standardizing visual harmony. It's hard to say that particular colors will *always* work well together because a composition can have many variables that affect color in different ways, but there are compositional factors and general color relationships that can be relied upon to guide the color choices, all of which we discuss in depth in *Color: How to Use It*. As an example, in *Can't See the Trees for the Forest* in Figure 1.1, the reds and greens are complements; the colors are low intensity; and the values range from high to low.

Today we have answers to these these questions and more. Social changes, advances in the fields of psychology and technology, and color research have continually enhanced what we know about color theory. We are able to use color to communicate with each other, and as a tool to direct a viewer's emotional reaction to our compositions. But, the study of color is a fluid concept, one that is likely to continue to evolve indefinitely.

Ancient Civilizations

The Egyptians and the Ancient Greeks

 Plato

 Aristotle

Advances in Color Theory

Artists from the Fourteenth to Twentieth Centuries

 Jan van Eyck

 Leonardo da Vinci

 Isaac Newton

 Johann Wolfgang von Goethe

 Jacques Le Blon

 Moses Harris

 Philipp Otto Runge

 Michel E. Chevreul

 Wilhelm Ostwald

 Hermann von Helmholtz

 Ogden Rood

 Ewald Hering

 Albert Munsell

 Josef Albers

FIGURE 1.1 Marcie Cooperman: *Can't See the Trees for the Forest.* Watercolor, 26″ × 40″, 2011. Marcie Cooperman.

Ancient Civilizations

THE EGYPTIANS AND THE ANCIENT GREEKS

Although we may not be able to understand it through the eyes of our culture today, the comparison of our culture with ancient times allows us to put our knowledge about color into context. We can better understand how much we know when we see how far we have come.

The Egyptians (3000 BCE–400 CE) and the ancient Greeks (900 BCE–140 BC) used color in paintings to show symbolic meaning, rather than as an accurate visual representation of a particular object. Surface color was not a concept familiar to the Egyptians.

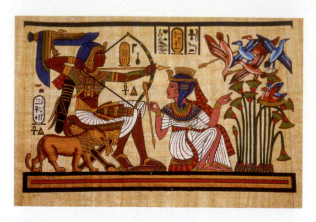

FIGURE 1.2 Antique Egyptian papyrus. © Thomas Sztanek / Fotolia.

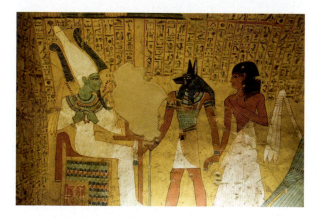

FIGURE 1.3 Osiris sitting on his throne in a tomb painting.
© BasPhoto / Fotolia.

Certain colors represented deities, natural forces, locations, or events. Artists used these colors to make references to the gods and mythical stories, and to daily life. Each color had meanings widely understood within the culture. Consequently, for us to do a correct reading of an Egyptian tablet, we would need to know what each color represented.

Red, for example, was the color of life and victory because it was the color of blood, but to Egyptians, it also referred to death, chaos, and evil, as in the papyrus in Figure 1.2. The god of death, Seth, was always red in a painting. Red also had a practical use in warding off death; a red amulet protected the wearer. Different hues identified other gods, like green for Osiris, who was associated with vegetation, in Figure 1.3, and yellow for other gods.

Some colors had meanings similar to those we use in modern Western culture. As they do today, green represented verdant, life-giving properties, and blue symbolized water as well as the sky. Also, white was the color of purity and holiness, and black symbolized death as well as resurrection.

From the ancient Greek writers' descriptions of the colors of daily life, it's difficult to determine how the Greeks perceived colors. It's not clear what meanings they attributed to colors, nor is it apparent that to them objects had their own local colors apart from any meaning. The ancient language seemed to be limited to only a few words for color descriptions.

Homer, for example, the legendary author of the *Iliad* and the *Odyssey*, used only four words—*purply red, greenish yellow,* and *black* and *white*—but he mysteriously used them to describe all manner of objects. He spoke about "the wine-dark sea," using a Greek word that is considered to be yellowish green and that also was used to describe sheep, honey, and blood. Complicating matters is the fact that he was traditionally thought to be blind, although it is generally believed that his mastery was reciting epic poems that had been handed down in the oral tradition.

From research, it seems that color names used by the Greeks referred to the quality and texture of the object's surface in addition to the color they might actually have held. And to make modern color analysis even more difficult, Greek color words also relate to the four fluids of the human body, known as bile, and how they contribute to a person's health. Those colors are red, yellow, black or dark, and white or light.

Polygnotus of Thasos, who lived in the middle of the fifth century BCE, is considered to be the first to work at artistic painting. Using pigment in wet plaster, he painted frescos on interior walls. According to the Roman philosopher Cicero, (106–43 BCE), he used only four hues, identified by Pliny the Elder as white, yellow, red, and black. It is not known whether the Greeks at that time had access to minerals that produced all hues, even though 3,000 years earlier the Egyptians ground up lapis lazuli for blue pigment.

Apollodorus, who lived about 420 BCE, is credited with being the founder of "real" art, painted on a surface that sits on an easel. His works give the illusion of reality, and mix many colors to show light and shadows. Certainly by his time, pigments of all colors were available to the ancients.

Plato (427–348 BCE)

Plato observed that light defined day and then changed into the blackness of night; therefore, he called "darkness" and "light" the first two primary colors. Plato's third and fourth primary colors were a combination of the tears that form in the eye (the name he used was "radiant"), and the fire that the eye sees as gleaming through the tears ("red"). Mixing white light with darkness, red, and radiant formed secondary colors. According to his theory of vision, rays of light ("visual fire") emanate from the eye itself and they interact with daylight to form a "single homogeneous body."[1] Then it "strikes upon whatever object it encounters outside."[2]

Aristotle (384–322 BCE)

Aristotle said that the struggle between darkness and light produced seven primary colors including black and white, all of which we can see in the sky as daylight turns into dusk and then night. To display the colors visually, he arranged them in a line in this order: white, yellow, red, violet, green, blue, and black. He related them to the four elements of nature, as well as to darkness and light: Yellow represented sunlight, blue related to the air, green represented water, and red recalled fire. Aristotle wrote the first known book about color, called *De Coloribus*.

Advances in Color Theory

In many civilizations throughout history, colors used in works of art continued to be chosen by their association with the gods or subjects that they symbolized. The interactions of colors, their placement on the page, and their effects on the viewer were not considered in the least. However, their meanings were not consistent from one culture to another. Only black, white, and red were universally accepted to be symbolic in specific ways. As it is today in Western civilizations, black was a sign of mourning, white meant innocence and purity, and red stood for blood and fire.

More than a thousand years after the ancient Greeks lived, artists during the Renaissance period realized that different materials and light conditions influenced the colors of objects, and they finally abandoned the purely symbolic use of color. Reasons artistic and otherwise for choosing colors became the norm.

Color decisions throughout this period of history were often influenced by prestige, rather than the hue itself. Patrons who commissioned artists commonly requested that certain pigments be used. Rare and hard to get pigments were highly desirable, as not everybody could afford them. In this way, a patron who requested expensive pigments was able to show off his or her wealth in his portrait.

Tyrian violet was one such prestigious pigment; it came from a gland in the *Murex* sea snail in Figure 1.4. Imagine how expensive it would be to produce a quantity of color from these tiny animals. The color was actually a type of violet red. As Pliny the Elder said in 77–79 CE, "the Tyrian hue … is considered of the best quality when it has exactly the color of clotted blood, and is of a blackish hue to the sight." Not only did Tyrian violet never fade, but its intensity improved with age.

Gold, another precious material, was ground to make golden paint. This was documented as early as the Egyptian period. Because the gold was often mixed with red, red symbolized prestige as well.

Ultramarine blue was another example of a prestigious and very expensive color available during the Renaissance period. The only way to obtain this blue paint was from the semiprecious stone lapis lazuli, as shown in Figure 1.5. It was so expensive that patrons who requested that ultramarine blue be used in their commissions specified to the artist exactly where it was to be used, and they paid dearly for it.

The Knossos throne room in Figure 1.6, decorated between 1700 and 1400 BCE, illustrates that red was an appropriate hue for royalty in Greece during that era. Red historically came from minerals such as ochre, realgar and cinnabar, as well as haematite—a mineral form of iron oxide. Another source of red, carminic acid, was produced by the cochineal, a scale insect, and mixed with aluminum or calcium salts to produce carmine. Originally used by the Aztecs in the New World, carmine found its way to the Old World in the sixteenth century. Carmine is still used today for food coloring and cosmetics.

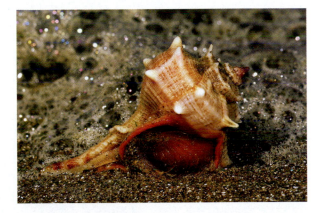

FIGURE 1.4 The *Murex* sea snail, which produced Tyrian violet.
© INTERFOTO / Alamy.

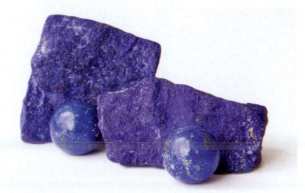

FIGURE 1.5 Lapis lazuli polished mineral specimens.
© Kacpura / Fotolia.

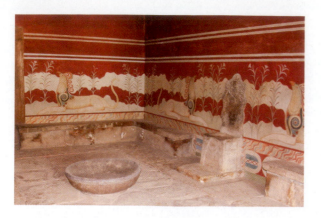

FIGURE 1.6 **Knossos throne room, Crete, Greece, built between 1700 and 1400** BCE. © Q / Fotolia.

Indian yellow was a transparent yellow pigment first used by Dutch artists in the fifteenth century. It was also a rare substance, with a myth attached stating that it came from India and was manufactured from the urine of cattle that ate only mango leaves. This was never proven, however, and the museum at Winsor & Newton's factory states that it comes from the earth on which those cows urinated. Jan Vermeer's *The Letter* in Figure 1.7 illustrates the vibrant hues that were attained from lapis lazuli, Indian yellow and carmine.

Wealthy patrons continued dictating colors for four hundred years more, until synthetic pigments were invented in the nineteenth century. Easily manufactured in large quantities that became widely available, these less expensive new pigments rendered the expensive natural sources no longer indispensable and therefore socially useless.

Jan van Eyck (1395–1441)

Jan van Eyck formulated a stable form of oil used as a binder for paints, which allowed them to resist fading upon exposure to sunlight and moisture. Using this oil with the pigments also allowed paint to be made less opaque than ever before. Several layers of transparent paint, called glazes, could be laid down in an area, and all those colors would work together to add dimension, catch the light, and make the painted object look real. Using these transparent layers of his paints with his new painting technique, van Eyck painted objects more realistically and with more detail than anyone had before. He delighted in using rare and expensive pigments like ultramarine blue with abandon to create clear and intense colors, like those in Figure 1.8, *The Lucca Madonna*. Van Eyck kept his formula a secret for years, but it eventually became known to the Venetian painting masters, who worked to improve on it.

Leonardo da Vinci (1452–1519)

Leonardo da Vinci named four primary colors in his *Treatise on Painting:* yellow, green, blue, and red. He visualized them on a straight line between black and white.

In his treatise, da Vinci wrote that light shining on an object changes its color, as well as that of nearby objects. Light, he said, reveals some parts of an object, and hides other parts in shadow. It unifies objects that are placed together in a painting, because it casts shadows and reflections on all of them. Light could make colors brighter, lighter, or darker.

Da Vinci pioneered and mastered the art of *chiaroscuro* based on his observations. Chiaroscuro is a painting technique that gives three-dimensional (3-D) depth to two-dimensional (2-D) forms by rendering the shadows and highlights caused by the light source. Da Vinci's *Benois Madonna* in Figure 1.9 shows extensive use of chiaroscuro on both the ermine and the lady. Continuing in the technique of chiaroscuro were painters such as Peter Paul Rubens (1577–1640), Diego Velazquez (1599–1660), and especially Rembrandt (1606–69).

During the Renaissance and even the following four centuries, most artists tended to paint objects

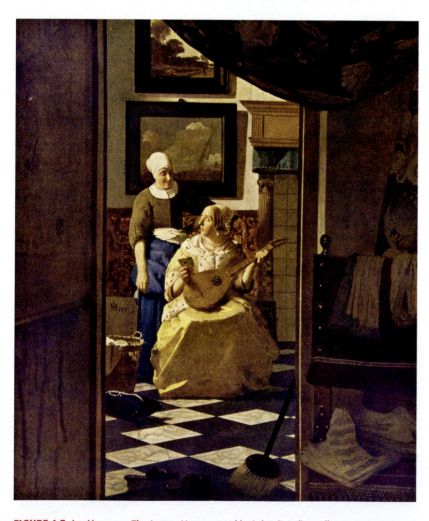

FIGURE 1.7 **Jan Vermeer:** *The Letter.* Vermeer used lapis lazuli, Indian yellow, and carmine. 1669. Oleg Golovnev / Shutterstock.com.

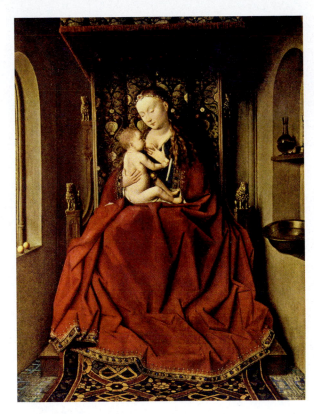

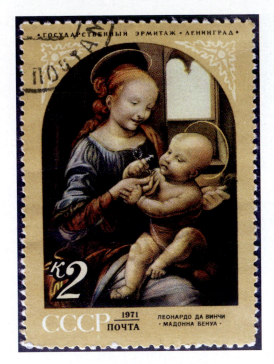

FIGURE 1.9 Leonardo da Vinci: *Benois Madonna,* as depicted on a postage stamp. Da Vinci used the chiaroscuro technique to show highlights and shadows in this painting. 1478. © apzhelez / Fotolia.

FIGURE 1.8 Jan van Eyck: *The Lucca Madonna.* 1436.
Oleg Golovnev / Shutterstock.com.

to appear as bright as possible, ignoring real lighting situations and their effects on color. However, da Vinci believed that the artist should use colors that appeared naturally.

Da Vinci said that to paint naturally occurring colors, the painter had to take into account several phenomena that occurred at the same moment:

- The color of the object (we will call this the *local color*)
- The colors of the adjacent objects
- The lighting source and its color
- The atmospheric conditions of the scene

The first item on da Vinci's list, local color, continues to be an important issue today. The debate rages on as to whether any object actually has its own local color apart from the lighting situation. All types of lighting throw off different colors that influence the color of an object, and when the light diminishes, our eyes are incapable of seeing color.

The most interesting phenomenon is the last on his list: the atmosphere. Da Vinci said, "The surface of every object partakes of the color of the [source of] illumination and of the color of the air that is interposed between the eye and that object, that is, of the color of the transparent medium."[3] This thought is similar to the concepts illustrated by the Impressionist painters much later on, in the late nineteenth century. They were concerned with painting the effects of the atmospheric conditions on natural objects, roads, and buildings.

Isaac Newton (1642–1726)

Isaac Newton conducted a successful experiment, published in 1672, to show that sunlight actually was made up of many colors. He set up a prism that caught the sun's light in a narrow beam and refracted it into sunlight's component hues on a wall 22 feet away, creating an effect like the prism illustration in Figure 1.10. Then he set up another prism to catch that beam of light and turn it back into the white light of the sun. Until that time, the ancient belief still held that color was produced by mixing darkness with light. But Newton's prism experiment changed everything making it clear that light itself was inherently responsible for producing color.

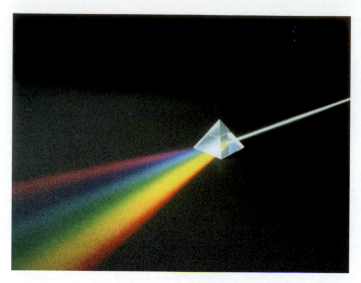

FIGURE 1.10 Prism splitting a beam of white light into the colors of the spectrum. © Imagestate Media Partners Limited - Impact Photos / Alamy.

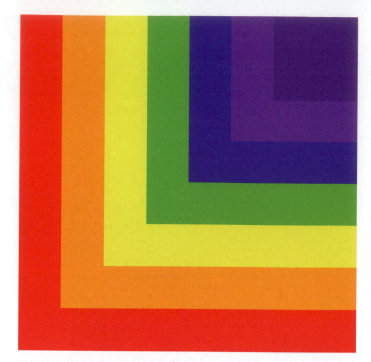

FIGURE 1.11 ROYGBIV—the spectral hues. Marcie Cooperman.

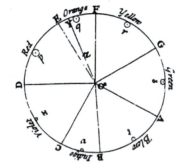

FIGURE 1.12 Newton's color circle. Each hue in Newton's circle has its own segment, which is proportional to its intensity. Newton, 1704, Book I, Part II, Plate III.

Newton distinguished seven spectral hues in the beam of sunlight: red, orange, yellow, green, blue, indigo, and violet, although each hue does not have exact lines of demarcation. In today's art classes, the name for that hue order is an old mnemonic friend, ROYGBIV, illustrated in Figure 1.11. Except for blue and indigo, each hue is in a different color family. *Indigo* is no longer used as a hue name because the human eye cannot distinguish it from other hues. It is thought to be a blue or violet. In color theory, we use the word *violet* to mean the indigo and violet hues.

Newton had an aesthetic reason for identifying seven primary hues, rather than a reason based in science: There are seven notes in a musical octave, and he wanted to relate light to sound. This, he thought, would make the process of choosing colors for a visual composition easy, as one could use the musical notes in chords as a guide. However, choosing colors is so much more complex than just looking at musical chords, because there are many compositional factors involved.

In 1704, Newton published his book *Opticks*, a dissertation of his theories. According to Newton, our perception of color is not only due to the sun; it is a combination of the sun's light being reflected by an object and our eyes' ability to perceive color. He said, "Indeed, rays, properly expressed, are not colored. There is nothing else in them but a certain power or disposition which so conditions them that they produce in us the sensation of this or that color."[4]

We are indebted to Newton for twisting his line of spectral hues into a circle (see Figure 1.12). He did this because he felt that red seemed related to violet, since red mixed with blue makes violet. Because of this circular form, Newton's design allows us to see the relationships that colors have with each other. For example, colors opposite each other are called *complementaries*, and color theorists after Newton noticed that they enhance each other in a composition. We will discuss this important color relationship and others in Chapter 3.

Johann Wolfgang von Goethe (1749–1832)

Johann Wolfgang von Goethe wrote *Zur Farbenlehre (The Theory of Colors)* in 1810, more than 100 years after Newton conducted his light experiment. In his book, Goethe described colors he saw in nature, as well as how he felt about them. He noticed that shadows have

colors, and that after looking at a color for a period of time the eye could see an afterimage of a complementary hue.

Goethe violently disagreed with Newton because he mistakenly believed that Newton did not recognize that the human eye is the tool that allows us to see color. Since the eye senses color, it must be included in an explanation of the experience. To Goethe, Newton was wrong in saying that color was a *scientific* experience produced by the light rays of the sun. Color theory was completely subjective rather than scientific. Goethe was certain that color theory should not be "mixed up with *opticks*."[5] He fought against Newton's ideas bitterly, maintaining his opposition throughout his lifetime. But he neglected to notice that Newton did take the eye into account in explaining that the rays of the sun produce in us the "*sensation* of this or that color."[6]

Goethe believed that colors were generated from the interaction between light and dark, and he thought that white light was indivisible. This concept conflicts with Newton's proof that color comes from sunlight, which *is* divisible into the various hues. However, Goethe was more concerned with how we perceive color than where it comes from. His greatest contribution to the study of color is the concept that our eyes influence perception. Goethe's sketch of the color circle is in Figure 1.13.

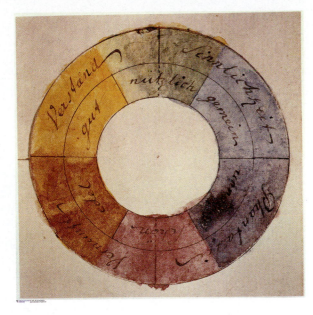

FIGURE 1.13 Johann Wolfgang von Goethe: Sketch of the color circle, 1809. bpk, Berlin / Freies Deutsches Hochstift, Frankfurt am Main, Germany / Art Resource, NY.

Jacques Le Blon (1667–1742)

Jacques Le Blon worked in printing, which made it clear to him that black and white are not primaries. He noticed that only red, yellow, and blue inks can be combined to produce all other hues. He also was the first to realize that mixing all three primaries together produces black, whereas the primaries of light, mixed together, produce white.

Moses Harris (1731–85)

In the *Natural System of Colors* (1766), Moses Harris printed two enormous color circles. The first one placed the primary hues red, yellow, and blue equidistant from each other, and in between them were the secondaries and tertiaries produced by their mixtures. The second color circle illustrated secondary hues and their mixtures, which were types of browns and grays. Each color circle produced 20 different intensity levels in concentric circles, moving toward gray at the center—a total of 360 colors per circle. In the center of each color circle were three triangles of the corresponding primary hues that produced all of the colors.

Philipp Otto Runge (1777–1810)

Until Philipp Otto Runge published his ideas in 1810, color theorists used a straight line or circle to represent all colors. Runge visualized a 3-D sphere (Figure 1.14) to accommodate the achromatic hues black and white at the poles, as well as chromatic hues on the exterior around the equator. The chromatic hues become *tints* as they move toward white at the top, and *shades* as they move toward black at the bottom. Cutting slices into the sphere reveals the chromatic hues moving toward grays, which form the central axis of the sphere.

Michel E. Chevreul (1786–1889)

Michel E. Chevreul is truly the founder of color theory. While all the people we are discussing have offered an important, or even essential, contribution to our study of color theory, Chevreul

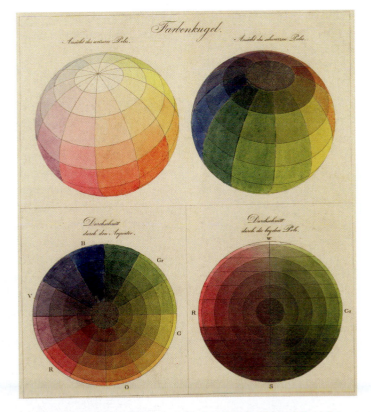

FIGURE 1.14 Philipp Otto Runge: *Farbenkugel (Color Sphere)*. Engraving, aquatint, and watercolor, 8.8" × 7.4". Twelve hues are on the periphery of the sphere; black, gray, and white form the core. On the top row are the top and bottom of the sphere. © The Art Gallery Collection / Alamy.

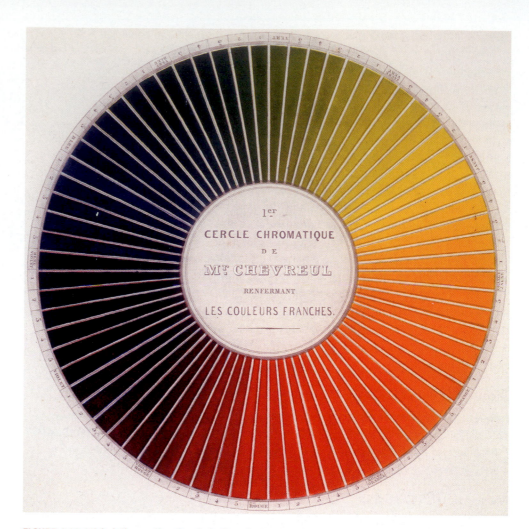

FIGURE 1.15 Michel Chevreul's color circle, from his book *Expose d'un moyen de definir et de nommer les couleurs*, published in Paris by Firmin Didot in 1861 (color lithograph). akg-images.

stands above them all for discovering the mysteries of color interaction, and applying the rules in great detail to many design fields.

Chevreul delineated his laws in his 1839 book *The Principles of Harmony and Contrast of Colors.* Like the scientist that he was, he was careful to back up every one of his concepts with color experiments for each spectral hue. Chevreul's law of *simultaneous contrast* is his most important contribution to color theory. This law states that two adjacent areas of color influence each other's color: Each appears as opposite to the other as possible. Figure 1.15 shows Chevreul's detailed color circle.

Although we have no proof that the Impressionist (late-nineteenth-century) painters read Chevreul's book, their work seems to indicate that they did. They were entirely concerned with using complementary colors to illustrate their impression of the effects of light. And, Neo-Impressionist painters at the turn of the twentieth century paid close attention to Chevreul's laws as a catalyst for their theories for reproducing effects of light on their subjects. In Chapter 3, we will examine Chevreul's laws in greater detail.

Wilhelm Ostwald (1853–1932)

Wilhelm Ostwald wrote *The Color Primer* in 1916, a preferred textbook in color theory classes for decades afterward. Like Chevreul, he was a chemist who was concerned with the fact that some colors were pleasing together and some were not. Ostwald worked to find a mathematical system that would reliably produce harmony. Giving numbers 1 to 24 to each hue on his color circle, he theorized that hues at intervals of 3, 4, 6, 8, or 12 produced harmonious combinations. This means that hues 3 steps apart worked well together; so did

hues 4 steps apart, as well as 6, 8, or 12 steps apart. Ostwald's color harmony schemes were used in the design industry until the 1960s. At that point, they became outmoded, perhaps because of the explosion of color in the psychedelic era.

Hermann von Helmholtz (1821–94)

Hermann von Helmholtz was a scientist who invented the ophthalmoscope. In 1867, he wrote a color handbook called *Treatise on Optics* in which he definitively demonstrated the difference between mixing primary hues of light and mixing primary hues in pigment.

Ogden Rood (1831–1902)

Ogden Rood's books on the human perception of color were well studied by the Neo-Impressionists. *Modern Chromatics,* published in 1879, explained the science of using complements to produce better colors. It also gave directions for mixing small dots of color to produce *luminosity*, the effect of sunlight reflecting from an object, and this formed the basis of the Neo-Impressionists' painting technique. It was Rood's theory that there is no such thing as the local color emanating from an object; color has to be relative to the light situation. In *Modern Chromatics,* Rood also clarified the concept of the intensity of a color, which we will discuss in Chapter 2. Along with Le Blon, Rood was among the first color theorists to understand that mixing primaries in pigments gives a different result from mixing primaries in light. He noted that mixing yellow and blue pigments together would produce some type of green, but mixing yellow and blue light gives "a more or less pure white, but under no circumstances anything approaching green."[7]

A fascinating example of Ogden Rood's Victorian sensibilities would be his distaste for very strong colors "when freely interspersed among those that are weaker."[8] In music, he disapproved of this discord, which produces "beats, which are merely rapid alternations of sound and silence following each other at such intervals as to allow the sensitiveness of the ear to remain at a maximum, and hence producing disagreeably intense sensations which offend."[9] This sounds remarkably like rock music of exactly one hundred years later, which did indeed offend adults in its infancy but has now become the standard in music.

Ewald Hering (1834–1918)

Ewald Hering proposed his theory of opposite colors in 1892, often called the "color opponent" theory. He said that the eye sees three sets of hues that are psychological primaries. Each set is composed of two opposite hues: yellow and blue, red and green, and black and white. Each hue produces an afterimage of its opposite hue. According to Hering's theory, colors cannot be mixtures of yellow and blue, or of red and green, as those are pairs of opposites. Colors can be mixtures of yellow and green, yellow and red, blue and red, or blue and green. The opponent theory is important because it is the basis for CIELAB color measurement also known as LAB,[10] which plots the color that the human eye can see, as we will discuss in Chapter 10.

Albert Munsell (1858–1918)

Albert Munsell was the first to recognize hue, value, and chroma (his word for intensity, or saturation) and the relationships between them. He designed an image that illustrated these relationships.

Many scientists used the sphere to illustrate color, where each hue at its most intense level is on the surface. But since all outside surface points of the sphere are the same distance from the core, this shape does not take into consideration the fact that every hue has a different value at its most intense level. For example, yellow has the highest value, and violet has the lowest, and the other hues' values are in between.

To solve this problem, Munsell designed a 3-D image called a color tree with each hue a branch of a different length, circling the central axis in spectral order (Figure 1.16). His color tree illustrates every hue at every value and chroma (intensity), as well as their relationships

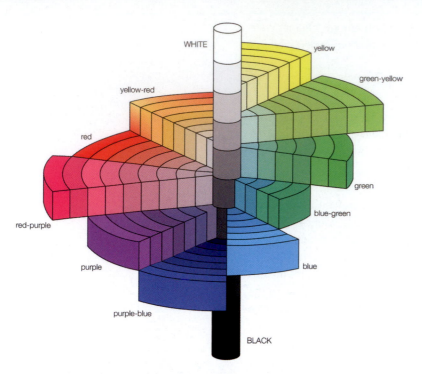

FIGURE 1.16 The Munsell color tree, a 3-D representation of the Munsell system that defines colors by a scale of hue, value, and chroma. © Universal Images Group Limited/Alamy.

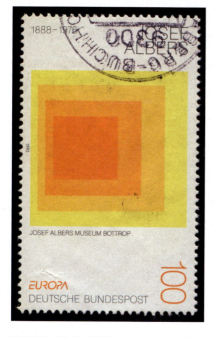

FIGURE 1.17 Josef Albers: *Homage to the Square—Within a Thin Interval,* as depicted on a postage stamp. Oil on masonite, 1967. © rook / age fotostock.

with each other. The central axis illustrates the range of value, with white, the highest value, at the north pole and black, the lowest value, at the south pole, and gradient grays running between them. One hundred hues consisting of the 5 principle hues, (red, yellow, green, blue, and violet), plus intermediate hues occupy horizontal circles around the core, each circle aligned with its corresponding value of gray at the central axis. The hues are at their most intense level at the farthest point from the axis, and least intense (gray) where they join the axis.

An example of a Munsell color notation would be 5PB 6/8. This means 5 violet–blue (which is in the middle of the violet–blue circle), with level 6 value (fairly high) and level 8 chroma. We will define *hue, value,* and *chroma (intensity)* in greater detail in Chapter 2.

In 1905, Munsell devised a system called *A Color Notation* to measure, note, and codify color. His goal was to accurately note how much red, yellow, and blue pigment, plus white or black, was in each color so that manufacturers of pigments could standardize their color formulas. This allowed textile and paint manufacturers to specify exact colors for their products. Today, product colors are so standardized that we can match sheets with towels, and with sofa fabrics, and even with cars. No, we most likely won't be parking our cars in our living rooms, but we may be so enamored of a particular color that we want it for everything.

Josef Albers (1888–1976)

Josef Albers was an artist and a renowned teacher who began his career at the Bauhaus School in Germany. When the Nazis closed the Bauhaus in 1933, Albers moved to America to direct the Black Mountain College in North Carolina, then on to Yale in 1950, where he developed his series of paintings *Homage to the Square* (Figure 1.17). These paintings, which consumed him for the rest of his life, explored using colors together in the simplest of forms—the square. In 1963, as a continuation of the theories of simultaneous contrast formulated by Chevreul, Albers wrote *Interaction of Color.* He is known best for his reputation as an influential teacher of color theory.

summary

These teachers, scientists, and artists, as well as many more who lived after them, explored the elements of color in pigment and in light, and worked hard to explain to students how to understand it. They created charts and graphs to show the primary and secondary hues that we see in the spectrum. Some realized that a more complex shape or structure was necessary to illustrate those colors that can be obtained by mixing primaries and secondaries with black, white, and gray. Some of them devoted their lives to teaching students how to understand what colors are made of and how to work with color. We are especially indebted to Michel Chevreul for his explanations of the fundamentals of color theory, and to Albert Munsell for his color notation system, which allowed color to be easily matched commercially.

Now it's your turn to take advantage of their discoveries and investigate how to successfully work with color in design. This knowledge will open up the world of color for you, and allow you to use it confidently to achieve any of your design goals.

Color Theory History

Color Perception and the Elements of Color:
Hue, Value, and Intensity

What Is Color Perception?

LOCAL COLOR

The color we perceive on the surface of an object, which we call the object's **local color** and think of as its real color, is not a consistent quality. We could not say that this object is visually always that color. That is because we know today, after centuries of research into color theory, that the colors we see are formed by a combination of light and our eye's ability to perceive them, as well as our brain's ability to process the information. The color of an object is a matter of perception and lighting, not an absolute fact.

In Figure 2.1, you can see the color effects of a particular light situation produced by the time of day and ambient weather conditions on the Galapagos Islands. On another day, at another time, the color of the sea and sky would be entirely different.

As another example, the color of a McIntosh apple may definitely appear to you to be a combination of red and green, but take a look at it in the dark; what do you see? Certainly not red and green; most likely the apple is now a range of grays. Shine a strong incandescent light on one side, and again the colors vary: The lit side is brighter, possibly with yellower

FIGURE 2.1 Joel Schilling: *Galapagos Landscape #3.* Galapagos Islands, Ecuador, photograph, 2009. Joel Schilling.

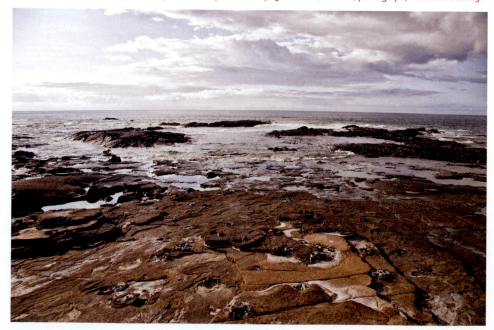

reds and greens. The other side is in shadow, but it is not without color. The shadows have added low value blue to the apple's color at that spot.

If you have a fluorescent light, you can see amazing changes in that same apple, as the colors will appear to be different from what they were under incandescent light. Clearly, the lighting situation has something to do with what we see.

But the color also depends on something as hard to pin down as the eye's perception. Perhaps you know someone who has color blindness. That person may not have the ability to see red, or green, or some other color. Without knowing exactly how he or she sees, you still know that what the person sees is different from what you see. Because of our biological differences, even people who supposedly have no such deficiencies will see colors of the same object differently.

And just to complicate matters, our perception of the color of an object also depends on the colors adjacent to it. Surrounding colors do two things:

1. **They influence the color that a neighboring object appears to have.** This influence of color on color is also known as simultaneous contrast, a concept that we will examine in Chapter 3.

2. **They reflect colored light on an object.** For example, if a white cup is surrounded by a red tablecloth, the red of the tablecloth will reflect on the white cup. How long we look at this scene can also change our perception of it. After a few seconds, the eye tires of the red and makes us see the greenish glow of its opposite hue; this glow will also reflect on the object.

Psychologically, we evaluate and judge the colors we see from the point of view of our own cultural attitudes. Different cultures attach different meanings to the colors as well as the objects being viewed, which affects how we feel about them. For example, in some cultures white means purity while in others it is symbolic of death. In Chapter 10, we will discuss in depth the cultural meanings of color.

All in all, these differences in perception make it essential for manufacturers of such daily products as sheets, towels, cars, and clothing to evaluate and measure the colors they need to use. They need to make sure that the colors appeal to their customers. And working with colors professionally creates the necessity for standards in color language, so that all suppliers and producers are talking about the same colors.

THE VISIBLE LIGHT SPECTRUM: ELECTROMAGNETIC WAVES

Visible light, ultraviolet waves, infrared light, x-rays, and microwaves—you are familiar with all of these in some way, but did you know that they are all the same thing? They are all electromagnetic rays, essentially *radiation*, emanating from the sun through outer space to Earth.

Visible light and microwaves don't seem to have anything in common. If they are the same thing, why do they appear to be so different? More relevant to our study, why is it impossible to see all of these waves except for light waves?

The crucial difference comes from the particular wavelength of the electromagnetic ray. The only waves with dimensions that the human eye can see are light waves. They exist in a very narrow band of waves in the electromagnetic spectrum, from 400 to 700 nanometers (a nanometer is one billionth of a meter). These wavelengths produce light composed of seven different identifiable wavelengths, each of which the eye perceives as a **spectral hue**; these are the hues we identified in Chapter 1 as ROYGBIV (red, orange, yellow, green, blue, indigo, violet).

Red is the longest wavelength, and violet the shortest. When they strike your eye in a sunbeam, all the colors combine as clear white light. But many things can refract them into the rainbows of visible color: a prism, lead crystal, oil, "interference" flakes of titanium-coated mica that are sometimes used in paint finishes (for nail polish, cars, toys, and product packaging), bird feathers, butterfly wings, beetles, bubbles, ice crystals, and drops of water in the atmosphere that produce a "real" rainbow when the sun shines through. For example, the atmosphere on Maui, Hawaii, in the area where the leeward side and the windward side meet, has so much moisture that there are rainbows every day.

key terms

acromatic (hues)
additive (process)
balance
broken (hues)
chiaroscuro
chromatic hues
color circle
fluting
gradient
hue
intensity (chroma, saturation)
local color
middle gray
pigments
primary (hues)
secondary (hues)
shade
spectral hue
subtractive color
tertiary (hues)
tint
tone
unity
value
value scale

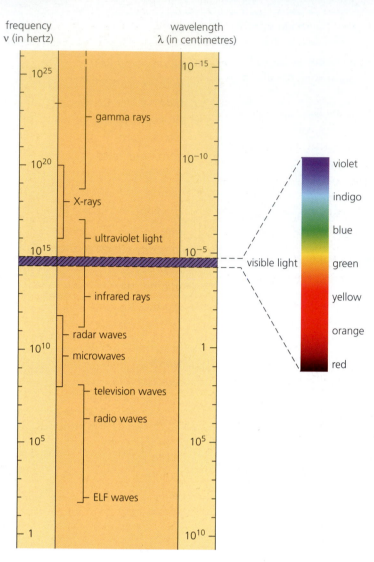

frequency
ν (in hertz)

wavelength
λ (in centimetres)

- 10^{25}
- 10^{-15}

gamma rays

- 10^{20}
- 10^{-10}

X-rays

ultraviolet light

- 10^{15}
- 10^{-5}

visible light

violet

indigo

blue

green

yellow

orange

red

infrared rays

- 10^{10}
- radar waves
- microwaves
- 1

television waves

radio waves

- 10^{5}
- 10^{5}

ELF waves

- 1
- 10^{10}

FIGURE 2.2 The visible light spectrum in the range of electromagnetic radiation.

Figure 2.2 illustrates the range of electromagnetic waves, ranging from the lowest and longest wavelengths, which are called ELF (ultra-low frequencies), to gamma rays, which have the smallest and most energetic wavelength. Visible light waves can be seen in the middle of the spectrum as a very small band, relative to the size of the range of waves.

Visible light is a color system. Light wavelengths reflect from the surfaces of everything we look at, and determine the colors that we see. An object appears to be a certain hue because it reflects the visible light wavelengths of that hue. The other light wavelengths are absorbed, and these are the hues that we do not see in that object. For example, an object looks blue because it reflects the wavelengths that our eye interprets as blue. The blue object absorbs the red or green wavelengths, and it does not look like those hues.

The object will *always* reflect the same hue when the same light source hits it. The physical properties of an object that allow it to reflect a specific color are independent of the amount of light available. Even in a low-light situation, where there might be only 20 percent of the amount of light in a bright-light situation, the properties are intact. We may not see the actual hue because we do not have enough light to see, but the properties of reflectance are still in effect.

In Chapter 10, we will discuss measuring the reflectance of light to determine an object's hue, as well as matching color in industry.

Subtractive and Additive Systems of Color: Pigments Versus Light

Pigment and *light* are two different color systems, each with corresponding primary and secondary hues (both terms are defined later in the chapter). In this text, we will be working with pigments to produce two-dimensional compositions, and therefore we will be concerned with their primaries and secondaries, with a focus on the interaction of colors.

PIGMENTS—THE SUBTRACTIVE SYSTEM

Pigments are colors obtained from rocks and clay, organic materials like plants and flowers, and residues created by insects. They are ground and blended, boiled or combined with chemicals, ultimately producing the hues used for paints and printing inks. To make different types of paints, the pigments are blended with a medium, and sometimes driers, anti-foaming agents and other substances.

The hues we see depend on the pigments used. When light hits an object, the pigment absorbs some of the light rays, and reflects others back to our eye. The light rays that are reflected are those of the hue from that object.

Why are pigments called the **subtractive color** system? This is because when two hues of paint are mixed together, the original hues disappear and a third one results. For example, mixing yellow and blue results in green (see Figure 2.3).

The pigment primaries are red, blue, and yellow. Red and blue produce the secondary hue violet; blue and yellow produce green; red and yellow produce orange. With pigments, the combination of all hues is black, and the absence of all hues is white.

LIGHT—THE ADDITIVE SYSTEM

We call mixing light rays together an **additive** process. A light-based system is relevant to anyone working with light in the theater or television, on videos, or on websites viewed on a computer monitor. This system of light has different primaries—and produces totally different results—than the subtractive system (see Figure 2.4).

Whether we see light from the sun or from lamps or on the computer screen, this system has consistent rules about its primaries and its secondary color mixtures. The primaries are red, blue, and green. Red and blue produce the secondary hue magenta; blue and green produce cyan; red and green produce yellow. In light, the combination of all hues is white, and the absence of all hues is black (because there is no light).

How We See

This section describes the two influential factors responsible for the colors we see around us.

- **Our human physical properties.** Rods and Cones explains how our eyes perform the task of color vision. Psychological Perception and Color Comprehension examines how our brains allow us to comprehend the nature of color, and describe it to others.
- **Type of Lighting.** The source of light alters the color of the object, and the light levels work with our rods and cones to influence what we see.

HUMAN PHYSICAL PROPERTIES

Rods and Cones

Our retinas have two distinctive kinds of photoreceptors that allow us to see: rods and cones. The rods are much more active at low levels of light than the cones; this means that in a room with very little light, we are primarily using our rods to see. They enable us to see basic shapes.

But the rods do not perceive color. Only the cones are responsible for our ability to see color. Since the cones need light to work, we have no color vision at low levels of light. You might have noticed that you can't see clearly what color things are at night.

There are three different types of cones in the retina, each of which can absorb one color of the light that is reflected from an object: red, green, or blue. These three colors are called the eye's **primary** colors. When an object appears to us to be a certain hue, it is reflecting that hue's wavelengths and absorbing all other hues. Objects that are colors other than red, green, or blue are a combination of these primary hues, and they cause the corresponding cones to respond.

From person to person, there is a wide variation in the shapes and distribution of rods and cones, just like other

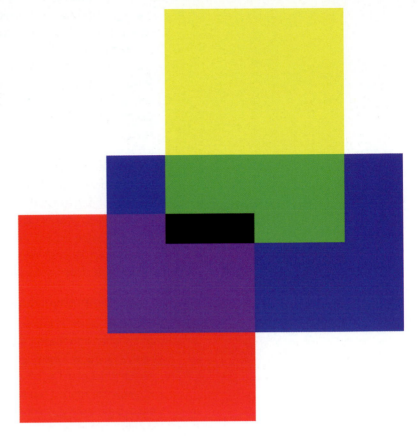

FIGURE 2.3 Subtractive system: Primary hues include red, blue, and yellow; secondary hues include orange, green, and violet. The mixture of all three primary hues is black. Marcie Cooperman.

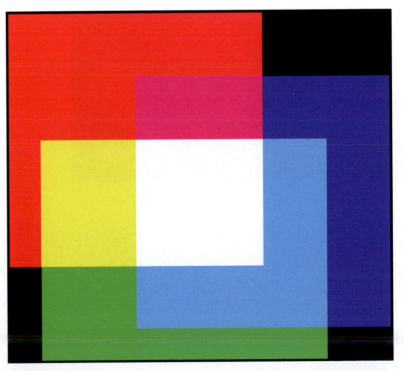

FIGURE 2.4 Additive system: Primary hues include red, blue, and green; secondary hues include yellow, cyan, and magenta. The mixture of all three primaries is white. Marcie Cooperman.

physical variations. This variation affects the way a person sees shapes and color. Some people are color blind because the type of cone that perceives a certain color is missing in their retinas.

Did you know that birds see with far greater acuity than humans? Birds can actually see ultraviolet light, magnetic fields (produced by magnets and electrical currents), and polarized light. Their retinas have four types of light receptors, as opposed to our two, and birds have more nerve connections between the photoreceptors and the brain. They need better vision to navigate their relatively tougher life, flying and foraging for food. Birds of prey need to see their food source from high in the air. Sea birds especially need the ability to see amid misty conditions and water reflections.

Psychological Perception

In tandem with the lighting situation and the physical aspects of the eye, we see color because our brain allows this sense to exist. Here's an example of how your brain controls what you see: Press your fingers gently against your closed eyes. Do colors appear? They do, but your eyes were closed! Another example: Do you dream in color? If you have ever seen a color in your dreams, with your eyes closed during sleep, then you know that vision is actually a sense that does not completely depend on what the eye sees.

Color Comprehension

Our brains allow us to perceive and identify color as well as forms, even in less than ideal situations when information is missing. We can identify the color of a white piece of paper that is partly in shadow, where some of the sides appear to be gray. If lit by colored lights, we still understand the paper to be white. Even with the variations produced by different materials such as shiny silk, rubbed suede, or translucent neon light, we can interpret the hue. The human brain ignores the variations that are actually there, and identifies the color that we understand should be there. Even if we don't actually perceive the color, we think we know what color it is.

TYPE OF LIGHTING

What color is an object on the table in front of you? Do objects really have their own color—their local color? Does that color always appear to be the same, no matter what time of day it is seen? Since light and shadow influence an object's color, the question arises as to whether there is in fact something called *local color*.

Color perception depends on the light source, in addition to the cones in our retinas. We know this is true because we can see that the color of an object sometimes changes when it is placed under different types of lights. Incandescent light has a slightly yellow cast, but is closest to the white light of the sun. Fluorescent light can be bluish or pink. Sodium light, in many streetlights, has an orange glow. Should you be lucky enough to have a color-viewing light box, the traditional tool for color physicists, you would be able to turn on various types of lights and see how they change the color of an object. To provide the whitest light for your design work, it is best to use a combination of incandescent and fluorescent bulbs. Figure 2.5 illustrates various types of light bulbs.

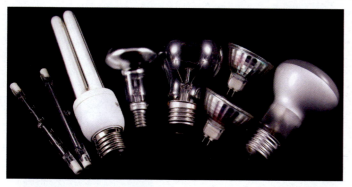

FIGURE 2.5 Tungsten and other types of lightbulbs. BlackSnake / Shutterstock.com.

Balance and Unity—Basic Definitions

Balance and *unity* are two concepts that are important to any composition, and even before we discuss them in depth later in this book, it is a good idea to have a rudimentary understanding of both terms. As we discuss the elements of color in this chapter, and move through succeeding chapters, keep the concepts of balance and unity in mind. In Chapter 6, we will examine them in detail, and you will then gain a full understanding of how to achieve them.

Simply defined, **balance** means that no side of the composition seems to be heavier than the other side, appearing as if it were about to fall over.

Unity means that no element appears to be overwhelming in terms of hue, value or intensity, or size or location. It means that every element in the composition works together in conveying the same visual idea. This doesn't mean that the design elements are all the same, just that there isn't one that appears to be too strong compared to the others. As you gain expertise in creating successful compositions, you will also learn how to create excitement in your work by using various levels of strength in color.

The Three Elements of Color: Hue, Value, and Intensity

If your friend asks you to paint a room blue, very shortly you will feel the need to ask more questions. What kind of blue should it be? A blue that looks like the summer sky? A blue that is like the color of the Caribbean Sea? Or a blue like the deep part of the Pacific Ocean? Light or dark? A bright blue or a dull blue? These questions illustrate that describing a color is more complex than saying, "It is blue." In your quest to understand what your friend meant, you have actually referred to the three basic elements of color: hue, value, and intensity. Let's explore these concepts in depth.

HUE

Hue is the color name (blue, red, etc.). The word *hue* tells us nothing about how light or dark a color is (that refers to *value,* which is discussed later), or about how saturated and intense it is (that refers to *intensity,* also discussed in the following text); it tells us only what we would call it. We differentiate *hue* from *color* because when we use the word *color,* we are referring to the total combination of the three elements of color: hue, value, and intensity. When we ask what hue an object is, we want to know only the color name, such as red or blue.

Spectral Hues

Spectral hues are the seven hues that can be refracted from the white light of the sun (see the discussion of ROYGBIV in Chapter 1).

Chromatic Hues

Chromatic hues include the spectral hues, their mixtures, and any hues that are mixed with black, white, or gray, such as broken hues. We say these hues have **chroma**, as opposed to black, white, and gray. Only black, white, and gray are not chromatic hues because they have no chroma.

Achromatic Hues

Black, white, and gray are considered **achromatic** because they have no chroma (Figure 2.6). They are not found in the spectrum, and they are not mixtures of chromatic hues. White is the lightest hue possible because it reflects 100 percent of the light. Black is the darkest hue possible because it reflects none of the light and absorbs all of it, and each value of gray reflects a portion of the light.

Primary Hues

Red, yellow, and blue are the three pigment **primary hues** (Figure 2.7). They are primary because you cannot mix other colors together to get them. Mixed together two at a time in specific but not equal percentages, primaries produce the secondary hues. Each primary hue is pure, meaning that it has absolutely none of the other primaries in it.

Secondary Hues

Orange, green, and violet are the **secondary hues** (Figure 2.8). Orange is the result of mixing red and yellow; green comes from mixing blue and yellow; and violet is the result of mixing blue and red. When using pigments in your paint box to mix

FIGURE 2.6 Achromatic hues: Black, white, and gray. Marcie Cooperman.

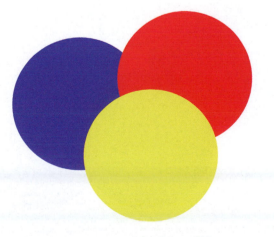

FIGURE 2.7 Primary hues: Red, yellow, and blue. Marcie Cooperman.

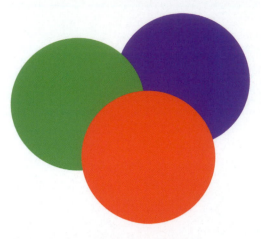

FIGURE 2.8 Secondary hues: Orange, green, and violet. Marcie Cooperman.

FIGURE 2.9 Cynthia Packard: *Beach-Forest*. 154″ × 96″, oil and wax on board, 2010. Cynthia Packard.

FIGURE 2.10 Some tertiary hues: Orange–yellow, orange–red, red–violet, violet–blue, blue–green, yellow–green. Marcie Cooperman.

secondary hues from primary hues, you must choose hues that are as similar to the pure primary hues as possible. This means that the red you choose should not appear to have any yellow in it, which would make it lean toward orange, and it should not seem to have blue in it, which would make it lean toward violet. Your blue should not have any red in it, which would make it appear more violet, and it shouldn't have yellow in it, which would make it look greenish. Your yellow should not have any red in it, which would make it look more orange, and it shouldn't have blue in it, which would make it look greenish. If your hues are not pure, you are actually mixing *three* primaries together, and your result will be brown.

Cynthia Packard's *Beach-Forest* in Figure 2.9 illustrates how the secondary hues of orange and green look when placed in a composition together with black and a high value red.

Tertiary Hues

Tertiary hues are those between the primary and secondary hues on the color circle (Figure 2.10). To name them, use the descriptive color name first, and the color being described second. For example, orange–red is actually red with some yellow in it so that it begins to move toward orange. Red–orange is actually orange, but it leans toward red. True orange, in comparison, is visually in the middle between yellow and red. The other tertiary hues can be named in the same way.

Broken Hues

Broken, or intermediary, hues are hues that have been mixed with gray, black, or white (Figure 2.11). In pigments, two complementary hues can also be mixed together to make a broken hue. Complements are opposite each other on the color circle. (We will discuss complements and other color relationships in Chapter 3.) Browns are a good example of broken hues made by mixing complements. The term *broken* most likely refers to the fact that they are not hues that are found on the color circle, and their intensity is lower than that of pure hues. (We will discuss intensity later in this chapter.)

Hue Names

Describing a color accurately involves translating a visual image into language. To be consistent, we need a good system and commonly accepted words. But even though we do have a system that is used by professionals, laypeople generally use words of their own preference to describe colors. Their meanings are inexact and are subject to many interpretations. For example, the words *shade* and *tone* are both often used incorrectly to mean varieties of one color. Does the phrase "a shade of green" mean a lighter or darker version, or a green slightly different because it has a yellowish cast to it? Or does it mean a bright or dull green? You might be using the phrase "a shade of green" to mean all of these things.

Many of our descriptive words come from animals, plants, or minerals. We use them with confidence, not realizing that they have different meanings to different people. How dark is forest green, and what kind of green is it—yellowish or bluish? Is taupe dark or light, brownish or grayish, or tending toward some hue? Which is darker, beige or tan? How bright a pink is salmon, and have you ever actually seen coral that was coral pink? Does sage appear to be more of a gray, more of a green, or is it a yellow? Is khaki actually a green, a beige, or a gray? What is the difference between sky blue and baby blue? Some more inaccurate, yet well-used, names are aqua, teal, and periwinkle, and the inscrutable mauve. Since we cannot agree about hue names like these, and we do not all have the

ability to see and assess color accurately, real hue names whose meanings are clear to everybody should be used.

The presence of unhelpful or even ridiculous color names was relevant even in 1891. A writer named J. G. Vibert wrote a satire called *The Science of Painting,* featuring the colorist Michel Chevreul. Chevreul tells a young artist that because of his color system, the artist could now replace hard to understand terms such as "turtledove-gray," "dead-leaf," "nymph pink," and "Dauphin brown"[1] with real hue names. Over one hundred years later, dove-gray is acceptable as a color name, thus continuing evidence of Vibert's call for sarcasm.

There are a limited number of accepted hue names in color theory. These are red, blue, yellow, green, orange, violet, pink, brown, black, gray, and white. But, out of all of those, only black and white are singular and absolute. Each hue name can refer to a range of color, as we can see by looking at the color circle. For example, green can range from extremely yellowish, through basic pure green, to a blue–green. Red could describe hues starting at reddish orange, through pure red, to a violet–red.

FIGURE 2.11 Broken hues. Marcie Cooperman.

To solve that problem, we can use hue names together to define a color and distinguish it from one that is similar; for example, red–violet or blue–violet. It is easy to understand what type of violet each one is. We can describe a specific red by noting whether it appears to have yellow in it (it would tend toward orange and be called orange–red), or blue (it would tend toward violet and be called violet–red). We can do the same for blue: If it has yellow in it, it would be a greener blue, called green–blue; if it has red in it, it would tend toward violet and be called violet–blue. For yellow, if it has red in it, it would tend toward orange and be called orange–yellow; if it has blue in it, it would tend toward green and be called green–yellow. Of course, we can describe the secondary hues the same way.

Color Temperature

People like to describe colors in terms of whether they are warm or cool. Color temperature is technically not an element of color, like hue, value, or intensity, but it is a handy way to describe a color. Warm colors have some red in them, and cool colors have blue in them. With the addition of red to any hue, we can see that its color temperature appears to become warmer. A good example is red–violet (the left-hand oval shown in Figure 2.12). With the addition of blue, a color's temperature appears to become cooler, like blue–violet (see the right-hand oval in Figure 2.12). We would call red warm by its very nature, and consider any type of violet warmer than blue or green. However, as we will see time and again, everything about color is relative to its situation in the composition, and color temperature is no exception. For example, a violet that seems warm when placed on a blue background can be made to feel quite cool when placed next to a warmer color like red. Figure 2.13 illustrates how yellow warms up when red is added, and Figure 2.14 shows a warmer blue next to cyan, which is a cooler blue.

Tints, Tones, and Shades

When white, black, or gray are mixed into a hue, the result is a color that becomes lower in intensity because the percentage of the original hue has become lower. In Liron Sissman's *Cycle of Life* in Figure 2.18, the complementary hues red and green are tints in the flowers and shades in the leaves.

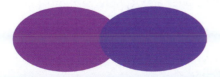

FIGURE 2.12 Warm violet (left), cool violet (right). Marcie Cooperman.

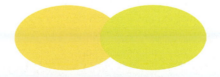

FIGURE 2.13 Warm yellow (left), cool yellow (right). Marcie Cooperman.

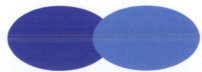

FIGURE 2.14 Warm blue (left), cool blue (right). Marcie Cooperman.

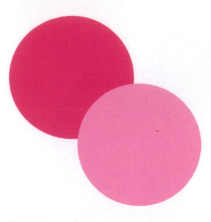

FIGURE 2.15 Magenta mixed with white is a tint. Marcie Cooperman.

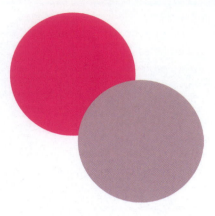

FIGURE 2.16 Magenta mixed with gray is a tone. Marcie Cooperman.

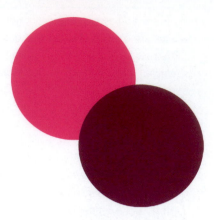

FIGURE 2.17 Magenta mixed with black is a shade. Marcie Cooperman.

FIGURE 2.18 Liron Sissman: *Cycle of Life*. 20" × 24", 2005. Private collection, Liron Sissman. Tints and shades and complementary hues are the color story of this painting. Liron Sissman.

Mixing a hue with white is called a **tint** (Figure 2.15).

Mixing a hue with gray is called a **tone** (Figure 2.16).

Mixing a hue with black is called a **shade** (Figure 2.17).

The Color Circle

A **color circle** is a basic tool for organizing hues and illustrating their relationships with each other. A basic color circle includes the three primaries and three secondaries, a total of only six hues. Using 12 different hues, like the color circle in Figure 2.19, allows the color circle to illustrate some tertiary hues. But to really illustrate how the hues move from one to the next and help us visualize color relationships, a color circle could have 18 different hues, which would include the three primaries and secondaries as well as two tertiary hues placed between each primary and secondary. You can continue inserting tertiary hues between the hues until there are no discernible differences between them, but this would not be an effective tool to use in working with color.

Newton designed the first color circle with the seven hues that he identified in the spectrum, uniting the red and violet to show their similarity. Johannes Itten (1888–1967), a world-renowned color expert, published a 12-hue color circle in his 1961 book *The Art of Color*. Inside his circle of primary hues were triangles of the secondary hues that pointed to their primary *parents*. Itten was a painter and a teacher at the Bauhaus from 1919–1922, after which he opened his own art school in Berlin from 1926–1934, and moved on to hold administrative posts at other schools and museums.

Only spectral hues are represented on a 2-dimensional color circle. There are no tints, tones and shades, or broken colors. To include all of those as well, color theorists since Newton have attempted to invent other ways of visually representing all possible colors. Munsell's 3-dimensional color tree is the most successful, and he parlayed that success into a color notation service for designers. (See Chapter 1 for information about Munsell.)

Certain color and placement rules must be followed in constructing a color circle. Hues should be placed accurately so that the complementary hues are opposite each other, and the jumps between each hue are equal. (We will discuss complements and other color relationships in detail in Chapter 3.)

The complements are:

▲ red ▲ green
▲ blue ▲ orange
▲ yellow ▲ violet

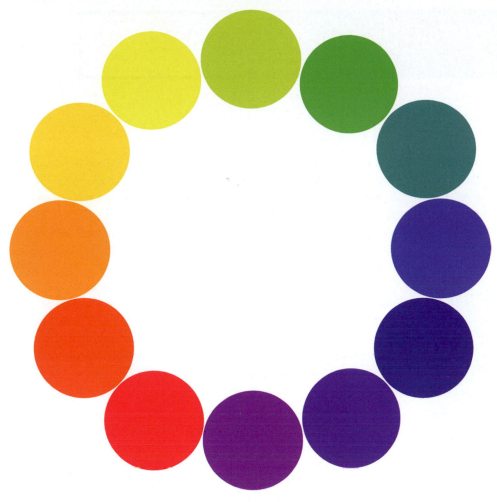

FIGURE 2.19 Color circle. In chromatic order around the circle, with primaries and secondaries bolded, the hue names are red, red–orange, orange, yellow–orange, yellow, yellow–green, green, blue–green, blue, blue–violet, violet, red–violet. Marcie Cooperman.

VALUE

Value—how light or dark a color is—is the second piece of information we need to accurately describe a color. In describing the color of a shirt to friends, we can convey more information about the color by saying "It is a light blue" rather than merely "It is blue." The shirt example explains the concept of value. We can say a color has a *high value*, or a *light value*. The opposite would be a color that has a *low value*, or a *dark value*. High values reflect more light than low values. Color theorists use the term *brightness* to describe this light reflectance. The word *value* has only recently become used as a description of how light or dark a color is. Munsell emphasized that meaning in 1905, in order to keep professional terminology consistent.

We can understand the meaning of value most clearly on an achromatic **value scale** like Figure 2.20, where white has the highest value possible, and black has the lowest value possible. On a scale from 1 to 9, absolute black is located at 1 and absolute white is at 9, with all other values existing as the grays between them. The value scale is useful when comparing two grays because it offers a comparison in a numerical, easily understood order.

In reality, there may be infinite steps on the value scale between one value and another, but the human eye is not capable of distinguishing more than a few steps. If you are wide awake and the light is good, it might be possible to place a value (call it "1.5") between two that you already have ("1" and "2"), where the steps are no longer discernible between

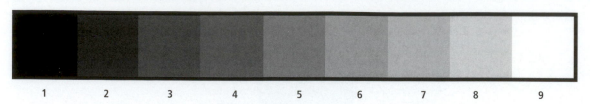

FIGURE 2.20 On this value scale, 5 is middle gray. Marcie Cooperman.

them. Then, 1 looks extremely similar to 1.5, and 1.5 looks almost exactly like 2—they all appear to be the same value. However, you would know they are not all the same, because if you remove 1.5, you'd see the difference between 1 and 2. To keep the scale simple and usable, it is best to keep 1 and 2, but not 1.5.

Tints, tones, and shades are examples of value. Tints, because they are lightened by white, are higher values. Shades, because they have black mixed into them, are lower values. Tones are middle values.

Each of the spectral hues has a measurable value level that corresponds to a specific gray on the value scale. For example, yellow has a higher value than red; this is because a lighter color like yellow reflects more light than red. In other words, yellow is brighter. Red and green have similar values. Red is lighter than blue, and violet is darker than blue. Orange is between yellow and red in brightness.

Middle Gray

The value we call **middle gray** appears to be the point halfway between black and white, at No. 5 in Figure 2.20. Middle gray is a useful value to be familiar with, a tool to help you observe values more carefully. Keeping this value in your head and being able to refer to it mentally allows you to compare and place the value of a gray in its proper location on the value scale.

Value Comparison

How do we compare values? The values of two colors can be compared with each other using one of two methods:

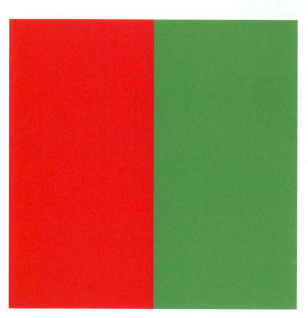

FIGURE 2.21 The red is lower in value than the green.
Marcie Cooperman.

1. **Compare two colors side-by-side.** Squint your eyes. When you squint your eyes, you are allowing the rods in your retinas to take over the job of vision from the cones, and the rods do not receive color information. But they do allow you to discern lighter and darker value levels without being distracted by hue. Squinting as you compare two colors side-by-side allows you to see if one is darker than the other. If it is, the edge where the two colors meet will be visible. If they are the same value, they will blend into one another, appearing to be the same color. Use this method to assess the red and green in Figure 2.21, the tints in Figure 2.22, and the shades in Figure 2.23. How do the values in each figure compare?

FIGURE 2.22 The yellow–green tint on the left is the same value as the yellow tint on the right. Marcie Cooperman.

2. **Compare one color at a time with alternating values of gray.** Every color has a value that can correspond to a level of gray that visually describes how light or dark it is, without the distraction of a chromatic hue. Using the same method of squinting, compare one color at a time with alternating values of gray on the achromatic value scale, to see which one matches it with no visible line where they meet, as in Figures 2.24 and 2.25. By comparing the grays to each other, you can see which one is darker as in Figure 2.26.

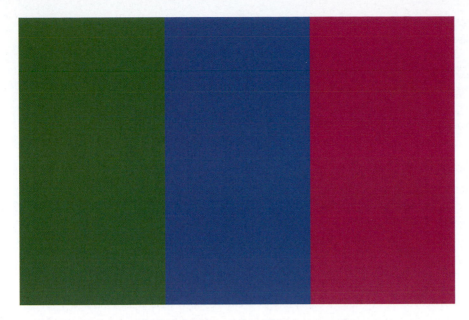

FIGURE 2.23 These three shades have the same low value. Marcie Cooperman.

FIGURE 2.24 Step 1: Compare the red to the three values. The matching value is the gray in the center. Marcie Cooperman.

FIGURE 2.25 Step 2: Compare the green to the three values. The matching value is the gray on the right. Marcie Cooperman.

Fluting

Take a good look at your completed value scale from Exercise No.1, and you might notice something unusual. Even though you know that each gray step is a single value, when they are lined up together, each gray appears to change value slightly at the borders of its two neighboring values. The edge that meets the higher value will appear darker, and the edge that meets the lower value on the opposite side will appear lighter. It is so strong an effect that you might have to isolate the value from its neighboring steps to check whether things have changed overnight! Of course, when you do that, you are eliminating the effect of the nearby steps and you can see that the value of that step is perfectly level.

This fascinating phenomenon is called **fluting**, also known as Mach Bands. It is an illusion of comparison that illustrates a basic law in color theory: The value of any color makes an adjacent one as different from it as

(a) (b)

FIGURE 2.26 Step 3: Compare these grays. The value for red is lower than the value for green. (a) Gray match for green (b) Gray match for red. Marcie Cooperman.

possible. Michel Chevreul stated this in his law of simultaneous contrast, which we will discuss in the introduction to Chapter 3.

For any color, wider areas appear to have lower value than narrower areas. For example, a composition of thin horizontal black lines will appear to be higher in value than a black rectangle. This is because the black and white areas are optically mixing together to form gray. The hedcut in Figure 2.27 (short for headline cut) is produced by black dots, all of which are the same value. Dots farther from each other mix with the surrounding white and produce a higher value than dots close together.

Gradient Values

Achromatic or monochromatic values can offer various arrangement possibilities in a composition. Several values of one hue (they are monochromatic) lined up in sequence from lightest to darkest, as in Figure 2.28, are said to be in **gradient** order. *Early Morning* expresses distance through gradient values in Figure 2.31. The value chart in Figure 2.20 and Figure 2.29 are achromatic examples of values in gradient order, unlike the values in Figure 2.30.

Chiaroscuro A painting technique called **chiaroscuro** uses three or more values in gradient order to make an object appear to be a three-dimensional form, when there is one light source. Leonardo da Vinci was the most talented painter in the execution of this technique.

Figure 2.32 illustrates chiaroscuro with a ball on a table. When using chiaroscuro to render a form, an artist considers the object, and the surface or table on which it is resting. The artist works with six specific areas of light and shadow. Highlight, light, shadow, and reflected light from nearby surfaces are areas on the surface of the object, the core of shadow is the crevice between the object and the table, and the shadow cast from the object is on the table.

As a general rule, for each area you can assign value stages on a scale of 1 to 10. The number of value steps between each may vary depending on the lighting situation.

If the surface of the object is hypothetically 8, here are appropriate values stages for each area:

Highlight on the object: 9–10

Light on the object: 8

Shadow on the object: 5

Reflected light on the object from nearby surfaces: 8–9

Core of shadow where the object meets the surface: 1

The shadow cast from the object on the surface: 4

Value Conveys Information

Value is the most important element of color in a composition because it has the greatest influence on the composition's balance. The arrangement of values in a composition gives us visual information. Skillfully placed values can provide a framework for understanding where things are located in that perceptual space. Poorly chosen or arranged values could destroy balance. When several levels of values are used, they contrast with each other, and can perform many functions for the designer. They can move the eye around the composition in specific, consistent ways.

What type of information does value convey?

- Value describes perspective in 3-D space. We define how far back objects seem to go in relation to each other because of their values. Value can show us depth of field and the effect of great distance. For example, when mountains are far away, the atmosphere renders them higher in value as well as less intense. Figure 2.33 illustrates higher values

FIGURE 2.27 In this "hedcut" drawing, all the lines are the same value of ink, but the varied size and shape of lines produces several visual levels of value.

FIGURE 2.28 A tint, a tone, and a shade of red are in gradient order of value. Marcie Cooperman.

FIGURE 2.29 These values are in gradient order. Marcie Cooperman.

FIGURE 2.30 These values are not in gradient order. Marcie Cooperman.

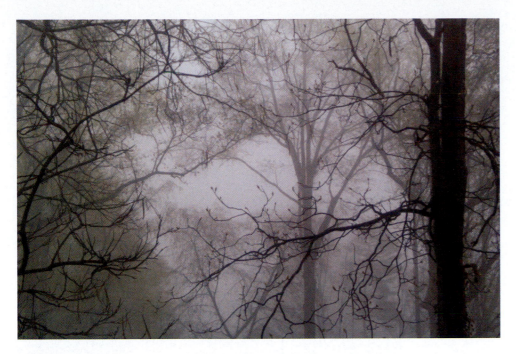

FIGURE 2.31 Marcie Cooperman: *Early Morning.* Photograph, 2011. Marcie Cooperman.

along the sides of the buildings in the distance. (Chapter 7 will discuss planes and visual movement in compositions.)

- Lower values can describe shadowy depth inside a tube or a tunnel, or the darkness under trees.

- In a two-dimensional (2-D) pattern, we distinguish between perceptual locations of the various areas because of their values. Higher values appear to be closer to the eye than lower value areas, which appear to be on a plane farther back. Substituting values in a pattern completely changes their locations relative to each other. (Chapter 13 will explore patterns in depth.)

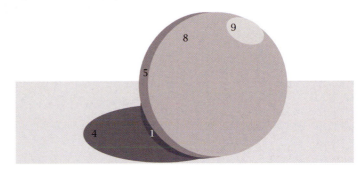

FIGURE 2.32 Illustration of chiaroscuro. Marcie Cooperman.

- Value conveys to us the time of day because of the relative quality of light and shadow. Bright shadowless effects mean midday brightness, whereas long shadows indicate late afternoon.

Value Contrasts Perform Many Functions

Contrasts in value can perform many functions for a composition, because they are effective at attracting the eye.

Value contrasts can:

- Lead the eye in any direction through the composition. In Figure 2.34, values show us the focal point in the center.

- Play optical tricks and seem to produce other hues, as in Figure 2.37.

- Form an accent that attracts the eye, as in Figure 2.35.

- Form a border on the sides of a focal point to hold the eye on it, as in Figure 2.36. (We will discuss borders in depth in Chapter 9.)

- Form a partial border along the sides and bottom of the picture to cradle it and allow the eye to float upward.

- Be a partial border on the top and sides to give an oppressive feeling of entering a tunnel.

- Describe perspective and give the impression of deep space or faraway objects, as in Figure 2.33 and Figure 2.38.

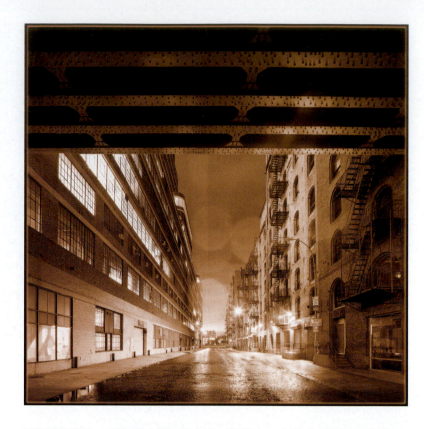

FIGURE 2.33 James Bleecker: *The High Line #7*. Photograph. The buildings have higher values in the distance than in the foreground. James Bleecker.

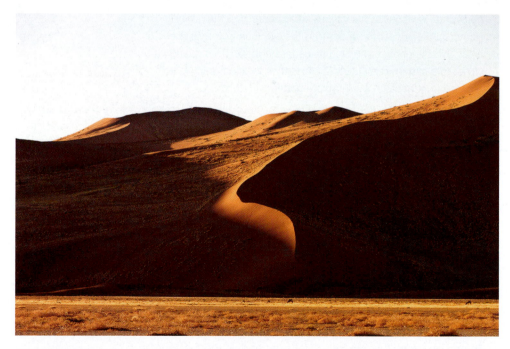

FIGURE 2.34 Gary K. Meyer: *Namibia, May 17, 2009*. Photograph. The low values establish the solidity of the huge dunes and the high values lead the eye through the composition. Gary K. Meyer.

FIGURE 2.35 Syed Asif Ahmed, bedueen: *Queens, NY.* Photograph, 2011. The contrast of the low values against the high values forms a pattern that attracts the eye and leads it through the photograph. Syed Asif Ahmed.

Cynthia Packard's *Jen* in Figure 2.39 demonstrates how very different hues can be the same value. By squinting your eyes, you will notice that the edge is not visible between some of the pinks and oranges under the figure, proving that they are the same value. The low values cradle the image on the sides and bottom, supporting the figure and providing hue and value contrast against the pink and orange.

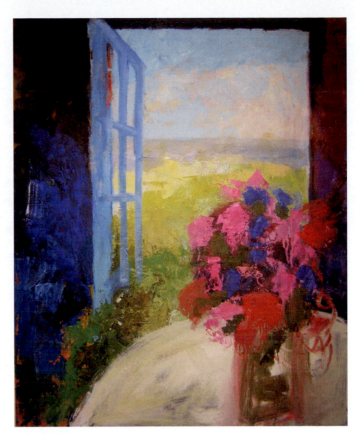

FIGURE 2.36 Liz Carney: *Blue Door Table and Flowers.* Oil on canvas, 40" × 50", 2011. The low values on both side edges keep the eye focused on the flowers in the middle. Liz Carney.

INTENSITY

Intensity means how different a color is from gray. It refers to a color's location on a scale that plots the range between a pure spectral hue and gray. Other words for intensity are *chroma* and *saturation*. Spectral hues are the most intense, and each one is at a different level of intensity. Chromatic hues are less intense than spectral hues. Colors that are a mixture of a chromatic hue and white, black, or gray are even lower in intensity. In fact, the higher the percentage of an achromatic hue in the mixture, the lower the intensity. Tints, tones, and shades are low-intensity colors for this reason. The achromatic hues of white, black, and gray have zero intensity.

Pure hues like red, yellow, blue, violet, and so on are all at their most intense level possible. At its most intense level, each spectral hue has a different level of value. Yellow has the highest value, and violet the lowest. Blue's value is slightly higher than violet, orange's value is slightly lower than yellow, and red and green are about equal in the middle of the range.

An interesting fact is that when mixed with a tiny amount of black or blue, yellow's intensity decreases immediately, and the yellow quality is gone as the hue turns green.

Two complements mixed together produce low-intensity colors. Depending on the proportions used, the result can be brown, black, or gray. We could say that low-intensity colors look dirty or dingy. They could be light or dark, soft or moody. Low intensity is effective when used in a composition as a contrast for saturated hues. Surprisingly, when placed next to gray, they appear to be more intense than they really are.

Intense hues are useful tools in a 2-D composition. They attract the eye and help direct it through the composition, to a focal point. Our favorite intense hues would be perfect for children's toys, for grabbing our attention, and for cheering us up. Fire engines, stop signs, and caution tape use intense colors for the express purpose of attracting our attention.

Compare the following intensity scales with the value scales shown earlier to understand the difference between value and intensity. Rather than measuring how light or dark a color is, the scale measures how gray or saturated with chroma the color is.

FIGURE 2.37 Bridget Riley: *Hesitate*. Oil on canvas, 43 3/8″ × 45 1/2″, 1964, Tate Modern Art Museum. Black, white, and gray are the only hues in this painting, yet other hues are produced optically. The low values in the middle and the lower right corner direct the eye to the highest values in the middle, and the contrast makes them appear to be faded. Tate London / Art Resource, NY.

FIGURE 2.38 Alyce Gottesman: *Captivity*. Charcoal on paper, 41 1/2″ × 29 1/2″, 2005. Values indicate how close to the viewer or far back in space each area appears to be. The black area appears to be deep space. Alyce Gottesman.

Levels of Intensity

How can we describe intensity? Students might have difficulty in describing the level of intensity of a color, or how two colors compare to each other in terms of intensity. A good way would be to ask yourself certain questions that build on levels of information, to place the level of intensity on a scale ranging from very low intensity to very intense.

Very low intensity: This color would be very gray, and the only thing you would be able to determine is the answer to this question: Is the color warm or cool?

Moderately low intensity: This color would be clearly warm or cool; however, you cannot answer the question: What is the hue? In Figure 2.45, this would be color d.

Median intensity: You can determine the hue, but you would answer yes to the question: Does it appear to be a very dull tint, tone, or shade? In Figure 2.45, this would be color c.

Medium intensity: The hue is apparent, and it would not be very dull, but you can answer yes to the question: Does it seem *somewhat* grayed or whitish? This would be colors b or e in Figure 2.45.

High intensity: This one is the simplest to determine. The question is: Does it shine with color? The answer is yes, as in colors a and f in Figure 2.45.

Low intensity tints, tones and shades look different from each other because of the presence of white, gray or black. Figure 2.40 illustrates an intensity scale of tones, where we can see how violet changes when mixed with gray. In Figure 2.41, white makes the lower intensity a pastel color. Fig. 2.42 shows how black changes the intensity.

In a painting, what you see can fool you. It may appear that a level of intensity is higher than it really is, because next to its neighbors it looks more saturated. For example, in Janos Korodi's *Innersea* in Figure 2.46, even though the green–blues are low intensity, they look saturated against

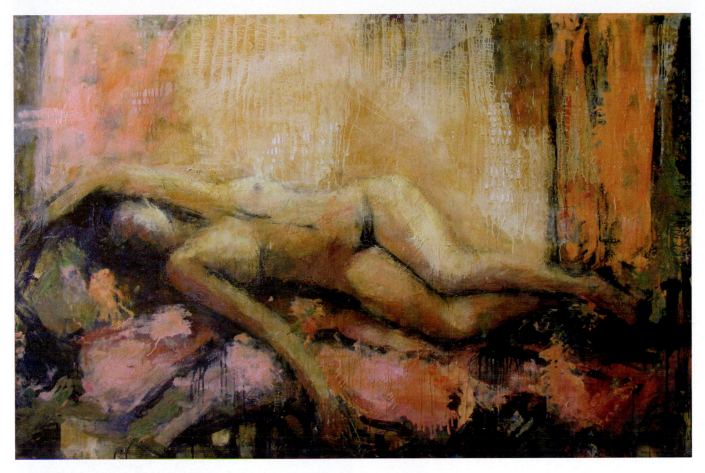

FIGURE 2.39 Cynthia Packard: *Jen.* Oil on canvas, 48″ × 72″, 2011. Cynthia Packard.

FIGURE 2.40 An intensity scale of tones: red–violet to gray. Marcie Cooperman.

FIGURE 2.41 An intensity scale of tints: yellow–green to white. Marcie Cooperman.

FIGURE 2.42 An intensity scale of shades: yellow–green to black. Marcie Cooperman.

Color Perception and the Elements of Color: Hue, Value, and Intensity

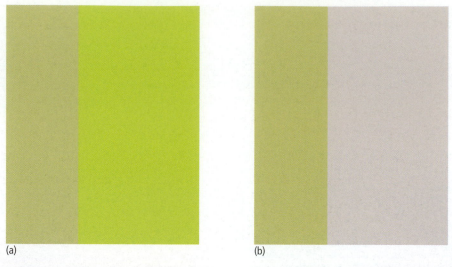

(a) (b)

FIGURE 2.43 (a) There is no doubt that the green tone is low intensity, yet in (b) it looks more vivid next to gray. Marcie Cooperman.

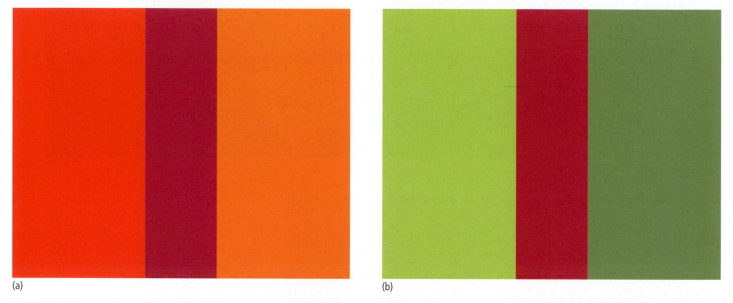

(a) (b)

FIGURE 2.44 A comparison of intensities. (a) The reds, on the other hand, are higher in intensity, and by contrast, they make the middle red less intense. (b) The intensity of the red in the middle appears to be higher when placed with lower-intensity greens. Marcie Cooperman.

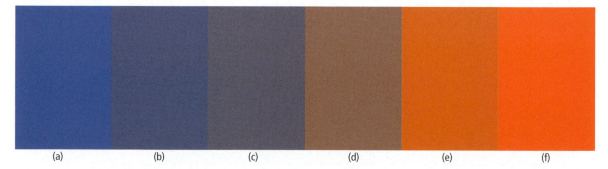

(a) (b) (c) (d) (e) (f)

FIGURE 2.45 Two complements mixed together produce lower-intensity colors, as in this complementary scale with blue and orange. The hues at either end of the scale (a and f) are at the highest intensity. Just a bit of orange mixed into the blue immediately lowers the intensity, as does the opposite action of mixing a bit of blue into the orange. At some point in the middle, browns (d) and then grays are produced, with the lowest intensity of all. Marcie Cooperman.

the even lower-value, lower-intensity black and grays. We will discuss seeing colors next to other colors in greater depth in Chapter 3.

Look carefully at Alyce Gottesman's *Monkey Point* in Figure 2.47 to identify the various intensities of the reds, as well as the different red hues. Can you see where red is mixed with white, with yellow, and with gray? Those mixtures lower the intensity of much of the painting's area, but because they are placed next to the higher-intensity reds, they make them glow.

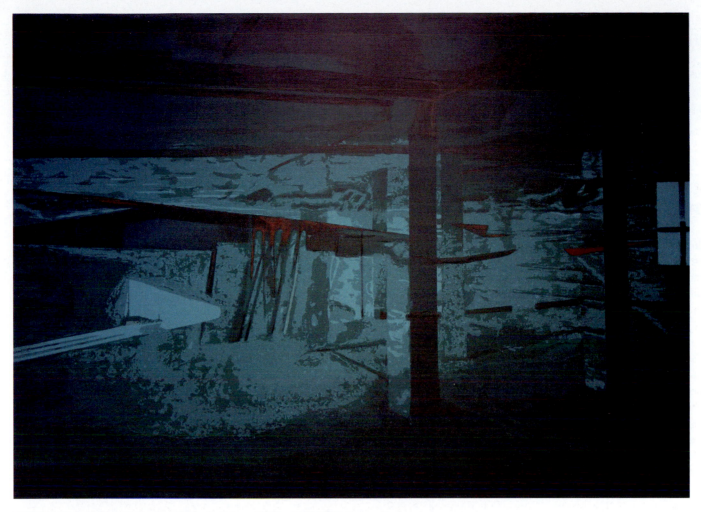

FIGURE 2.46 Janos Korodi: *Innersea*. Tempera on linen, 54.3" × 73.6", 2005. Janos Korodi.

FIGURE 2.47 Alyce Gottesman: *Monkey Point*. Small encaustic and oil on wood, 15" × 18", 2003. Alyce Gottesman.

summary

In this chapter, we learned how the human eye perceives light and color, and how the type of lighting can alter our perception. We defined some basic terminology used in the study of color theory.

Most important, we identified how the three elements of color—hue, value, and intensity—can vary tremendously, and how those differences influence the colors that surround them.

exercises

Parameters for Exercises

There are many factors of color and color relationships in compositions, and all of them can affect the way the colors appear to the viewer. The best way for students to learn through their color exercises is to have simple objectives and fairly strict *rules* about the type of lines and colors to be used. We call those rules "parameters." With strong parameters allowing only a minimum of elements, it is easier to observe the direct relationships between colors, and to see the differences between the students' compositions. When lots of compositions hang together for a critique, it becomes clear which ones are successful in achieving the goals.

As students learn the objectives and build on their skills, they will become more adept at using color. They will gain the ability to tolerate more complications because they understand the ensuing interactions. Therefore, as we move through the chapters, the restrictions on composition size and the number of lines and colors will be gradually reduced. Larger compositions, more colors, and more types of lines will be allowed. However, certain ground rules will remain the same: Flat color and nonrepresentational shapes will remain constant parameters, and the goal of every assignment will be a balanced composition. Five specific parameters include:

1. **No recognizable objects are allowed.** In 1910, Kandinsky asked the question, "What is to replace the missing object?" This might very well be your question, as you contemplate the first of our ground rules for the exercises. All compositions must be nonrepresentational designs—nothing we can recognize as objects or fanciful shapes, such as hearts, butterflies, and the like. Why the emphasis on nonrepresentational? Because a recognizable object immediately takes away the attention of the viewer from the color interaction, adds another dimension to the composition, and distracts from the study of purely color and composition.

2. **All colors are to be flat and nongradient, with hard edges that don't fade away.** Although it might be boring, the study of color can't tolerate changes in the esthetic appearance of colors, leading us to the second of our ground rules. Metallic-like affects; soft, fuzzy edges; indiscriminate layers of colors—all of these complicate the appearance of color and make it harder to see what is going on. If you use pigments to make the colors for your exercises, mix them thoroughly and paint them opaquely. If you use an electronic program to create your assignments, fill areas with color, or stroke the lines, without special effects or edges.

3. **White is always considered a color, even if it is the background.** If two colors are allowed in an exercise, and you use white as the background, it is considered one of the two.

4. **Only neatly cut and pasted papers are appropriate.** Messy work obscures the lessons to be learned about color. To cut papers properly, whether Pantone swatches or your own painted shapes, paint areas larger than your needs, then measure and cut out the shape you need with a sharp matte knife against a metal ruler, on a proper cutting surface. Use a roll-on removable glue stick to attach the shapes to your measured and precut foam core board, with no borders. Make sure all edges are pasted down flat.

5. **Balance and unity** are *always* the singular goal of every composition.

Use the colors on the Pantone color cards that came with this text to complete these exercises.

1. *Create a value scale.* Using pigments, paint your own nine-step value scale. Total size should be 1" × 9".

 This will require mixing paint into nine paint cups. For acrylic paint, be sure to use paint extender to retard drying, and make enough paint to accommodate changes. Put white paint and black paint in different cups. Mix the value you think is correct for middle gray. Then mix six more values—three between black and middle gray, and three between white and middle gray. For the light part of the scale, start with white and a tiny bit of black, then gradually add more black for the next lower values. For the darker end of the scale, start with black, and gradually add more white. *Hint:* For the lightest grays, it is easier to add gray to the white, rather than black, as it can be measured more precisely. Acrylic paint changes value when it dries, so evaluate all values when dry.

 For a value scale to be useful in your study of color, it makes sense to keep the steps visually distinguishable and regular. Each step should appear to be halfway between the one before it and the one after it. Too large a value scale becomes unworkable as a tool. With only nine steps from black to white, each step should be distinct. You will know if one of your steps is wrong if the visual distance between the two values appears to be greater than that of another step.

2. *Color match.* Match three colors to their corresponding achromatic values in your own value chart. Choose a color, and place it *adjacent* to a gray from your value scale, with no space between the two. Then squint your eyes and try

to evaluate whether you can see the edge where the color meets the gray. If the edge is visible, it is because either the color or the gray is darker, and you need to try another gray. If they blend into each other, they are of the same value. During the critique in class, they can be held up next to their proper values for the class to evaluate.

3. **Create an intensity scale.** Create an intensity scale with a pure hue at one end and gray at the other. Total size should be 1" × 5". Use the technique you used for creating the value scale in exercise 1. There should appear to be even steps between each color.

4. **Evaluate values of the same hue.** Choose 10 reds from the Pantone cards and place them in order of value, from lightest to darkest. Choose 10 blues, then 10 yellows and evaluate them as well.

5. **Evaluate values of different hues.** Choose 10 different colors from the Pantone cards. Place them in order of value, from lightest to darkest. Choose more colors and evaluate them as well.

6. **Evaluate intensities.** Choose 10 reds from the Pantone cards and place them in order of intensity, from least to most intense. Choose 10 blues, then 10 yellows and evaluate them as well.

7. **Determine values in a color painting.** Choose a painting that has large areas of flat color so that there is enough area to help you determine the values. Choose five colors in the painting. From the Pantone cards, choose values of gray that correspond to the colors in your painting. For evaluation during the critique in class, place these gray values next to the corresponding colors.

8. **Reproduce a painting.** For a more complicated value study, choose a painting with mostly flat colors and copy the composition in achromatic values.

Color Relationships

key terms

adjacent hue
afterimage
analogous hue
color circle
color relationship
complement
Goethe's proportions
harmony
simultaneous contrast
split complement
triad

Michel Chevreul and Simultaneous Contrast

" *In the case where the eye sees at the same time two contiguous colors, they will appear as dissimilar as possible, both in their optical composition, and in the height of their tone. We have then, at the same time, simultaneous contrast of color properly so called, and contrast of tone."* [1]

—*Michel Chevreul,*
founder of color theory

Colors are slippery characters, always ready to deceive. Although we may feel like we can trust our eyes, we really can't. Our perception of any particular color depends on its surroundings. The characteristics of any color are relevant to the adjacent colors. Amazingly, two different colors can appear to be the same when each is placed on a different background. Even more surprisingly, a dull color can suddenly appear to be much more saturated when placed on a less intense background. Apropos to this question, one might wonder: Why are

FIGURE 3.1 Joel Schilling: *Manarola From the Sea.* Manarola, Italy, photograph, 2004. Joel Schilling.

the colors of the houses in Figure 3.1, *Manorala From the Sea,* so vibrant? After reading this discussion, see if you can answer that question.

How can we explain the effect that colors have on each other? Why do some combinations create balance while others repel each other or disrupt balance? A good question; it is the basis for color theory, and the issue that concerns us in this chapter.

Leonardo da Vinci was the first scientist to notice that adjacent colors in a painting influence each other. But after commenting on it, he explored the phenomenon no further. For centuries afterward, rather than attempting to understand color interactions, scientists were engrossed with the problem of how to illustrate all possible colors on a model, using shapes like a circle, triangle, rectangle, or sphere.

The first person to understand and comprehensively explain color interaction was Michel Chevreul. In 1839, after years of careful research, he introduced to artists a topic that had been debated previously only within the scientific community: the impact of color next to color. He realized that all of the colors within a composition influence each other enough to completely alter how we perceive them. He called this phenomenon the law of **simultaneous contrast**. Chevreul explained how his experiments could be reproduced, and showed that they substantiated his rules for the changes that can occur. His point was that color behavior is based on fact, and is not capricious or dependent on subjective opinion.

How did Chevreul come across this amazing discovery? In the 1800s, Chevreul was renowned as a chemist who had discovered margarine, and who made important contributions in animal and vegetable fats. When he was 40, in his capacity as director of the Gobelins Tapestry Works, it was his job to consider complaints from customers about the clarity of certain colors in their rugs and fabrics, which were produced by his factories. The chemist was thus drawn into the world of color theory. One major complaint was that the black wasn't dark enough. When he compared his black yarns with those of his competition, he saw that his were indeed as dark as their yarns. Apparently the problem was due to some factor other than the Gobelins black dye.

As the scientist that he was, Chevreul researched the situation carefully, and he realized that the visual interaction of the black with adjacent colors was actually altering the appearance of the colors. Blue gave an orange cast to the black next to it, and this made it appear lighter than it actually was. Why was this happening? His interest piqued and he methodically placed color next to color and noted the effects, embarking on a 10-year course of intense and thorough research into colors and their interactions. In 1839, he compiled his observations in *The Principles of Harmony and Contrast of Colors.* Sparing no expense, he illustrated them with carefully chosen colors on large, full-color plates—quite an achievement at that time.

Initially published in France, after 20 years the book was no longer in print in that country. In 1854, *The Principles of Harmony and Contrast of Colors* was translated and printed in England, the first English book there to use color printing. In 1855, an English reprint of his book called *The Principles of Harmony and Contrast of Colors and Their Applications to the Arts* included specific applications of his law of simultaneous contrast to many visual fields such as furniture, uniforms, painting, printing, maps, lighting in museums, frames, textiles, interior decoration, stained glass, and horticulture. Fifty years after his laws were first published, France celebrated the great man's 100th birthday with a centennial edition of his original book, which we can still find in public libraries.

CHEVREUL'S LAW OF SIMULTANEOUS CONTRAST

When viewed simultaneously, two colors force each other to appear as dissimilar as possible. In other words, color A forces its neighbor B to look as unlike A as possible, while color B forces its neighbor A to look as unlike B as possible. We use the word *color* because this law refers to the three elements of color: hue, value, and intensity. Chevreul warned that a painter or designer unaware of the law could mistakenly use color combinations that either are unappealing, or that exaggerate their contrasts and create an unbalanced composition.

Chevreul emphasized that the law of simultaneous contrast is constant, and that it has a huge effect on all colors in any two- or three-dimensional composition, including the compositional figures, the background, and the borders. The law can be applied to any field of design or art: paintings, clothing, fabrics and furniture, frames and borders of paintings, and even gardens.

How It Works for Hue

Adjacent hues force each other to look as opposite as possible—and there is no more opposite hue than the complement. For example, if one hue in the composition is red, it will force nearby hues to look as "un-red" as possible, and that means greenish. Green is the most un-red color because it is red's complement. (We will discuss complements later in this chapter.) This effect is strongest when we see hues right next to each other, but it also works to a lesser degree for all hues in the composition. For example, in Figure 3.2, notice how different the very same gray appears on the two different backgrounds. The violet background pushes the gray away from violet, toward yellow. And the yellow pushes the gray away from yellow and toward violet. The red square in Figure 3.3 is redder and more intense the green

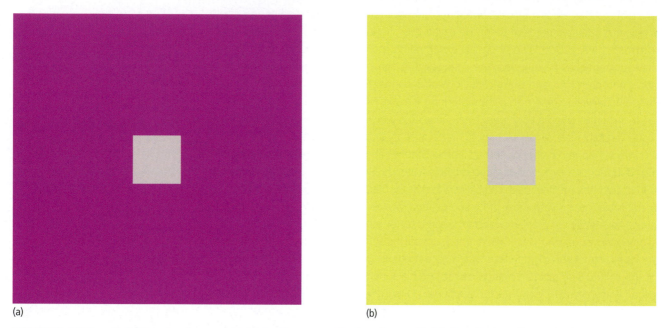

(a) (b)

FIGURE 3.2 (a) The red–violet pushes the gray to have a yellow cast and makes the gray look lighter. (b) The yellow pushes the gray to look like red–violet, and darkens it. Marcie Cooperman.

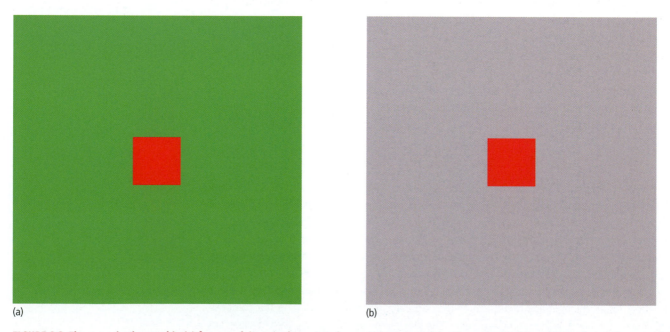

(a) (b)

FIGURE 3.3 The green background in (a) forces red, its complement, to be as strong as possible. Consequently, it is redder, and more intense, than it is on the gray background (b). Marcie Cooperman.

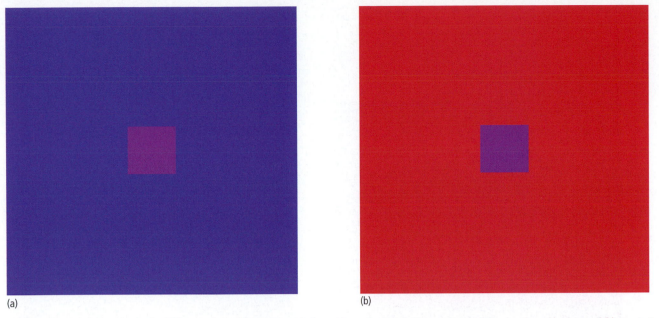

(a) (b)

FIGURE 3.4 The same color looks different! The red–violet square looks redder on the blue background (a) and bluer on the red background (b). Marcie Cooperman.

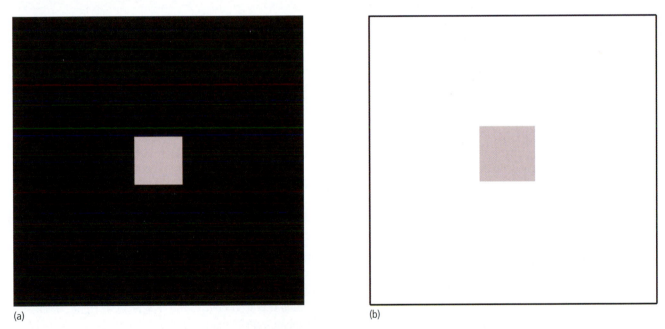

(a) (b)

FIGURE 3.5 Simultaneous contrast affects value. The gray looks lower in value on the white (a) than on the black (b). Marcie Cooperman.

background—its complement. In Figure 3.4, the violet looks bluer on the red background, and redder on the blue background. This is because the blue ground "steals" the blue from the violet, and the red "steals" the red from the violet.

How It Works for Value

Simultaneous contrast changes the values we perceive, too. The value of a color has a strong opposite effect on the value of an adjacent color. For example, the lightness of the white background in Figure 3.5a darkens the value of the gray square, but the black background has the opposite effect on the same gray, making it seem lighter.

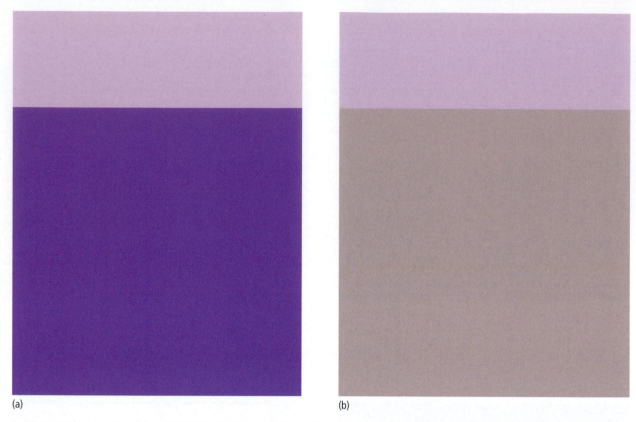

(a) (b)

FIGURE 3.6 The intensity of the violet tint in (a) is low relative to the more intense red. In (b), the violet tint appears more saturated.
Marcie Cooperman.

How It Works for Intensity

The law of simultaneous contrast creates fascinating intensity changes; it is possible to place low-intensity colors in the right combinations and make them seem to be high intensity, or more saturated. This is a useful tool in creating compositions of subtlety and sophistication. A color may appear to be low intensity because it has some gray mixed in it, but when placed next to an actual gray, it suddenly gains in relative intensity and could even appear to be a strong color. You can see how this works in Figure 3.6. In Figure 3.6a, the violet tint's intensity appears quite low next to the red–violet because the red–violet steals the red from the tint, rendering it grayer and "dirty" looking. The violet's intensity is so much higher next to the gray in Figure 3.6b, that it looks like a completely different color.

In Figure 3.7, you can see how this works in Gary K. Meyer's *Namibia, May 22, 2009*. Although the orange of the dune tops is not saturated, the intensity seems high next to the lower-intensity yellow–green grasses. The blue sky appears to be even more saturated relative to the ground colors. However, imagine it placed next to the red–violet in Figure 3.6a, and you can see that the blue is really a lower intensity tint.

In Figures 3.8 and 3.9, the same color red appears to be a different color in each of the four backgrounds, illustrating changes in hue, value, and intensity. Can you describe the visual differences in these three elements?

Did you figure out the answer to the question about Figure 3.1? The house colors are so vibrant because of their simultaneous contrast with the achromatic whites and the complementary greens of the hillside.

Color Relationships

Why do some colors "play" together well whereas others fight with each other? Why would two colors coexist in a friendly fashion but cause trouble when a third is added? The answers arise from the similarities that unite the colors in question. Similarities in colors, which we call **color relationships**, are like those in people: they can bring harmony and integration to

FIGURE 3.7 Gary K. Meyer: *Namibia, May 22, 2009.* Photograph. Gary K. Meyer.

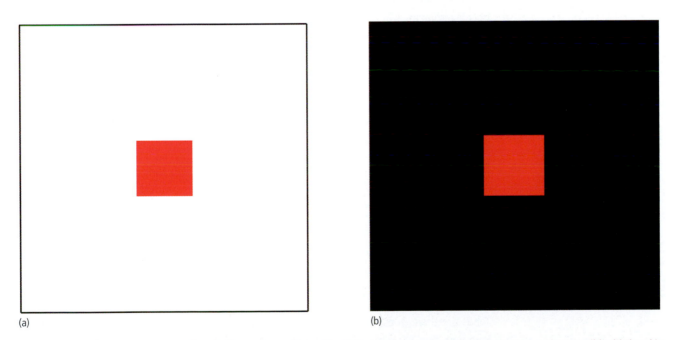

(a)

(b)

FIGURE 3.8 Simultaneous contrast makes the hue, value, and intensity of the square as opposite from the background as possible. (a) The white background makes the value of the red seem darker. (b) The black background makes the red square appear lighter, as well as more intense. Marcie Cooperman.

a composition. Groups of colors within a relationship are said to be in a family. Colors exist in families the way we humans do: Certain interactions between colors can be anticipated, and generally they get along better with family members than they do with "strangers" with nothing in common. Colors that have no relationship with each other do not have this natural affinity. They tend to contrast in an unpleasant way, although sometimes the elements of size and distance mitigate the mutual negative effects.

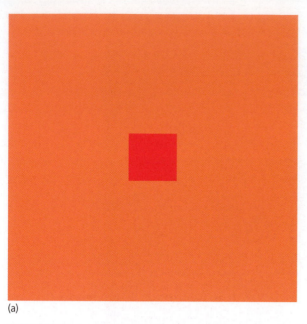
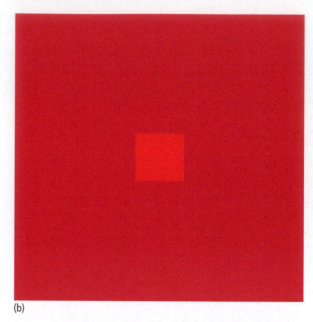

(a)　　　　　　　　　　　　　　　　　　　　(b)

FIGURE 3.9 Red on the blue–red background (a) appears to be higher value and more intense, and have more yellow in it than the red on the red–orange background (b). Marcie Cooperman.

A **color circle** shows relationships among pure hues, which are called *spectral* hues because they exist in the spectrum. Relationships among tints, tones, and shades as well as broken colors can be represented on a 3-D model such as those of Albert Munsell or Philipp Otto Runge.

The color circle identifies hue families. The circle can be marked at each of its 360 degrees, and the location of each hue is noted. We can then see that similarities occur among certain hues with set mathematical distances between them. These hues are said to be in a relationship with each other.

These are the primary relationships between hues found on the color circle:

- **Triads:** three hues, each 60 degrees apart
- **Complements:** two hues, each 180 degrees apart
- **Split complements:** any hue, plus the two hues adjacent to its complement
- **Analogous hues:** hues that contain a hue in common
- **Adjacent hues:** two hues next to each other

TRIADS

Triads are three hues, each 60 degrees apart on the color circle. The primary hues red, yellow, and blue are equidistant from each other and form the three points of an equilateral triangle, with each angle measuring 60 degrees (Figure 3.10). These hues are unique because they have no chromatic relationship with each other; by definition, because of their nature as primaries, their hues are completely distinct from each other.

The secondary hues green, violet, and orange have the same mathematical relationship, although their chromatic relationships with each other are different from those of the primary hues: Since each is a mixture of two primaries, any pair of secondaries has a hue in common (Figure 3.11).

Because of their relationships, triads create a unique balance, with compatible characteristics. *Rebirth*, in Figure 3.12, illustrates the primary triad, with two secondaries: orange and green.

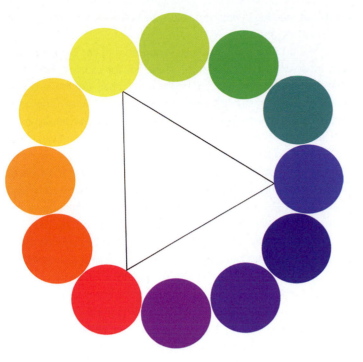

FIGURE 3.10 Triad. Primary hues. Marcie Cooperman.

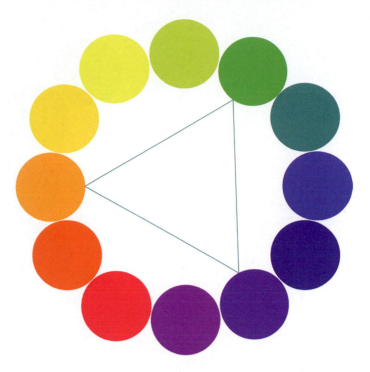

FIGURE 3.11 Triad. Secondary hues. Marcie Cooperman.

COMPLEMENTS

Complements are two hues, 180 degrees apart on the color circle. Every hue is opposite, or across the circle from another hue that we call its complement (Figure 3.13). Complements have a special relationship: they work together to *complete each other*. With pigments, completing each other refers to the fact that these hues make black when mixed together. Only complementary pigments can produce black when mixed together (using the proper proportions) because together they always contain all three primaries.

Complements have a unique influence on each other in a composition: They enhance each other's hue with more vigor than any other pair of hues. In other words, each makes the other as strong as it can be. Each complement in a pair is influencing the other in a circuitous process, strengthening its partner as well as itself. For example, a red next to a green will appear as red as possible, given what the red's hue, value, and intensity will allow; the green will likewise be as green as possible. No other hue has the same strength of influence on the red, and none has more influence on the green.

The law of simultaneous contrast says that the power of the complementary influence is so strong that every hue *sends every neighbor as far from itself as possible* and toward the hue's complement. In other words, every color makes its neighbors look as opposite from it as possible. Therefore, red makes all adjacent colors look less red, and it attempts to make them as green as their intensity and value make possible; blue keeps its neighbors from looking blue and makes them as orange as possible; orange

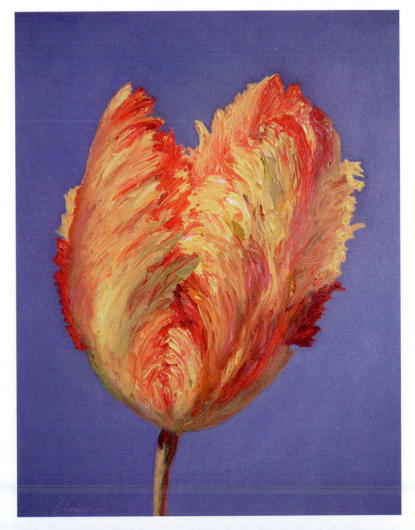

FIGURE 3.12 Liron Sissman: *Rebirth*. 14" × 18", oil on canvas, 2004. Private collection, Liron Sissman. The three primaries are represented in this painting, with two secondaries: orange and green. Liron Sissman.

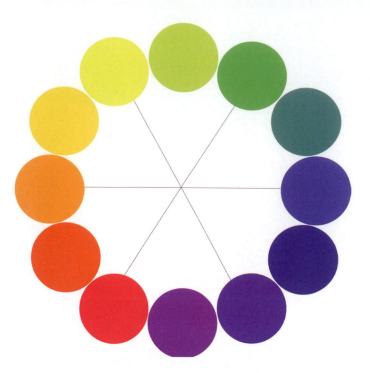

FIGURE 3.13 Three sets of complementary hues. Marcie Cooperman.

brings out the blue in adjacent colors; yellow enhances the violet in nearby colors; and so on.

In the art world, several thinkers noticed that complements give each other unparalleled strength. Leonardo, for example, saw that adjacent "intense contraries" intensify each other. Goethe said that complements "continuously seek one another" by influencing adjacent colors to look complementary. Chevreul said about complements, "it is evident that the colors of the two objects in contact will purify each other, and become more vivid." However, to him complements were not the most harmonious of contrasts, possibly due to his early-nineteenth-century sensibilities. Consequently, he did not recommend it except for use on the printed page, possibly the only place where strong contrast was preferable to avoid eye fatigue. Chevreul said that according to his law of contrast, black and white could be called complements to each other because they are complete opposites.

Eugene Delacroix (1798–1863) applied Chevreul's theories about the power of complementary contrast. Many of his themes were drawn from war and revolution, and he used red with green to express violence and terror, saying, "The more contrast the greater the force." He realized that his expression of the force and drama of these stories could best be visually expressed through the complementary contrasts. Delacroix contrasts red effectively against green in his *Dante and Virgil in Hell* (Figure 3.14).

FIGURE 3.14 Eugene Delacroix: *Dante and Virgil in Hell.* Oil on canvas, 74" × 95", 1822. Red and green express violence and terror. Erich Lessing/Art Resource, NY.

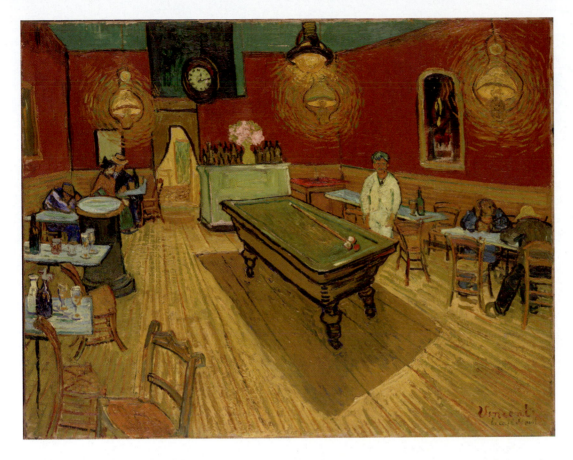

FIGURE 3.15 Van Gogh: *The Night Café*. Yale University Art Gallery, New Haven. The hues express his negative feelings. Oil on canvas, 11.2" × 14.3", 1888. Yale University Art Gallery.

Vincent van Gogh (1853–1890) was influenced by Delacroix's use of color (Figure 3.15). He felt the power in Delacroix's paintings and saw red and green as a strong combination capable of expressing his own negative feelings about human passion. He said, "In my picture of the 'Night Café' I have tried to express the terrible passions of humanity by means of red and green … the café is a place where one can ruin oneself, go mad or commit a crime. There are six or seven different reds in this canvas, from blood red to delicate pink, contrasting with as many pale or deep greens."[2]

More recently, Whitney Wood Bailey used a theme of red and green for Extraordinary Geometries. The complements meet each other across the center diagonal line of top left to bottom right, and balance each other across this line through placement of values and intensities. The ground in-between the curvilinear lines consists of tiny, carefully placed lines of red, green, white and other colors. They mix together and read as gray at a distance, providing a color balanced background for the intense reds and greens (Figure 3.16). In Figure 3.17, Cynthia Packard's *Zinnias* illustrates the complements red and green in much lower intensities and values.

Primary and Secondary Complementary Hues

Only three pairs of complementary hues on the color circle include the primary and secondary hues—red–green, orange–blue and yellow–violet; all other pairs are composed of tertiaries. These three pairs are distinct enough that we can discuss the unique characteristics of each, and establish rules about using them in achieving balance within the composition.

Red–Green On the color circle, the values and intensities of red and green are at an equal level, giving this pair an egalitarian relationship. Red and green usually balance each other when

FIGURE 3.16 **Whitney Wood Bailey:** *Extraordinary Geometries.* Oil and mixed media on canvas 72″ × 72″, 2012. Whitney Wood Bailey.

placed in equal quantities in a composition, although any variation in their values and intensities will alter the balance. For example, on a less intense green, a very intense red would require a smaller quantity for balance. Too much of the intense red would overwhelm the composition because it stands out so much. As an example of quantities that work, in the background of *Zinnias* in Figure 3.17, there is a lower quantity of the more saturated red than the lower intensity green. The houses in Figure 3.1 illustrate that low intensity red tints appear to be more vibrant when viewed simultaneously with even lower intensity, lower value green.

Orange–Blue This pair of complements has a special scintillating action that makes them seem like they are more vivid than the other two pairs. It is not even necessary for them to be high intensity for the scintillation to occur; even blue and orange tints can produce the same effect.

FIGURE 3.17 Cynthia Packard: *Zinnias*. Oil on canvas, 36" × 48", 2010. Cynthia Packard.

Perhaps this is because they are not too different in value, but counter each other in temperature. Samantha Keely Smith's *Asunder* in Figure 3.18 illustrates the power of orange and blue together.

Yellow–Violet Yellow and violet are distinguished by two inherent extreme contrasts: value as well as intensity. Perhaps because it is so intense as well as high value, yellow resists attempts to define its edges and spills out of its boundaries. In contrast, violet's low value gives it an almost three-dimensional quality similar to the sky, a quality that we call "atmospheric." Rather than reflecting onto adjacent colors, it absorbs most light. Deep, low-value violet balances yellow's vibrant, glowing qualities.

Complements are powerful enough to have an effect on each other wherever they are placed in the composition. Rudolf Arnheim said: "Since the eye spontaneously seeks out and links complementary colors, they are often used to establish connections within a painting between areas that lie at some distance from one another."[3] Since complements direct the eye from one color to the other, they can be used as a way to draw the eye through the composition—always an essential goal for the designer.

Goethe's Proportions for Complements

When using complements, how can we determine what quantity of each should be used in a particular composition for hue balance? Although the answer to this question would depend on how large each color area is and where it is in the picture, Goethe suggested **proportions** to use, based on their wavelengths (Figure 3.19).

He assigned number values to each primary and secondary hue, corresponding to ratios that can be used: yellow 3; orange 4; red 6; green 6; blue 8; violet 9.

FIGURE 3.18 Samantha Keely Smith: *Asunder.* Oil on canvas, 56" × 64", 2006. Samantha Keely Smith.

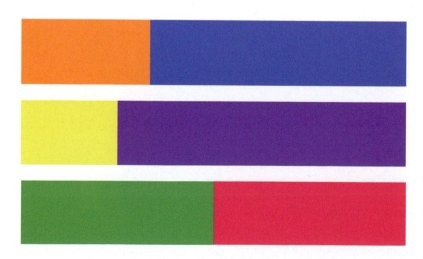

FIGURE 3.19 Goethe's proportions for complementary pairs. Marcie Cooperman.

In Figure 3.20, Gary K. Meyer's *Namibia, May 19, 2009*, puts together very high and very low-value oranges and blues. Including the ground, there is slightly more blue than orange, hewing closely to Goethe's suggested proportions:

- **Yellow–Violet = 3/9.** The total amount of violet should be three times the amount of yellow. Another way to look at it would be: 1/4 of the composition is yellow, and 3/4 is violet. Only a very small quantity of yellow is required to stand out against a dark color like violet (or black; think of the yellow line in the center of a blacktop road). A composition with a greater quantity of yellow than violet often seems to be out of balance.

- **Orange–Blue = 4/8.** There should be twice as much blue as orange. The composition should have 1/3 orange and 2/3 blue.

- **Red–Green = 6/6.** They are exactly the same. The composition should be 1/2 red, 1/2 green.

Sometimes the eye likes to keep things simple and ignore hue differences. We know that the law of complementary contrast means

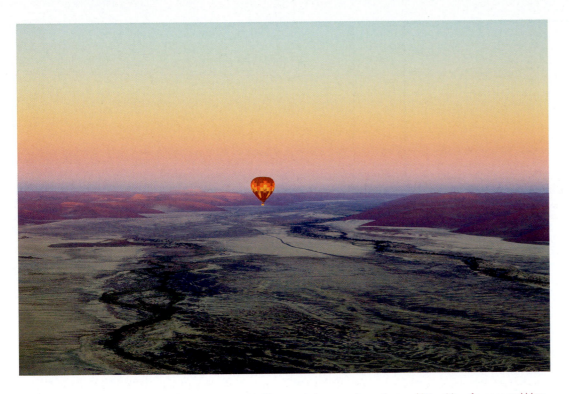

FIGURE 3.20 Gary K. Meyer: *Namibia, May 19, 2009.* Photograph. It uses various values and intensities of orange and blue in quantities similar to Goethe's proportions. Gary K. Meyer.

that adjacent colors tend to appear as opposite in hue as possible. For example, the differences in hue, value and intensity between a yellow–red and an adjacent blue–red are enhanced by their proximity. But there are times when the eye groups slightly different hues together in the interests of simplicity, and we actually perceive their similarities rather than their differences. As an example, small areas of various reds placed around a composition would catch our eye, and we might see them as the same hue, as in Figure 3.21.

The eye ignores hue differences if one or more of the following situations exist:

1. There is little hue difference between the two colors.

2. They each encompass very small areas, so that it is difficult to determine the exact nature of their hue.

3. They are surrounded by their complement, so that they are united by their complementary relationship to it.

FIGURE 3.21 **These reds are all different hues.** But the eye tends to ignore differences, and it groups all three red squares together in terms of hue, value, and intensity. Marcie Cooperman.

Afterimage

The effect of making adjacent colors look like the complement is partly explained by the perceptual process called **afterimage**, which Chevreul named "successive contrast." We see an afterimage when we focus on one hue for a few seconds, then move to a white surface. It is a reaction of fatigue, where a ghostly complement appears hovering over the nearby surface. Why does this happen? After staring at the red, the red sensors of the eye are fatigued, and they take a break while your other cones produce the complementary color. Try for yourself with Figure 3.22.

You've seen the afterimage effect without knowing why it was there. When someone takes a photo of you using a flash, your eyes see a ghostly image of the flash's violet–blue complement for a few seconds. Not only do you see the complementary hue, but you also see the opposite value of the original color.

(a) (b)

FIGURE 3.22 Afterimage: Focus on the red square for a few seconds (a). Then look at the black dot in the second square (b). You can see an afterimage of complementary blue–green. Marcie Cooperman.

What is actually happening? Remember the discussion in Chapter 2 about the cones in our retinas? We learned that there are three types of cones that help us see hues, each of which responds to one of light's three primary hues. When the eye looks for a while at a particular hue, the cones that respond to and perceive that hue are bombarded with it, and become fatigued. They are oversaturated with the stimulus, and they can't adapt quickly. Our other cones, which respond to the other hues, are not being taxed at all. Therefore, when we stop looking at that spot and look at another spot, the eye will perceive the complement of the original hue for a short while. This is because at this moment, the cones that were not fatigued are continuing to respond, but the fatigued ones are briefly taking a break. This lack of input from some cones affects the color we perceive.

Because the eye tires of a hue within a few seconds, as you look at successive objects of the same hue, the intensity of each will be reduced sequentially. In industry, this would have an effect if you were looking at successive fabrics or pieces of yarns. The first one or two would be perceived as more saturated than the later ones; in other words, you might think the later ones were not as beautiful and richly colored as the first few. That means it's time for a few minutes' rest for your eyes.

Every hue in a 2-D composition produces an afterimage. In other words, every hue "reflects" its complement around itself. This reflected complement mixes with the hues of surrounding colors, altering them as much as possible to resemble the complement. For example, if the afterimage is green, green will be added to surrounding colors in this way: yellow will turn green–yellow, blue will turn green–blue, and a green will be strengthened with more green.

The afterimage hue also mixes with the hue of the surface it reflects onto. If we stare at a green square on a yellow surface, then remove the green, we see a ghostly orange square for a few seconds. The red afterimage is mixing with the yellow on the surface, and making orange. If we then place the green square on a blue background, the afterimage will be violet, the combination of the blue surface and the red afterimage.

SPLIT COMPLEMENTS

A **split complement** means a hue plus the two hues that are adjacent to its complement.

Split complements suggest the complementary relationship, but the complement itself is actually not included. To find the split complements of a hue, look on the color circle to find its complement 180 degrees away, then use the hues adjacent to it on either side. These two hues are used, but the complement is dropped. For example, in the color circle in Figure 3.23, you can see that yellow's complement is violet. For split complements, choose the red–violet on one side of it, and the blue–violet on the other, and use them with the yellow. Or the reverse can be done: Start with the violet, and add the red–yellow and green–yellow on either side of yellow on the color circle.

Split complements are a way of adding richness and hue complexity to a composition, and hinting at more hues than are present. Together these split complements represent all three primary hues, which lends the composition the unique hue balance of that triad.

ANALOGOUS HUES

Analogous hues are hues located near each other on the color circle that have a hue in common, linking them in a family. As you can see in Figures 3.24 and 3.25, it's possible for a secondary hue, for example red–violet, to be in two different analogous families, since by definition it's made of two primary hues (violet is made of both red and blue). Analogous hues appear to have the same characteristics of temperature, and that gives color harmony balance to a composition. Analogous hues also give three-dimensional form to shapes, where the lowest-value hue seems to be farther away and in shadow. You can see three main hues that have yellow in Alyce Gottesman's *Visceral Impressions* (Figure 3.26)—yellow, green, and orange. While they are clearly different hues, they are united by their common hue.

ADJACENT HUES

Adjacent hues are hues that are right next to each other on the color circle. Because they are in that position, adjacent hues are also *analogous*—in a family. Adjacent hues give a harmonious feeling to a composition. Gary K. Meyer's *Antarctica, December 7, 2009* in Figure 3.27 is completely composed of two adjacent hues: blue and violet.

FIGURE 3.23 Yellow with its split complements red–violet and blue–violet. All three primaries are represented. Marcie Cooperman.

FIGURE 3.24 Analogous hues with red in them. Marcie Cooperman.

FIGURE 3.25 Analogous hues with blue in them. Marcie Cooperman.

FIGURE 3.26 Alyce Gottesman: *Visceral Impressions.* Encaustic on wood, 18" × 15", 2001. Alyce Gottesman.

A useful advantage of adjacent hues is that they would allow a hue that is not adjacent to stand out in contrast. In Figure 3.28, adjacent hues of greens and blues form the water reflections, and the yellow–green of the leaf allows it to stand out.

Color Harmony

Color **harmony** has been the goal of designers and theorists for ages. Harmony means identifying those colors that can always be relied upon to work well together, whether in a 2-D composition, interior design, fashion design, or any other type of use. Since the early days of color theory research, that has been a most intriguing question. The need to know the

FIGURE 3.27 Gary K. Meyer: *Antarctica, December 7, 2009.* Photograph. The blue and violet are adjacent. Gary K. Meyer.

answers has provided a career for many teachers, scientists, and psychologists. Color theorists who joined the quest aimed to identify harmonic combinations of colors, and to write the ultimate guide to color harmony for all artists. Their goal was to establish reliable rules so that designers would easily be able to consult the proper charts to help them with their work. Moreover, with such a guide, those who are in the building trades who may have no color expertise would be able to offer guidance to homeowners in their design plans, makeovers, and renovations.

Unfortunately, there are as many ideas and rules for color harmony as there are color theorists, and several are discussed here. Not all of these "rules" apply to every composition. Feel free to experiment with all of them to see which ones work for your compositions.

Many theorists have attempted to associate colors with musical notes. Theoretically, the color circle could be aligned with the mathematical organization of musical notes to provide stable and reliable formulas on which we could base our hue

FIGURE 3.28 Marcie Cooperman: *Tree Reflections—First Fall Leaf.* Gouache, 6" × 8", 2009. Marcie Cooperman.

decisions. Newton, for example, said that the spectrum produced by the sun's white light could be compared directly to the seven-note musical scale. But to make that happen, he needed to add a seventh hue that is not really present (indigo), as he was able to identify only six distinct hues. Using the musical scale as an analogy for choosing colors is not easily done, if it is possible at all, because the elements of color (hue, value, and intensity) and composition complicate the situation by their influences on how we perceive color.

Michel Chevreul was the first color theorist to consider rules for colors that worked well together. He identified three situations where harmonious combinations could be found:

1. ***Various values of one hue.*** Several values of one hue can be used together to achieve *monochromatic* harmony, like the gray–greens in Figure 3.29. Tints, tones, and shades of

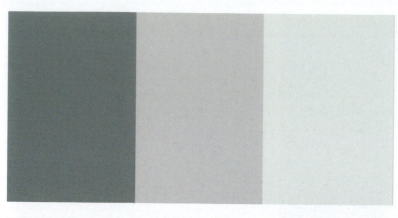

FIGURE 3.29 **Three values of one hue.** Marcie Cooperman.

FIGURE 3.30 **Similar values of analogous hues—green, blue, and violet.** They all share blue. Marcie Cooperman.

one hue can produce various values. Small amounts of other hues can be mixed in to offer slight variations.

2. ***Similar values of analogous hues.*** Colors that share a hue combine harmoniously when their values are similar. The hues in Figure 3.30 share blue, and their values are the same. This is an effective way to test to see if colors have the same value: If you squint your eyes, the boundary lines between them seem to disappear.

3. ***Harmony of a dominant hue.*** A dominant hue is one that stands out or takes up most of the area in a composition. Here is one way to produce this effect: Place colors of your choice (paint or place using colored pieces of paper) on the page, and then cover them with a transparent layer of color such as a piece of stained glass, a colored filter, or a transparent layer of paint. The overlying transparent layer seems to unite them to look like variations of that color.

In Figure 3.31, blue is the dominant hue. The adjacent hue of green (made from blue and yellow) is interspersed with the blue sky and water.

Our review of color theorists in Chapter 1 included Wilhelm Ostwald, Johann Wolfgang von Goethe, Albert Munsell, and Ogden Rood, all of whom long debated the best way to achieve color harmony. Ostwald differed from other color theorists by saying that value is the primary element that determines harmony, and it is more important than hue. Value does indeed determine balance in a composition; with poorly chosen values, no matter what hues are in the composition, there can be

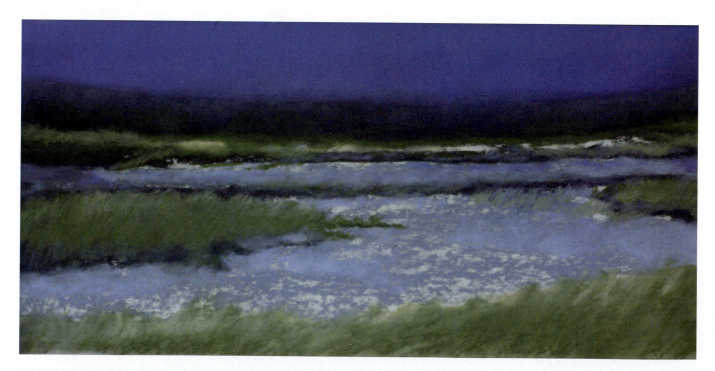

FIGURE 3.31 **Catherine Kinkade:** *Cheesequake.* Pastel, 14″ × 23″. Catherine Kinkade.

FIGURE 3.32 The "pale unsaturated colors of nature" according to Rood—we know them as broken hues.
Marcie Cooperman.

no balance. (We will discuss balance in greater detail in Chapter 6.) However, it is impossible to discount the primary role of hue in color harmony.

Goethe said there was harmony only if all three primaries were in a composition, often in an arrangement that included complements. This seems like a severely limiting rule to have to abide by, as it would make every composition extremely similar.

Albert Munsell saw harmony in colors when two of the three elements of color were held similar, and only one varied. For example, if two different hues were at the same low levels of intensity and value, they would be harmonious. But if those two hues had very different levels of intensity and value, they would not be harmonious.

Ogden Rood was particularly persnickety in his choices of appropriate colors for paintings and decorative objects. In his day, abstract painting had yet to occur; the idea of color as the subject matter itself in a painting did not burst upon the world until a few years after his death. He said, "The object of painting is the production, by the use of color, of more or less perfect representations of natural objects." Therefore, "the painter is to a considerable extent restricted in the choice of his tints; he must mainly use the pale unsaturated colors of nature, and must often employ color-combinations that would be rejected by the decorator"[4] (Figure 3.32). Pale colors were meant for painting or attempting to reproduce nature in a realistic sense. Intense colors were prohibited for painting, unless the intent was decoration. And, he said, a decorative object should not "forsake its childlike independence" by using pale colors.

Rood maintained that certain relationships of hues were harmonious, but some were not. He had strong opinions about unsuccessful hue combinations. Many of his observations can be traced to his contemporary Victorian sensibilities toward color and style, and would not be relevant today. For example, he opposed using green with violet because he thought they were not harmonious, and he also said that green and blue make a poor combination. Colors that are "not too opposite" each other on the color circle, yet not right next to each other, provided a "hurtful contrast." As an example, he felt that red and violet, or yellow with yellowish green, do not work well together. However, Rood went on to say that the artist could mitigate the hurtful contrast by making one of the "offending" colors darker or its area smaller, or by adding a complement of one of the hues to make three colors. Figures 3.32 and 3.33 illustrate Rood's "pale unsaturated colors of nature."

Some say that there can be no rules governing color harmony, that harmony is solely dependent on individual preference. If people agree that certain colors are harmonious, they *are* harmonious, says Ken Burchett in *A Bibliographical History of the Study and Use of Color from Aristotle to Kandinsky.* "Good color harmony is defined by whether someone likes it or not."[5]

It is impossible to state simple principles of color harmony. Every viewer has a subjective opinion based on things remembered, personal experiences, and temperament, as well as

FIGURE 3.33 Catherine Kinkade: *Fall Marsh.* Pastel, 17" × 21". Catherine Kinkade.

the present mood at any particular time. Even the next day, our opinions can vary enough to change our decisions about whether certain colors look harmonious together.

But even more important, in a composition the shapes and sizes of color spaces, the surrounding colors, and other compositional elements influence the appearance of the colors themselves. These factors make it possible to negate any broad, general rule of what colors look good together. Just change their sizes, and those colors have to be reevaluated. The context in which we find any combination of colors will also determine whether we like them. For example, colors that look fine in an abstract painting will be shocking in a realistic landscape.

Each time period and culture is associated with color preferences that seemed wonderful to the people of that time. (We will discuss relating color to cultural meaning in Chapter 10.) But looking back from a different location and a later generation, those color choices seem quaint and evocative of a specific era. Even color experts like Wilhelm Ostwald have created color harmony schemes that are now outdated.

In 1993, in *Colour and Culture, Practice and Meaning from Antiquity to Abstraction,* John Gage said that color harmony was a sustaining ideal for color theorists until "well into the twentieth century,"[6] implying that the relevancy of the issue has diminished. However, it appears that color professionals today, and others in many fields involving color, are still interested in finding harmonizing color combinations.

Now that paint companies offer almost unlimited numbers of paint colors, the search for perfect combinations has become even more complicated. Even many professionals in the world of decoration—interior designers, paperhangers, house painters—may not be knowledgeable about the makeup of colors, and they may have little ability to discern the differences between them. Portable colorimeters have been devised so that amateurs can measure a color on the job, and identify a match choosing from several popular lines of paint. One such device even offers advice about colors to use together. It seems as if the computer determines these combinations, but of course, teams of people had to work hard to program this information into it.

As you can see, our ideas of good combinations have changed as the centuries passed, and in reality, it's difficult to lay down hard and fast rules.

summary

In this chapter we learned that colors have relationships with each other based on where they are located on the color circle, and this influences their hue interactions. However, it isn't possible to state that certain hues are always harmonious combinations. Color harmony depends on the hues, values and intensities, as well as quantities of each color that we view simultaneously. Based on a particular situation, we can conclude that certain colors "play nicely" with each other and exist in harmony sometimes, and not other times.

quick ways . . .

Study your composition carefully, using the following steps, one at a time.

1. Colors: Count the number of discrete hues. Too many will be confusing and inhibit balance. Too few will be boring—a result to avoid!

2. Colors: Evaluate the predominance of one hue, to make sure it is not overwhelming.

3. Colors: What are the color relationships together in their various combinations, and what are the resulting effects of simultaneous contrast? How does their placement affect the balance of the total composition? Would moving an element change things for the better?

exercises

Parameters for Exercises

There are many factors of color and color relationships in compositions, and all of them can affect the way the colors appear to the viewer. The best way for students to learn through their color exercises is to have simple objectives and fairly strict rules about the type of lines and colors to be used. We call those rules "parameters." With strong parameters allowing only a minimum of elements, it is easier to observe the direct relationships between colors, and to see the differences between the students' compositions. When lots of compositions hang together for a critique, it becomes clear which ones are successful in achieving the goals.

As students learn the objectives and build on their skills, they will become more adept at using color. They will gain the ability to tolerate more complications because they understand the ensuing interactions. Therefore, as we move through the chapters, the restrictions on composition size and the number of lines and colors will be gradually reduced. Larger compositions, more colors, and more types of lines will be allowed. However, certain ground rules will remain the same: Flat color and nonrepresentational shapes will remain constant parameters, and the goal of every assignment will be a balanced composition. Five specific parameters include:

1. No recognizable objects are allowed.
2. All colors are to be flat and nongradient, with hard edges that don't fade away.
3. White is always considered a color, even if it is the background.
4. Only neatly cut and pasted papers are appropriate.
5. Balance and unity are *always* the singular goal of every composition.

1. ***Create a 12-step color circle.*** The objective is to make your own color circle that can be used for reference in this class, with properly placed complements, and correct variation of hues. Using the technique you learned by painting your value scale, with extender to keep your paints from drying out, mix the correct hues into plastic cups.

 Begin with red, blue, and yellow. Make sure your yellow does not tend toward red, that your red does not tend toward yellow, and that your blue is not too red. Pure primaries make the best secondaries. Mix the three secondaries from the primaries, and then mix one tertiary for in between each primary and secondary. Paint areas of your paper with each hue, evaluate for accuracy, then cut 1" × 1" squares of each hue. Place them in a circle properly, with complements directly across from each other.

Parameters: For the following exercises, only vertical lines that run from top edge to bottom edge are allowed. Total size should be 5" × 7". Choose your hues, paint large areas for each color on your paper, then cut out the shapes you need and glue them on your foam core using a removable glue stick. Your goal is overall balance, as always. Your second goal is to learn what quantity of each color will achieve balance.

2. **Find complements.** The objective of this exercise and exercise 3 is to find the successful quantities of each complement in a pair, keeping the other elements of design very simple. Make a balanced composition using two complementary hues (so that one hue does not appear to overwhelm the other). First, plan for the locations and widths of your vertical lines for each hue in the composition. Then, cut one hue 5" × 7"—this will be the background. Cut the other hue into the widths you need, and place them on the first one, evaluating the balance as you move them around. While you are thinking about proper line widths, cut extra lines of different widths, and evaluate the success of using them instead. Glue down the ones that satisfy you.

3. **Find complements (continued).** Make another balanced composition, as in exercise 2, using a different set of complements. This one will require different amounts of each hue, which you can evaluate.

4. **Find harmony with intensity.** The objective is to discover the quantity of intense color that will produce a balanced composition. Choose two hues: one intense hue, and one that is much lower in intensity. Make a balanced composition, using the procedure in exercise 2.

5. **Use split complements.** The objective is to learn how to use split complements and achieve balance with the proper quantities. Carefully decide which are the split complements of your favorite hue, and then use the three colors to make a successful composition with vertical lines.

6. **Find harmony with hues.** The objective is to analyze colors and choose a relatively large quantity that together can provide a balanced composition. From the perforated pages in the back of the textbook, choose five colors that you think work together well. Hang them together for evaluation during the critique in class.

Lines of Composition

The Line of Composition

Try this exercise: Describe Janos Korodi's *Spaces No. 5* in Figure 4.1. What would you choose to mention? You might say that the colors are red, blue, green, and white (don't forget the white), and that most of the lines are diagonal. You have just described the **dominant line of composition** —the main type of line whose direction has the most influence over the skeletal structure, and the mood and artistic message of every composition.

In *Spaces No. 5*, the diagonal lines are the most influential lines; they are responsible for the dynamic feeling of sunlight moving across the site. Therefore, we can say that *Spaces No. 5* has a diagonal dominant line of composition.

In some compositions, the dominant line of composition is determined by *several shapes* placed next to each other to lead the eye from one to the next, rather than *just one line*. The shapes may even be different from each other, but as long as they are lined up, they move the eye in their direction and determine the line of composition. For example, in Figure 4.2, the people and the buildings are lined up horizontally, drawing the eye from left to right.

FIGURE 4.1 Janos Korodi: *Spaces No. 5.* Acrylic and oil on linen, 19.7" × 31.5", 2003. Janos Korodi.

key terms

dominant line of composition
energy
focal point
implied curvilinear line
orientation
*secondary/subordinate line of
 composition*

In every image, the direction of the strongest line, whether horizontal, vertical, diagonal, or curvilinear, establishes the line of composition and leads the eye through the whole picture. The line of composition wields a powerful influence on how the colors interact with each other, because it establishes the order in which we look at them. And the order must be clearly defined to the viewer. A jumbled line or too many different lines can confuse the eye, move it away from the focal point, or even worse—off the page. Confusing lines may even keep the eye occupied in a corner, never to venture out to look at the other areas of the picture and making them irrelevant.

But the line does much more than that: It is the primary way an image uses its colors to communicate its artistic message to the viewer. Each type of line infuses the composition with its own particular mood or feeling. A clear line of composition delivers a quick impression that engages us to respond with an emotional reaction, whether positive or negative.

There is another type of line that also has an effect on the image, but one that is not as strong: the secondary line of composition. In Figure 4.1, this would be the blue horizontal line at the bottom, and it stabilizes and slows down the dominant diagonal movement.

This horizontal line is called the **secondary line of composition**. In Chapter 5, we will discuss in detail the many types of lines and angles, and the way they influence the composition. In this chapter, however, the focus is on the main lines.

COLOR AND THE DOMINANT LINE OF COMPOSITION

The colors of an image and the dominant line of composition interact with each other. On the one hand, colors with a clear contrast draw the eye, establishing the line. But on the other hand, the dominant line can lead the eye to a color. However, the line of composition has a primal role in organizing the image, even more influential than the colors. Color can enhance the line or disturb it by slowing down the movement of the eye, but color usually can't change or destroy a strong line of composition. Conversely, the dominant line of composition has the ability to keep the viewer from noticing a color. The exception is in images where the line of composition is *ambiguous*, where shapes can line up in different orientations depending on the colors used. In that case, color choices certainly could alter it.

FIGURE 4.2 *Way to the theater.* The horizontal line of composition moves the eye from left to right. © www.TouchofArt.eu/Fotolia.

EVALUATING LINES OF COMPOSITION

How do you determine what type of line of composition you see in an image? Compositions can have many lines and shapes, and sometimes it's hard to see right away which define the line of composition, or even whether there is just one major line. Not all lines are integral to the mood of the picture as a whole. And not all of them contribute to the movement of the eye through the image. Some are too indistinct to do anything more than support or follow other lines, and some just obstruct movement.

Only the clearest lines stand out as the ones with the most influence. You can usually see at a glance which ones are the strongest, because they attract the viewer's eye. Looking at those lines, just ask yourself: Do these lines contribute to the movement through this composition? What is the main type of movement they describe? Is it horizontal—or vertical, diagonal, or curvilinear? The particular type of movement that you see would define the major line of composition.

In an abstract composition, which is made up of lines and shapes, the line of composition might be more obvious. We can easily see that a rectangle that is wider than it is high has a strong horizontal line, and this would establish a horizontal line of composition. But how do we decipher the lines of composition in a *representational* image with three-dimensional objects? Simply convert the 3-D image into flat 2-D shapes in your mind's eye, and its **orientation**, or direction, becomes clear. Even the fact that there is perspective doesn't interfere with the movement of the line of composition; everything can convert. For example, a road running back into the distance is a pyramid, which is a type of diagonal line of composition with a horizontal base.

Sasha Nelson's *Avian Conversation* (Figure 4.3) is an example of a complex composition with many different types of lines. Do you see the diagonals and horizontals in the branches and curvilinear lines in the birds and leaves?

**FIGURE 4.3 Sasha Nelson: *Avian Conversation.* Photograph, 2007. Sasha Nelson.

What are the strongest lines, and what type of compositional line do they define? The answer is found by the shape delineated by the two birds sitting above the three birds, supported by the thick diagonal branch on the left viewed against the diagonal branches on the right side—a *pyramid*. A pyramid has a strong horizontal line at the base contrasting against a triangle made of a secondary diagonal compositional line. In *Avian Conversation,* we notice the horizontal line by the solid and unmoving quality of the branches and the birds, contrasted against the meeting point of the diagonals at the top, which forms the triangle. The fat and curvy little birds also describe the horizontal line as they perch in a line on the branch, and even the black line on their chests do the same.

OBJECTIVES FOR THE DOMINANT LINE OF COMPOSITION

The dominant line of composition is a useful tool that can accomplish many goals. Based on the desired result, the designer can use it to:

1. ***Direct the eye through the composition to the focal point.*** Because the compositional line has the power to demand that the eye follow it, it can draw the eye through the composition to a particular location where it rests, called the **focal point**. There are many ways for the line of composition to make this happen. For example, it can aim directly at the focal point, forcing the eye to move right to it. This is the situation in Gary K. Meyer's *Wyoming, 2010* (Figure 4.4), in which the vertical lines of the trees point up through the haze to the ghostly sun. Joel Schilling's *Cypress Lined, Tuscan Countryside, Italy* (Figure 4.5) demonstrates the lines pointing to the focal point more directly, as the diagonal lines converge in the distance at the villa.

FIGURE 4.4 Gary K. Meyer: *Wyoming, 2010.* Photograph. Gary K. Meyer.

FIGURE 4.5 Joel Schilling: *Cypress Lined, Tuscan Countryside, Italy.* Photograph, 2002. Joel Schilling.

Or, several lines can radiate from it, making it the center of attention. For example, the curvilinear lines of the petals in Suzanne DiStefano's *Rose Spiral* (Figure 4.6) wind around the center, implying a curvilinear motion and making it the focal point.

2. ***Provide contrast against the lines of the focal point.*** A strong contrast can be established through overtly dissimilar lines. For example, in Figure 4.7, the curvilinear rocks are the focal point, but their vertical orientation and the grass lines establish a contrasting vertical dominant line.

3. ***Serve as the main line that sets the mood of the composition and tells the artistic story.*** For example, in Figure 4.8, the dramatic curving *Cliffs of Moher No. 2* protect a safe and secure cove. As we will learn in Chapter 5, the concave cliff line has a passive, accepting type of energy that enhances the feeling of peace.

4. ***Serve as the secondary line to contrast against the main line of composition.*** Two lines of composition can work together in many ways, their strengths juxtaposed to create a unique configuration. We will explore combinations of lines of composition in detail later in this chapter.

Types of Lines of Composition

Lines and angles have **energy**, which is the ability to exert force in the image. The force can do things like creating an emotional reaction in the viewer, and directing movement

FIGURE 4.6 Suzanne DiStefano: *Rose Spiral.* Photograph, 2009. A curvilinear composition formed by the spiral of the petals. Suzanne DiStefano.

FIGURE 4.7 Catherine Kinkade: *Susan's Brook II.* Oil on canvas, 30" × 40", collection Vernita McNeal. The vertical dominant line contrasts against the curvilinear focal point of the rocks. Catherine Kinkade.

through the composition. Energy can make an area stand out or become a focal point, make it visually vibrate or scintillate, or create a feeling of tension, or even establish a peaceful feeling.

Each type of line of composition has its own unique form of energy that is useful in accomplishing various visual goals. Your choice of line for your composition would depend on the particular needs of the image—whether you want to express calm or an excited mood, speedy or leisurely movement, or no movement at all, or whether you need to emphasize details such as height or width.

HORIZONTAL LINE OF COMPOSITION

The **horizontal line of composition** emphasizes width. Because of this, it provides a supportive base that can contrast well with other types of line. It is placid and peaceful, uniting elements with harmonious but static energy. Together, several horizontal lines form layers, and those layers more strongly establish the horizontal movement, rather than moving the eye vertically between them. If the top line is shorter, as in a pyramid, it feels more settled, but if the bottom line is shorter, it feels less stable, because nothing can balance well on a point. In Figure 4.9, the two pyramids formed by the shadowed hills stabilize their broken reflections.

Strong movement would not be your goal when using a horizontal line of composition. Aside from a gentle side-to-side direction, it does not contribute much to movement into or through the composition. Its real value is in establishing stability, or setting the groundwork for

FIGURE 4.8 Joel Schilling: *Cliffs of Moher #2*. Photograph, 2010. Joel Schilling.

other movements to occur. Sasha Nelson's *Fraser Island* in Figure 4.10 shows how several horizontal lines set a solid base for the flock of birds crossing the clouds.

Things that are horizontal include roads and bodies of water; horizons; large buildings; and objects that have a wide horizontal base, such as mountains. A pyramid shape has the static quality of a horizontal line because of its base.

VERTICAL LINE OF COMPOSITION

Vertical lines of composition are obstructionist. They block movement beyond them into the distance, and don't contribute to a side-to-side movement through the composition. They are strong and dominant, emphasizing their power with energy that barely moves—and that moves only up and down. Because of this type of energy, height contrasts stand out, enhancing the taller element. Notice how the trees in Sasha Nelson's *Tall Trees* in Figure 4.11 provide an obstruction barring the distant mountains.

FIGURE 4.9 Marcie Cooperman: *Sunset on the Daintree River, Blue Mountains, Australia.* Photograph, 2007. Marcie Cooperman.

Things that are vertical include tall buildings, trees, standing people, and fences. *Brooklyn Bridge 6* in Figure 4.12 shows how a vertical line of composition can be created by diagonal lines. Most of the cables are actually diagonal lines, yet they are so thin and upright that they give an impression of verticality.

FIGURE 4.10 Sasha Nelson: *Fraser Island.* Photograph, 2007. Sasha Nelson.

FIGURE 4.11 Sasha Nelson: *Tall Trees.* Photograph, 2007. Sasha Nelson.

DIAGONAL LINE OF COMPOSITION

The **diagonal line of composition** is vital and energetic. Heavy diagonal lines can illustrate stress and excitement, especially with angles pointing toward each other, as we will examine in detail in Chapter 5. A diagonal line is an extremely useful way for the designer to suggest movement in a composition.

Lines become diagonal the moment they begin to diverge from a horizontal or vertical orientation. Angling a horizontal line slightly into diagonal begins to make it directional for the eye, and the more it is tilted, the faster the movement. Steep lines are like a highway the eye follows at top speed. Since Western Hemisphere denizens read from left to right, the line of composition moves the eye in that direction for them, and a diagonal line speeds it along.

Two diagonal lines angled toward each other direct the eye to their intersection, just like train tracks receding into the distance. They form an angle that points like an arrow, directing energy there. Look back at Figure 4.5 (Joel Schilling's *Cypress Lined, Tuscan Countryside, Italy*) for this structure.

Pointing upward, two diagonal compositional lines can suggest an object of great height, such as a skyscraper or tree. Aiming toward each other this way, they describe foreshortening, which gives the illusion of height.

In Joel Schilling's *Salmon Running, Katmai National Park, Alaska* (Figure 4.13), the diagonal line of composition is established by two diagonals: the salmon running in one direction, and the white reflections in the opposite direction. The eye tends to move in a ceaseless clockwise motion, following the light reflections from top right to bottom left, then picking up the red lines at top left and sliding down them toward bottom right, then picking up the reflections again. The complementary relationship of the red and green hues enhances their differences and strengthens the movement.

FIGURE 4.12 Jose Gil: *Brooklyn Bridge 6.* Jose Gil.

Mercedes Cordeiro Drever's *Sensual Lines, Grand Canyon—Arizona* in Figure 4.14 illustrates fast-running diagonal lines in the rocks. Orange adds to the energy level.

Things that are diagonal include cast shadows, lines of buildings, fences, and streets that show perspective as they move into the distance.

X-Shaped Line of Composition

All diagonal lines give movement to a picture, but their particular orientation can fine-tune it. In the X-shaped line of composition, the eye is drawn back through the picture to the point where the X lines meet, a tool especially useful for illustrating perspective. We often see X-shaped lines of composition in a landscape. According to the rules of perspective, all lines in an image of real life converge together in the distance. An X-shaped line of composition shows us where that point is, at the convergence of the elements of the landscape. *Jet Boats in the Lake, Queenstown, NZ* (Figure 4.15) illustrates the X-shaped line of composition.

Things that are X-shaped include landscapes of mountains and rivers or trees that recede into the distance.

FIGURE 4.13 Joel Schilling: *Salmon Running, Katmai National Park, Alaska.* Photograph, 2005. The diagonal lines move in two opposite directions in this diagonal composition. Joel Schilling.

FIGURE 4.14 Mercedes Cordeiro Drever: *Sensual Lines, Grand Canyon—Arizona.* Photograph, March 2010. The diagonal line of composition is emphasized in the many lines on the rocks. Mercedes Cordeiro Drever.

FIGURE 4.15 Marcie Cooperman: *Jet Boats in the Lake, Queenstown, NZ.* Photograph, 2007. Marcie Cooperman.

CURVILINEAR LINE OF COMPOSITION

The **curvilinear line of composition** has a sinuous motion that feels organic, feminine, and graceful. Like the diagonal line, curves create movement, but where the diagonal movement is direct and abrupt, the curvilinear movement is smooth and easy. Joel Schilling's *Gourd No. 5* in Figure 4.16 moves the eye around the gourd in a continual looping motion.

Sometimes the lines and shapes themselves are not curvy, but the movement is curvilinear because of their placement. We call this an **implied curvilinear line**. The lines in Janos Korodi's *Spacedeconstruction* (Figure 4.17) are straight, but the blues are placed in locations that *imply* a curvilinear movement, rotating the eye around the image from one to the next.

Things that are curvilinear include organic and natural forms like ivy, greenery, and leaves on trees; clouds; balls; the human form; and winding rivers.

Two Lines of Composition in One Image

How many types of lines of composition should an image have? Compositions are often comprised of many types of lines, but most of them are usually subordinate lines that do nothing to determine the direction the eye travels in the image. The *lines of composition*, however, are the dominant types of lines that do attract and direct the eye. For a composition to be understandable,

FIGURE 4.16 Joel Schilling: *Gourd No. 5.* Photograph, 2010. Joel Schilling.

FIGURE 4.17 Janos Korodi: *Spacedeconstruction.* 63" × 94.5", acrylic and egg tempera on linen, 2003. Janos Korodi.

it should have only one or two of those. More than two dominant lines would be confusing, because the eye could not focus on any particular area. The result is that the artistic message would not be communicated, and the entire composition would seem muddled.

The two dominant lines work together in an image to give the composition its particular energy. This relationship requires that when one line is chosen as the main directional one, the secondary line must offer a balancing direction. Either the two lines can both have the same level of strength and influence on the composition, or one can be the major line with the strongest directional energy, with contrast provided by the secondary line.

The major and secondary lines of composition are two tools that can be used together to perform many miracles in a composition. Think of them as indispensable as your right and left hands together. Each imposes its characteristic effects on the whole, and the combination of the two creates the unique mood of the composition. They may form angles together, or combine into shapes not possible with just one line of composition.

Even with only two coexisting lines of composition, the wrong placement or orientation of line could muddle movement and confuse the eye. They need to support each other, and work together for the same goals in terms of bringing the eye in the desired direction. With practice, you will be able to see how angling a secondary line one way or another would work better with the dominant line of composition.

SOME POSSIBLE COMBINATIONS OF LINES OF COMPOSITION

Horizontal Line with a Secondary Type of Line

The horizontal line sets the stage with a settled tone. It imposes the effect of a placid and still horizon on a composition, and the addition of a secondary type of line gives it some movement.

Main Horizontal Line with Secondary Vertical In Joel Schilling's photo *Boats at Rest, Ascona, Switzerland* (Figure 4.18), the lined-up boats create a static and unmoving horizontal

line, enhancing the feeling of boats at rest. The faded secondary vertical line of the masts makes a gentle visual plus sign that keeps the eye moving just above and below the horizontal line. The intense blues on the boats hold the eye amid very low-intensity, high-value blue water and sky.

Main Horizontal Line with Secondary Curvilinear In Janos Korodi's *Persian Bay* in Figure 4.19, the movement is serene because it is horizontal, with a wavy attitude due to the curvilinear lines.

Main Horizontal Line with Secondary Diagonal Mercedes Cordiero Drever's *Defined Layers, Grand Canyon—Arizona* in Figure 4.20 shows the power of the horizontal line, aligned with a secondary diagonal line of composition. The massive horizontal rock implies absolutely no movement, and it even forces the diagonal line that is moving away from it to be fairly still. The diagonal "moves away" from the horizontal because we read it as sliding downward from left to right, and the small

FIGURE 4.18 Joel Schilling: *Boats at Rest, Ascona, Switzerland.* Photograph, 2001. Joel Schilling.

FIGURE 4.19 Janos Korodi: *Persian Bay.* Oil on canvas, 55" × 55", 1999. Janos Korodi.

FIGURE 4.20 Mercedes Cordiero Drever: *Defined Layers, Grand Canyon—Arizona.* Photograph, 2010. Mercedes Cordeiro Drever.

figures strengthen our perception by walking in that direction. Their small stature enhances the size of the rocks.

Although the rock lines actually are slightly scalloped, the line they define is horizontal. This image proves another point that has to do with our perception of the world: Even if a line isn't exactly horizontal (or vertical), we correct its "defect" and call it horizontal (or vertical). The diagonal line's movement is enhanced by its orange color, and its intensity, higher than the horizontal rocks behind it.

Vertical Line with a Secondary Type of Line

The value of the vertical line of composition is in achieving these goals: keeping the eye within its borders, moving the eye up and down, obstructing some type of view, or enhancing height. The secondary line of composition can work with this strong directional tool by softening it.

Main Vertical Line with Secondary Horizontal We've seen how vertical lines can move the eye up and down, or form an impediment just like a fence. In Figure 4.21, *Seeing Through* by Liron Sissman, the vertical tree trunks do both. They define a strong vertical line of composition that acts as a visual block to the shoreline in the distance. But the horizontal shore sets its natural serene tone, holds the trees together, and grounds the verticals with stability. It draws the eye into the distance with a tempting image. Without the contrasting secondary line of composition, the eye would never move beyond the barrier.

There are two other types of lines in this image: the diagonal branches and curvilinear reflections in the water. They are not as strong, and their job is to help the eye to move around, but not to dominate the flow. They help the verticals provide a lacy, playful screen that allows further movement into the distance by diffusing the verticals.

Against the low-value verticals, the shoreline has a slightly higher value, which enhances its attraction for the eye. The blue water and sky background contrast in value and define the location, but they are without detail and they fade into the distance.

A major line of vertical tree reflections in Gary K. Meyer's *Wyoming, 2010* in Figure 4.22 suggests very tall trees, contrasting with a secondary horizontal line of water ripples that shows us that this is a horizontal water surface. The duck and the large blue ripple stand out as focal points because of their value and hue contrasts; in the case of the blue ripple it is a complementary relationship with the water.

Main Vertical Line with Secondary Diagonal The danger of a vertical line of composition is of sending the eye off the canvas at the top, and the secondary line has the advantage of being able to counteract this motion. In Cynthia Packard's *Seated Nude* in Figure 4.23, the vertical orientation of the canvas and the upright figure give the image a vertical line of composition. Although the secondary diagonal lines near the top point upward, they open downward in a pyramid shape with no horizontal bottom, enveloping the figure. This sends the eye back down to her, keeping her as the focal point.

Main Vertical Line with Secondary Curvilinear The vertical lines establish the up and down energy quite strongly in Liron Sissman's *There* (Figure 4.24). The curvilinear leaves draw the eye through the composition and prevent the vertical trees from sending the eye off the image.

FIGURE 4.21 Liron Sissman: *Seeing Through.* Oil on canvas, 24" × 36", 2006. Liron Sissman.

FIGURE 4.22 Gary K. Meyer: *Wyoming, 2010.* Photograph. Gary K. Meyer.

FIGURE 4.23 Cynthia Packard: *Seated Nude.* Oil and wax on board, 36" × 96", 2009. Cynthia Packard.

The vertical lines in *Delft Entrance* in Figure 4.25 direct the movement up and down, and like the typical vertical blockade, they do nothing to help move the eye sideways. The curvilinear railings are responsible for that.

Diagonal Line with a Secondary Type of Line

Diagonal lines lend energy and movement to a composition. A secondary line of composition can hold it back somewhat, reducing the energy or providing end points for it. Each type of line brings its characteristic qualities to the combination.

Main Diagonal Line with Secondary Horizontal In Ivan Valliela's *Salt Marsh in Cape Cod* (Figure 4.26), a gentle diagonal line of composition curves the eye lazily to the bottom right. The secondary horizontal line keeps the energy serene and anchors the diagonal waterline to the horizon. The sky and water share the same color, enhancing the peaceful effect, made stronger by the contrast with the complementary orange reeds.

Main Diagonal Line with Secondary Vertical The diagonals in Janos Korodi's *Spaces No. 1* in Figure 4.27 blast out toward the right, radiating out from the blue vertical window-like shapes on the left side, and stopped by the red vertical shapes in the bottom right corner, as well as the white vertical lines of trapezoids above. Verticals obstruct, and these verticals do stop movement. Although the brown and white lines are the ones forming the diagonal movement, the orange enhances their strength because it is an energetic color, contrasting against its complementary blue. The orange shapes themselves are not diagonals and not even in a diagonal orientation, but it takes a moment of observation to realize that. The top orange area is somewhat horizontal, but being arrayed in a fanlike shape with the white diagonal lines enhances the diagonal line.

In Gary K. Meyer's *Wyoming, 2010* in Figure 4.28, the diagonal lines of the stream form a pyramid that focuses the eye on its apex in the distance. The vertical trees on each side act as boundaries that keep the eye from moving off the picture on either side, and they frame the diagonal motion.

Main Diagonal Line with Secondary Curvilinear In Figure 4.29, the diagonal lines in *Lava Beach; Hana, Hawaii* give it the strongest movement. However, the distance the lines travel is tempered by the curvilinear bubbles, which keep the movement slower and more local. The black sand makes the white foam stand out, the contrast enhancing the swirling movement more than the more common colors of sand and water would. In Whitney Wood Bailey's *Crossroads Instinct Intellect* in Figure 4.30, the diagonal lines meet in the center, making the movement star like and static, but the rounded corners keep the eye moving around the edges of the image.

The strong diagonal lines in Cynthia Packard's *Fall Tree* in Figure 4.31 move the eye through the secondary curvilinear lines of the leaves in the background. The leaves energize the image, but don't do anything to move the eye through it.

Curvilinear Line with a Secondary Type of Line

Curvilinear lines make their presence known by the endless circles the eye makes through the composition. Often it takes a secondary type of line to direct this movement, slow it down, or give it character.

Main Curvilinear Line with Secondary Horizontal The curvy lines draw the eye around and through Henri de Toulouse-Lautrec's *Reclining Nude* in Figure 4.32, but the horizontal line settles down the image heavily. However, it also encourages a lazy side-to-side motion as the eye curves around the figure and fabric drapings.

FIGURE 4.24 Liron Sissman: *There.* Oil on canvas, 24" × 36", 2011. Liron Sissman.

FIGURE 4.25 Joel Schilling: *Delft Entrance.* Photograph, 2008. Joel Schilling.

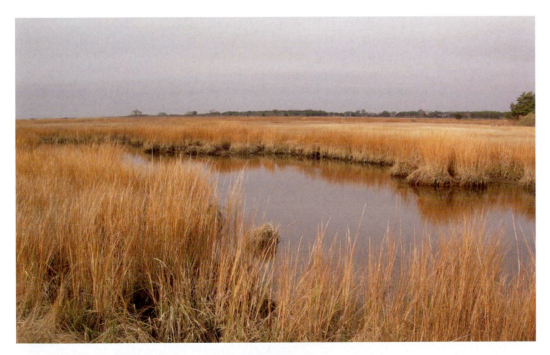

FIGURE 4.26 Ivan Valliela: *Salt Marsh in Cape Cod.* Photograph, 2009. Ivan Valliela.

Main Curvilinear Line with Secondary Vertical In Figure 4.33, the curvilinear lines of the pipes create dynamic energy that moves continuously around the composition, but they are held to a vertical orientation by the fence and its shadows.

Main Curvilinear Line with Secondary Diagonal In Syed Asif Ahmed's photograph in Figure 4.34, the orange curvilinear pipes exert the strongest movement from bottom left to top right. The energy is enhanced by the orange against the complementary blue sky. The secondary diagonal line of the shadows moves the eye down to bottom right, but the comfortable analogous relationship of the blue and green keeps the movement slow.

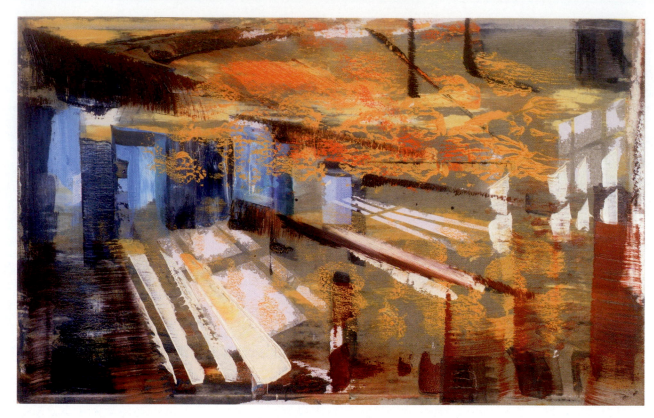

FIGURE 4.27 Janos Korodi: *Spaces No. 1.* Acrylic and oil on canvas, 19.7″ × 31.5″, 2002. Janos Korodi.

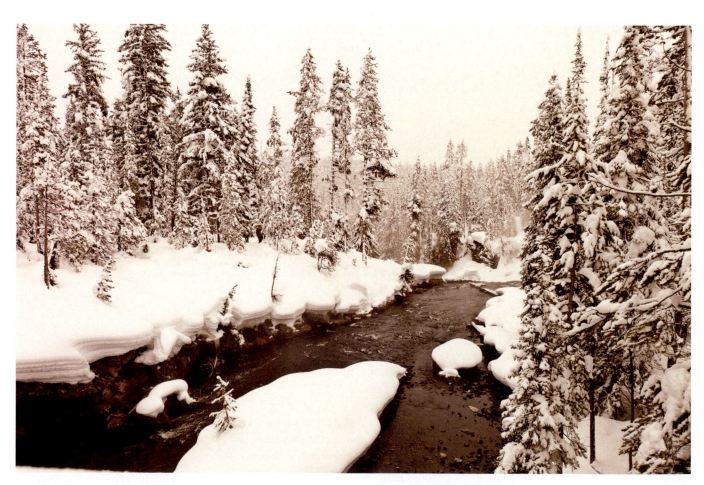

FIGURE 4.28 Gary K. Meyer: *Wyoming, 2010.* Photograph. Gary K. Meyer.

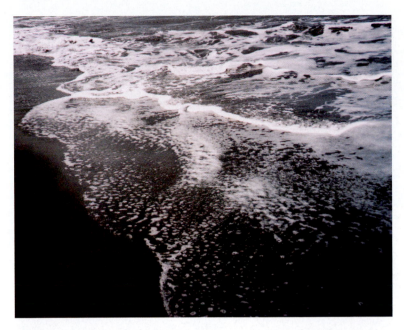

FIGURE 4.29 Marcie Cooperman: *Lava Beach; Hana, Hawaii*. Photograph, 2007. The curvilinear lines keep the energy of the diagonal line of composition within the edges of the photograph. Marcie Cooperman.

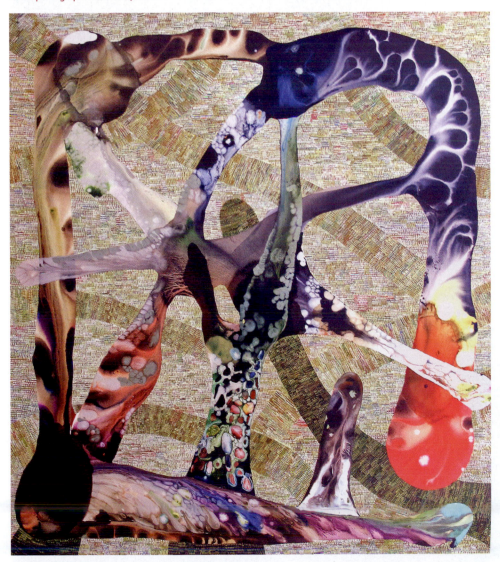

FIGURE 4.30 Whitney Wood Bailey: *Crossroads Instinct Intellect*. Oil and mixed media on canvas, 96″ × 84″, 2010. Whitney Wood Bailey.

FIGURE 4.31 Cynthia Packard: *Fall Tree.* Oil and wax on board, 96" × 96", 2009. Cynthia Packard.

FIGURE 4.32 Henri de Toulouse-Lautrec: *Reclining Nude.* This nude illustrates a curvilinear line of composition. Superstock 1114–1124.
© Barnes Foundation/SuperStock 1114-1124-I-P43D.

FIGURE 4.33 Marcie Cooperman: *Pier 54 Pipes*. Photograph, 2010.
Marcie Cooperman.

FIGURE 4.34 Syed Asif Ahmed, bedueen: *Queens, NY.* Photograph, 2011. Asif Syed Ahmed.

summary

By now, you most likely have a good understanding of how the line of composition can influence the artistic message and the mood of your image. The many types of lines can do their jobs in various ways, giving the designer so many choices, especially when used in combination. Whatever colors you use, you can alter the way they deliver the artistic message just by changing the type of lines in the image. It pays to play around with several possibilities when working on your design, to see where they lead, and to come up with the best possible arrangement.

quick ways . . .

To see whether the important lines in your composition are working well together, ask these questions:

1. In what direction does the eye move through the composition? If you can answer that, you have the answer to the question: What type of major line of composition do you see?

2. How many different types of *lines of composition* are there in your image? More than two? If so, how can you *reduce and simplify*—eliminate unnecessary lines—to restrict it to two?

3. If there are two, can you identify the directions of the major line and a secondary line? Are they working together? What type of relationship do they have together?

4. Does the line of composition establish and support one focal point or focal area? Or is it muddled with no focal point? Or does it create two competing focal points?

exercises

Parameters for Exercises

There are many factors of color and color relationships in compositions, and all of them can affect the way the colors appear to the viewer. The best way for students to learn through their color exercises is to have simple objectives and fairly strict *rules* about the type of lines and colors to be used. We call those rules "parameters." With strong parameters allowing only a minimum of elements, it is easier to observe the direct relationships between colors, and to see the differences between the students' compositions. When lots of compositions hang together for a critique, it becomes clear which ones are successful in achieving the goals.

As students learn the objectives and build on their skills, they will become more adept at using color. They will gain the ability to tolerate more complications because they understand the ensuing interactions. Therefore, the restrictions on composition size and the number of lines and colors will be gradually reduced. Larger compositions, more colors, and more types of lines will be allowed. hHowever, certain ground rules will remain the same: Flat color and nonrepresentational shapes will remain constant parameters, and the goal of every assignment will be a balanced composition. Five specific parameters include:

1. No recognizable objects are allowed.
2. All colors are to be flat and nongradient, with hard edges that don't fade away.
3. White is always considered a color, even if it is the background.

4. Only neatly cut and pasted papers are appropriate.
5. Balance and unity are *always* the singular goal of every composition.

1. ***Identify the types of composition:*** For Figures 4.35 to 4.37, identify the major and secondary types of line of composition. Write supporting explanations for your opinions and discuss them with your class in a critique.

Parameters: For the compositions in exercises 2 through 8, keep them simple by using only three different colors, and limit the size to 5" × 7". Bring these into class for a critique, and see if your classmates agree that you have achieved your goals.

2. ***Learn to use the horizontal line of composition:*** Make a horizontal composition in two ways:
 a. Use horizontal lines for the dominant line.
 b. Use no horizontal lines at all in this image. Create a horizontal line using other types of lines.

3. ***Learn to use the vertical line of composition:*** Make two compositions as in exercise 2:
 a. Use vertical lines for the dominant line.
 b. Use no vertical lines at all in this image. Create a vertical line using other types of lines.

4. ***Learn about the different types of diagonal compositional lines:*** Make diagonal compositions that do these things:

 a. One that establishes a placid and serene atmosphere.

 b. One that illustrates strong and forceful energy.

 c. One that illustrates an X-shaped composition.

5. ***Learn how the wrong colors can destroy your goals:*** Make the first two compositions of exercise 4, but use colors that:

 a. Change this previously serene atmosphere to become violent.

 b. Change this previously strong and forceful energy to become calm.

6. ***Learn to use the curvilinear line:*** Create compositions with the following goals:

 a. Three curvilinear lines that curve differently can work together to produce one focal point.

 b. The composition has one curvilinear line forming the major line of composition that keeps the eye on a focal point.

7. ***Create compositions using two types of lines:*** Make two compositions using a major horizontal line of composition and a secondary diagonal line. Each composition should make the eye move through the composition in a different way.

FIGURE 4.35 Cynthia Packard: *Daybed.* Mixed medium paper, lace, oil, tar wax, shellac and plaster, 60" × 60", 2010. Cynthia Packard.

FIGURE 4.36 Gary K. Meyer: *Ethiopia, January 14, 2009.*
Photograph. Gary K. Meyer.

FIGURE 4.37 Ando Hiroshige: *Horie and Nekozane.* Woodcut, 14.2″ × 9.1″, 1856.
Library of Congress.

Energy and Continuity

Compositions have energy! They excite the eye. Without our consent, they take control of how we perceive them. Sounds like an absurd concept, but it's true.

Although we don't think about it, we usually look at the various areas of a painting in a certain order. First, something attracts the eye. Then something leads us to another area, even if we couldn't necessarily say what caused us to look at it. Then we are directed to the rest of the picture, before settling finally on an area that holds the most interest for us. This process of visually moving through the composition is called **continuity**.

As an example, take a look at Samantha Keely Smith's *Segué* in Figure 5.1. What do you see the very moment you glance at it? It must be that area of radiant yellow light in the center, encircled as it is by the contrasting blue and orange areas. Tantalizing patterns bordering the glow pull us away as we follow their dripping, floating lines around to the right side and up to the top, then we slide down the point of the magnetic glow again.

FIGURE 5.1 Samantha Keely Smith: *Segué.* Oil on canvas, 48" × 64", 2008. Samantha Keely Smith.

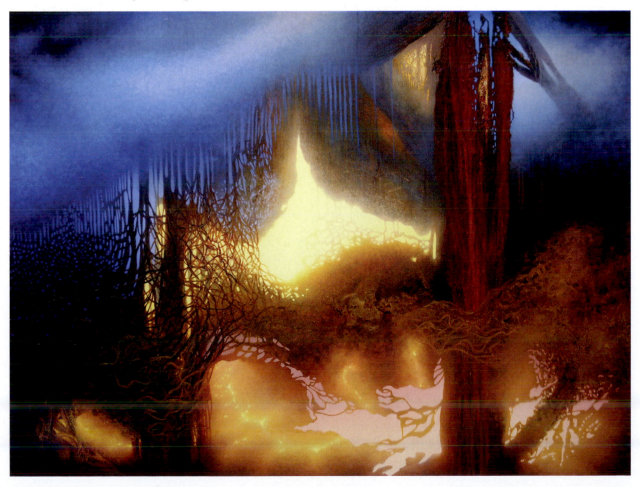

The designer can use the elements of color and composition as tools to facilitate continuity. These tools can grab our attention initially, then help us move around the picture and see everything, finally determining the area where we end up, known as the *focal point*. If these tools aren't used properly, the eye moves about randomly, or it gets stuck in a corner and misses other areas, and the design message isn't communicated. For example, as you can imagine, strong contrasts grab our attention first—perhaps an intense color, or light against dark. But too many exciting areas can cause fatigue or even boredom, hold our attention captive, and keep us from looking at the rest of the composition. Ultimately, this lack of control could destroy the balance of the composition.

In addition to the movement of the viewer's eye, elements of the composition appear to have energy between them. Energy is movement, or the potential to cause a change. For example, two lines would look different together than they do alone because they are seen in relation to each other. How they look and how they move together depends on their shapes and sizes, as well as where they are located in the composition.

In working with energy and continuity to create a balanced 2-D composition, the designer has two objectives: (1) to make the viewer's eye stay within the boundaries, and (2) to direct the viewer's eye around the *whole* picture.

To achieve these goals, the designer needs to think about *every area* of the composition, each of which contains elements that either have active movement or that passively support the active areas. Each area plays a part in keeping the eye from losing interest and moving off the page, and each is integral to the process of establishing the order in which the picture is viewed. Making changes such as altering a color, eliminating a line, or adding a shape alters the energy and the overall compositional movement, and consequently changes the order in which we would view the parts of the composition.

These two concepts, *energy and continuity,* work hand-in-hand to help the viewer enjoy the composition and receive the visual message the designer has in mind. In this chapter, we will look at the factors that allow the designer to control energy and continuity.

Energy

Energy (movement) is a natural product of the lines, shapes, and colors in a composition. There are two things that occur:

1. Elements themselves seem to be moving or are about to move, because of their interactions.

2. Their movement helps the eye move through the composition.

FOUR FORMS OF ENERGY IN A COMPOSITION

Tension (potential energy) is in the form of stored energy, where colors and shapes scintillate, or vibrate against each other. Tension is the feeling that something is about to move. However, the key phrase is *about to move*, not actually moving. Figure 5.2 shows the power of this type of energy.

Dynamic energy is a form of energy where elements seem to actually be moving. Dynamic energy moves our eye around the composition, led in one direction or another by the elements. Movement can vary; it can be jerky or smooth, in only one direction or back and forth between elements. Figure 5.3 illustrates dynamic energy in the red bars.

Marcel Duchamp's *Nude Descending a Staircase No. 2,* Figure 5.4, was the first to illustrate the dynamic energy of movement, rather than the object itself with its local colors

FIGURE 5.2 Orange and blue bars scintillate and create potential energy. Marcie Cooperman.

key terms

accent
breathing room
continuity
dynamic energy
energy
focal point
opposing angle
passive energy
static energy
tension (potential energy)
unopposing angle
visual weight

FIGURE 5.3 Red bars move the eye into the distance and create dynamic energy. Marcie Cooperman.

and 3-D form. As such, it caused tremendous controversy—most viewers could see no nude or staircase. It was rejected from the Salon des Indépendents, and a *New York Times* critic commented, "it looks like almost anything except a nude descending a staircase, and most—though not much—like an explosion in a shingle mill."[1]

Static energy is a quiet feeling of peace, where nothing seems to move. In Figure 5.5, the energy in the triangles is static, enhanced by the steady horizontal violet line underneath. The top point of each triangle lies vertically over its base edge, which supports it and prevents it from feeling like it will tip over. The small triangle on the left is slightly unsteady on its right side because its top angle lies outside its base edge. But it in turn is supported by the solid triangle next to it.

FIGURE 5.4 Marcel Duchamp: *Nude Descending a Staircase No. 2*. Oil on canvas, 57 7/8" × 35 1/2", 1912. This is the classic example of dynamic energy created by lines in the composition. The Philadelphia Museum of Art / Art Resource, NY and the Artists Rights Society.

In Figure 5.6, Helen Frankenthaler's *The Bay,* the blue form assumes an organic 3-D shape because of the blending of values, and although heavy, it seems to float peacefully like a cloud above a verdant landscape.

Passive energy is acceptance of, or being a nonmoving obstruction to, nearby elements. Curves, as in Figures 5.7 and 5.8, have a passive relationship to the shapes next to them. Concave curves are open and accepting of those shapes. They partially surround and hold them, allowing them to be the focal point. Convex curves form a passive obstruction, turning their backs on shapes next to them. These curves are passive because they transfer no energy to the elements while they do not let energy pass beyond them.

FIGURE 5.5 These triangles illustrate static energy. Marcie Cooperman.

FIGURE 5.6 Helen Frankenthaler: *The Bay.* Acrylic on canvas, 80.7″ × 81.7″, 1963. Detroit Institute of Arts, USA/Founders Society Purchase, Dr. & Mrs. Hilbert H. DeLawter Fund/The Bridgeman Art Library.

FIGURE 5.7 Passive energy: Convex lines obstruct other elements. Marcie Cooperman.

FIGURE 5.8 Passive energy: Concave lines accept other elements. Marcie Cooperman.

WHAT MAKES ENERGY?

Colors, angles, shapes, and lines create energy, as described in the following sections.

Colors

Pairs of complements produce tension, as do intense hues. Blue and orange together produce the most tension, even at low intensities, such as tints. They scintillate and vibrate, and can be used in a composition where a strong reaction is desired. Impressionists such as Monet and Renoir often relied on blue and orange to produce the impression of sparkling sunlight. The tension produced by other pairs of complements varies depending on their values and intensity levels; yellow and violet together are usually less vibrant than blue and orange. Red and green are most even, although their high intensities used together would vibrate.

Red is a forceful, dynamic hue, making it the ideal stop sign. Yellow glows beyond its boundaries, and is more ethereal than red; it is not the same tangible, oppositional force as red. Orange's energy is in between yellow and red. Figures 5.9 to 5.11 illustrate the energy of red, yellow, and orange.

FIGURE 5.9 The red rectangles are dynamic. They appear to be three-dimensional bars leading back through glowing yellow space. Notice that the same red appears to be darker here than in Figure 5.10 where red is the background. This is because smaller areas of color appear to be darker than larger areas. Marcie Cooperman.

FIGURE 5.10 The yellow bars have tension, but they don't have the dynamic energy of red. The value contrast here is stronger than in Figure 5.11, with the result that the red looks darker here than in Figure 5.11. Marcie Cooperman.

FIGURE 5.11 Next to red, orange's energy is reduced. The values are closer to each other, further reducing the energy. Marcie Cooperman.

FIGURE 5.12 The atmospheric blue background creates passive energy. Against blue, the warmer red–violet rectangles have potential energy. Marcie Cooperman.

FIGURE 5.13 Catherine Kinkade: *Dunes 3*. Pastel, 18 1/4″ × 25″, collection Verizon. Catherine Kinkade.

When hues like red, yellow, or yellow–green are saturated, they attract attention and energize an area, especially if there is contrast with a low-intensity color. That's why fire engines are painted in those colors, contrasting against the general outside environment. However, even middle intensity colors can feel stronger and create energy when placed against very low intensities.

Blue is intangible and atmospheric, and creates passive energy, as in Figure 5.12. This means blue seems to actually *be* the sky we can't touch, with infinite depth. Blue's energy is often passive or static as opposed to warmer hues, which have more dynamic energy. Blue, and cool hues that include blue in their mixture, tend to recede and allow the warmer hues to come forward. But higher intensity blue is more dynamic and fights its natural tendency to recede… *Dunes 3* in Figure 5.13 shows the passive energy of blue.

Angles

Angles point the way for energy to move. **Opposing angles** as in Figure 5.14 point toward each other, and appear to be resisting each other like the positive ends of two magnets. **Unopposing angles** as in Figure 5.15 face away from each other; they each send dynamic energy in the direction away from each other. Faces and flowers behave much like angles, sending energy in the direction in which they point. You can see proof of this in Figure 5.16, where the lilies each send energy away from each other to their closest upper corner. Compare this action to the lilies facing each other in Figure 5.17, all projecting hugely dynamic

FIGURE 5.14 Opposing angles create dynamic energy toward each other. Marcie Cooperman.

FIGURE 5.15 Unopposing angles send energy away from each other. Marcie Cooperman.

FIGURE 5.16 Marcie Cooperman: *Lilies Not looking at Each Other.* Photograph, 2011. Marcie Cooperman.

FIGURE 5.17 Marcie Cooperman: *The Lily Garden Speaks.* Photograph, 2011. Marcie Cooperman.

energy toward each other. A force seems to bounce up and down in Vs between the red lily and the others, leaving no escape route for the eye.

Shapes

Shapes can be polygons (polygons are closed shapes with three or more straight or curved sides), or circular, or organic (organic shapes are partly curvy, and they do not follow prescribed rules about number and shape of sides). Figure 5.21 shows two organic shapes. Some shapes

have angles that point the way dynamic energy will move, as in Figure 5.18. A group of similar shapes can create movement that follows their placement on the page. For example, shapes of any type placed in a circle create *implied curvilinear* motion like in Figure 5.19, even if they are not round themselves.

The stability of any particular shape can be influenced by the lowest angle or edge on which it is resting. Shapes with wider edges on the bottom conspire with gravity to appear weighted down and stable, like Figures 5.20 and 5.22. Shapes with wider edges on top or with an angle on the bottom have potential energy and feel less stable, like Figure 5.23.

FIGURE 5.18 The triangles point the way for energy to flow. Your eye follows the energy from the triangle toward the red circle. Marcie Cooperman.

FIGURE 5.19 These triangles move the eye in a circle because they are placed in implied curvilinear order. We read the image from left to right. Marcie Cooperman.

FIGURE 5.20 These rectangles are static, and they don't point the way for energy to flow. Marcie Cooperman.

FIGURE 5.21 The negative space between these two organic shapes sends energy along the contrasting straight edges, from top left to bottom right. Marcie Cooperman.

FIGURE 5.22 Because it rests on its widest edge, with two angles on the bottom, this triangle has static energy. Marcie Cooperman.

FIGURE 5.23 Because it balances on a point, gravity appears to be about to pull the top point down. Marcie Cooperman.

FIGURE 5.24 These verticals move the eye horizontally, as along a fence. Marcie Cooperman.

FIGURE 5.25 These vertical lines form a barrier that prevents sideways movement, and moves the eye upward. Marcie Cooperman.

Lines

Lines are the simplest and most direct way to produce energy and movement. A line can be thin or thick, but as the width of a line is increased, at a certain point its identity as a line disappears and it becomes a shape.

TYPES OF LINES AND THEIR MOVEMENT

Singular lines move the eye in the direction in which they are pointing. Depending on the type of line, they do so with varying amounts of energy. When several lines are placed together in a pattern of some sort, the linear movement alters and begins to include movement between them.

Vertical and Horizontal Lines

Vertical lines are not very dynamic, but they do provide vertical movement and act as obstructions to sideways motion, as in Figure 5.25. However, care must be taken in line length, placement, and color so that verticals don't block necessary movement through the composition. For example, colors that appear to be strong relative to their surroundings enhance that blocked feeling. But colors that make a weaker statement in relation to

FIGURE 5.26 Gary K. Meyer, *South Georgia Island.* Photograph, November 2009. Gary K. Meyer.

their surroundings, such as lower-intensity or middle values, could mitigate the obstruction a bit. To create horizontal movement and help move the eye from one vertical to another, add lines like horizontals, diagonals or curves. Figure 5.26 illustrates how the soft, rounded, brown babies help the eye move horizontally through the many vertical forms of the penguins.

Several similar-sized parallel lines together can move the eye along it in a horizontal direction. As the eye moves, it reminds us of prison bars, or a fence, as in Figure 5.24. If the lines are different sizes and heights like in Figure 5.25, the eye is drawn to their differences, overpowering sideways movement.

Horizontal lines are passive. They facilitate side-to-side movement, although they don't contribute to it actively. They define shapes that feel settled and lowered by gravity. A horizontal line that touches both side edges becomes more than just a line; in our perception, it assumes the role of the horizon. Horizontals in a composition benefit from the presence of other types of lines, to connect them or lead the eye upward through the composition. The horizontal dunes in *Little Sahara, Kangaroo Island, Australia* (Figure 5.27) create a heavy, static energy.

Diagonal Lines

Diagonal lines are dynamic in creating movement. Compare them to the vertical and horizontal lines in Figure 5.28 to perceive the difference in energy. Because we tend to read compositions from left to right, we can use diagonals to either flow with this movement, or provide a challenge to it. For example, sloping lines going from bottom left to top right as in Figure 5.29 can be read as climbing uphill. But diagonals from top left to bottom right as in Figure 5.30 appear to be effortlessly sliding down an incline.

FIGURE 5.27 Marcie Cooperman: *Little Sahara, Kangaroo Island, Australia.* Photograph, 2007. Horizontal lines produce shapes that feel heavy and settled. Only the blue sky is weightless at the top because of its color. Marcie Cooperman.

Curvilinear and Implied Curvilinear Lines

Curvilinear and implied curvilinear lines create flowing, smooth movement that is faster than that of horizontal or vertical lines. The curvy orchids in Figure 5.31 demonstrate how they make the eye whip around the image in a continuous motion.

The Space, or Distance, Between Shapes or Lines

Empty space, also known as negative space, becomes charged with meaning when it is in between two shapes or lines. It gains a role as the *distance between the lines,* and as such is instrumental in establishing the level of energy they exchange.

FIGURE 5.28 The diagonal cross appears to "move," but the vertical–horizontal one is static. Marcie Cooperman.

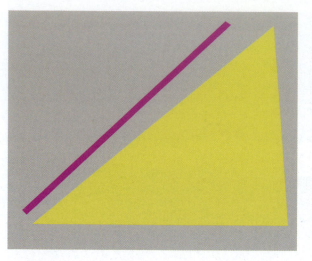
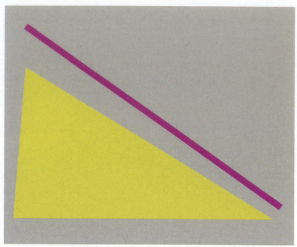

FIGURE 5.29 Since we read images from left to right, the diagonal movement going uphill to the right is arduous. Marcie Cooperman.

FIGURE 5.30 The diagonal movement from left to right effortlessly slides downhill. Marcie Cooperman.

FIGURE 5.31 Joel Schilling: *Orchid No. 3.* The curvilinear lines create an unending sinuous motion. Photograph, 2005. Joel Schilling.

The concept of distance is an essential tool for the designer. How do you determine the proper distance between shapes? First, it is necessary to understand what effect is desired, what visual or emotional message needs to be communicated. Then you can follow with the amount that will accomplish your goals.

When shapes or lines are close enough, they directly interact with each other, bouncing energy back and forth. Depending on the many variables of line and color, the connection can be calm, flowing and organic, or dynamic and vibrant.

When shapes or lines are far apart, their connection may be weaker or nonexistent, although similarity in shape, hue, value, or intensity can still move the eye between them across the distance.

FIGURE 5.34 Because they are farther apart from each other, the energy created by these two angles is weaker than in Figure 5.32. Marcie Cooperman.

FIGURE 5.32 Opposing angles bounce energy off each other. Marcie Cooperman.

FIGURE 5.33 The angles are too close together, so that they touch each other and become one shape. Marcie Cooperman.

DISTANCE BETWEEN ANGLES

The amount of distance between angles can increase or decrease the tension. When angles are close enough to each other, their oppositional tension can be felt, as in Figure 5.32. Energy between opposing angles is reduced if they are too close together or touching, when they can appear to be part of one shape as opposed to two separate elements, as in Figure 5.33. When opposing angles are too far apart, they don't relate to each other as strongly, and the energy they produce together is weaker, as in Figure 5.34. At some point, they are so far apart that they no longer bounce energy directly off each other. When you are designing angles, be careful to use the proper distance between them, so that they create the energy you need to have.

DISTANCE BETWEEN LINES

With the correct width and distance between them, lines relate to each other so strongly that they appear to be one visual unit, as in Figure 5.35. Lines farther apart from each other create weaker energy between them, or may not send energy back and forth at all. Lines that are on the edges of the composition as in Figure 5.36 are too far away from each other to send energy back and forth, although they can function as borders.

BREATHING ROOM

Some elements need a substantial amount of empty space around them, or else they seem crushed, cramped, or overwhelmingly large for the area. We call this empty space **breathing room** because it includes no details; it just allows the adjacent shapes the visual room they need without other elements competing for attention. How much room does a shape need? Enough. How much is enough? It depends on the existing spaces and objects in the composition. "Enough" room around an element can help make it a focal point and provide balance for a complex line or shape.

FIGURE 5.35 **These vertical lines come together as one visual unit.** Marcie Cooperman.

FIGURE 5.36 **The vertical lines in the middle are too far away from each other to send energy back and forth, or to form one visual unit, and the composition seems to have no focal point in an empty interior.** Marcie Cooperman.

FIGURE 5.37 **Marcie Cooperman:** *The Cloud, Queenstown, NZ.* Photograph, 2007. We can focus on the mountaintop and its cloud. Marcie Cooperman.

You can quickly evaluate if a shape seems cramped or needs more room: Cover up part of the space around it, assess it, then reveal it again to compare and see which looks better. Which composition allows the element in question to be the focal point? Which forces other elements to compete? By testing various amounts of space around shapes, you can determine the correct amount.

Look at the photos of *The Cloud, Queenstown, NZ* to evaluate which one has enough breathing room. In Figure 5.37, more space is devoted to the sky than in Figure 5.38. This provides breathing room for the small mountaintop and its cloud, supporting it as the focal point. Since the sky and dark mountain below the summit have little contrast or detail to

FIGURE 5.38 Marcie Cooperman: *The Cloud, Queenstown, NZ.* Photograph, 2007. Less breathing room for the mountain and cloud. Marcie Cooperman.

hold our attention, the eye can be attracted to the complementary color of the mountaintop and its immediate surroundings.

Figure 5.38 places the mountaintop in the center of the image, reduces the sky space breathing room, and increases the area of contrasting low value mountain. Because it has a larger area of interest, the mountain shadow makes it grab the eye just as much as the mountaintop. Now it isn't clear what to look at, as all areas compete as the focal point.

In Catherine Kinkade's *First Snow* in Figure 5.39, the white area in the bottom half provides wide-open snowy breathing room for the complex trees above, allowing the eye to focus on them. The almost empty high-value area is needed as breathing room for the entire scene. Without it the eye begins to pick out one or another detail to focus on, losing the vision of the whole. See for yourself: Cover up most of the white area and see how you begin to focus on only a detail, possibly the complex left side.

The Shape Influences How Much Space Is Needed

Different shapes have their own particular effect on the surrounding area, and this influences the amount of space needed.

Long vertical shapes provide static opposition to any adjacent open space, and function as an obstacle against that space. The effect often makes the adjacent open space appear to be *too large*.

Sharp, pointed angles focus strong dynamic energy on the adjacent space, and the space needs to be *large* enough to accept or absorb it. This shows a need for breathing room, as in the example of the mountain in Figures 5.37 and 5.38.

Like verticals, convex shapes present a barrier to an empty space; they also mold the empty space into a *concave space* (the opposite of the convex shape), making it visually support the convex shape. Figure 5.40 illustrates this concept. The white rocks on the right side are convex shapes that impose themselves on the snow above. In contrast, the edge of the snow against the rocks assumes the opposite shape, which is concave, and which passively accepts the rocks. The white snow creates breathing room and draws attention to the rocks, and the red water underneath. Compare this to the rocks amid the blue shadows and trees on the left side. They have an entirely different feel against the complexity of line and low values there—they *are* the breathing room for the intricate lines around them.

FIGURE 5.39 Catherine Kinkade: *First Snow.* Oil on canvas, 4 1/2″ × 6″. Catherine Kinkade.

FIGURE 5.40 Catherine Kinkade: *Susan's Brook—Winter.* Oil on canvas, 24″ × 60″, collection Yoga and Meditation Center of Upper Montclair. Catherine Kinkade.

On the other hand, concave shapes passively accept the space they are open to, and therefore allow a *greater quantity* of open space to be visually comfortable. A concave shape tends to focus the eye on the adjacent space in a gentle and indirect way, leading the eye to it.

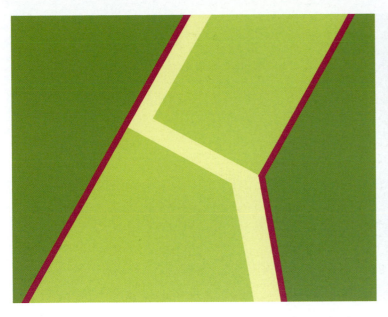

FIGURE 5.41 This composition is flatter than Figure 5.42, and the high value green areas seem to be one area bisected by the yellow line. Marcie Cooperman.

FIGURE 5.42 The yellow band is wider here than in Figure 5.41. Marcie Cooperman.

Distance Molds the Space Between Shapes

Look at Figures 5.41 and 5.42 to see the difference distance can make. In Figure 5.41, the green tints in the center can be seen as a single unit with the yellow line in front of it, rather than two separate shapes. The composition is flat, and the low-value green areas are borders. In Figure 5.42, the distance between the green tint shapes is about four times that of Figure 5.41. A completely different interior shape emerges. Now 3-D, it changes the structure of the composition. The entire center portion appears to be folded, where the green tint becomes shadowed areas facing us, and the yellow becomes a plane facing the top. The low-value green becomes background, and it seems to extend behind the center shapes.

Areas of a Composition Have Meaning

Living in the real world makes us imbue the parts of a composition with meanings we understand. For example, we often feel that the top of a picture is the sky, and the bottom is the ground. Wassily Kandinsky described these qualities of the four sides of a composition as the Square of Tensions, which he defined as Heaven, Earth, Home, and Distance. The areas on the bottom can be either the ground or a body of water depending on the color, and any horizontal lines we see suggests the horizon to us. Above it is Heaven, or sky. Home and Distance refer to the way we generally read compositions in Western cultures—from left to right. The left side where we start is considered Home, and the right side toward which we travel is Distance. This natural movement influences continuity in the composition.

Empty space can be perceived in a positive or a negative way, showing comfort or danger depending on our associations with its location. Low-value space at the top of the picture feels comfortable, as though it were a nighttime sky. But at the bottom, very low-value space can become a void to us. This can either send an uncomfortable message, or add dynamic energy to a composition, depending on how much space is devoted to it.

For example, in Figure 5.43, *Sunset Over the Hudson From Cold Spring, NY* illustrates how low-value space can feel like a void. Figure 5.44 benefits from a smaller proportion of black space at the bottom. It can now allow the eye to focus on the sunset, properly balancing the sky. The very small area of the sun's reflection in the river at the bottom draws the eye into the picture, functioning as an arrow that points to the setting sun above.

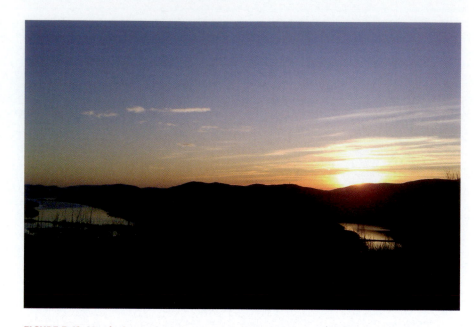

FIGURE 5.43 Marcie Cooperman: *Sunset Over the Hudson From Cold Spring, NY.* Photograph, 2009. The overly large amount of black space at the bottom feels like a void. Marcie Cooperman.

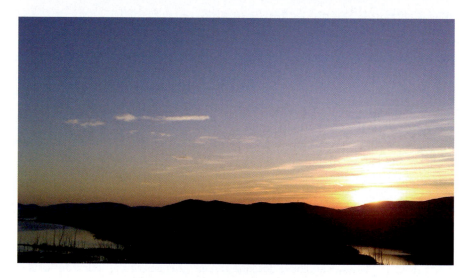

FIGURE 5.44 Marcie Cooperman: *Sunset Over the Hudson From Cold Spring, NY.* Photograph, 2009. The correct amount of black space at the bottom enhances continuity. Marcie Cooperman.

Visual Weight

An object has **visual weight** if its color, size, shape, or location make it stand out relative to the other elements. Visual weight lends an object power and strength and the ability to be the focal point.

Rudolf Arnheim says that there are *unseen forces* within a composition that affect the lines and shapes that are actually there, and bring visual weight to an element. For example, the gravity we feel in real life makes its presence known in a composition, even though the objects in the picture aren't subject to physical demands. They appear to have physical weight because we bring our assumptions of life to the picture.

The center of a picture is an area of tremendous energy. Although it isn't marked, we unconsciously feel its presence the way we feel gravity, and we measure shapes and lines in the composition against it. We habitually look for symmetry, and we can feel that a shape is off center because we see it in relation to that unseen center mark.

The center point helps determine the visual weight of elements. A shape farther away from the center weighs more than one that is closer to it. Perhaps this is because its distance from the center appears to be marked by invisible strands of energy between them, turning the center point into a fulcrum, or the pivot on which the shape is supported.

The edges of a picture, especially the corners, have their own gravitational pull. Compositional elements not too close to the center tend to move out toward the edges, attracted by this pull. And finally, the bottom edge of a composition pulls down all within it, much like our physical gravity.

NATURAL PHYSICAL LAWS DIRECT COMPOSITIONAL MOVEMENT

Gravity pulls things down in real life as well as visually on the page before us. Because of gravity, the top and bottom of a composition exert their own influence on elements. Shapes appear heavier and look larger on top than they do on the bottom. At the top, they seem ready to move or fall down in a way that is directed by their shape. For example, vertical lines might seem ready to tip over, shapes on top of diagonal lines will slide down, and strong shapes might threaten to crush weaker shapes beneath them.

Using colors and lines that work in accordance with laws of nature is the most effective way to balance a composition. A heavy element can appear comfortable at the top of the picture only if it is balanced by heavier elements below it to compensate. If the color is made lighter relative to the adjacent colors, its weight can be reduced. For example, intense red often appears too heavy when it is placed in the top half of a composition; but a *shade* of red might cooperate better. Likewise, to visually float or move upward against gravity, elements have to appear to be comparatively lighter than the other elements.

COLOR: WHAT'S HEAVY AND WHAT'S LIGHT?

General rules can be stated about the weight of colors *at their most intense level*. By altering their intensity and value, we can change their gravitational weight. Their weight can also change by leaving them the same and altering the surrounding colors, since the law of simultaneous contrast says that colors and their behavior are relative to their surroundings. The rules are as follows:

- **Intense colors.** Intense colors are heavy, especially surrounded by lower-intensity colors. By making an intense color smaller, you can reduce its weight.

- **Light colors.** Light colors are heavier than dark colors, as they tend to appear larger than their dimensions. To counterbalance a light area, a dark area would have to be relatively smaller.

- **Red.** The color red is heavy. On the top of the page, red seems literally heavy and about to succumb to gravity and fall. If this is not desired, a shade or tone of red lowers the intensity enough to make it float more easily. If the colors on the bottom of the composition have weight, this also supports a heavy color at the top. Alyce Gottesman's *Sailing in Blue* (Figure 5.45) demonstrates how the heaviness of red works with gravity, feeling solid at the bottom of the composition. The bottom red area also visually connects with the little red bar in the middle, and keeps the tension as strong as magnets between them.

- **Black.** Black, or very low-value colors such as **violet,** look amazingly natural and rather weightless at the top of the page, a surprise because one might think they would be heavy. They are not, because we tend to relate them to reality and perceive them as a dark sky, which has atmosphere and depth.

- **Blue.** Blue is weightless and looks "right" on top, and it attains immeasurable depth—no surprise because we tend to feel like it's the sky, which is infinite space. On the bottom of the composition, blue can appear to be a body of water to us, again with qualities

FIGURE 5.45 Alyce Gottesman: *Sailing in Blue.* Gouache, 11″ × 8″, 2011. The red bar in the middle connects visually with the red on the bottom. Alyce Gottesman.

of depth. In Figure 5.46, Gary K. Meyer's *Ethiopia, January 2, 2009,* the blue appears weightless against the heavier warm colors of the stone wall. This location causes dynamic tension by reversing a comfortable relationship we have with color, where we equate blue with the sky above us. However, the intensity of the blue makes it appear to glow, giving it visual weight and confirming it as the center of attention.

- **Green and brown.** Green and brown weigh more than blue but less than red. Green and brown on the bottom can look as natural as the ground.

- **Yellow.** Yellow is light, weightless, and formless. It glows like sunlight, and doesn't appear to be heavy and about to fall, as red might do. It advances somewhat, but not as much as red does. In Catherine Kinkade's *Pine Barrens* in Figure 5.47, the hues behave the way one would expect them to. The yellow area is the farthest back in the landscape, yet it glows and comes forward in front of the green areas. The blue water does not exhibit this behavior, but warmed with red, the violet area does move in front of the blue.

WHAT MAKES AN ELEMENT HEAVY?

A number of factors determine the visual weight of objects:

- Geometric shapes have more weight than organic shapes.

- Horizontal shapes are heavier than shapes of other orientations. Sitting solidly on their wide base, they are more visually stable than diagonal and vertical shapes, which seem to be about to move.

- Vertical shapes have more weight than diagonal shapes because they are more stable.

FIGURE 5.46 Gary K. Meyer: *Ethiopia, January 2, 2009.* Photograph. Marcie Cooperman.

FIGURE 5.47 Catherine Kinkade: *Pine Barrens.* Oil on canvas, 7′ × 4 1/2′, collection Exxon. Catherine Kinkade.

- Larger objects have greater weight than smaller ones.
- Intricate, more complex objects have more weight than simpler ones.
- Objects in the distance have more visual weight than elements closer to the viewer.
- Elements farther away from the center of the composition are heavier than elements closer to the center.
- Elements at the top weigh more than at the bottom, as gravity appears to be pulling them down.
- Isolated objects have greater visual weight than those surrounded by nearby objects because they have no competition for attention. Even if an isolated element is very small, or has very low intensity or indiscernible hue, it can hold the eye. A good example is Gary K. Meyer's *Namibia, May 11, 2009* in Figure 6.9 in Chapter 6, where the tiny moon grabs the eye in an otherwise empty sky. In fact, the presence of the moon is very important in creating balance for the intense red–orange land below. Without it, the sky would indeed be empty.

COLORS THAT OBLITERATE THEIR BOUNDARIES

Colors That Want to Expand

High-value colors as well as high-intensity colors make shapes seem to be larger than they are because they reflect so much light. Yellow is high in both intensity and value, and this is reflected in the fact that it seems to glow like the light of the sun. For these reasons, yellow lettering would be indistinct and indecipherable if not outlined, unless the yellow is low value and low intensity. Figure 5.48 illustrates these qualities.

Colors That Want to Contract

Black and low-value colors make areas look smaller than they really are, as they absorb light and render their limits invisible. It can make a shape appear to be a hole or a tunnel, rather than an object with physical form. This quality is valuable as an artistic tool, much like the beloved "little black dress" that makes women look thinner. In Figure 5.49, the black area on the left edge of Alyce Gottesman's painting disappears like a void behind the blue and orange areas.

Continuity

"Composition is an arrangement of visual elements creating a self-contained, balanced whole, which is structured in such a way that the configuration of forces reflects the meaning of the artistic statement."[2]

—*Rudolf Arnheim*

Every effective composition uses its elements and its forces to reflect its artistic statement, send a message, or create an intended response. As an example, the message in an ad could be to feel an emotion, understand a situation, or be carried away to a special place. How

COLOR COLOR COLOR

(a) (b) (c)

FIGURE 5.48 **(a) The intense yellow is the most difficult to read. (b) The low-intensity, low-value yellow is easier to read. (c) The red is the easiest color to read.** Marcie Cooperman.

FIGURE 5.49 Alyce Gottesman: *Blue Boundaries.* Encaustic on wood, 25″ × 30″, 2005. Alyce Gottesman.

does the visual arrangement of the shapes, lines, and colors accomplish this goal? Through continuity—a path through the composition.

DEFINITION AND PROCESS

Continuity is a roadmap for the viewer to view the whole composition and by doing so, to receive the artistic message. Successful use of compositional elements such as lines, shapes, and colors forms this roadmap. Its goal is to "tell" the eye which way to move to see everything in the composition—where to begin, how to move on to the next stop, and in which direction to move as indicated by the lines of composition. The roadmap needs to encompass the entire composition, eventually sending the eye to the focal point. Primarily, it should not lead the eye out of the composition.

Continuity is one of the most important processes in creating a successful composition, as it allows the designer to *take control*, rather than letting the compositional elements usurp control and create havoc. When well done, with all elements doing their jobs, the method of achieving continuity is invisible. The viewer doesn't have to understand why a composition is a good one to receive the message it is communicating.

A composition that does not control continuity feels unbalanced and randomly composed. As a result, the eye might miss some important parts that appear to be extraneous. Also, a composition could have too many active areas competing for attention and creating too much visual energy. Visual miscommunications to the viewer could result, such as confusion about which areas to focus on.

Each part of a composition needs to be integrated, to give the same message. Such an integrated composition is considered to have *unity* (this concept will be explained in detail later in this chapter). If areas aren't needed to actively "speak," they must quietly support the active areas and allow them to do their job. The old KISS method of composition is recommended: Keep It Simple, Silly.

In representational compositions, objects that we recognize play an important part in directing the eye. For example, faces are a primary method of attracting and holding our

attention, and often to the exclusion of other elements in the picture. An arm or hand can point the way, as does the direction the body is facing. A road, trees in graduating order, or another object that leads into the distance directs the eye that way. To avoid confusion about where to look, color and compositional elements must support and follow the lead of the recognizable object, and not take attention away from it. For example, a high-intensity background will fight for attention with the figure of a person.

In abstract compositions, we rely on just the compositional elements to do the work and lead the eye. There is no representational element to take attention away from the interaction of colors.

Each Element Has a Job to Do

Some functions are directive and active, and some are passive and supportive. Here are some elements of a composition and the functions they can serve:

Lines Lines lead the eye in the direction in which they point, as we discussed in Chapter 4. For example, in Liz Carney's *Blue Door Red Flowers* in Figure 5.50, the blue lines lead the eye, from every location, through the composition to the red flowers.

Shapes Shapes can point the way with an angle or sharp edge, or several shapes in a row can make the eye follow them.

**FIGURE 5.50 Liz Carney: *Blue Door Red Flowers*. Oil on canvas, 36″ × 36″, 2011. Liz Carney.

Empty Space Empty space is known as ground, background, or field. Ground may not appear to be important or active, but it has a fundamental job nonetheless: supporting the active areas. Ground physically and visually holds directional objects as well as the focal point. Physically, ground works according to the laws of gravity and motion. Visually, as we discussed earlier, complex objects sometimes need space around them so that they don't feel crowded, and ground can give them this *breathing room*. Also visually, the shape and color of empty space interacts with the colors of the figure, and can determine whether it feels three-dimensional or flat, far away or up close. We will discuss color behavior in depth in Chapter 7 and backgrounds in Chapter 9.

Barriers and Borders Barriers and borders can place color within or around the composition to prevent the eye from moving past them, with stronger barriers formed by intense or heavier colors. For example, barriers surrounding the focal point can keep the eye focused on it. Borders placed on the periphery of the composition can hold the eye within it. We will focus more on borders in Chapter 9.

In Janos Korodi's *Outlook* in Figure 5.51, the black barriers on the bottom and left side prevent the eye from moving in those directions, and hold attention within the center of the composition.

Figures 5.52 and 5.53 show how color can form an effective border. In Figure 5.52, against the yellow ground, the green border around the circle doesn't focus the eye on the circle, as the more interesting contrast is the green line against the lower-value violet on the bottom. But in Figure 5.53, the red border around the circle keeps the eye focused on the circle.

FIGURE 5.51 Janos Korodi: *Outlook.* Oil on linen, 48" × 34", 2010. Janos Korodi.

Sidebars Sidebars are minor areas of interest that occur when visually obstructive colors, shapes, or borders break up the surface of the composition into sections. These areas are useful in many ways: uniting the composition, leading the eye through the

FIGURE 5.52 The green border around the circle doesn't focus the eye on the circle. Marcie Cooperman.

FIGURE 5.53 The red border around the circle keeps the eye focused on the circle. Marcie Cooperman.

FIGURE 5.54 Janos Korodi: *Under Construction.* Oil and tempera on linen, 49.2" × 80.7", 2006. The verticals separate the painting into sections. Janos Korodi.

composition, or emphasizing the focal point. They can offer secondary, oppositional energy through your choices of color and shape to balance the main focal point. In Figure 5.54, Janos Korodi's *Under Construction*, the verticals separate the painting into sections. The outer areas can be seen as sidebars that support the line and color activity in the center two sections.

Stepping-Stones Stepping-stones help continuity like a traffic officer directing traffic. They are elements with a graduating relationship that move the eye from one point to the next. They work together to provide visual storytelling tension. For example, similar shapes with decreasing sizes pull the eye from large to small. Shapes with a gradient of colors move the eye, too—for example, a range of values or intensities of one hue, or adjacent hues on the color circle.

In Figure 5.55, Joel Schilling's *Barga Rooftops, Barga, Italy,* the tile roofs interspersed with black shadows underneath act as stepping-stones, moving the eye from one to the next, up to the peaked roof at the top. The blue background forms a complementary hue contrast with the top roof, and the dark trees on either side act as partial barriers and hold the eye on that focal point.

Outlines Outlines separate shapes and downplay their color contrasts. The color contrasts between the shapes are never totally eliminated, since we still see them simultaneously. However, the strongest color contrasts are between the figure and its adjacent outline, and between the outline and the ground right next to it.

Color Contrasts Color contrasts grab our attention and move the eye around, with or without directional shapes that point the way. They can be the deciding factor in whether the composition is balanced.

FACTORS IN THE EVALUATION PROCESS

There are three factors to consider when evaluating a composition: the accent, the movement, and focal point. If they function efficiently and keep the eye within the composition, and the colors work well together to foster the same goals, then the composition is balanced and has unity.

1. *The accent.* An area of strongest contrast will grab the eye first, referred to as the **accent**. The contrast can come from hue, value, or intensity, or an element of composition. Although strong, this area should be relatively simple, to allow the eye to notice

FIGURE 5.55 Joel Schilling: *Barga Rooftops, Barga, Italy.* Photograph, 2004. Joel Schilling.

the rest of the composition. It should be clear which one area serves as the accent. If there are several areas of similar contrast and complexity, there could be confusion as to where the eye hits first. When most values, hues, and intensities are similar, the eye tends to begin at the left side and move toward the right side.

2. ***The movement.*** Next, elements of line, shape, or color engage the eye and direct it around the composition.

3. ***The focal point.*** Finally, the eye is attracted to an area of contrast and interest—the **focal point**. The relative strength and complexity keeps the viewer focused on that part of the composition. Sometimes this area is complex enough to keep the eye moving within it among several of the elements. Sometimes the focal point is the place where the eye first alighted on the composition, making it the same element as the accent. Figure 5.56, Liron Sissman's *The Power of One,* illustrates the latter situation.

The accent: The complementary hue contrast of the violet flower amid the yellow ones grabs the eye, although this interaction is slightly reduced because the violet flower is actually surrounded by blue.

The movement: The eye moves from this accent to the yellow flowers, and then from flower to flower around the entire composition.

The focal point: The eye goes back to the violet flower. The accent area also serves as the focal point in this continuous motion around the image.

FIGURE 5.56 Liron Sissman: *The Power of One.* The flower acts as the accent as well as the focal point. Oil on canvas, 30″ × 40″, 2011. Liron Sissman.

PATHS OF MOVEMENT IN A COMPOSITION

Designers can create an infinite number of ways for the eye to move through a composition, moving from the accent to the focal point. However, the color and compositional elements always need to have the same goals and work together.

The important factors in creating the paths of movement are:

- The eye needs a clear path to follow.
- All areas of the composition should be utilized.
- The important elements should work as the focal point: they should *demand* attention.

Take a look at the following compositions, as we evaluate how the eye moves about. Remember the three questions we ask:

1. Which element is functioning as the accent by grabbing the eye first?

2. Which direction does the eye take as it moves through the composition?

3. Where is the focal point, the area that keeps the eye captive?

In Figure 5.57 the intense yellow circle is the accent. Then the eye follows the line of yellow and green circles down through the violet ones to the small black one at the bottom. But ultimately, that one doesn't prove to be as fascinating as the yellow one, which grabs the eye again as the focal point as well as the accent.

In Figure 5.58 the eye alights somewhere along the rocky shoreline on the left side of the image, then follows the shoreline up to the top right, where the angle of the beach at the top points left and leads the eye toward the horizon. The circling clouds return the eye to the sandy angle of the beach, and the process begins again.

FIGURE 5.57 Marcie Cooperman: *Circles in Space.* Digital painting, 2010. The largest yellow circle attracts the eye first. Then the movement follows the successively smaller circles as they fall down into the hole to the smallest black ones at the bottom, popping back up to the yellow circle. Marcie Cooperman.

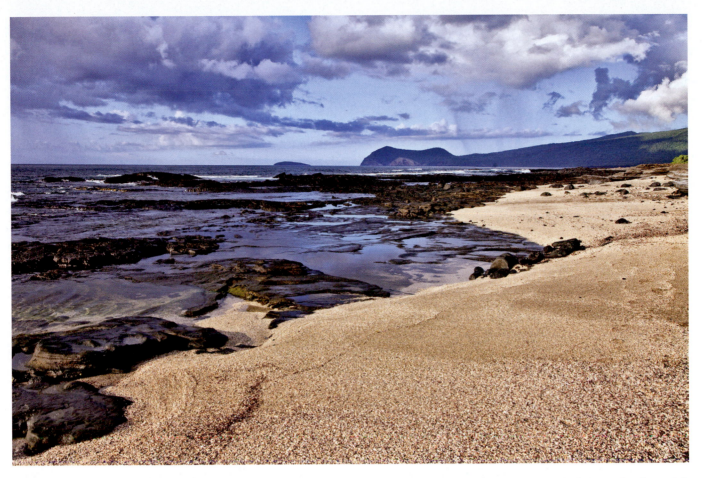

FIGURE 5.58 Joel Schilling: *Galapagos Landscape #1, Galapagos Islands, Ecuador.* Photograph, 2009. The strong diagonal line leads the eye from bottom left to top right, and the clouds return the eye to the beginning for this continuing circular movement. Joel Schilling.

Figure 5.59 is different; no matter which element grabs your eye first, everything leads to the red barn, which demands attention against the complementary green fields. If you start at bottom left, the verticals of the fence point up to the barn, and the horizontals of the fence subtly bar the eye from slipping down off the page. Starting at the trees, the line of cows leads into the barn, and the fence holds the eye there.

The blue jeans on the black horizontal line of the balcony in Figure 5.60 serve as the accent as well as the focal point in this composition. Slightly more intense and lower in value than the shutters, and a complementary contrast against the warm hues of the walls, they first grab the eye, then allow the eye to notice the line of shutters and then move back again to the jeans. The tiny yellow and red toys enhance the jeans as a focal point. Without the jeans, this photo would suffer from no central focus, condemning the eye to wander aimlessly throughout the composition.

Types of Compositions That Don't Provide a Clear Path

Types of compositions where the lines don't work together to create a path of movement include the following:

- *Two or more main directions exist, or there is more than one focal point.* If the viewer has to decide in which direction to travel, the designer has lost the most crucial and basic method of getting the visual message across. Figure 5.61 illustrates a composition with two competing focal points.

- *Lines, shapes, and colors are not organized and don't provide any directional cues.* The advantage of contrast is not utilized in any particular fashion. Sometimes a line or shape with visual weight that touches the edge actually leads the eye off the edge and

FIGURE 5.59 Gary K. Meyer: *Palouse, Washington, June 11, 2009.* Photograph. All shapes and lines lead to the red barn. Gary K. Meyer.

FIGURE 5.60 Joel Schilling: *Florentine Balcony, Florence, Italy.* Photograph, 2004. The jeans are the accent as well as focal point. Joel Schilling.

FIGURE 5.61 Both blue circles in this image attract the eye as focal points.

FIGURE 5.62 Gary K. Meyer: *Madagascar onions.* Gary K. Meyer.

out of the picture. The remedy for that situation could be another line leading from the edge back into the composition.

- **Too many visual stimuli exist.** Too much contrast is overwhelming and gives no information to the viewer. When many complex lines fail to indicate a direction to travel, and all shapes and colors compete for attention, the eye is left to its own devices and travels randomly throughout the composition.

- **A lack of variation exists.** This type of composition consists of similar hues, values, and intensities, and there are no contrasts to attract the eye to an accent or a focal point, as in Gary K. Meyer's *Onions, Madagascar, October 2011* in Figure 5.62.

There could also be no direction for the eye if all contrasts are repeated evenly throughout the composition. This type of composition gives the appearance of continuing the exact same way in all directions beyond the dimensions of the composition. Any area will do in representing the whole painting, as none of it seems essential to its balance. Even if the composition is enlarged or shrunk, or elements changed, its essence, color interactions, and balance would not alter at all. These compositions could be stronger if attention were paid to continuity.

summary

Our discussion in this chapter has been about continuity and energy. We have seen how the eye moves through the composition, and how energy from each individual element contributes to this process. All relationships between compositional elements influence our perception of color, and that perception in turn influences how the eye travels through the composition. We can now understand how altering any element changes its influence on the entire process. Successful color usage depends on the designer's understanding of each element and its effects.

quick ways . . .

You can assess a composition by breaking it down into the working forces, and evaluating each one separately. Focus on just one of the following elements at a time:

1. The spaces between shapes: What type of energy do they cause and how well do they enable continuity? Do they seem crowded together?

2. Values: Are there well-defined levels of value? Does their distribution in the composition direct continuity effectively?

3. Areas of contrast: Limit the quantity of strong contrasts to preserve their effectiveness. Look for too many contrasts, which will confuse the eye, but do make sure that at least one contrast exists.

4. Lines, curves, and angles: Focus on all edges and intersections of lines and shapes to see how they relate to each other, making the angles they form together *your choice*, and making sure that the distances appear deliberate. Lines that are close yet not touching may appear to be a mistake, and ruin continuity. What type of energy do your lines create? Are the distances between them appropriate for your directional goals? What shapes are formed in all areas between the lines, curves, and angles?

5. Arrangement of lines and shapes: Do they provide good continuity and balance?

6. Amount of empty space: Does it support compositional elements and allow them to breathe?

7. The focal point: Perhaps the most important question to ask is: Which area is the focal point? If the answer is the spot you wanted, congratulations. But if instead the eye focuses on something nearby, a small adjustment needs to be made—with the compositional lines, or with the colors, or possibly in the size or location of shapes. If the focal point is entirely another part of the composition, a serious reevaluation needs to be done.

exercises

Parameters for Exercises

There are many factors of color and color relationships in compositions, and all of them can affect the way the colors appear to the viewer. The best way for students to learn through their color exercises is to have simple objectives and fairly strict *rules* about the type of lines and colors to be used. We call those rules "parameters." With strong parameters allowing only a minimum of elements, it is easier to observe the direct relationships between colors, and to see the differences between the students' compositions. When lots of compositions hang together for a critique, it becomes clear which ones are successful in achieving the goals.

As students learn the objectives and build on their skills, they will become more adept at using color. They will gain the ability to tolerate more complications because they understand the ensuing interactions. Therefore, as we move through the chapters, the restrictions on composition size and the number of lines and colors will be gradually reduced. Larger compositions, more colors, and more types of lines will be allowed. However, certain ground rules will remain the same: Flat color and nonrepresentational shapes will remain constant parameters, and the goal of every assignment will be a balanced composition. Five specific parameters include:

1. No recognizable objects are allowed.
2. All colors are to be flat and nongradient, with hard edges that don't fade away.
3. White is always considered a color, even if it is the background.
4. Only neatly cut and pasted papers are appropriate.
5. Balance is *always* the singular goal of every composition.

Parameters For the following exercises, you may use only three colors in any shapes you choose. The size for each should be 5″ × 7″, landscape or portrait. Choose your hues, paint large areas for each color on your paper, then cut out the shapes you need and glue them on your foam core using a removable glue stick.

Objectives

Your main goal is overall balance, as always. Your second goal is to learn how to successfully conduct the eye on a tour of the *entire* composition, and your third is to learn how to correctly use all the chapter concepts.

Note: The objective for exercises 1 to 4 is to discover the differences between the various types of energy, and to learn how to produce them through design.

1 and 2. ***Create static and dynamic energy compositions:*** Make two compositions, one showing static energy and one showing dynamic energy. Your choices of colors and shapes will have a strong effect on your achieving the objective.

3. ***Create a passive energy composition:*** Make a composition using lines or shapes that are concave or convex, to demonstrate passive energy. Successful concave lines will accept nearby shapes passively, and convex lines will provide a passive obstruction to nearby shapes.

4. ***Create a composition showing tension:*** Using only vertical lines, make a composition to show how your three colors can produce tension (potential energy).

5. ***Show continuity in compositions:*** The objective of this exercise is to master the process of continuity using value and intensity. Make two compositions, one using similar levels of value and intensity, and one with varying levels. To check out possibilities before committing to a particular arrangement, paint and cut pieces of various choices of colors for each element to evaluate which ones achieve your design goals. Before gluing down your elements, move them around to determine the most satisfactory placement.

6. ***Use empty space:*** Your objective in this exercise is to provide the proper amount of empty space adjacent to your focal point, to support it in a balanced way. Using your choice of shapes and three colors, carefully determine the shape of your focal point and the path you want the energy to take through the composition. Think of the empty space as a design element in your composition, and adjust its dimensions to bend to your design needs. Evaluate it larger and smaller, and see which size is successful.

Balance

What makes an advertisement compel us to look at it as soon as we open a magazine and see it? The colors, of course! Colors are the first thing to claim our attention. We look before we even engage our minds and think about it. But an ad holds our attention for only three seconds! Then we move on to another image. Three seconds, however, is not long enough to sell you something. The advertiser needs some way to incite your curiosity to keep you focused on the ad longer, and to keep you away from the competition's ads. What would do it? The colors and their arrangement—where the colors are placed and in what quantities.

Conveying an artistic message in a painting, print, or graphic design also requires the same attention paid to arrangement. The colors might be enough to start the process, but it is the organization of the picture that entices the viewer to stay a little longer, and provides something to engage with intellectually or emotionally—and this engagement gives the viewer the incentive to try to understand it.

Take a look at Figure 6.1, *Emerging Spring* by Marsha Heller. Its exciting diagonal arrangement includes complementary contrasts in the upper left and lower right corners, and strong value and intensity contrasts throughout. The curvilinear lines help the diagonal movement by pointing toward these two opposite angles, yet also keep the eye moving within the edges of the painting. We learned in Chapter 5 that diagonal lines really make the image move. Read on to see how you can accomplish such successful arrangements.

FIGURE 6.1 Marsha Heller: *Emerging Sprint.* Painting. Marsha Heller.

key terms

asymmetrical balance
balance
center line
extraneous object
symmetrical balance
unity

What Is Balance?

Balance is the plan for the organization of a composition: the arrangement of the colors, lines, and shapes based on their relationship to the center of the composition. Balance is the skeletal framework, known as the *armature*, of a composition, the major tool at the disposal of the designer to help accomplish the goals of conveying a message and keeping the viewer intrigued.

A balanced arrangement in a composition allows the energy we learned about in Chapter 5 to operate. It allows continuity to work, providing a path to wander about the picture, digest the color relationships, and connect the parts to work out the story. It is the magic that can hold your eye hostage within the picture, expertly allowing all areas to play their part in keeping you there. Balance gives strength to even a simple composition, and makes a painted landscape draw the viewer in as if it were a real place. An arrangement that has balance is mesmerizing, and has been known to make the viewer plunk down money to buy the picture to keep looking at it forever.

A lack of balance is just as influential: The wrong arrangement in a composition can stop you dead in your tracks and keep you from seeing the whole picture—or worse, lead you off the picture. A lack of balance can also confuse you and make you turn away in despair or distaste. Often the difference between unbalanced and balanced is as simple as a single shape placed in the wrong location, and moving it solves the problem. Since the elements in every composition are different, it's necessary to learn how to perceive a balanced composition.

Visual Weight Holds the Key to Balance

THE CENTER LINES

A central factor of balance is that compositions are arranged in relation to the center point, and by extension, in relation to two imaginary **center lines**, one vertical and one horizontal. These lines are not actually visible in the composition, but their presence is nonetheless felt by any viewer. Areas, shapes, and lines on either side of a vertical center line relate to each other, each side measured against the other in terms of visual weight. One side of the composition can balance the other if they are the same visual weight, even if they include elements of different sizes, shapes, and colors. But if one side appears to be stronger than the other side, it will feel heavier and unbalanced.

The same balancing center conditions exist with the horizontal center line. Shapes above the line are measured against those below it, and there are many ways to arrange elements of various visual weights to achieve balance. But the horizontal line has a special significance, because it represents the horizon in a landscape painting, or an implied horizon in an abstract painting. This imposes an atmospheric quality on the upper part, which we associate with the sky. This can lend weight to a figure placed there, and cool colors and low values enhance this quality. Cool colors placed below the horizon can lead us to associate that area with a body of water.

Imagining a physical scale with weights helps us understand what compositional balance is about, as in Figure 6.2. The center support for the scale is the *fulcrum*. We know that even if objects on either side of the fulcrum are different sizes and shapes, as long as their weight is the same, they can balance the scales. Just like on a physical scale, the center point of a composition is the fulcrum, or pivot point for balance, and elements on either side should balance each other. In the center itself, objects of any shape or size have equilibrium, and are balanced by themselves.

FIGURE 6.2 Balancing color on scales. Marcie Cooperman.

ACHIEVING BALANCE IS A PROCESS

Achieving balance in your composition is a fluid procedure that continues until the very moment the final touches are applied. The balance process consists of looking at objects, lines, and shapes to determine what new shape is needed; assessing the effect each new element has on the whole; and making adjustments in the sizes and locations of everything already there. For example, while adding something to the right side, you may decide that although you like your addition, the left side now needs a little something to balance it better and altering its visual weight would accomplish your goal. You might do that simply by making it larger or smaller, changing its color, or changing its location. Refer to Chapter 5 to recall what is visually heavy and what is light.

In a composition, moving any element changes everything:

- ***The energy*** that each element directs toward the others changes with an increase or decrease in distance, or with a directional change in their placement.

- ***The path of continuity alters.*** Each time elements are added, there could be a different path of continuity, especially if the visual weight of the new elements strongly moves the eye, or captures attention away from the movement that existed before. Sometimes the result is a block on continuity because the new elements hold the eye captive in a corner of the picture, and then the arrangement has to be adjusted.

In Figures 6.3 and 6.4, the difference in balance can be attributed to the change in color of just one shape. In Figure 6.3, the yellow does not have enough weight to balance the other colors, whereas in Figure 6.4, the red is strong enough to do so. With the yellow triangle, continuity is lost. There seem to be two unrelated areas of color because the yellow triangle doesn't move the eye to the other objects. Changing the triangle to red sends the eye like an arrow from the red triangle up to the green ones, and finally to the red rectangle.

- ***The way the colors look near or adjacent to each other changes*** when colors are moved or new colors are added. Color relationships are the key to the effects of these alterations.

- ***Altering, removing, or adding any element also changes the focal point.*** New elements add competition for attention. Taking away elements focuses the eye in a new way on the shapes that are already there. Sometimes too many elements are added, forming a second area of interest that draws the eye away from the desired focal point, and the balance has to be reevaluated.

FIGURE 6.3 The yellow triangle does not have enough weight to balance the other colors. Marcie Cooperman.

FIGURE 6.4 The red triangle balances the other shapes better than the yellow triangle does in Figure 6.3. Marcie Cooperman.

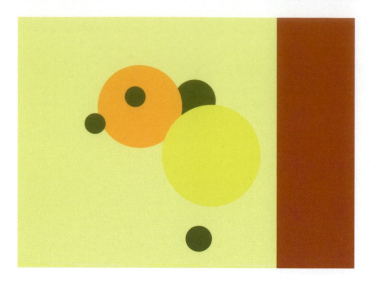

FIGURE 6.5 The yellow–green ground is the same value as the adjacent yellow circle, making it hard to focus on the yellow. Marcie Cooperman.

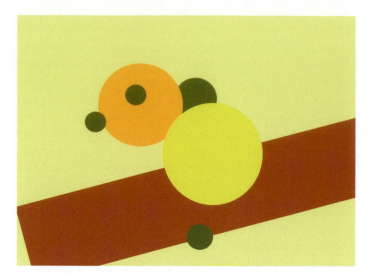

FIGURE 6.6 The low value of the red-brown line supports the yellow circle as a focal point. Marcie Cooperman.

Figures 6.5 and 6.6 illustrate how the focal point changes when shapes and colors are moved. In Figure 6.5, the yellow–green ground and adjacent yellow circle are viewed simultaneously, which makes it hard to see the yellow. Both are the same value and similar hue, and that renders the yellow indistinguishable from the ground.

In Figure 6.6, adding the adjacent red-brown defines the yellow circle's area, increases its intensity, and allows us to see the hue. The red-brown's location has another effect on the circles. In Figure 6.5 the vertical red-brown line squeezes the circles into a smaller area, and stops movement to the right side. This forces the eye to focus on the orange circle. In Figure 6.6, the red-brown line gives the circles more room to float, supporting them from below. The focal point is changed to the yellow circle because of its hue and value contrast against the red line. The tiny pale-green triangle at the bottom left part of the red-brown line gives the picture a three-dimensional appearance.

BALANCE DEPENDS ON RELATIONSHIPS IN THE COMPOSITION

Because a composition is by definition a combination of several elements that are seen simultaneously, they affect balance together.

Distance from the Center Point

As we learned in Chapter 5, an object's distance from the center increases its visual weight. In arranging one side to compensate for the other, objects can be placed closer to or farther away from the center point, as needed. As an example, when paintings have an object close to one side of the center line, to balance it there is often an object far from the center line on the other side, as in Figure 6.7, *Constant 5* and *Ingres' studio in Rome*, Figure 6.11.

In Krista Svalbonas' *Constant 5*, the small rectangle and the vertical line balance each other through their similar distances away from the center point. The other shapes lead the eye from the rectangle to the line, connecting them visually. Even the very slight blue hue of the rectangle contrasts with the complementary oranges.

FIGURE 6.7 Krista Svalbonas: *Constant 5*. Encaustic, 12″ × 12″. Krista Svalbonas.

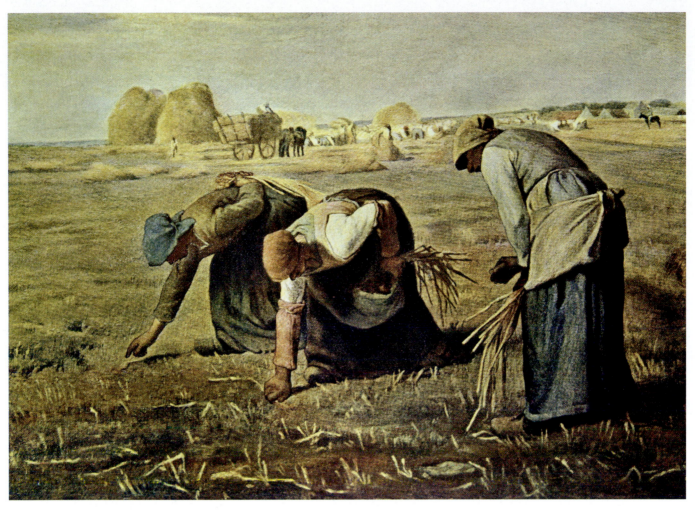

FIGURE 6.8 Jean-Francois Millet: *The Gleaners.* Moscow, Russia, 1901. Oleg Golovnev / Shutterstock.com.

In Figure 6.8, Millet's *The Gleaners*, one might wonder why Millet placed a figure so far from the center along the right edge, when the two bent over figures seem nicely balanced in the center. You can understand his thinking by covering up that right-hand figure. The center figures are revealed as actually static, and she is giving the painting its dynamic movement through her placement. How does she do this? Although she is at the edge of the painting, she attracts the eye away from the center because she is taller. As she is bent toward the two lower figures, we follow her gaze over to them, and then we move along the hay bits on the ground back to her, completing a circle and staying within the painting.

Isolation

An area of complexity and weight can be balanced by an isolated shape, since empty space surrounding an object gives it strength and draws our interest. Gary K. Meyer's *Namibia, May 11, 2009,* Figure 6.9 illustrates the weight of a tiny moon in an empty sky in balancing a more solid and heavy orange–red desert landscape. The quantities of the complements blue and low-value orange–red help the balance because they somewhat follow Goethe's suggestions of the perfect ratio of complements.

Opposites

Sometimes opposites balance each other across the balancing axis. For example, a small shape in a high-intensity color can balance a large shape of lower intensity. Or, opposite locations can assist with balance; objects closer to the viewer can be balanced by objects in the distance even if they are relatively smaller. This is because an object's weight is increased by its distance from other objects.

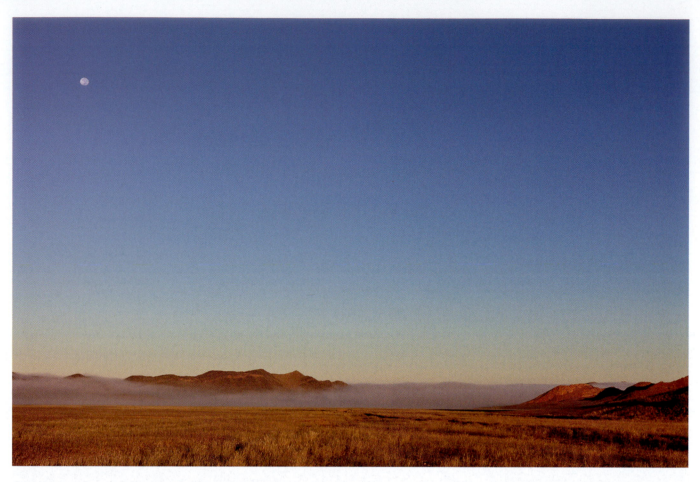

FIGURE 6.9 Gary K. Meyer: *Namibia, May 11, 2009*. Photograph. The isolation of the moon and its location far from the center increases its visual weight and enables it to balance the heavy orange–red ground. Gary K. Meyer.

In Vincent van Gogh's asymmetrical composition in Figure 6.10, balance is achieved through opposites in size and intensity, as well as location. The sailboats lined up and sailing off in the distance balance the larger and higher-intensity boats on the left. By pointing with their masts toward the distant sailboats, the boats on the left keep the eye moving over to the other side of the picture, actively contributing to continuity and balance, and assisted by the echoing water line. Because they are lined up in gradient order, those boats in the distance move the eye from one to the next. But as they are not complex enough to hold our attention, the sailboats on the left grab us back.

The *Ingres' studio in Rome* in Figure 6.11 uses location to balance the two figures. The woman on the bottom right corner balances the man sitting in the chair in the next room. Because they are looking at each other, energy is passed back and forth between them.

In a study of opposites, the German locksmith's sign in Figure 6.12 balances fanciful wrought iron curves against a smaller static gold sun and silver moon. The heaviness of the black wrought iron offsets the strength of the gold and silver.

Balancing a composition is an active process, with much reshaping until you are satisfied with the result. However, there isn't only one answer; an endless number of shapes and colors, and varieties of sizes and locations, can create good balance. Balance is the key to design, but it is as boundless as the creativity of the designer.

The Center Point

The center has a special power due to its location, unmatched by any other: It is the one spot of least mobility and least dynamic tension, and it is the base point for balancing the composition. Why is the center so stable? All sides of a composition exert a gravitational pull on all objects within its boundaries. An object closer to one side of the composition appears to be attracted to that side, like a magnetic force. The center is the place where an object is

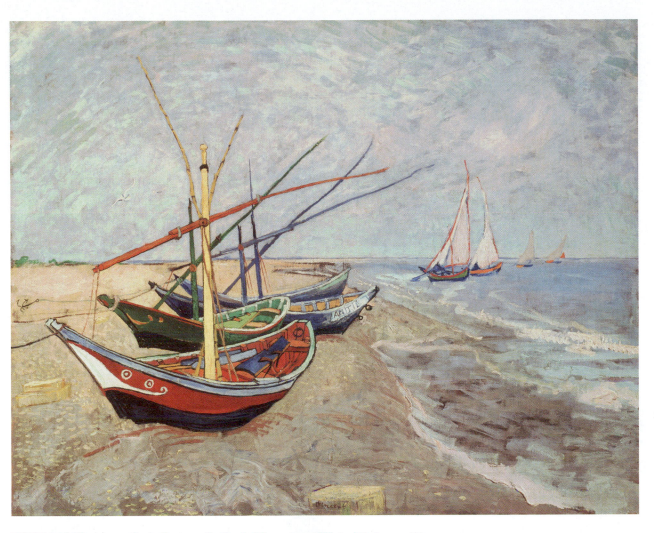

FIGURE 6.10 Vincent van Gogh: *Boats on the Beach.* Oil on canvas, 1888. Snark/Art Resource, NY.

FIGURE 6.11 Jean-Auguste-Dominique Ingres: *Ingres' studio in Rome.* akg-images.

FIGURE 6.12 *Wrought iron sign.* Alexander Kondratenko/Shutterstock.com.

equally located in relation to every side. Since objects in the center are pulled equally from all sides, there is no movement there, which adds up to stability. Not less significant is the fact that the center exerts its own gravitational pull.

Rudolf Arnheim stressed the primary importance of the center point in balance. He said that balance is "the dynamic state in which the forces constituting a visual configuration compensate for one another. The mutual neutralization of directed tensions produces an effect of immobility at the balancing center." He noted that the forces are dynamic, referring to the fact that each side depends on the other side for balance. And he explains that their energies compensate for each other through the act of balance, making the center immobile. Arnheim stated that "a central position conveys weight, stability, and distinction" and it "acts as the *balancing center* [my italics] for the entire composition."[1]

In all compositions, whether or not there is an object in the center, we sense that the center is there, as a point of attraction, or the center of movement. Because of this power, the center spot gives significance to whatever object occupies it, making it a natural focal point. Especially in an equilateral picture or a circle, the shape in the center attracts the eye, no matter how insignificant in size or visual weight. Even if there is nothing in the center taking advantage of its power, the eye circles around it, moving from element to element. Because of its importance, this central spot is a useful tool for you to use in conveying your composition's story to the viewer. Objects can be placed in and around this spot to take advantage of its mesmerizing energy, and to assure that energy moves in a circular fashion, staying within the frame of the picture.

Mercedes Cordeiro Drever's *Survival Hug* in Figure 6.13 illustrates the power of the center. Although on a diagonal moving up and out, the tree occupies the center of the image, with the roots and branches running to the edges of the picture, anchoring it, and moving the eye to all locations.

The photograph of *Remarkable Rocks* in Australia (Figure 6.14) is an example of using the center to convey the artistic message of the composition—the colossal and delicate rock. A central location casts the little girl as the fulcrum and the focal point. Human figures are visually magnetic, but in addition her violet jacket contrasts slightly against the achromatic rock. These factors give her visual weight enough to balance the entire rock, even as unique in shape as it is. Her tiny size allows us to judge the colossal size of the rock, and it gives the rock massive physical weight, which its curvilinear shape undoes to a certain extent. The horizontal line is important to the balance of this composition because it acts like the horizon, defining the top area as atmospheric blue sky, which contrasts with and enhances the physicality of the rock. The rock pyramid is solidly planted on the ground because of its wide base at the bottom, and it is anchored also by the rock below the horizontal line. This balances the curvy top edge, which gains visual weight because of its undulating shape. The lower right rock edge curves upward like fingers, made stronger by a value contrast against

FIGURE 6.13 Mercedes Cordeiro Drever: *Survival Hug, Grand Canyon—Arizona. Photograph, March 2010. Mercedes Cordeiro Drever.

FIGURE 6.14 Marcie Cooperman: *Remarkable Rocks, Kangaroo Island, Australia.* Photograph, 2007. An immense and fanciful rock is well balanced against a tiny figure. Marcie Cooperman.

the lighter part of the sky. Measuring the left against the right side, it balances the left top edge.

The Center Line

The vertical center line has a special quality that doesn't exist elsewhere in the composition. A line drawn there "marks the line along which a composition most easily breaks into two halves"[2] Amazingly, if a line is placed just to the left or right of the center line, it does not have that effect. But we do notice that it is off-center and because we describe it that way, it proves the magnetic strength of the center line.

In Howard Ganz's *Filtered Light,* Figure 6.15, the high-value blue vertical line is just to the left of center. With this location, the zigzag becomes clear and reads as the distant mountains meeting a river, and the line itself appears to be reflections of light in water. You can compare the line's behavior to how it would look in the center by covering up enough of the right side to make it equal with the left side. Everything about the balance changes; suddenly the line loses its light reflection quality and becomes a structural vertical

FIGURE 6.15 Howard Ganz: *Filtered Light.* Digital painting, 2002. Because the high-value blue line is slightly to the left of the center vertical, it does not seem to break the composition in two. Harold Ganz.

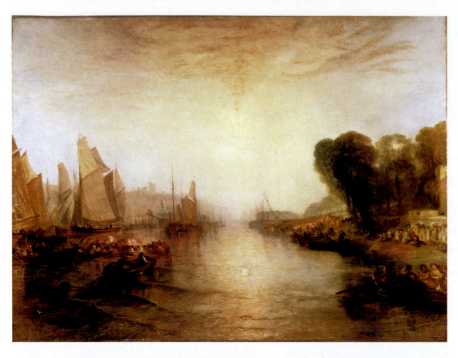

FIGURE 6.16 JMW Turner: *East Cowes Castle*. Oil on canvas. This is a similar use of light placed near the center vertical line, but not on it. © V&A Images/Alamy.

FIGURE 6.17 Liz Carney: *Red Crane in Provincetown Harbor*. Oil on canvas, 36" × 48", 2001. The red crane and posts illustrate the power of the center. Liz Carney.

post that forces right and left shapes into symmetry. JMW Turner's painting in Figure 6.16 exhibits a similar construction with the same effects.

Liz Carney's *Red Crane in Provincetown Harbor* in Figure 6.17 plays with the center line with its red elements. None of them are exactly in the center, and the two vertical posts straddle the center somewhat unequally. The left one extends up to the top of the painting with a light gray line, revealing at that point that it is not actually in the center. But they are all near enough to utilize the center's power of attraction. And the diagonal dock railings pull the eye from the edge right to it all, as do the cable lines. The colors are the primary triad red, blue, and yellow, their difference from each other ensuring that the reds stand out.

Types of Balance

Several types of balancing arrangements can be used as the basis for a composition. We will discuss the following: symmetrical balance, asymmetrical balance, radial balance, the pyramid, circular balance, and balance through contrast of line.

Each method of balance provides a different type of energy, producing an alternative manner of moving through the composition ranging from peaceful or static to a dynamic motion. Your intended artistic message would dictate your choice. For example, to express serenity, a pyramid or symmetrical balance would do the trick because of the pyramid's stable energy, as we learned in Chapter 5. On the other hand, to express excitement, you might consider using circular balance because of its dynamic energy. To provide a unified message with each type of structure, your color choices should support its energy. The wrong choices would make the picture express a different feeling from that of the arrangement, and this can confuse the viewer. We will discuss this concept of unity later in this chapter.

Symmetrical balance depends on the center line as the base for the entire structure, and it makes that line visible through the forms that straddle it. Asymmetrical balance is achieved by measuring and comparing the visual weight of all the forms in the picture, and arranging them to balance each other. Radial balance radiates from the center point, emphasizing it. The pyramid and circular balance use the center as a focal point, but don't radiate from it. Balance through contrast of line depends more on the direction of line as the theme, although as usual, elements must be balanced on either side of the center.

SYMMETRICAL BALANCE

When one side of a dividing line is the mirror image of the exact configuration of shapes and lines as the other side, it is called **symmetrical balance**. Each side has parts equal to the other side. The axis for symmetry is often, but not always, in the center of the composition. Symmetry is also known as formal balance. It has order, stability, and consistency and is easily achieved

and quickly comprehended by the viewer. Symmetrical layouts provide visual equilibrium, although, as we discussed in Chapter 5, the top and bottom have different rules affecting visual weight, which may affect the equilibrium.

A composition could have just a few elements of symmetry without being completely symmetrical. For example, the same color can be on both sides of the center line, and even though the background may be different, the eye recognizes the similarity. This makes the eye want to move from one to the other, and aids in the process of continuity.

The Axis of Symmetry

Symmetrical elements balance with identical parts across the vertical center line creating vertical symmetry, or the horizontal center line creating horizontal symmetry, or even across a diagonal center line. But some symmetrical compositions have more than one axis of symmetry. Biaxial symmetry has two, where the elements across both the vertical axis *and* the horizontal axis are exactly the same. This divides the composition into four equal quadrants. Some types of compositions could have three axes, such as a kaleidoscope or a snowflake, or even more than three.

Vertical Symmetry

Draw an imaginary vertical line down the middle of your composition. When the design elements to the right of this line are a mirror image of those to the left, the image has vertical symmetry. The laws of gravity clearly affect vertical symmetry. Elements in the top half of any composition have more visual weight, and more importance, than those in the bottom half, because gravity is pulling them down. For that reason, vertically symmetrical compositions with smaller and less complex shapes on top and a wider bottom are balanced, whereas those with the wider shapes on top feel top heavy.

Horizontal Symmetry

An imaginary horizontal line forms the axis for horizontal symmetry, as in Figure 6.18, Joel Schilling's *Wonder Lake Reflection No. 2, Denali National Park, Alaska*. Shapes above this line are identical to shapes below. Elements along the horizontal line have equal visual weight.

FIGURE 6.18 Joel Schilling: *Wonder Lake Reflection No. 2, Denali National Park, Alaska.* Photograph, 2005. This is an example of horizontal symmetrical balance, but with the horizontal line not exactly in the center. Joel Schilling.

FIGURE 6.19 Cynthia Packard: *Reclining.* Oil and wax on board, 36″ × 48″, 2010. Cynthia Packard.

Diagonal Symmetry

The diagonal edge of the figure in *Reclining* (Figure 6.19) cuts the painting fully in half, balancing the figure and her chair against the blue ground above her. The intensity of the blue ground gives it enough visual weight to balance the more compelling nude figure. The visual weights of both halves are evenly matched because the colors all contain blue.

ASYMMETRICAL BALANCE

We have seen how symmetry is orderly and understandable, and that symmetrical balance is easily achieved. It is so easy, in fact, that one would be tempted to use it for all compositions. But this would quickly become boring because the artistic message coming from symmetry usually centers on stability, and the eye longs for variety. The alternative to symmetry is asymmetrical balance.

Asymmetrical balance depends on elements on opposites sides of the composition that are different yet weigh the same visually. Careful manipulation of color and compositional elements can give you stunning and unpredictable results.

A great many compositions are balanced asymmetrically, using unlimited combinations of shapes, sizes, and colors. Although it can be more challenging to design this type of

composition, there is a reward: greater variety and dynamic motion, and the power to formulate any type of artistic message.

In an abstract composition, Howard Ganz's *Bountiful* in Figure 6.20 balances the greens on the top right side against the greens on the bottom left. The violet and blue circles draw a line up to their balancing orange circles at the opposite corner on the top left.

In Figure 6.21, Liz Carney's *Hollyhocks* is also an example of asymmetrical balance, where the tall flowers against the blue door on the right side balance the red flowers in front of the landscape on the left.

Syed Asif Ahmed's photograph in Figure 6.22 balances the orange–yellow sign on the right against the orange–yellow corrugated metal at the top left. The eye moves easily from one to the other by following the diagonal lines. The complementary blue balances the yellow–orange using Goethe's proportions.

In another example of asymmetrical balance, *Lotus,* in Figure 6.23, balances the open flower on the right against the unusual bud and diagonal grasses that are across the center vertical line.

Sometimes a composition can masquerade as symmetrical with halves that may appear to be equal because they are the same shape or the same colors. However, on closer inspection they prove to be different in some other way. They may have roughly the same dimensions balanced across the center axis, but not exactly the same shapes. Or they may be the same color, but a very different shape. Because they are not exactly the same, they are not symmetrical—they demonstrate asymmetrical balance. For example, *Cactus in Marfa, TX,* in

FIGURE 6.20 Howard Ganz: *Bountiful.* Digital painting, 2006. An example of asymmetrical balance. Howard Ganz.

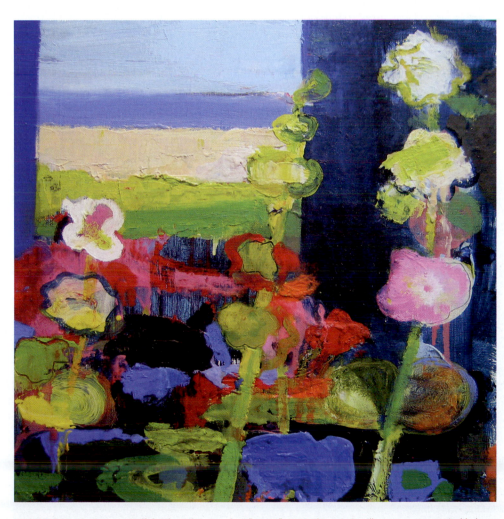

FIGURE 6.21 Liz Carney: *Hollyhocks.* Oil on panel, 12" × 12", 2005. This painting illustrates asymmetrical balance using different shapes from those in Figure 6.20. Liz Carney.

FIGURE 6.22 Syed Asif Ahmed, bedueen: *Queensborough Bridge, NYC.* Photograph, 2011. This photo illustrates asymmetrical balance through placement of complementary hues. Asif Syed Ahmed.

Figure 6.25, appears to be exactly the same on either side of the vertical line but, in fact, the sides are not the same.

RADIAL BALANCE

Radial balance occurs when the lines and shapes radiate out in all directions from a point in the center, giving it emphasis and allowing movement to swirl around it, as in Figures 6.24 and 6.25.

THE PYRAMID

With its apex at the top and its base on the bottom, a pyramid has great stability and little movement. Within a composition, the pyramid structure comes from shapes placed in locations corresponding to the three points. It successfully keeps the eye within the composition, as the viewer's eye moves around to each point. In Figure 6.26, with her arm upraised and flying the French colors, Liberty forms the apex of the pyramid, while the bodies of the brave patriots that lie horizontally on the bottom form the base. Syed Asif Ahmed's train tracks photograph in Figure 6.27 shows the stability of the pyramid, as well as the great depth it brings to the image. Due to perspective, the lines meet at the receding train in the hazy distance, drawing the eye there.

CIRCULAR BALANCE

In this type of structure, shapes are placed in a concentric circle around the center point, moving the eye around with great energy. We can see that happening in Figure 6.28—the leaves appear to move in a great clockwise circle. Why do they move the eye that way? The leaves are pointing in a circular direction around the submerged leaves in the center, although the clockwise orientation comes from our culture.

FIGURE 6.23 Marcie Cooperman: *Lotus.* Photograph, 2012. Marcie Cooperman.

BALANCE THROUGH CONTRAST OF LINE

Balance based on contrast of line establishes the dominant line of composition, offset by lines that move in an opposing direction. In Chapter 4, we learned about the various types of compositions, and how the major line of composition is not usually the only line present; for contrast, compositions need lines that move in other directions. Also, sometimes the major line itself is actually composed of differently oriented lines or shapes that are located along it, as we saw in Figure 4.2 in Chapter 4. Looking at this concept in the light of what we are now learning, another way to say it is that often the major line of composition is *balanced by* lines going in another direction.

For example, in Figure 6.29, *Vessels* has a major horizontal line of composition balanced by the vertical bottles that compose it.

FIGURE 6.24 Joel Schilling: *Cathedral Ceiling, Seville, Spain.* Photograph, 2008. Although slightly askew, this composition has radial balance, giving it both horizontal and vertical symmetry. Joel Schilling.

Color Balance

Color contrasts provide interest when balancing a composition. Contrast comes from elements that are different from, maybe even opposite to, each other. Together, each element allows you to see the strength and beauty of the other. For example, a very complex pattern stands out best next to an area of quiet; an intense color shines adjacent to a gray area;

FIGURE 6.25 Marcie Cooperman: *Cactus in Marfa, TX.* Photograph, 2005. Radial balance: All the leaves swirl around the sharp center leaf, which is below the horizontal center of the photograph. Marcie Cooperman.

FIGURE 6.26 Ferdinand Delacroix: *Liberty on the Barricades.* 1963. This painting illustrates pyramid balance. Oleg Golovnev/Shutterstock.com.

FIGURE 6.27 Syed Asif Ahmed, bedueen: *Tangail, Bangladesh.* Photograph, 2010. The pyramid is formed by the train tracks meeting in the distance. Asif Syed Ahmed.

complements look strongest next to each other. In *The Starry Night*, Figure 6.30, the high-value yellow stars and light reflections vibrate next to the dark blue night sky and Rhone River. The blue ground emphasizes the warmth of the yellow, and the lights are the most intense when reflected in the low-intensity, dark waters.

Theoretically, a composition could be all one color, and *technically* it is balanced. You could come to that conclusion because with all one color, no area is overwhelmingly heavier than the rest of the picture, if the forms are completely aligned for balance. But with just one color it would most likely lack interest and make no statement, unless variety in another factor rescued it, such as texture. The best way to save such a picture from the doldrums and help the viewer appreciate the color is to provide a contrasting color next to it.

At the same time, the essence of balance is making sure that one part of the composition isn't screaming out for attention, while other areas are ignored. *Different* is great, and desired, but relating to the rest of the composition is the best way to capitalize on that contrast. That's where the process of balance—determining quantities of colors and shapes and their arrangements—becomes useful. The most incredible contrasts can work if the right quantities are used, and located in places that make the eye naturally want to go there.

Artists have always thought about balancing contrasts of color to accomplish their goals. Vincent van Gogh hoped to express his intense emotions and moods through the use of color contrasts alone. He said, "I am always hoping to make a discovery there to express the love of two lovers by a marriage of two complementaries, their mingling and

FIGURE 6.28 *Leaves maelstrom in forest.* Painting. Vladimir Mucibabic/Shutterstock.com.

FIGURE 6.29 Cynthia Packard: *Vessels.* Oil on canvas, 48″ × 60″, 2011. This painting shows balance through contrast of line. Cynthia Packard.

their opposition, the mysterious vibrations of kindred tones. To express the thought of a brow by the radiance of a light tone against a somber background. To express hope by some star, the eagerness of a soul by a sunset radiance."[3] *The Starry Night* demonstrates this expression in the orange light reflections and yellow stars against the complementary dark blue sky and Rhone River.

FIGURE 6.30 Vincent van Gogh: *The Starry Night.* Oil on canvas, 28.5" × 36.2", 1888. © Peter Barritt/Alamy.

In evaluating color balance, ask these three relevant questions:

1. What colors are in the composition and what are their three elements?

2. Where is each color located?

3. How large is each color area?

Visual weight, as always, is your guide for placement and quantity. Color gives you three elements to play with: hue, value, and intensity. Each one can be manipulated and adjusted separately, to find the proper contrast for balance.

Let's look at the color balance in Pamela Farrell's paintings *Lacuna 3* and *Lacuna 7* (Figures 6.31 and 6.32). Although the immediate impression in both paintings is one of low intensity because of the ground, it allows some very delicate hues to stand out against it. The red elements are carefully balanced using similar locations in each painting, but in different quantities and intensities, and with different adjacent colors. Red's immediate neighbor in *Lacuna 3* is blue of the same value, which allows the red to disappear. In *Lacuna 7*, the red stands out because it is adjacent to the higher value ground, and enjoys a complementary contrast against the ground's greenish hue.

HUE BALANCE

Hue balance depends on the weights of the colors, as determined by their size and location. At their most intense levels, some hues, like red, are very heavy and attract attention no matter where they are in the composition, while others more easily fade into the background due to their low weight. Red is a fascinating hue to work with, compelling as it is for the eye. Many artists enjoy playing with the possibilities for balancing a red object in their paintings. Such a heavy weight needs an equally heavy weight to balance it, such as complexity, larger

areas of lower intensities, or smaller areas of intense colors. For example, the low value and low intensity red in Cynthia Packard's *Rising* (Figure 6.33) rests solidly on the bottom, balanced by a greater area of lighter weight oranges, warm yellows, and complementary greens.

Alyce Gottesman's *Yellow Fantasy* in Figure 6.34 contrasts the small red area on the left edge against the blue square at the top right plus the yellow around it, supported by the red–orange areas at the bottom right. The wide-open yellow area allows enough breathing space around the blue square to emphasize it, giving it the required visual weight to balance the red left edge. The gray stripe next to the red one mitigates the red's weight in three ways: by separating it from the rest of the canvas, by reducing the amount of open area around it, and by providing another point of interest to take away some of the red's dominance.

As we discussed in Chapter 5, all colors are heavier on the top of the composition, and they are also heavier farther away from the center. As a result, in those locations they are more prominent, which might cause trouble for heavy colors there. Unless they are well balanced by an equally heavy object on the bottom, they will seem overweight. Figure 6.35 shows what it takes to balance red at the top. The heavy red ground and figure on top are visually supported by the blocks of color below. The yellow ground itself would not be heavy enough to balance the red, but the complexity of the blocks' hues and shapes provide enough contrast with the figure to balance it.

VALUE BALANCE

Values are the most directional element for continuity, causing some to say that they are the most important element of color. An effective contrast of low values against high values can be instrumental in organizing the flow of energy through the composition. Well-placed low values have a recognizable spatial relationship with each other, can form shapes we recognize, lead the eye on a path through the picture, and send a message of order or unity. If a painting has balanced values, it would have depth and volume no matter what hues or intensities are used. See for yourself: Make a painting of a spoon with crazy hues like violet and green, using the lower-value violet to describe the depth of the bowl of the spoon, and notice how realistic it is.

Value is so important that it is not possible to completely fix a composition that has poorly balanced values by altering only the hues and intensities. Compositions with badly placed values are confusing and unorganized, and appear to have extraneous material. A composition too heavy in value on one side will always feel lopsided. Compositions in which all values are high appear to be weak, with no direction. Even a small number of low-value areas in a composition with mostly high values can strongly direct the eye and provide balance.

FIGURE 6.31 **Pamela Farrell:** *Lacuna 3.* Encaustic on panel, 24″ × 24″, 2007. The red element at the right edge is balanced by the smaller, more numerous reds on the left. The vibrancy of the reds is ensured by their contrast with the adjacent lower-intensity colors. Pamela Farrell.

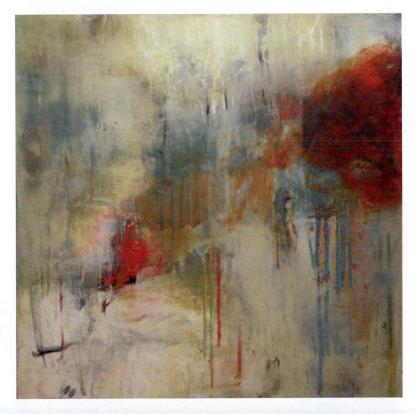

FIGURE 6.32 **Pamela Farrell:** *Lacuna 7.* Encaustic on panel, 24″ × 24″, 2007. The large low-intensity red element on the right edge is balanced by the rather isolated higher-intensity red on the left, and connected by the red drips in between. Pamela Farrell.

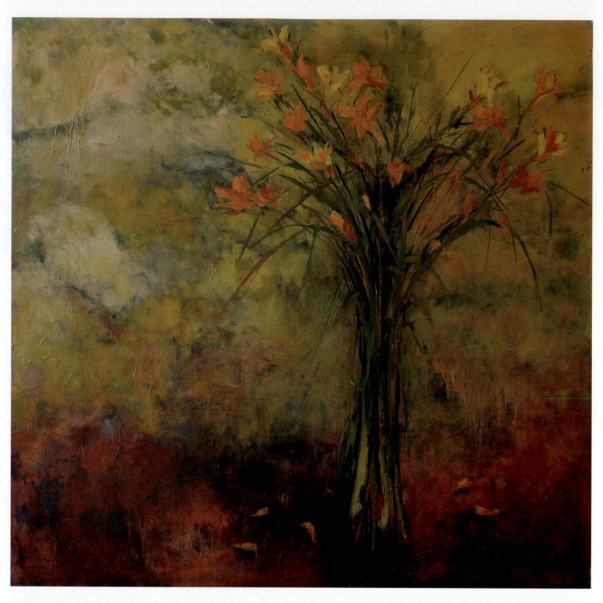

FIGURE 6.33 Cynthia Packard: *Rising.* Oil on canvas, 84″ × 84″, 2011 The red at the bottom keeps the heavy weight at the bottom, while the orange, yellows and greens are lighter in contrast. Cynthia Packard.

FIGURE 6.34 Alyce Gottesman: *Yellow Fantasy.* Encaustic on wood, 15″ × 18″, 2001. Alyce Gottesman.

FIGURE 6.35 Michael Price: *Chromatic Composition No.2, Rhythm and Blocks.* Natural and mineral pigments in tempera and oil on linen glued to wooden panel, 12.7″ × 28″, 2005. The red on top is balanced by the blocks of color on the bottom. Michael Price.

To evaluate the balance of values in your composition, squint your eyes as you look at it; this reduces the ability of the cones in your retina to see color, while black and white are unaffected. The lower-values form patterns that stand out and their placement can reveal problems in balance, such as heaviness in the wrong places, or too much weight on one side as compared to the other.

Steen's painting in Figure 6.36 shows good balance of values. The high value forming the top half of the image is an upside down triangle on its apex, which balances the high value on the floor. The woman's face and arm connect the top and bottom parts. Their contrast against the surrounding low values draws our eye to the center.

In *Maui Sugarcane* in Figures 6.37 and 6.38, strong value contrasts between the mountains and the sugarcane silhouette are crucial to the balance of the composition, and the quantities are important. Figure 6.38 is cut horizontally in half at the line of contrast, making the heavier black area overwhelm the mountain and sky. At the line of contrast, half the picture is eliminated because it is a void. The photo in Figure 6.37 is more successful. The silhouette has just enough space to set up a strong bottom that supports the higher values, and the sugarcane edges bring the eye up, allowing it to focus on the slightly differentiated clouds and light effects in the sky.

FIGURE 6.36 Jan Hovickszoon Steen: *Feasting.* Painting. Oleg Golovnev/Shutterstock.com.

FIGURE 6.37 Marcie Cooperman: *Maui Sugarcane, Maui, Hawaii.* Photograph, 2006. The amount of black space at the bottom balances the composition better than that of Figure 6.38. Marcie Cooperman.

FIGURE 6.38 Marcie Cooperman: *Maui Sugarcane, Maui, Hawaii.* Photograph, 2006. The black area overwhelms the composition. Marcie Cooperman.

In Mercedes Cordeiro Drever's *Refine Perspective, Grand Canyon—Arizona* (Figure 6.39), the lower values of the bottom and left side balance the brighter slope and deep view, and allow the eye to focus there.

INTENSITY BALANCE

The arrangement of levels of intensity goes a long way toward making a composition interesting. High intensity makes an object heavy, especially when it is in contrast against an area of low intensity. This contrast can be instrumental in attracting attention to an accent, making a point, and holding attention on a focal point. Because high intensities are vigorous in directing the eye through the composition, continuity benefits from high intensities placed among low intensities. This relationship can help you in making your placement decisions.

Quantity is also important in working with intensity. To impart a message of high intensity, it is not necessary for a composition to include a lot of it. A relatively small number of intense colors contrasts well against a larger area of lower-intensity colors. An area can look quite saturated even if it has small spots of high intensity resting on larger areas of lower-intensity levels, as those small spots spread their glow and raise the intensity of the whole area. For example, in *Corn Hill Fall II,* Figure 6.40, there are only a few areas of high-intensity red contrasting against many low-intensity tints, and they help the red stand out. In fact, too many areas of high intensity in a picture would be overwhelming and could create more than one focal point, since the eye looks at every point of high intensity.

On the other hand, too much low intensity is muddled and has either no message or an unclear message. Creating a focal point would be harder using only low intensities because nothing stands out to show us where to look. Without the higher-intensity daisies popping up in Gary K. Meyer's photograph (Figure 6.41) of a field in Talouse, Washington, the equally low intensities of the fields and flowers would not provide movement or focal point. Also, the reeds in the center are vital to the compositional balance because they point up, moving the eye up to the sky above the horizon. Cover them with your fingers and you can see no path to move up past the strong horizontal bottom half of the composition.

Alyce Gottesman's *Above and Below* in Figure 6.42 illustrates how to utilize a large quantity of saturated colors and avoid creating an overwhelming composition. The green–blue background and some of the green and yellow are very intense, but they are balanced by many small areas of low intensity well distributed throughout the composition.

FIGURE 6.39 Mercedes Cordeiro Drever: *Refine Perspective, Grand Canyon—Arizona.* Photograph, March 2010. The lower values of the bottom and left side cradle the deep view and focus the eye on the brighter slope. Mercedes Cordeiro Drever.

How to Know When a Composition Is Balanced

When a composition is balanced, it cannot be improved by making any changes. Arnheim stated, "In a balanced composition, all factors such as shape, direction and location are mutually determined in such a way that no change seems possible, and the whole assumes the character of 'necessity' in all its parts. An unbalanced composition looks accidental, transitory and

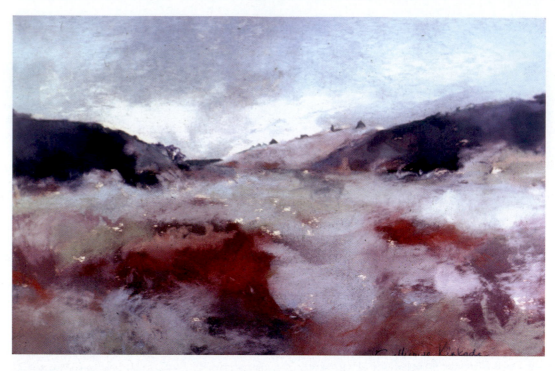

FIGURE 6.40 Catherine Kinkade: *Corn Hill Fall II.* Pastel, 15.5″ × 20″, collection Pastel Society of America. Catherine Kinkade.

FIGURE 6.41 Gary K. Meyer: *Talouse, Washington, June 12, 2009.* Photograph. Gary K. Meyer.

therefore invalid. Its elements show a tendency to change shape or place in order to reach a state that better accords with the total structure."[4]

This means that the balanced composition appears to be perfect as it is, where no change makes it better, and everything in it has to be included. Taking out an element would force more changes in order to regain balance.

In a balanced composition, the influence of the colors on one another is beneficial. If a particular color looks "ugly" compared to the others, it might signal that there is a problem with it. This could be due to its quantity or where it is placed in relation to the other colors.

When all elements are in balance, the visual path that the eye must take through the composition is clear, with no elements blocking the eye's progress—no obstacles that prevent you from taking in the entire composition. Empty space works as breathing room for a shape, rather than something that needs to be filled up. And busy spaces feel like they are exciting and dynamic, rather than crowded. The feeling that something is about to move is one of dynamic movement suggested by the forms, rather than a result of an overweight element feeling like it's about to fall.

How do you know when two objects are the right distance from each other? When are they too close together or too far apart? Two objects have a relationship to each other through color (their hue, their value, or their intensity), size, or shape. If they are the **right distance apart**, they relate to each other in one of several ways.

We can compare two shapes to two people talking to each other: If people are too far apart, they would seem to be two separate satellites whose movements are independent; they simply won't relate to each other. If they are loud, a greater distance between them can work, but if they speak very softly, the great distance will not allow them to talk to each other.

Shapes can have the same strong or passive features affecting the amount of room they need to occupy together, and their colors and relationships affect their needs.

If they are the correct distance apart, they "talk" to each other, or even attract each other. The space between them is vibrant and vital; it holds them in their locations and allows their energies to reach across the space to each other, especially if their movement or energy is similar or complementary. If they are too far apart from each other, we would not identify the space between them as associated with them both. If they are too close, they might repel each other.

Gary K. Meyer's photograph *Namibia, May 17, 2009* (Figure 6.43) illustrates that proximity is crucial to the movement created by the trees. They appear to be figures dancing with each other, arms in the air. And with each one facing a different direction, the unique energy of the composition depends on all of them being there. Check the balance by covering up one at a time with your finger. You can see that suddenly the movement is arrested.

FIGURE 6.42 Alyce Gottesman: *Above and Below.* Encaustic and oil on wood, 18" × 15", 2003. This illustrates balance using high intensity colors. Alyce Gottesman.

BALANCING PROBLEMS

There are a number of reasons for a composition to appear unbalanced:

- **Extraneous objects:** Sometimes just one element prevents the composition from being balanced, referred to as an **extraneous object**. When you have reached a point where the balance appears to be good, try this test to check each object's reason for being included: Visually eliminate objects one at a time by covering them up with your finger. Each time you hide a shape, evaluate if all the shapes on that side of the vertical and horizontal center lines are still balanced by shapes on the other side. Then reveal the object and compare them to see which looks better, with or without it. Sometimes when you cover up a shape you can't see any difference in the composition's balance. This might mean that the shape was extraneous and should be eliminated, because keeping it doesn't improve the composition.

FIGURE 6.43 Gary K. Meyer: *Namibia, May 17, 2009.* Photograph. The trees appear to be dancing together. Gary K. Meyer.

- **Overweight:** Too many heavy elements on one side of a composition could produce an overweight situation. Eliminate some elements to fix the problem.
- **Underweight:** The opposite problem would be too little weight on one side.
- **Undefined balance:** Sometimes the balance is muddled by a compositional element that isn't clearly defined. It creates a weaker composition because it looks like a mistake has been made. In each situation, the answer is to sharpen the uncertain quality of the element. This problem could arise from the following examples:

 ° Hues that should be the same, but are slightly different; adjust the hue to be exactly the same, or vary it enough that it is obviously different.

 ° The relationship between the shapes is not clear. They may be almost, but not quite, lined up, or they are too far away to communicate. Line up the locations, or move them to change the relationship. Moving a shape might make the difference between muddled balance and brilliance.

 ° The elements are almost, but not quite, symmetrical; either perfect the symmetry, or alter it enough that it is clearly not symmetrical.

Unity

Unity in a composition means organizing the elements of a composition to work together to communicate your chosen theme. Hues, values, intensities, shapes, location of shapes, balance, and line of continuity are all tools that can be used by the artist for this job. But with so many variables for each tool, it could be hard to know how and where to begin.

The best way to start is to answer this question: What is your goal—what story do you want to tell? What is the main idea or theme of the picture? Are you expressing a simple and graphic idea, such as the color red, or brightness, or sharpness? Is it the story of a lovely mountainous landscape, or the movement of dancers? Or is your theme more complicated, perhaps a philosophical concept such as the idea of abandonment, or an emotion such as a hopeful mood? Once you know the answer to this question, you have a plan. The plan can direct your choices for translating the idea into visual marks.

To achieve unity, you need to organize your elements so that each has a specific role to play. Just like a play cannot have all lead actors, not every compositional element needs to "say" the same thing. In a play, if every actor were involved in actively declaiming, it would be utter chaos and impossible to hear or understand anything, not to mention extremely unpleasant. Some actors have to be supporting characters, and some are even more relegated to the background by being extras who don't speak. Similarly, if every element in your composition clamors to be heard, it would be strident and confusing. For example, imagine if you wanted to express force, and made color choices so that every element did that. Rather than force being expressed, confusion might be the result. Conversely, if the idea of peace and quiet is to be expressed, and all elements illustrate this, it might bore the viewer without actually expressing the main idea. And boredom and confusion are equal villains.

Continuing the analogy, to express an idea in your picture, you need to choose which elements are to actually be the lead actors, and which should be supporting characters, and finally those that quietly provide the background and support the other elements. By separating the elements this way, you can identify the ones that can effectively translate your idea visually.

You have unity when no one element is so strong that it overwhelms everything else; nothing feels out of place, in need of change. No line goes in a confusing direction; no color feels like it's screaming so loudly that we can't see the others. When all the compositional elements are chosen properly and placed in the right locations, we can understand the theme.

You don't have unity when the energies coming from the various elements do not act in a supportive way for each other. A composition without unity gives the impression that the shapes and spaces are chosen for no reason. You can tell changes need to be made, even if you aren't sure where to begin.

Syed Asif Ahmed's photo in Figure 6.44 is a successful example of unity in color, line, and balance. Squint your eyes to be able to see the values almost unimpeded by color. The diagonal lines and low values open up the center focal point area for the bird by wrapping around it and holding it there. Diagonal lines are dynamic, but the low angles of these lines are almost as static as horizontals, and they form a stable contrast for the fitful bird. The low-intensity orange balances the blue, and the achromatic bird contrasts against it.

In Janos Korodi's *Electric Burns II* in Figure 6.45, all the elements contribute to the potential energy. The shapes are laid out in areas that balance each other in almost symmetrical locations; the complementary red and green vibrate evenly together, the black areas frame the entire composition and allow the center to be the focal point, and the black figures on the bottom lead the eye up into the center.

FIGURE 6.44 Syed Asif Ahmed, bedueen: *Queensborough Bridge, NYC. Photograph, 2011. All elements in this photo show unity. Asif Syed Ahmed.

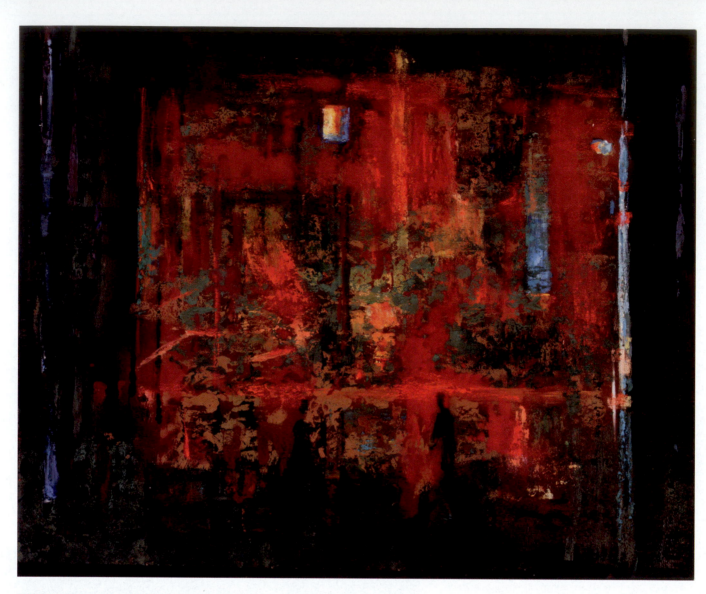

FIGURE 6.45 Janos Korodi: *Electric Burns II.* Mixed media on canvas, 39″× 47″, 2005. All elements work in unity to create potential energy. Janos Korodi.

summary

After reading this chapter, you can see why balancing the composition is a constantly changing process, right up until the last moment. The elements of color and composition can have qualities that conflict with each other, with each behaving in various ways depending on their relationships with other elements. The composition isn't balanced until everything works together to produce the desired effect. When your composition is finally balanced, it sends a simple and clear idea. You know it's finished when eliminating or changing anything would compromise the message, make a mess of continuity, or generally make you feel like you are missing something.

Even the old masters didn't achieve balance in every painting, so you should never despair because of the complexity of the process. By looking at paintings with balance concepts in mind, you will learn to recognize good balance as opposed to a lack of balance, and you will enjoy being able to critique the compositions you see in art, advertising, and design. To test your understanding and learn how to understand what to do to help a composition achieve balance, it pays to practice by doing exercises and discussing them with your classmates. Seeing and evaluating the balance choices that they make will also further your training.

quick ways . . .

By focusing on one compositional element at a time, it is possible to see if each has a balance problem, free from influence from the other elements. Then, looking at them altogether, you can see their influences on each other.

1. Focusing on the balance for each element, ask these questions:

 • **Color balance:** What is the weight of each color in its location? Is it balanced by another area? Do any colors cover too large an area?

 • **Value balance:** Value balance is a good element of color to start with, as that element is most crucial to the composition. Does the arrangement of values suggest an effective path of continuity? Does it lead the eye through the whole composition, or does it lead into a corner where the eye gets stuck? Or worse, does it lead the eye off the picture? Are all areas included as part of the whole?

 • **Hue balance:** Is there a lack of recognizable relationships of hue?

 • **Intensity balance:** Is there enough contrast of high and low intensities? Or is most of the composition too high, or too low?

 • **Line balance:** Line balance is also crucial for continuity: Are all lines the right distance from each other, providing the desired type of energy and enhancing continuity? Do the lines lead the eye on a clear path around the composition? Is there a diversity of types of lines to provide contrast and balance? Are areas of strong, dominant lines balanced by quieter areas? Or are there too many lines, confusing the eye and making the picture seem crowded?

2. Focusing on the composition as a whole, ask these questions:

 • Can you recognize one of the various types of balance we have discussed concerning placement of shapes? Are the shapes the right distance from each other?

 • Does the bottom half support the weight of the upper half? Or do elements at the top feel uncomfortably as if they are going to fall?

 • Does the right side balance with the left side?

 • Does an area feel bare? Do you feel that something needs to be added to it? Or do empty spaces balance and support other areas?

 • Does an area look crowded? Does covering up an element with your finger relieve the problem?

 • Can you see the focal point clearly? Or are there two focal points competing for attention?

exercises

Parameters for Exercises

There are many factors of color and color relationships in compositions, and all of them can affect the way the colors appear to the viewer. The best way for students to learn through their color exercises is to have simple objectives and fairly strict *rules* about the type of lines and colors to be used. We call those rules "parameters." With strong parameters allowing only a minimum of elements, it is easier to observe the direct relationships between colors, and to see the differences between the students' compositions. When lots of compositions hang together for a critique, it becomes clear which ones are successful in achieving the goals.

As students learn the objectives and build on their skills, they will become more adept at using color. They will gain the ability to tolerate more complications because they understand the ensuing interactions. Therefore, as we move through the chapters, the restrictions on composition size and the number of lines and colors will be gradually reduced. Larger compositions, more colors, and more types of lines will be allowed. However, certain ground rules will remain the same: Flat color and nonrepresentational shapes will remain constant parameters, and the goal of every assignment will be a balanced composition. Five specific parameters include:

1. No recognizable objects are allowed.
2. All colors are to be flat and nongradient, with hard edges that don't fade away.
3. White is always considered a color, even if it is the background.
4. Only neatly cut and pasted papers are appropriate.
5. Balance and unity are *always* the singular goal of every composition.

1. ***Assess balance in a square by moving shapes around your paper:***

 - **Background:** Choose a color; use it to fill a 6″ × 6″ square.

 - **Figures:** On another piece of paper, fill in two different irregular shapes and cut them out. Arrange them in several locations on your square background to see which combination is balanced. How close does each need to be to the center point or an edge? Write your impressions and bring them to class for a critique.

2. ***Assess balance in a rectangle:*** Do the same exercise within a 5″ × 7″ rectangle. How does the rectangle change your decisions for locating the two shapes?

3. ***Balance hue:*** Create a balanced composition for each of the following groups of parameters. Decide on the proper quantity for each of your colors, as well as their location within the picture:

 - **Red background:** For the background of this composition, use a red with your choice of value, intensity, and type of hue. Choose two other colors for shapes of any type and number, size, and location. The goal is to balance the other shapes against the heavy weight of the larger red background space.

 - **Red figure:** This time, the figure should be the red of your choice and the background is any color you wish. Use a third color as a figure somewhere in the composition. Red figures present a different balance situation than a red background.

4. ***Balance intensity:*** Use a very low-intensity color and your choice of two higher-intensity colors. The goal is to enhance the beauty of the "ugly" color and make it integral to the composition.

5. ***Balance value:*** Using black, white, and any gray, create a balanced 6″ × 8″ composition.

6. ***Evaluate the balance of a work of art:*** Find a painting done by your favorite artist. What is your assessment of the overall balance? What is the type of balance used? Which elements balance each other? What is your assessment of the balance of each of the various color elements: hue, value and intensity? Write your observations and bring them to class for a discussion.

7. ***Create balanced compositions:*** Make two 5″ × 7″ compositions with the same colors, each with your choice of shapes. One should be a pyramid type of balance and the other circular balance.

Planes and Color

Figure and Ground

> " *Figure and ground —The distinction between perceptual objects and the space surrounding them. A figure is generally observed as lying in front of an uninterrupted ground—the most elementary representation of depth in drawing and painting. Dynamically, the figures and the 'negative spaces' of the ground are centers of forces that keep one another in balance.* "[1]
>
> —*Rudolf Arnheim*

Within the confines of a 2-D composition, as soon as a line is drawn, two elements are delineated: the **figure** and the **background**. The line is the figure, and the area around it is the background. The presence of the line turns its surroundings into the background, also known as **ground** or **field**.

FIGURE 7.1 Joel Schilling: *Fortification Remains, Zahara, Spain.* Photograph, 2008. Joel Schilling.

key terms

background
field
figure
foreground
ground
object
picture plane
picture plane level
plane
representational art
visual perception

We see the figure as existing in the **foreground**, meaning *in front of* the surrounding field. Conversely, the **background** is *behind the figure*. We also call the figure positive space, and the background negative space.

If we twist a line around to make a circle, the area within the circle's edge achieves definition as the foreground area. No longer just a line, it is a circumscribed area that is perceived as in front of the surrounding background, which apparently continues uninterrupted behind the circle. It is very interesting that the ground *is* visually interrupted, and yet we perceive it as uninterrupted, continuing behind the figure. This is one of the principles of the *Gestalt principles of perception*, which we will be discussing in Chapter 8.

Why do we perceive the circle in front of the other area, instead of behind it? Why isn't the other area considered the figure and in the foreground, and the circle considered the background? The answer is that the circle is the smaller shape. As long as it is fairly small, it is the figure. If we were to "grow" the circle, at some indeterminate point it would become too big to be considered the figure and it would take on characteristics of *background*, just like the other ground area.

Color, which is always relative, can create exceptions to this figure–ground situation. If, for example, the circle is a very low value relative to the background, it can appear to be a hole in the ground, and the ground now becomes the figure. By definition, the hole is behind the surrounding area. Or, if the circle is high intensity relative to the ground, it pops forward and becomes the figure, even if it is larger.

The amount of perceptual space in a composition is another fun element to play with. Certain colors tend to move forward or back visually, and they establish distances from each other through their color relationships and the other compositional elements. Take a look at Figure 7.1, and notice how far away the castle tower seems to be from the cactus and flowers in front. In part, this happens because of the size and detail of the cactus in opposition to the tiny stones of the tower, and in part it's because of the high intensity of the flowers in contrast to the low intensity and high value of the tower (which establishes distance).

How big is a background? As opposed to a circumscribed area like a figure, it is seen as limitless because it has no apparent edges other than the edges of the composition. Even the edges of the composition appear to form a "window" looking out on the background, which we feel continues beyond what we see. Once again, color can alter this limitless appearance if different colors are placed around the background. But that's for you to explore and discover.

THE OBJECT

Figure and ground create the basic relationship of elements in a composition. **Figure** is something that the eye perceives as a focal point, an object of interest in the composition. In a **representational** style of painting, which is what we call art that represents life the way we see it, the figure is called an **object**, and it depicts a real thing such as a person, a boat, fruit, or a table, and so on. Representational art imitates nature. In abstract art, the figure is a shape that represents the focus of the composition without imitating nature.

In art history, the story of the disappearance of the object from paintings explains how abstract art came into existence. Until the beginning of the twentieth century, all art was representational, but during the last half of the nineteenth century, the objects and the backgrounds began to become less recognizable. In the late 1860s, Claude Monet (1840–1926) and his Impressionist friends began depicting objects using many small brushstrokes that illustrated their impression of light dancing on the landscapes at different times of the day. *The Cathedral of Rouen,* in Figure 7.2, shows how sunlight changes the colors of its face. Painting like this was shocking and unacceptable to the public for many years, but for artists, it lit a spark of creativity that continued undeterred.

Once the Impressionists had broken the unwritten social agreement artists had with the public, other young artists began pushing the limits with the ways objects could be depicted. For example, you might recall seeing the work of the Neo-Impressionist Georges Seurat (1859–91), *A Sunday Afternoon on the Isle of La Grande Jatte,* in Chapter 5 with its tiny dots covering the canvas. Paul Signac's *Cassis, Cap Lombard* in Figure 7.3 uses tiny dots to show reflections of rocks in the water.

Paul Cézanne (1839–1906), Paul Gauguin (1869–1954), and Vincent van Gogh (1853–90) followed their own inner muses in terms of the way they used color to express their emotions and show the form of the objects. For example, in Figure 7.4, Cezanne gave the houses and the background the same weight, using the same hues, intensity and values. Consequently, squint your eyes to see the houses disappear and the canvas appear to be only color breaking up the surface. In van Gogh's *The Road to Saint Remy* in Figure 7.5, strokes of color link this painting to the Impressionist style, yet show van Gogh's own personal stamp in its color usage. His strokes are larger, longer, and bolder than the Impressionists', and the colors are more intense.

Gauguin especially was influential on the young artists of the late nineteenth century in terms of using color more as decoration than as a faithful rendition of nature, which was the issue raging at the time. While, at that time, no paintings were made without forms of nature, objects, or people, the colors used and the painting techniques were beginning to take flight away from naturalism. In 1891, Maurice Denis (1870–1943) was quoted as saying, "I think that above everything else a painting should be an ornament. The choice of subjects or scenes means nothing. It is through its colored surface, through the value of tones, through the harmony of lines that I attempt to reach the mind, arouse the emotion."[2] You can see the results of his convictions in his *Women Guarding a Cow Near the Sea,* with its free use of unnatural colors and flat surfaces.

Several art movements ensued in quick succession after 1900. The Fauvists led by Henri Matisse (1869–1954) expressed themselves through their wild and unnatural colors that had no relation to the objects they were depicting. For example, in Matisse's *Blue Nudes* in Figure 7.6, the women are depicted as totally flat using an intense blue.

The Cubists—Pablo Picasso (1881–1973) and George Braque (1882–1963)—and those they influenced began to think about how to change the look of the flat, two-dimensional surface of the composition itself, and they further distorted the objects in their compositions, like Picasso's *The Three Dancers* in Figure 7.7.

Wassily Kandinsky focused on the colors and lines in his paintings, which resulted in almost unrecognizable objects. But still, the basic relationship of the object and the background persisted—until one day, he realized that the object could be eliminated. Abstract art was born! Kandinsky is called the founder of abstract art, as he was the first person to contemplate the idea of a painting without an object, without an image that represents real life. In 1910 or 1913 (it is disputed), he painted the watercolor in Figure 7.8, illustrating his daring concept. Art collectors, dealers, and the general public were not likely to understand and applaud his efforts. His work was too different to be comfortable.

Did he realize that he would be setting off a revolutionary attitude toward painting? Most likely he did. With this fascinating and enticing idea in his head, faced with the blank canvas awaiting his work, Kandinsky said, "A terrifying abyss of all kinds of questions,

FIGURE 7.2 Claude Monet: *The Cathedral of Rouen Effects of Sunlight.* Oil on canvas, 39 5/8" × 26", 1894. Scala/Art Resource, NY.

FIGURE 7.3 Paul Signac: *Cassis, Cap Lombard, Opus 196.* Oil on canvas, 26" × 31 7/8", 1889. The dots painted in the water deftly illustrate the reflections of the complementary orange rocks and hill. Paul Signac.

FIGURE 7.4 Paul Cézanne: *On the Bank of a River.* We can barely perceive that there are houses. At the time, society complained that Impressionist artists like Cézanne didn't know how to draw, which was agreed to mean a serious lack of talent. Tony Souter / Dorling Kindersley.

a wealth of responsibilities stretched before me. And most important of all: What is to replace the missing object?"[3]

REPRESENTATIVE OBJECTS GRAB ATTENTION

Representative objects can help us differentiate figure and ground more easily than abstract images. In fact, things we recognize, such as a face, often tend to come to a forward plane and steal attention away from other areas, whether they are relatively simple or complex. As an example, in Gary K. Meyer's *Namibia, May 11, 2009* in Figure 7.9, most likely you are focusing on the elephant, even though the grasses and rocks are quite complex.

In contrast, abstract compositions allow the elements of color and composition to play a greater role over color behavior and the determination of figure and ground. Figure 7.10 sits on the line between an abstract and a representational composition. At first glance, it is abstract, but once the diagonal lines running from the bottom to the center send the message that this is a train platform, you can no longer see it as abstract. The impact of the red–blue color relationship gives way to the depth of the station.

FIGURE 7.5 Vincent van Gogh: The Road to Saint Remy. Oil on canvas, 16" × 13", 1890. Erich Lessing/Art Resource, NY.

FIGURE 7.6 Henri Matisse: *Two Nudes.* Depicted on stamp. The Impressionists' work in 1875 broke the ground for wild expressions of color like this one in 1905. Christian Delbert/Fotolia.

FIGURE 7.7 Pablo Picasso: *The Three Dancers.* Depicted on stamp. rook76/Fotolia.

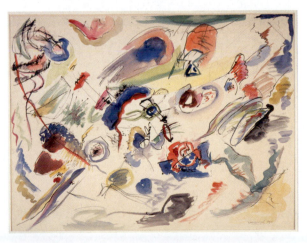

FIGURE 7.8 Wassily Kandinsky: *Study for Composition VII.* Watercolor, pencil, India ink, 19.5" × 25.5", 1910 or 1913. This is Kandinsky's first abstract watercolor painting. It has many shapes, but none recognizable as a real-life object. CNAC/MNAM/Dist. RMN-Grand Palais/Art Resource, NY.

Relating Figure and Ground

DIVISION OF SPACE

An artist or a designer planning the division of space in a composition essentially considers the figure and the ground as two distinct areas. They are distinct because we can *usually* tell which areas in an image are figure and which areas form the background.

However, as we will see later, the Cubist period in art history saw the commingling of figure and ground for the first time, and this technique continues to be intriguing today for many artists. The possibilities for this division of space are numerous. For example, some abstract paintings divide the image into blocks of color and texture, or patterns, essentially using the entire space as the figure. Some paintings dissolve the boundaries between recognizable figure and ground throughout the composition.

On an intellectual level, we often recognize the figure in a representative painting as an object we see in our daily lives. Even though this object can vary in shape and form, we recognize it because of its similarity to something with which we are familiar. For example, even though all bridges vary, we know we can recognize one in a painting and understand it as the figure.

But if the figure is abstract, and our memory of shapes is of no use, there are cues we look for to recognize it. The most basic cue is that the figure's edges have continuity and appear to be in front of the background, while the background is obscured by the figure. Sometimes the edges of the figure use color to contrast with the background, so we can see where one stops and the other begins.

What doesn't work: Certain situations destroy the supportive relationship between figure and ground, and do not allow an objective of having the figure stand out:

- If the ground fights the figure with competing color, line, or shape, the eye is confused about what to look at. This pulls attention away from the figure.

- If there is too much ground area, the figure looks lost and doesn't attract the eye as a focal point should.

FIGURE 7.9 Gary K. Meyer: *Namibia, May 11, 2009.* Photograph, 2009. The elephant is the figure because it takes our attention away from the grasses, no matter how intricate they are. If there were no elephant, the grasses would be the figure. Gary K. Meyer.

FIGURE 7.10 Janos Korodi: *Metro.* Nine-layer silkscreen print on canvas panel (single print), 11″ × 15″, 2004. This apparently abstract painting becomes figurative once the image of tracks is realized. Janos Korodi.

Although the figure and the ground can be two very different entities, in a strong composition they relate to each other through color and compositional elements, and work together toward the compositional goal—continuity. Artists can combine and choose from many strategies to do this, keeping the desired type of continuity in mind. Here are a few:

1. **The goal:** The figure stands out as the focal point.

 The method: Generally, the figure has distinct boundaries. The colors of the ground have less weight than the figure's colors, to allow it to stand out. But the ground relates to the figure through similarity in hue, value, or intensity or through a color relationship.

 For example, in Figure 7.11, *The Black Bow* by Georges Seurat, most of the figure has distinct boundaries through value differences, except for the bottom, where the figure blends into the ground. Most fascinating is the way Seurat has delineated the boundaries—the left side of the body is dark against the light ground, and the right side of the body is relatively light against the dark ground. Although the value of the background on the right side is as low as much of the figure, relating figure and ground, the line of value contrast at the arm defines the figure quite clearly. The same situation exists along the entire left side.

2. **The goal:** The eye is magnetized by the entire composition, and keeps bouncing back and forth between the figure and the ground.

 The method: The colors of the figure and the ground have similar weight. The ground has strong colors and shapes that continue to attract attention, but the figure attracts the most attention because it's the focal point. Cynthia Packard's *Dune Woman* in Figure 7.12 unites figure and ground this way.

3. **The goal:** The entire composition actually is the figure.
 The method: Color interaction is the theme; no representational shapes confuse the eye and provide competition for it. The entire space is divided into areas of color, with none standing out as a figure, and none working as ground. Although *Carpet* in Figure 7.13 has a partial black border around three sides which appears to be background, the balance of the painting demonstrates this type of division of space.

4. **The goal:** Confusing figure and ground boundaries, in some areas, the elements can play a double role—as figure as well as ground. In those areas, you cannot determine which is which. This is different from #3 above, where there is no figure ground distinction.
 The method: The ground's hues, values and/or intensities have weight that is equal to the figure's weight, and they seem to interact with the figure more than ground elements by definition should. For example, the green areas in Figure 7.14 could represent the leaves of the trees, yet their shapes don't relate completely to the trunks.

INTEGRATION OF FIGURE AND GROUND

Artists have historically established and separated figure and ground in a composition, until the advent of abstract art around 1910. At that point in time, all rules were ripe for change and the question of how to integrate figure and ground was raised as well. Cubists answered it by reversing techniques—they flattened parts of the figure and for the ground they used the traditional technique of modeling forms with chiaroscuro. This gives the ground a 3-D characteristic that rivals the figure. Cubists also took lines, shapes, and planes from the figure and spread them about in the ground, giving it apparent mass, or form. Sometimes they placed areas of transparency in both figure and ground, playing with our notions of solidity of form.

When we look at such a composition, we perceive that things that are supposed to be figure are enmeshed in the ground, and ground takes on the characteristics of figure. For the viewer, this integration of figure and ground is confusing but intellectually attractive. For the designer, it is an absorbing exploration of new ideas. Refer back to Pablo Picasso's *The Three Dancers* in Figure 7.7 to see how the figures are almost completely unrecognizable. Picasso used his Cubist technique of gradient levels of values in the background to give it the depth that the figures would have.

TRANSPOSITION OF POSITIVE AND NEGATIVE SPACE

Figure comes forward and ground falls back behind it, setting up positive (the figure) and negative space (the ground). This is the typical relationship in a composition. More often than not, we see it that way because of the continuous, unbroken lines of the figure. But how interesting it would be to use this situation as a catalyst for design, substituting ground for figure. By using continuous lines for the ground, some paintings use both figure and ground to represent the figure. This is related to the previous goal of integrating figure and ground. However, the difference is that the goal here is not mystery; it is to reverse figure and ground so that ground is clearly read as figure. In Figure 7.15, Andrea Pires's *Bon Soir Amiens* creates the figures out of both positive and negative space using this technique.

This technique is also effective with text. In ads and logos, text is obviously the figure. Using unexpected colors, patterns, and effects for the text provides interesting contrasts that attract the eye. In Lee Conklin's two-color 1968 Concert poster for Procol Harem, Santana, Salloom Sinclair and Holly See, Fillmore West in Figure 7.16, both red and black are used as figure and ground, and both figure and ground create the letters.

FIGURE 7.11 Georges Seurat: *The Black Bow.* Conté crayon on laid paper, 12.5" × 9.8", 1882. The figure has distinct boundaries everywhere except at the bottom, where the figure and the ground are integrated. Private Collection/Giraudon/The Bridgeman Art Library.

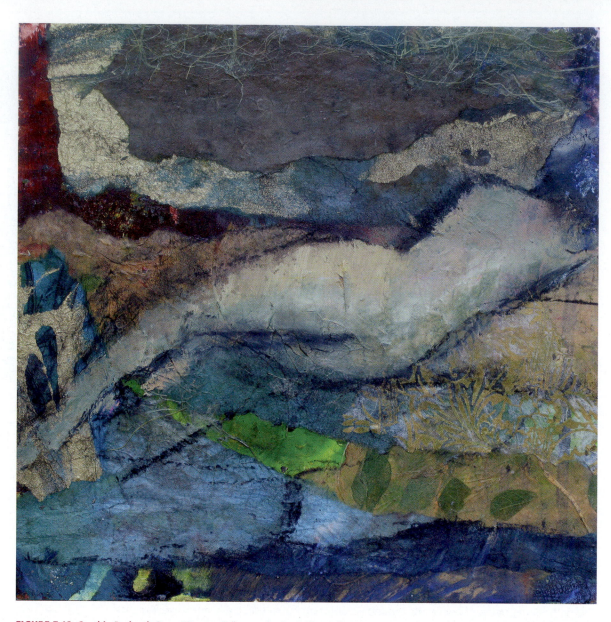

FIGURE 7.12 Cynthia Packard: *Dune Woman.* Collage and paint, 24" × 24", 2010. Figure and ground imitate each other in hue, value, intensity and even line and shape. Cynthia Packard.

In Figure 7.17, Wes Wilson's 1966 Concert poster—Bill Graham presents Jefferson Airplane, James Cotton Blues Band and Moby Grape, Fillmore West Auditorium—cuts through the figure to create borders around the striped ground, forming letters from the illusion of transparency. Readability was not the issue at the time, as it was assumed the reader would gaze at the poster long enough to figure out the message.

In Figure 7.18, the figure and ground distinction appears to be completely reversed. The white and black areas appear to be numbers, which would allow them to be the figure. However, their borders are not continuous because they are overlaid by the red. The red areas have the appearance of background because of their quirky, nonspecific shapes, but their continuous borders negate this. Also, the red wants to come forward and not behave like a proper background. It is very difficult, if not impossible, to make your eyes place the white and black areas on top of the red, forcing them to be background instead of figure.

CAMOUFLAGE EFFECTS

Camouflage effects can obscure locations of planes, forcing the viewer to confuse figure and ground. Camouflage is a situation where objects are actually visible and uncovered, yet are hidden from view because their colors match the background's colors. This is a very useful

FIGURE 7.13 Janos Korodi: *Carpet.* The entire composition is the figure. Oil on canvas, 55" × 55", 1999. Janos Korodi.

FIGURE 7.14 Marcie Cooperman: Philadephia 1969 was Not a Very Good Year. Watercolor, 26" × 40". Figure and ground are well integrated, erasing the distinction between them. Marcie Cooperman.

FIGURE 7.15 Andrea Pires: *Bon Soir Amiens.* Mixed media, 3" × 4", 2007. Carefully arranged positive and negative spaces both create the figure. Andrea Pires.

effect not only for soldiers and chameleons, but also for animals of prey as well as their victims, which you can see illustrated by the lizard in Figure 7.19.

Planes

Every composition gives us visual information about where its images are apparently located in space. In reality, of course, they are all flat images on a two-dimensional surface. But with our human gift for perception, we can see them as located somewhere in space in relation to each other. We call these locations **planes**. The planes we are discussing are vertical, lined up like a deck of cards of any number, parallel with the page, with the *front* plane closest to the viewer (also known as the *foreground* or *forward*) and the *back* plane farthest away, deeper in visual space.

THE PICTURE PLANE

The **picture plane** is the flat surface—the paper or canvas—of the 2-D composition. It is a vertical plane. The top, bottom, and side edges of the composition define the limits of the picture plane, and we say they are on the **picture plane level**. Shapes and lines in the composition can appear to be on the same level as the picture plane, or they can be on a plane in front of it or behind it. Together, all colors, lines, and shapes in the composition determine the planes on which they lie *relative to each other*. Figure is usually on a front plane, and ground is behind it.

All of the 3-D planes of reality that serve as our subject matter are transferred onto this flat surface, where *the illusion* of 3-D is preserved. Because 3-D objects take up many planes, their 2-D representation in a photo or painting also apparently takes up several planes, and the *front plane is on the picture plane level*. In Ross Connard's Mood Paint advertisement in Figure 7.20, the *front* of the hand and glass are on the picture plane level because they are attached to

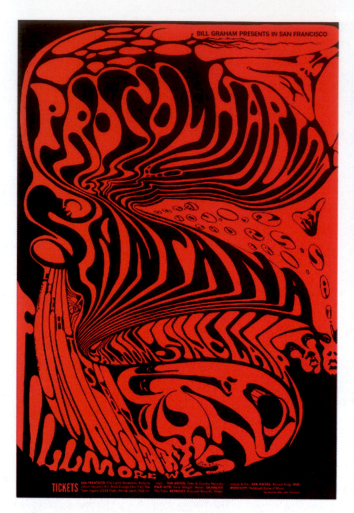

FIGURE 7.16 Lee Conklin: Concert poster for Procol Harem, Santana, Salloom Sinclair and Holly See, Fillmore West. Bg143, 14 1/8" × 21 1/4", October 31, 1968. Both figure and ground create the letters in this poster. Lee Conklin: LeeConklin@MLode.com.

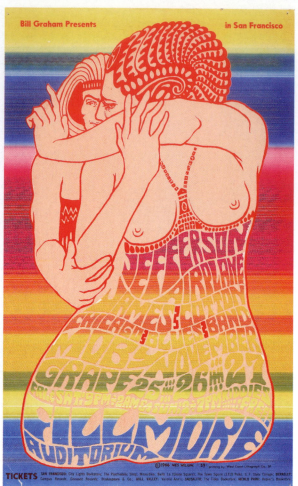

FIGURE 7.17 Wes Wilson: Concert poster——Bill Graham presents Jefferson Airplane, James Cotton Blues Band and Moby Grape, Fillmore West Auditorium. 13 7/16" × 22 1/4", November 25, 1966. The background becomes the foreground for the letters and numbers. Wes Wilson: livingwaterranch2@gmail.com.

FIGURE 7.18 Samuel Owen Gallery and Nat Connacher: *Typographic Cluster Orange.* Is the red, background or foreground? Pigment print on canvas, 30" × 30", 2009. Nat Connacher.

FIGURE 7.19 A lizard is camoflauged in this photo. Matt Jeppson/Shutterstock.

the top and bottom edges of the picture. The back of both the can and glass (which we don't see) are *behind* the picture plane.

The Picture Plane's Shape and Size Influence the Composition

A composition exists inside its edges, which we see at the same time as the painting itself. Since *the edges and the composition* are in the same visual space, *both* have to be considered together when making decisions of type of composition, and how to divide up the space. You've seen proof of this in working with photographs, in which you have a choice to frame your work as a portrait shape or a landscape shape. The tall portrait shape has qualities that benefit pictures of a person, while the wide landscape option works better for outdoor views.

To see for yourself what effect the picture plane has on a composition, form a frame with your hands and, with one eye closed, move it around the area in front of you. That eliminates your depth perception and allows you to focus on shapes and lines within a limited range. By framing these spaces you are making tiny compositions that suddenly relate to the shape of the picture plane newly formed by your hands. There are now two sides, plus a top and a bottom. By moving your hands around slightly you can change the balance of the elements in new locations. For example, that chair you are looking at can be in the bottom corner on the right, or maybe it would be better on the left side.

Framing the Composition Changes Its Message

In a landscape, would it be better to give the sky three-fourths of the height of the composition, or only one-fourth? That would depend on the creative message you want to illustrate. The focal point usually gets more space. Often a visual story about the sky is best expressed by giving it most of the compositional space; if the message is about the land, it often works better if most of the space is land. To put it simply, knowing the message allows you to make creative decisions.

How Elements Relate to the Picture Plane

Since everything we put in a picture is seen relative to the composition's edges, the relationship of all lines and shapes to the picture plane is integral to the composition. The worst choice would be to not make a choice because where the relationship is not clear, the message gets lost. This relationship can be one of many forms. For example, shapes can be vertically, horizontally, or diagonally *aligned with the edges*. In Gary K. Meyer's photograph (Figure 7.21), the horizontal dune lines echo the wide panorama shape of the picture plane, strengthening the message of expanse of sand.

The designer can make sure that the lines do not touch the edge, with the distance between them carefully thought out and large enough to make form and edge clearly separate elements. Or the lines can distinctly touch the edge. It's important to make the relationship between line and edge clear—either touching or not touching.

Shapes can be perpendicular to the edges, or instead they can hit the edges at a different angle. As an example, in Asif Syed Ahmed's Bangladesh photograph in Figure 7.22, the diagonal lines of the tracks, roof and looming train attach to the edges at the picture plane level and run deep into the background. Diagonal lines create dynamic energy, but attaching them to the picture plane holds the image in place, keeping the energy static. There is the danger in this image that the radial lines could lead the eye from the center of the left edge off any of the other three edges, but the curious, almost invisible person sneaking underneath the train provides movement as it pulls the eye back into the composition.

Wassily Kandinsky said that diagonal lines lie loosely on the picture surface. Diagonals have the most movement, and keeping them unattached to the picture plane keeps them moving. Vertical and horizontal lines are more firmly attached to the picture's surface, because they mirror the spatial direction of the edges. In Figure 7.23, the diagonals form an X and create lots of energy. Because the lines are not attached to the picture plane at its edges,

FIGURE 7.20 Ross Connard, student at Pratt Institute, Undergraduate Dept. of Communications Design: Mood Paint ad, 2010. This image illustrates several levels of planes. The front of the glass and hand are on the picture plane because they are attached to the edges of the picture. Ross Connard.

FIGURE 7.21 **Gary K. Meyer:** *Namibia, May 12, 2009.* Photograph, 2009. We get the message of a huge expanse of sand because most of the space is dedicated to it. Gary K. Meyer.

FIGURE 7.22 **Asif Syed Ahmed/bedueen:** *Airport Station, Dhaka, Bangladesh.* Photograph, 2011. The train, station and tracks attach to the picture plane on all sides, keeping them motionless. It takes a minute, but you eventually notice the person amazingly running under the train—the only movement occurring. Asif Syed Ahmed.

the figures are free to circle around in a clockwise direction. The parallel lines at the edges of the image add energy to help things moving around.

Influences on Location in Space

Looking at a composition, we automatically accept that it encompasses the spatial qualities of life we see around us, including locations of shapes and lines relative to each other. We assume that some are in front of the others and closer to us, some are right behind those, and some are much farther back. And at the same time, we understand that this is not really a 3-D view; it is still 2-D. No matter how we turn our heads and view it from other vantage points, everything is still in the exact same planes. But if it is not 3-D, why do we see shapes in front of other shapes?

Several phenomena work together to help us determine whether one shape is in front of another, and how deep the space is. Color is the most complex and powerful, so we will discuss that last. Overlapping shapes and continuous lines, chiaroscuro, and visual perception are three other forces.

OVERLAPPING

Overlapping is the most definitive way to establish which shape is on the front plane, presenting as it does incontrovertible evidence. The continuous lines of the shape on top show quite clearly that nothing interrupts it. It in turn interrupts the lines of the shapes behind it, and places them on planes further back, creating the sense of moving back in space.

In Figure 7.24, blue lines border the inside of a white square, which is apparent only because it has a gray border on two edges and it overlaps the red square. But if the blue border

FIGURE 7.23 The diagonals form an X, which creates energy that helps move the forms around in a clockwise direction.

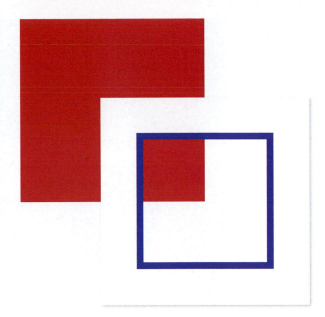

FIGURE 7.24 The white square with the blue inside border are uninterrupted, which makes them clearly on top of the red square.

weren't there, we would see two gray lines forming an angle, a red ninety-degree angle facing them, and a small red square.

Black usually lies behind other colors, but in Alyce Gottesman's *Rope Lines* in Figure 7.25, the continuous, unbroken aspect of the black rope lines places them on a plane in front of the higher-value ropes and ground. Two other factors are at play here in a secondary way, supporting the black ropes as being in front: We know that higher values stay back in the distance in landscapes, and the rope lines touch the edges, keeping them attached to the picture plane.

CHIAROSCURO

Chiaroscuro is da Vinci's system of shadows that renders a 3-D form on a 2-D surface such as your paper, as mentioned in Chapter 1. As the form curves away from the viewer, it gets darker, just like a real-life object sitting in front of you. The higher values differentiate the forward planes from those planes in shadow, which go back. Chiaroscuro demonstrates that it is the values that usually determine these planes, not the hues themselves. Jean-Honor Fragonard's *Furtive Kiss* in Figure 7.26 is an effective example of how chiaroscuro defines a white skirt's volume in space.

VISUAL PERCEPTION

Visual perception describes our assumptions about what we see, independently from the actual visual status. For example, as we learned in Chapter 5, we perceive the bottom of a composition to be the earth, which is closest to the viewer, and the top appears to be the sky, which is farthest away. Figure 7.27 demonstrates this in a photograph of the river landscape. Gary K. Meyer's photograph in Figure 7.28 could be a puzzle, but our abilities to perceive it correctly help us out. Although, in the picture, the old car is actually directly above the wagon wheels, we understand from our perception of life, and the car's size and location, that in reality, it is in the distance.

We also make assumptions about lines and shapes that intersect each other. For us, a line that is on either side of a shape continues behind the shape, as in Figure 7.29. We actually see two lines, but we assume that they are just one line interrupted by the shape. In Chapter 8, we will learn that this is because of the way our brain closes interrupted shapes and lines—a visual principle called *closure*.

FIGURE 7.25 Alyce Gottesman: *Rope Lines.* Ink, graphite on paper on wood, 24″ × 20″, 2007. In this image, the black lines are in front of the higher value lines. Alyce Gottesman.

FIGURE 7.26 Jean-Honor Fragonard: _Furtive Kiss._ Reproduction from illustrated Encyclopedia, Art Galleries of Europe, Partnership M. O. Wolf, St. Petersburg, Moscow, Russia. 1901. The range of values in the girl's skirts illustrates how chiaroscuro models volume. Oleg Golovnev/Shutterstock.

FIGURE 7.27 Marcie Cooperman: _Still Home._ Photograph, 2009. The bottom of the composition is closer to the viewer and the top is farther away. Marcie Cooperman.

COLOR

Color is the most powerful tool to use in setting up the visual space in a composition. Depending on the designer's choices, the picture surface can range from quite shallow to almost limitless depth, and the locations of the design elements' planes can vary tremendously: Some can hover right next to each other, while other planes appear to be very far apart.

Why would you want to control distances between planes? Because your composition's colors help determine what your viewer sees, and they send your theme or message to your viewer. This is a crucial goal whether you have designed an ad, with commercial objectives, or a painting. Shapes that are close to each other can bring visual tension or excitement to a composition, giving you the ability to create themes such as speed, diversity, activity, youthfulness, and strife. Conversely, greater distances can send a message of aloneness, depth, peacefulness, childhood, or pleasure, or they can isolate and highlight the text or image that delivers your message directly.

Each hue has particular qualities that determine its behavior in a composition. Some colors advance, some are neutral, and some recede. A color that *advances* pushes forward, and shortens the depth of the space between it and any element placed in front of it through overlapping or chiaroscuro. A color that *recedes*, placed in the same location, allows much more space between itself and another element. The art critic and curator Will Grohmann

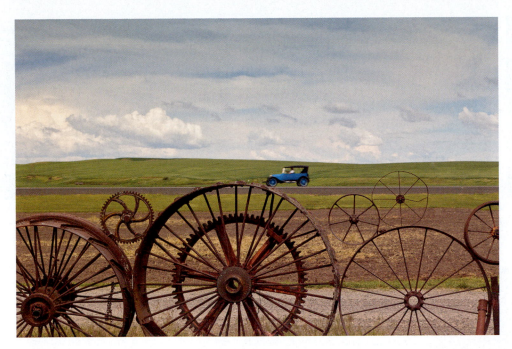

FIGURE 7.28 Gary K. Meyer: *Palouse, Washington, June 13, 2009.* Is this a small toy car or a real one in the distance? Photograph. Gary K. Meyer.

said, "Spatially, the actual picture surface can be moved forward and backward like an accordion, chiefly by means of color."[4]

Since colors are seen simultaneously in a composition, their relationships with each other have an effect on where planes are located. So, for example, even though a color like red wants to advance, this can be mitigated somewhat by the other colors in the composition. If the other colors are complements, there is no competition for the red's pugnacious behavior. But if the other colors are also reds or other high-intensity colors, things get more complicated and their color qualities influence which one ends up in front.

Value and intensity are fundamental influences on the *strength* of hue behavior, although not necessarily on the actual tendency for its movement. Blue, for example, tends to recede, and most blues routinely do that. An intense blue, however, would advance ahead of its neighbors if they were less intense. But, paired with red, chances are the blue would defer to the red's movement, and appear to be on a plane farther back. Indeed, Howard Ganz's *Quantum Patchwork* in Figure 7.30 shows how the red elements of the ground push through the overlapping intense blue elements and appear to be in front of them, because of red's tendency to come forward.

The Power of Color

Color can actually contradict the information that is conveyed by overlapping. For example, look at Catherine Kinkade's *Changewater* in Figure 7.31. We perceive the trees as figure because they overlap the water with continuous lines. But the choice of the red for the water does not allow it to exist happily in the background. Its red quality wants to advance, and it indeed pushes forward against the trees and blue water lines. This creates dynamic tension, making the background alive, as if it were on fire. Even the blue water lines, high value and intense as they are, do not come forward as much as the red.

Incongruity between the colors and the lines or shapes could create confusion in this painting if the goal were not a message of tension. For example, if the theme were to be one of peace, the colors would fight the message. In that case, the composition would feel more integrated if colors that advance were used for the figure in front, and colors that recede were used for the ground.

FIGURE 7.29 There are two light gray lines on either side of the rectangle in this composition, but they appear to be one line that continues behind the rectangle. Marcie Cooperman.

FIGURE 7.30 Howard Ganz: *Quantum Patchwork.* Digital painting, 2006. The red elements push through the overlapping blue elements and appear to be in front of them. Howard Ganz.

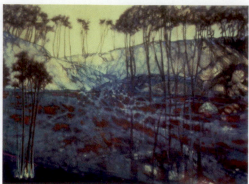

FIGURE 7.31 Catherine Kinkade: *Changewater.* The red of the water advances in front of the blue elements. Triptych, oil on canvas, 18′ × 4.5′, collection A T & T. Each panel 4.5′ x 6′. Catherine Kinkade.

FIGURE 7.32 Original Contemporary Painting with White Square Abstract Background. artellia/Shutterstock.

FIGURE 7.33 Sasha Nelson: *The Hike.* Photograph, 2009. The lines of the road lead into the distance, and the colors support this movement with high values and lower intensities. Sasha Nelson.

Color Behaviors

Color behaviors are as follows:

▲ Reds, and colors that include red, advance.

▲ High values and high intensities advance.

▲ Blues, and colors that include blue, recede.

▲ Low values and low intensities recede.

In Figure 7.32, the artist uses color to locate the shapes in space. The white square appears to be the figure, but it is barely in front of the other red shapes because it is bordered by a gradient red. After the white square, the high-intensity red is the most forward area, followed by the yellow and yellow-reds. The black area in the center top supports this arrangement by appearing to be infinite distance. The gray is on a plane near the front, but it does not compete with the chromatic hues, and lies comfortably behind them.

Colors and Distance

In real life, objects in the distance, like mountains, are bluer and higher in value than if they were close by. This is because particles of water vapor, dust, and gases in the atmosphere filter out red and yellow light rays, and scatter the blue rays everywhere. The atmosphere also renders the low sky at the horizon higher in value than the sky high above us. We can use that color information in a composition to illustrate distance. Although the viewer might not know the mechanics of it, the message is understood. Sasha Nelson's photograph in Figure 7.33, *The Hike*, shows how high values and low intensities indicate distance at the end of the road.

The reverse is true when expressing depth inside a tunnel or other shadowed area. The deepest part would be lower in value as well as in intensity. And indeed, very low-value areas in any composition read as shadows or a hole, as in Pamela Farrell's *Dam Wall 7* in Figure 7.34.

In Samantha Keely Smith's *The Shelter of Tangled Wings* in Figure 7.35, the reds do what they are supposed to do and come forward, the blues recede, and the yellows glow cloudlike somewhere in between.

FIGURE 7.34 Pamela Farrell: *Dam Wall 7.* Digital photo, 9″ × 12″, 2009. The black area has infinite depth. Pamela Farrell.

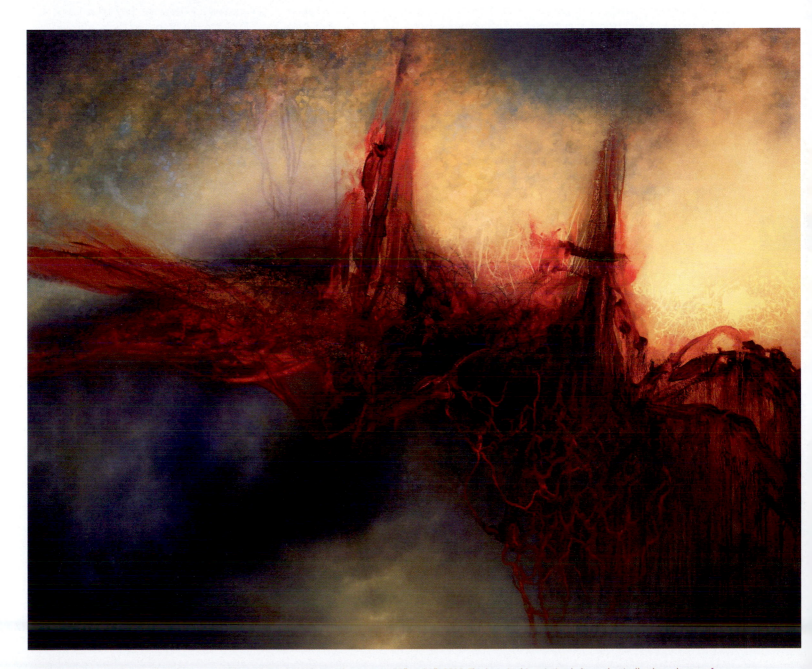

FIGURE 7.35 Samantha Keely Smith: *The Shelter of Tangled Wings.* Oil on canvas, 52″ × 64″, 2010. The hues in this painting behave classically: the reds come forward, the blues recede, and the yellows glow like the clouds in an undisclosed location. The atmospheric blue is strong enough to support the normally heavy red, which gains lightness through its web-like structure and low intensity and value. Samantha Keely Smith.

summary

In this chapter, we learned the power of color and how it can determine where shapes are located in the implied three-dimensional space of a composition. Changing the colors in a composition can provide unending variations in our perceptions of the visual space.

Chosen properly, the colors can be manipulated by the designer to achieve any design goal. They can use space and dimension to transmit any type of theme or message to the viewer, ranging from tiny aloneness to enormous depth.

quick ways . . .

Assess your composition by focusing on each factor one at a time. Your colors and planes may be helping you express your theme, or they may be preventing your audience from getting the message. You must find out! First, ask yourself this question: What do you want to express? Then begin by looking at these factors:

1. What hues are there, and how do these hues behave *in general*? For example, we know that red advances and blue recedes. Are yours behaving that way relative to other hues in your composition? Why or why not? Remembering that value and intensity influence hue behavior, evaluate those one at a time:

 a. What are the values in your composition and how are they influencing hue behaviors? The Law of Simultaneous Contrast says that each value makes adjacent values appear to be as different as possible. Although the many different values in a composition make things more complicated, some have more influence than others. Which are the dominant values in your composition, and what are their effects?

 b. What are the intensities and how are they influencing hue behaviors? Evaluate the intensities the same way as the values.

2. What is the placement of your colors? Do several values produce chiaroscuro in any places? How does this affect the planes?

3. How are your lines influencing color location? Do the lines show that some shapes overlap others? Are the colors working in unity with those overlap situations or are they fighting it? Which message are you interested in communicating—compliance or resistance?

4. Where is the picture plane? How do the lines relate to it? How close are the planes in your composition?

5. How is the continuity influencing the planes and color behavior?

6. What is your relationship of figure and ground? Are they visually separate, or are they integrated in some way?

exercises

Parameters for Exercises

There are many factors of color and color relationships in compositions, and all of them can affect the way the colors appear to the viewer. The best way for students to learn through their color exercises is to have simple objectives and fairly strict rules about the type of lines and colors to be used. We call those rules "parameters." With strong parameters allowing only a minimum of elements, it is easier to observe the direct relationships between colors, and to see the differences between the students' compositions. When lots of compositions hang together for a critique, it becomes clear which ones are successful in achieving the goals.

As students learn the objectives and build on their skills, they will become more adept at using color. They will gain the ability to tolerate more complications because they understand the ensuing interactions. Therefore, as we move through the chapters, the restrictions on composition size and the number of lines and colors will be gradually reduced. Larger compositions, more colors, and more types of lines will be allowed. However, certain ground rules will remain the same: Flat color and nonrepresentational shapes will remain constant parameters, and the goal of every assignment will be a balanced composition. Five specific parameters include:

1. No recognizable objects are allowed.
2. All colors are to be flat and nongradient, with hard edges that don't fade away.
3. White is always considered a color, even if it is the background.
4. Only neatly cut and pasted papers are appropriate.
5. Balance and unity are *always* the singular goal of every composition.

These exercises can serve as an inspiration for further research into colors and planes.

1. *Critique an existing painting:* Bring a photo of a painting to class. In the critique, state which part of the painting is the figure and which part is the ground. Explain how the shape of the figure is related to the edges and the dimensions of the picture plane. Explain how the ground relates to the figure, and describe the continuity in the composition.

2. *Create your own compositions, and critique the figure–ground relationship:* Create two compositions with the exact same *representational figure* and ground. Each composition should have the figure placed in a different location. Even with the same ground, the difference in location will alter the figure–ground relationship because of the color and compositional qualities of the figure (color, shape, etc.). Bring both to the class critique. Discuss each in terms of the figure's location, how the figure relates to the picture plane, and how the ground relates to the figure.

3. *Integrate with the picture plane:* Create two versions of one composition, each using different colors, in which at least two different shapes touch an edge. For the class critique, analyze them both to determine the plane levels on which your color areas live, and see which ones are on the picture plane level. The shapes that touch the edge should be on the picture plane level; are there colors that create energy that contradicts that information?

4. *Show how color determines plane locations:* Make a composition using the following hues, with your choice of intensity and value: yellow, orange, red, violet, blue, and green. Your goal is to place the hues in this composition in spatial order so that the closest one is at the bottom and the farthest away is at the top. Bring them to the class critique and explain on what plane each color lives and how close the planes are to each other.

5. *Make red recede:* Red is useful for its tendency to advance in a composition. Your goal in this exercise is to make red recede purely due to its qualities in relation to the other colors. Use flat color alone, with no overlapping or chiaroscuro. For reasons of simplicity, keep the number of colors to a maximum of four.

6. *Demonstrate visual depth:* Make two compositions, each with a different visual depth. The first one should seem to have infinite depth, starting at the picture plane level in the front, and going back to infinity. The second one should appear to have a depth of only a few inches between the front most color element and the one farthest away.

More Composition: Gestalt Theory and Dominance

The Gestalt Theory of the Principles of Perception

❝ *The fundamental formula of Gestalt theory might be expressed in this way. There are wholes, the behaviour of which is not determined by that of their individual elements, but where the part-processes are themselves determined by the intrinsic nature of the whole. It is the hope of Gestalt theory to determine the nature of such wholes.*❞[1]

—*Max Wertheimer,*
cofounder of the Gestalt principles of visual perception

Compositions are complex entities composed of many elements that affect the interactions of the colors. So far, we have focused on the influential elements of composition to learn how they operate, such as color relationships; laws of balance; energy expressed by shapes, lines, and colors; planes; continuity; and figure and ground.

Because every composition is unique, and some of the many color interactions that occur contradict each other, compositions can be very confusing. If the brain didn't have a way of organizing everything, it could appear to be a very complicated and incomprehensible mess. But we do subconsciously establish some rules of organization that simplify the unruly nature of visual compositions. These rules are called the Gestalt theory of the principles of visual perception, as identified by psychologist Max Wertheimer (1880–1943), who theorized about our tendency to see things as a whole rather than as the sum of its individual parts. He used music as an example, asking what it was that made us remember a tune and react with a certain emotion to it. The whole song is different from its individual parts; what makes the song is not just the individual notes, not only the spaces in between the notes, but something greater than those admittedly integral things.

In the same way, you can see how a visual composition is more than an assemblage of lines, shapes, and colors. You could not remove one line and say that it represents the whole composition. We organize these elements into a greater whole because they all interact with each other, and change each other, to produce that larger reality.

The Gestalt theory is a combination of two things:

1. How the composition itself is organized
2. How our brains perceive and organize what we see

The word **Gestalt** means "whole form," referring to the fact that we identify pieces of information that are meaningful, and we group them together, arranging all of them into a whole form that we can understand. This grouping process is a way to help us figure out what is most important and what we should look at. Our method is to notice patterns among elements in the image that seem to belong together. We group together things that are similar, things that make sense together, and things that are near each other. So integral to our comprehension is this tendency that it can upend perfectly balanced designs that were created without taking it into account. We may get an entirely different message that was not intended because of the way we group the elements together.

Our human method of organization allows us to receive the composition's artistic message, but more than that, it is the backbone of perception for us. Because we notice similarities, we can understand the repetitive structure of a musical composition or a ballet, we feel rhythm and we can rhyme, and we can put together a jigsaw puzzle. We can understand mathematical equations, conduct and analyze research, and group similar people into market segments. Grouping similar things together is part of our social experience as well. We use clichés like "The whole is greater than the sum of its parts," and we worry about "missing the forest for the trees."

In a composition, the lines, shapes, and colors are the pieces of information that we organize as we search out relationships of similarity and proximity between the parts. We use our understanding of this visual information to help us move through the composition efficiently and make sense out of what we see.

One further note about the Gestalt theory: It is not possible to denote a hierarchical order, in which one takes precedence over another. There is no way to predict how a complex composition will work in terms of how the eye will group every element into wholes. It always depends on the "whole" of the composition.

There are six principles of perception relative to design: order, similarity, proximity, figure and ground, good continuation, and closure. Often these principles work together, as you will see in the following examples.

As an example, how do we know that the tree in Figure 8.1 is not growing upside-down? Our understanding of how trees grow allows us to comprehend that there must actually be two trees at different angles. Because we see the ripples in the water, we can come to the conclusion that the tree must be a reflection of one on the opposite shore.

ORDER

The principle of **order**—also called **pragnanz** or "good form"—says that we recognize the best way to organize individual lines and shapes together into *one good shape*. Often lines can assume various forms together, but the simplest pattern is the one we see

key terms

closure (grouping by)
dominance
figure and ground (grouping by)
Gestalt
good continuation (grouping by)
order (pragnanz; grouping by)
proximity (grouping by)
similarity (grouping by)
subdominant (opposing)
subordinate
vector

FIGURE 8.1 Marcie Cooperman: *Reflections of Providence 2. Why is this tree upside-down?* Photograph, 2012. Marcie Cooperman.

at first glance—regular, orderly, and if possible, symmetrical. The following three illustrations show how our perception varies depending on the lines.

Looking at Figure 8.2, we see two overlapping squares. This is the easiest organization of shapes. Although we can try hard to see it as two right angle shapes and a square, it is not as easy for the eye.

Adding lines can totally change the shape. Figure 8.3 adds just three lines connecting the corners, but now we can no longer see the original image; it has disappeared into the new composite shape. It is now a three-dimensional cube, with the back face angling toward the right side. We have to work hard to see it the two other possible ways it can be perceived. One is a cube balanced on its bottom edge, bottom left in the back, top right in the front. Stare at it and it will come into view, before it slips back to the original shape. The second is a flat 2-D shape. That last one is the hardest one to see; it keeps slipping away even as you get ahold of it.

Figure 8.4 has the addition of two lines forming triangles on the top left and bottom right corners. The image has become flat and the 3-D image has disappeared.

Color also changes how we view the image, as you can see in Figure 8.5 to Figure 8.8. Figures 8.5 and 8.6 show how the center square, in a value equal to or lower than the red or green, gives the impression of transparent hues overlapping. It works even if the resulting hue (the purple square) would never be the result of the combined hues. But, as we see in Figure 8.7 and Figure 8.8, no matter what the hue, if the value is higher than the red or green, it no longer appears to be two overlapping squares. We see two right angles, and a separate middle square.

The cubes show how color changes our perception of the whole image. In Figure 8.9, with the lower value on the bottom, the image of a cube that is angling bottom left to top

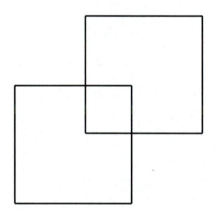

FIGURE 8.2 This is two overlapping squares.

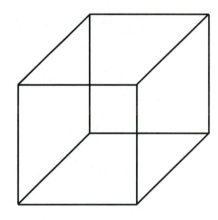

FIGURE 8.3 This is a 3-D cube.

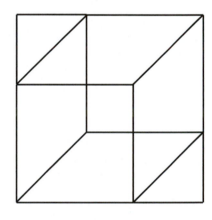

FIGURE 8.4 This is now a flat image.

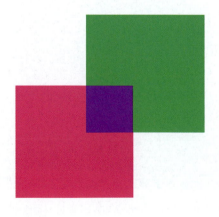

FIGURE 8.5

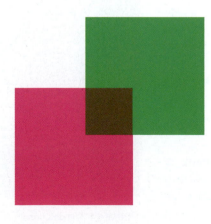

FIGURE 8.6

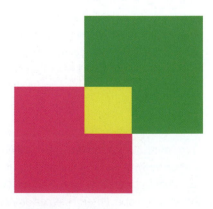

FIGURE 8.7

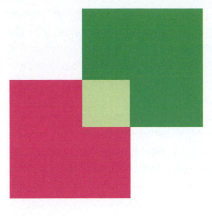

FIGURE 8.8

FIGURE 8.9

FIGURE 8.10

FIGURE 8.11

FIGURE 8.12

right becomes apparent. In Figure 8.10, coloring the middle square and adjacent triangles flattens the image. In Figure 8.11, the combination of values emphasizes the corners, which appear to be flaps folded over.

The Olympic logo presents a good example of the order principle. The similarity in the shape of the circles and the way they are evenly lined up allows us to see it as a chain. In fact, because of the repetition of circles, it's almost difficult to perceive the logo as five separate differently colored circles with broken edges, which is what they indeed are.

Our predilection for order is strong enough to enable us to see when words are not lined up correctly, and we have to quell an urge to fix it. Does the image in Figure 8.12 bother you?

SIMILARITY

The Gestalt theory's principle of **similarity** holds that we group together similar elements because we perceive them as related to each other. Elements can be alike in color, shape, or size and sometimes in all of those qualities. Amazingly, even if the elements are completely different except for just one quality, we still group the shapes into a family. The eye ignores differences in its attempt to connect things. For example, in Joan Miro's *The Escape Ladder* in Figure 8.13, all of the red elements are different shapes and sizes, but the eye relates them to each other because they share the red hue.

Our tendency to group similarities is so strong that location of the elements can be irrelevant. Even if several shapes of one color are dispersed around the entire canvas, we

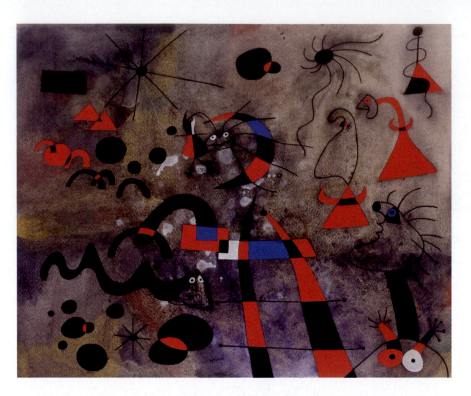

FIGURE 8.13 Joan Miro: *The Escape Ladder.* Gouache, watercolor and brush and ink on paper, 15 3/4" × 18 3/4", 1940. Digital Image © The Museum of Modern Art / Licensed by SCALA / Art Resource, NY.

perceive them as connected with each other, and we move from one to another through the whole composition. The red shapes in *The Escape Ladder* are a good example of the principle of similarity creating continuity around the whole image.

Here's another interesting example of how similarity organizes our perception of images. In Figure 8.14a, proximity makes us group the green dots into columns because they are closer together vertically than horizontally. But in Figure 8.14b, using the same spacing, the dots in the center row are red and it changes how we group them: we now see them in rows.

Figure 8.14c shows all green elements, but the middle row has become squares rather than dots. Once again we perceive it as rows. This shows that similarity in shape alone is enough to make us group the middle row of squares together, and separate it from the dot rows.

In Krista Svalbonas' *Transparency 2* in Figure 8.15, the squares are perceived as massed together in a block that balances the rectangle.

In Pamela Farrell's *ATF—Unsilent* in Figure 8.16, we mass the colors into three separate groups: black lines on top, green shapes beneath, and white ground. The eye connects all the green into a unit with a message of stable but disconnected energy. The sharp black curvilinear lines block the green, meandering around and through each other, spiked by barbs, providing dynamic energy throughout the composition.

When a composition includes variations of a hue, the eye accepts them as similar. For example, Janos Korodi's *Space* in Figure 8.17 includes blue–greens and yellow–greens, but the eye registers them all as the same hue: *green*. In fact, you may not even have noticed the hue differences.

Grouping hues together in Janos Korodi's *Sunset* in Figure 8.18 helps us understand this complex composition. It seems to have activity on several levels of existence, possibly as reflections. We understand that this is true by observing the colors, and grouping into three levels the oranges, the higher value shadows, and the lower value "reality." The orange rectangles seem to be reflections; the shadowy lines could be reflections of shadows on another level; and the "real" location appears to be the low-intensity green, gray, and blue sections and dark ceiling.

Repetition of Similar Elements

We are all busy. We see, hear, and read many things all day, whether it's online, in the media, or spoken by other people. With so much to pay attention to, we need a way to distinguish what is really important from the noise and clutter of ads imposed upon us. That's where our Gestalt principles come into play. We notice elements that are repeated, as well as the larger shapes and stronger colors, and we forget the details. Marketers know this, and cleverly use repetition in selling us goods and services.

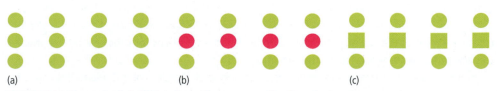

(a) (b) (c)

FIGURE 8.14 Elements of similarity change how we perceive these images. Marcie Cooperman.

They know that repetition is effective in achieving these goals:

- Conveying emphasis or importance
- Helping the viewer remember the image
- Communicating a message

Conveying Emphasis Did you ever walk into an electronics store and feel wowed by seeing an image repeated on a dozen large-screen TVs? Apart from the noise level, being confronted by so many screens with the same image is exciting, and it makes the visual experience stay in the memory longer. The repetition impresses upon us the *importance* of the video. In fact, it takes a strong character to walk out without feeling remorse for not buying a TV.

Repetition of a product in a store window or interior display emphasizes its significance as a specialty of the store. Viewers get the message that this is a very popular product, in demand among those in the know, and here is the best place to buy it. It's a case of repetition masquerading as social approval, a force strong enough to influence sales.

We get the point right away in Figure 8.19 with the repetition of blue shirts in the window display of this store.

Not incidentally, repetition goes a long way in conveying the feeling of the store's *brand image*. Whatever is repeated contributes to our impression of the brand and what it has to offer. For example, a display of cashmere sweaters in many colors shows that it represents a wide color choice. On the other hand, a display of many sweaters in the same color emphasizes textures, or possibly the fact that sweaters are trendy and the store offers many style choices.

Helping the Viewer Remember the Image How many times do you think you need to see a commercial on TV before you remember the brand? Advertising companies generally agree that the magic number is 3, although up to 10 has been suggested. Merely by their repeating it enough, you get used to hearing the brand name, and the sly fact is that your appreciation for the brand is enhanced that way. Even if you don't pay particular attention to the commercial, when you happen to need that product, you will remember the brand name.

Just as showing a commercial 3 or more times aids the memory and sells the product, in a visual composition repeating an element offers the viewer a chance to focus on that element and remember it. Since we are busy looking at the whole picture, we don't usually remember a specific part, such as a color or shape, unless something is done to help us see it.

Communicating a Message A successful composition uses its elements to direct us toward the shapes that contain the artistic message and tell the story. Repetition can help further this goal by making several things happen: creating shapes and patterns, emphasizing contrasts, and moving the eye in the right direction.

Strategies for Using Repetition

You can use several strategies in your design that take advantage of our propensity to group repeated or similar elements. They include using symmetry and gradient order, creating patterns through repetition, creating another shape using the repeated units, and contrasting dissimilar elements.

Using Symmetry Symmetry uses repetition of an element to create an orderly and predictable balance across an axis, making a larger design out of the separate units. We notice the larger design because we overlook the constituent pieces. For example, the Mitsubishi logo in Figure 8.20 uses three diamonds to form its arresting design.

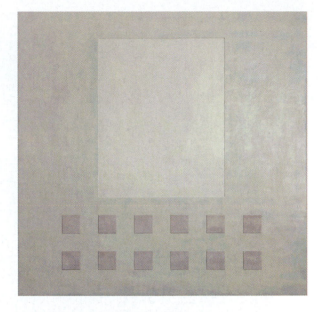

FIGURE 8.15 Krista Svalbona: *Transparency 2.* Krista Svalbona.

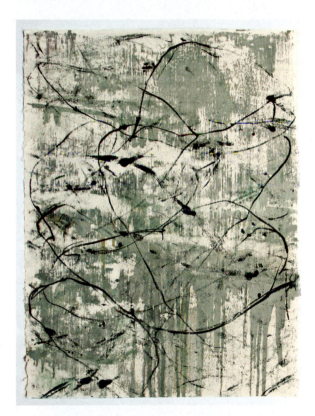

FIGURE 8.16 Pamela Farrell: *ATF—Unsilent.* Oil on mulberry paper, 20" × 30", 2010. We mass the three different hues into separate groups: white ground, black lines and green shapes. Pamela Farrell.

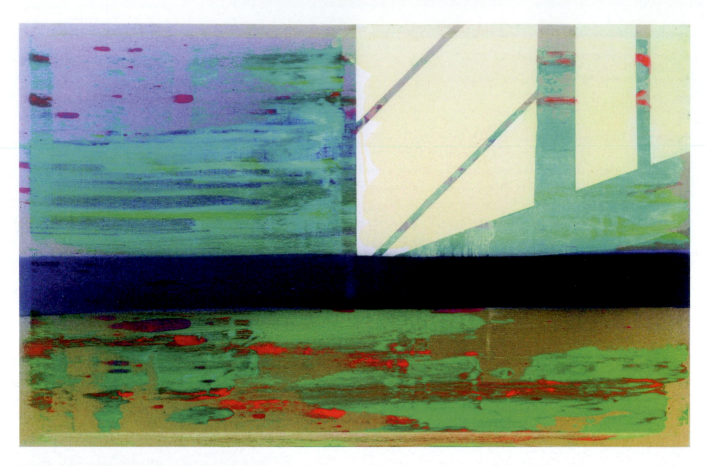

FIGURE 8.17 Janos Korodi: *Space*. Acrylic and oil on linen, 19.6″ × 31.5″, 2003. We group variations of a hue together, like the different greens in *Space*. Janos Korodi.

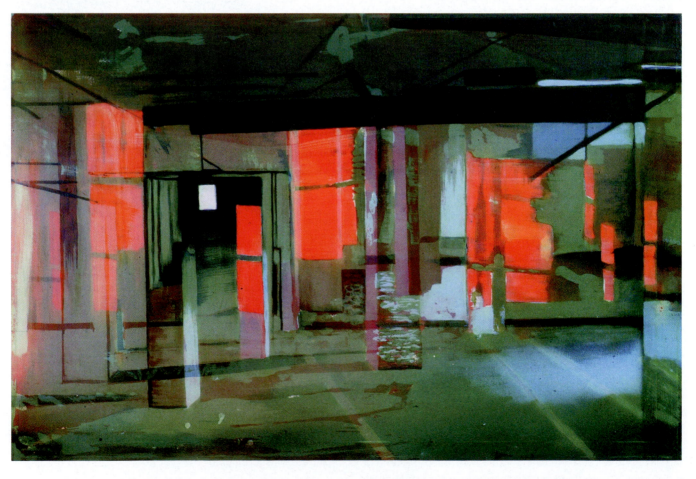

FIGURE 8.18 Janos Korodi: *Sunset*. Does color help you understand what is going on in this painting? Egg tempera and oil on canvas, 41.3″ × 63″, 2003. Janos Korodi.

FIGURE 8.19 Window display. Repetition allows us to comprehend that this store is emphasizing blue shirts. © Julija Sapic/Fotolia.

FIGURE 8.20 Mitsubishi logo. In this brand mark, we overlook the separate elements of diamonds, and see the entire design. Mitsubishi Motors North America, Inc..

Using Gradient Order Gradient changes in a composition can tell an artistic story if the other elements are held constant and repeated. We group the constant elements together as a background and notice only the one with the variations.

For example, in Shiri Cohen's Karasikov *Spectral Jars* in Figure 8.21, all of the jars are the same size, and they are lined up on shelves of the same height and length. On each shelf, the intensity and value is held constant and only the hues vary. They are placed in spectral hue order, with increasing intensity going toward the bottom shelf. With the other compositional elements held constant, the logical, natural, and appealing order of the hue changes can be appreciated, and we plainly see that the message is a story of color.

Placing hues in spectral order using repetitive shapes is so easy and instinctive a combination of elements that we see it time and again, in many types of commercial color usage. And yet it never fails to attract its intended audience and win approval. Why? Maybe it's in our chemical makeup to understand the rainbow so innately; maybe it's because we appreciate repetition; or maybe it's because it's just beautiful. We always think that it's fresh and new.

Creating Patterns Through Repetition When you put together a series of elements that have differences in their size, shape, or color, you create a sequence. A repetition of this sequence creates a pattern. When we see the sequence repeated several times, we anticipate that the remainder of the pattern will be the same. This is because the design rules have been laid down in that sequence, and we have *learned* from it what is supposed to come next. Because we have figured this out, we accept the premise that the individual elements are of secondary importance and we can relate to the pattern as a whole. But all of it is possible because of our Gestalt tendency to combine individual elements into the whole.

We are so accustomed to this process of combining different types of elements into a sequence that creates a pattern that we have names for familiar patterns, like checkerboards, stripes, herringbone, and plaid. Distinctive animal skin patterns like cougar and leopard (Figure 8.22) are more than the whorls and spots that make them up, and zebra stripes go beyond the individual bars of color (Figure 8.23).

The Gestalt theory of principles is like triage for the brain—a system where we choose what to pay attention to. If we paid attention to every element in an image, we would never realize the artistic reason for the combination and we would never see the pattern. For example, in Figure 8.24, we can discern the pattern that results from the similar alternating black and white shapes because we ignore the separate elements. (Note that there are not even two shapes exactly the same.) Even more importantly, we can visually

FIGURE 8.21 Shiri Cohen Karasikov: *Spectral Jars.* Values get lower toward the bottom shelves. Photograph, 2010. Shiri Cohen Karasikov.

FIGURE 8.22 Gary K. Meyer: *Kenya, 2010.* A leopard shows off its gorgeous skin. We are so familiar with this pattern that we don't see its individual elements. Gary K. Meyer.

FIGURE 8.23 Gary K. Meyer: *Kenya, 2010.* A zebra stands out in the veldt. Even little children are taught to understand a zebra pattern. Gary K. Meyer.

comprehend the complexity and implied 3-dimensionality because we understand perspective and shadows.

Repeating a sequence of elements creates a more complex configuration than repeating one element. All the elements we have learned so far about color interactions, location on a plane, balance, and the continuity and grouping due to the Gestalt principles are set in a delicate balance. The aggregation of elements and forces creates a living, breathing, dynamic structure that can transform if one element is changed. Even keeping the same colors in a composition, but altering their locations, can make the colors look completely different, throw off the balance, change the depth of the planes, or even flatten an image. Changing locations of colors causes us to group together new shapes that have similar characteristics and are near each other.

In Figure 8.25, the green areas act as spaces between the reds. We see the reds as grouped together in units of three overlapping rectangles, and the green is the ground behind them. But relocating the colors changes how we group them. In Figure 8.26, the entire image has been flattened and we no longer perceive the reds as grouped together. This complex rhythm of sequences and repetition is how patterns are formed.

Creating Another Shape Using Repeated Elements

Have you ever gazed at the clouds, combining them into recognizable shapes? That's your Gestalt theory of repetition at work, pulling together all cloudlike forms, and grouping them into decidedly noncloudlike forms, helping you grasp what's up there in the sky. No, you probably don't think there are elephants up there, and it is a silly game. But we do recognize shapes formed by groups of elements, once again choosing the composite view over the individual.

Sometimes when a composition is viewed from a certain distance, the individual shapes dissolve into a different whole image. Impressionistic painters were masters at recording their impression of the big picture when they painted a landscape, defining it using tiny irregular, seemingly unrelated brushstrokes. Up close, they seemed to be haphazard squiggles of color, but from the right distance, they congealed into perfectly formed boats, bridges, and landscapes.

A fascinating example of our grouping mechanism at work is illustrated in Figure 8.27, a dot mechanical printing process. Up close, we see a very imprecise image made of several colors of dots. But farther away, a perfectly realistic photographic portrait is astoundingly apparent.

Contrasting Dissimilar Elements These principles are the designer's accomplice; as we group repetitive shapes when we look at an image, we exclude the things that are different from the group, yet we notice them because they stand out. The group could be shapes in a painting or poster, images on a web page or an advertisement, a grouping of furniture in a room, or a special detail on a garment. The deviation can carry a message contrary to the repetitive elements, describing such emotional benefits as excitement amid monotony, beauty amid ugliness, disorder in the middle of a field of order, or strength in the middle of weakness.

In music, repetition is the basis for songs and compositions and can be used to construct rhythm (harmony) and create syncopation (deviations from harmony). Whole genres of music,

such as the blues, are based on repetition of chords in predictable order, but the improvisations (the deviations) represent the genius of the player.

In the postcard for Joe in Figure 8.28, the repetition of circles of brown coffee and white coffee cups inside the low-value rounded squares allow us to notice the differences: the Joe logo, and the noncircular, lined-up coffee measurers. The white ground ties it all together.

In the texturally complex but monochromatic *Green Shutters, Sienna, Italy* photograph by Joel Schilling in Figure 8.29, the deviation is the bright green shutters. Their dissimilarity of hue and intensity contrasts against the complementary red tiles and bricks.

If we group similar elements together, then by definition, we specifically *do not* group dissimilar elements together. A composition full of elements that are deviations from each other allows each element to stand on its own. For example, in Figure 8.30, there is nothing we can do to perceive the four areas as united because the hues are completely different.

PROXIMITY

The Gestalt theory of the principle of **proximity** refers to a fundamental reason that we perceive elements in a composition to be part of a group: they are near each other. Grouping nearby elements is also known as *massing* elements. We mass them because we assume there is a greater meaning associated with the group than with each individual element; together they might form a pattern or design, or they may tell a story.

Proximity can sometimes take precedence over similarity. In Figure 8.31a, the violet circles form two sets of columns because they are near each other. In Figure 8.31b, even though two of the columns are red, they are still grouped together with the violet columns to form the two sets. We don't group the red columns together because they are not close enough, and they look like they are part of the violet grouping.

Proximity is what makes a collage so successful a medium in telling a story, as it is by definition a collection of items that create a theme. For example, in the collage in Figure 8.32, the proximity of the red text and the images of soldiers, bombs and blood communicate a story of trouble and destruction.

Refer back to Chapter 6 to look again at Gary K. Meyer's photograph in Figure 6.43 of a group of expressive dead trees. The proximity of these trees gives them an identity as a group, and makes them play off each other in dancelike movements, their upward branches mimicking human arms. Relative to each other, we can say that they all reach out in different directions. Seen separately, the movement of each tree would be limited.

FIGURE 8.24 *Optical art.* Even with all shapes slightly different here, we can comprehend the checkerboard pattern. Fotolia © imagewell10/Fotolia.

FIGURE 8.25 We perceive the green as spaces between the red groups. Marcie Cooperman.

FIGURE 8.26 This image looks flatter than Figure 8.25. Marcie Cooperman.

FIGURE 8.27 This image uses dot mechanical printing process.
Terry Chan/Shutterstock.

Impact of Proximity

Proximity can impact perception in several ways:

- **Simultaneous contrast:** Simultaneous contrast is stronger between adjacent objects than between objects farther apart from each other. Simultaneous contrast is especially strong between an object and any outline it might have, because the outline interrupts the contrast between the object and the background. We will discuss outlines in detail in Chapter 9.

- **Relative importance:** The way that elements are grouped gives us information about their relative importance. Those massed together are equal in importance. The eye moves among them as equal members of a family. But elements separated from them are placed in a different category.

For example, in Figure 8.33a, all the squares are presumed to be equal. In Figure 8.33b, the top two are equal and the bottom two are equal. The top two have greater visual weight because they are higher, and therefore they may be slightly more important. In Figure 8.33c, because one square is separated and below the other three, it is seen as on a different level of importance. Its isolation gives it greater visual weight, therefore more prominence. Now look at the way the red square in Figure 8.33d stands out as the prominent square because of its separate location and contrasting hue. That's an effective way to use proximity and hue together to let the viewer know something is important.

How would this be useful in terms of design? Think about products we use every day—a video game controller, electronic products, power tools, and kitchen appliances such as the dishwasher, blender, and microwave. How do we know which switch to use to turn them on or make them louder or stronger? We get information about usage from the positions of the control switches. They must be arranged in a logical way that communicates to us the function and relative importance of each one. We assume that we will find the most important button, the one that turns it on and off, in a most conspicuous place apart from the others. A strong contrast in color helps us notice it. Other important buttons, such as those for speed, are grouped together, and those of less importance are less prominent.

FIGURE 8.28 Advertising postcard for Joe, 9 East 13th St., New York, NY. The dissimilar Joe logo and lined-up coffee measurers stand out among the circles. Marcie Cooperman.

FIGURE 8.29 Joel Schilling: *Green Shutters, Sienna, Italy.* Photograph, 2001. The green shutters are the dissimilar object in this photo, and they stand out against the complementary roof tiles and bricks. Joel Schilling.

As another example, Internet websites need to take advantage of the way in which we intuitively group certain functions together. Items on a drop-down menu must have related functions, and are assumed to be of lower importance because they are basically hidden. The most important functions must be easily identifiable by being large and in prominent locations.

- ***Illusion of a shape:*** Grouped elements can create the illusion of a shape. Even if the elements are different in such characteristics as shape, color, or size, their proximity might suggest a shape to us. In Figure 8.34, on a mostly complementary field of green, the red poppies mass together and create a diagonal line that moves the eye from middle left to upper right.

How would we utilize this information? Going back to the switches on an electric appliance or buttons on a web page, it is important to notice the shape that a group forms, especially if the product is distributed globally. Care must be taken about the meaning of shapes in local cultures.

FIGURE AND GROUND

Have you ever seen the classic set of profile illusions called Rubin's vase in Figure 8.35? This image was developed in 1915 by Edgar Rubin, the Danish psychologist who worked on **figure and ground** perception. It seems to vacillate between a white vase and an image of two black faces staring at each other. Why does this happen? It toys with the Gestalt theory of the principle that concerns our tendency to separate a composition into two entities: the figure and the ground.

We see objects as either one or the other, so that we know what we need to pay attention to. But the vase image can actually be the border of two distinct figures, so the eye sees both, flipping between them. The inside of the border lines describes a vase, but the reverse side of the same lines describes the faces. Since both areas are the same visual weight, we cannot decide which side of the line is figure, and therefore the most important area, and which is ground.

FIGURE 8.30 The hues are so different that each of the four areas stands on its own visually. Marcie Cooperman.

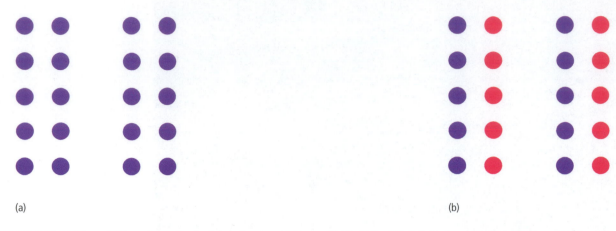

(a)

(b)

FIGURE 8.31 (a) We read this as two sets of columns because of the proximity of the violet circles to each other. (b) We read this as the same two sets of columns, even though two columns are red. Marcie Cooperman.

We usually see the figure in a composition as an object, smaller than the ground and on a plane closer to us than the ground. Figure is usually the most distinctive area with the most visual weight, and we know it is figure because it has unobstructed edges. We also know that those edges are the borders of the figure, not the border of the ground. The ground is usually larger, obscured by the figure because it seems to continue behind it, and it is not as prominent.

Many artists have enjoyed playing with figure and ground distinctions, blurring the line between them. The image in Figure 8.36 plays with an interesting transposition of figure–ground. The circle appears to be figure on top of the violet ground, but it is actually a continuation of the white ground next to it. We can see that because a section of its edge is open to the white ground, connecting them. Also the red triangle, which is definitely figure, forces the white circle into the role of ground.

GOOD CONTINUATION

The Gestalt theory of the principle of **good continuation** refers to our tendency to follow the lines that lead the eye in the simplest and most natural direction. Lines that are straight or have a slight curve direct the eye more effortlessly than those that take a sharp turn. Good continuation is related to inertia in our daily lives, which is the tendency for us to keep doing whatever it is we are already doing. As we move in a certain direction, it is comfortable to keep moving that way, for example as in dancing. We recognize comfortable patterns in music, too, in a sustained beat or repetitive chorus.

Wertheimer says that "additions to an incomplete object (e.g., the segment of a curve)" will achieve unity if they "*carry on* the principle 'logically demanded' by the original."[2] If a new line continues in the same direction, or in one that *feels* correct based on the original direction, it will feel like a natural addition. But lines placed at a sharp angle to a straight or slightly curved line will seem to be appendages, and is not as good a continuation as the straight line.

We can see proof in the examples in Figure 8.37. In Figure 8.37a, the yellow circles seem to form two curving lines, *a–b* and *c–d*. Changing half of each line to violet in Figure 8.37b doesn't change the path the eye takes; there is no temptation to follow the violet lines *a–c*, following the sharp turn "backward." This proves that good continuation takes precedence over similarity in color. For the two Gestalt principles to work together effectively, the color with more visual weight should be placed in the direction you want the eye to move, and that movement should be easy.

Good continuation in a composition can be arranged using gradient elements such as values, hues, or sizes. Edgar Degas's *The Dance Class* in Figure 8.38

FIGURE 8.32 *Either a hero! Become...one of the... unknown soldier$.* We interpret a story from the proximity of the words, colors, and images. Mixed media collage. KUCO/Shutterstock.

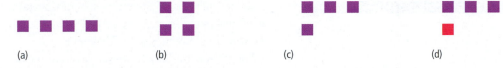

(a)　　　　　　(b)　　　　　　(c)　　　　　　(d)

FIGURE 8.33 Proximity and hue convey relative importance. (a) We perceive the squares as equal in importance. (b) The top two squares are slightly more important. (c) The isolated square is more important. (d) The red square is definitely the one to watch! Marcie Cooperman.

FIGURE 8.34 J. B. Schilling: *Red Poppies, Umbria Countryside, Italy.* Photograph, 2004. The red poppies mass together to form a line that brings the eye from left to right. Joel Schilling.

shows how gradient sizes form a slightly curved line through the composition. After our eyes alight on the accent of the front-most ballerina, we follow the other white tutus back into the classroom, all the way to the back wall.

In the Hungarian postal stamp of *The Birth of Venus* in Figure 8.39, after we notice Venus, the similarity of flesh hues moves the eye easily along her outstretched arms to the encircled Cupid, and finally, through the trees to the sky in the upper right corner.

All elements in the *Steamfitter* by Lewis Wickes Hine in Figure 8.40 suggest the clockwise curvilinear movement through the whole composition, while the round bolts especially emphasize it.

The Mies van der Rohe MR armchair in Figure 8.41 is a study in elegance. The repetition of the chair lines describes an easy curvilinear path from top to bottom, an example of good continuation.

Visual Links Create Vectors

Sometimes shapes in a composition are not close enough to each other to naturally make the eye move from one to another, and visual links must be added between them. The links can be shapes or lines that connect them and point in the proper direction. They create a **vector**, an imaginary and invisible line that determines the direction the eye moves.

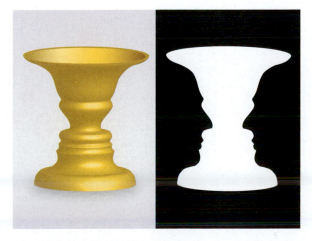

FIGURE 8.35 Rubin's vase profile illusion.

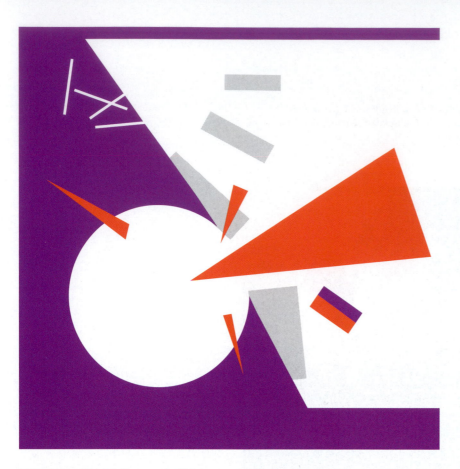

FIGURE 8.36 Which is figure and which is ground?

Rather than the addition of a separate shape, one of the elements can be angled toward the other, lining up a vector in that direction.

The photos by Gary K. Meyer illustrate these situations. The violet hills in *Palouse, Washington* in Figure 8.42 are attached by a blue road, establishing a vector that draws them together. That road is also attached to the horizontal blue road that moves the eye across the image to the right edge.

You can see the difference the vector between the hills makes. Cover up the road with your finger to see how the image looks without it—there is no way to jump from one to the other.

In *Namibia* in Figure 8.43, the dunes are unattached, but the vertical dune in the front points to the diagonal one in the back, creating the vector that allows the eye to continue looking up there.

CLOSURE

We use the Gestalt theory of the principle of **closure** in perceiving a whole shape even when it is missing some edges. The brain can be counted on to connect unattached lines that look like they logically belong together. In fact, we may not even notice that not all the lines are there. For example, we have no trouble reading words with missing parts, like the COLOR line in Figure 8.44 and the interrupted line of text in Figure 8.45.

In the same way, when shapes overlap, the one in the back appears to continue behind the one in front. The brain assumes the whole shape is actually there, hiding behind the shape that cuts it off, like the blue rectangle in Figure 8.46.

As part of the closure principle, we can perceive a shape that is merely suggested by the juxtaposition of several shapes, but has no actual edges. In Figure 8.47, the square appears because its apparent edges are defined by the edges of the triangles.

In Figure 8.48, Fernand Leger's sketch for the Swedish Ballet program cover allows us to see the concentric circles by interweaving values, even though many edges are missing.

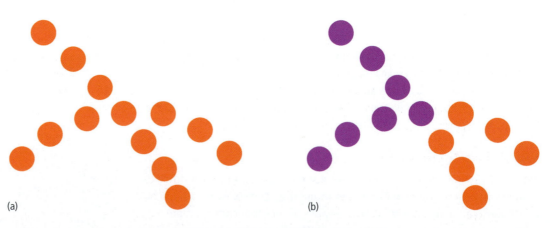

(a) (b)

FIGURE 8.37 Gestalt principle of good continuation takes precedence over similarity in color. (a) We move from c to d and from a to b. (b) It's easiest to follow the line from c to d, and a to b. Marcie Copperman.

FIGURE 8.38 Edgar Degas: *The Dance Class.* The gradient sizes of the similar white tutus draw us into the back of the room at the top of the painting. Oil on canvas, 32 3/4″ × 30 1/4″, 1874. © Tomas Abad/age fotostock.

In the *Coherence in Thought and Action* book cover in Figure 8.49, we can easily see the forms of two 3-D cubes hiding among the circles. We assume that the missing parts of the cubes are visible and they just blend in with the background because they are the same color. In reality, there is no cube; there are only many circles, and on each circle is a unique Y-shaped form. Figure 8.50 is similar; squares appear, but here the missing information is two sides of each square.

Dominance

Dominance in a composition means an object or an area stands out or has great influence because it has *greater visual weight* relative to all other elements in the image. The magnitude of a quality cannot be seen unless it contrasts with another element with the opposite quality; that opposite quality is known as the **subdominant,** or **opposing** element. Viewing the strong one simultaneously with the weaker element allows us to see its strength, a crucial contrast in creating dominance.

For example, the red square in Figure 8.51a is not large without a small element nearby. Alone it merely exists, but next to the smaller

FIGURE 8.39 The *Birth of Venus* as depicted on a Hungarian Postal Stamp. The eye moves up Venus' torso and follows her arms past Cupid to the sky in the upper right corner. © rook76/Fotolia.

FIGURE 8.40 Lewis Wickes Hine: *Steamfitter.* Gelatin silver print, 16 9/16″ × 12 3/16″, 1921. Good continuation moves in a continuous circular motion. Image copyright © The Metropolitan Museum of Art. Image source: Art Resource, NY.

FIGURE 8.41 Ludwig Mies van der Rohe: MR 20 armchair, tubular steel and painted caning. Photograph, H 31 1/2″, W 22″, D 37″, 1927. This elegant chair shows good continuation from the top around the arms and down to the bottom. Thomas Hernandez/Shutterstock.

FIGURE 8.42 Gary K. Meyer: *Palouse, Washington.* Photograph, 2009. The road is a visual link a vector, between the two blue hills. Gary K. Meyer.

FIGURE 8.43 Gary K. Meyer: *Namibia, May 18, 2009.* Photograph, 2009. The ridge of the dune in front is a vector that points up to the dunes in back. Gary K. Meyer.

FIGURE 8.44 This is completely readable even with parts of the letters taken away, because the eye connects the pieces. Marcie Cooperman.

You can read this even with the top cut off

FIGURE 8.45 An interrupted line of text–can you read it? Marcie Cooperman.

subdominant square in Figure 8.51b, it is *larger*. It is the dominant element. Figure 8.52a and 8.52b illustrate this concept with color.

We see this relationship everywhere in life. We are familiar with natural dualities such as night–day, hard–soft, big–small, intense–subdued, black–white, hot–cold, high–low, positive–negative, and masculine–feminine. These are the interconnected opposite forces of our daily lives—the yin-yang. We know that without one, the other doesn't exist because they are part of each other.

Often, there is a third area known as the **subordinate** area, forming a hierarchy of importance. The subordinate area is a completely subservient background that supports the dominant and subdominant areas.

In this way, relative visual weights create contrast, with contrast we can create emphasis, and emphasis conveys meaning. The contrast of visual weight can come from strengths in hue, intensity, value, or size, and sometimes several of these qualities at once. As we learned in Chapter 5, several elements working together give an object or area greater visual weight, which contribute to its dominance in the composition as a whole.

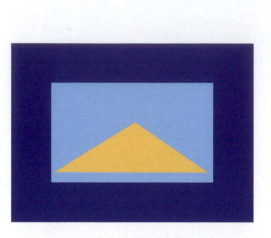

FIGURE 8.46 The high-value blue rectangle is assumed to continue behind the orange triangle. Marcie Cooperman.

FIGURE 8.47 These triangles seem to form a square because of their placement along its imaginary edges. Marcie Cooperman.

FIGURE 8.48 Fernand Leger: Sketch for cover of Swedish Ballet program, 1922. Even though parts of the circles are missing, closure dictates that we perceive them. Snark /Art Resource, NY.

FIGURE 8.49 Cover of *Coherence in Thought and Action.* Book by Paul Thagard, MIT Press, 2002. Can you see the cubes formed by the circles of Y's? Thagard, Paul, Coherence in Thought and Action, cover image, 2000 Massachusetts Institute of Technology, by permission of The MIT Press.

Alyce Gottesman's painting in Figure 8.53 illustrates how the red is dominant by having the largest area, as well as by being the most intense color in the painting. It even shows its strength against the green–blue on the bottom right corner by coming in front of it, a tough job, as the green–blue is high intensity. Also, because red is heavier on top, the blue–red's location there adds to its strength.

In Gary K. Meyer's *Ethiopia* in Figure 8.54, the high-value orange hue is dominant because of its strength against the achromatic and low-value water and the low-value complementary blue hills on the horizon. Notice that only a very small area is actually high-intensity orange, supported by surrounding lower-intensity oranges and violets. Their effect is to make it glow and increase its strength.

FIGURE 8.50 Squares appear, although in reality, there are only bottom right corners. Marcie Cooperman.

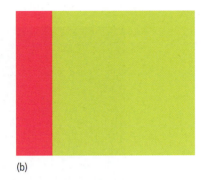

FIGURE 8.51 (a) By itself, this square is neither large nor small but, placed next to the small square (b), the large square dominates the smaller square, which is the opposing element. Marcie Cooperman.

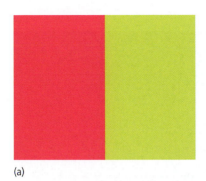

FIGURE 8.52 In (a) the red and green are equal and in (b) the green is dominant. Marcie Cooperman.

FIGURE 8.53 Alyce Gottesman: *Sky Pink Over Deep Red Hills.* Gouache, 11" × 8", 2010. Alyce Gottesman.

FIGURE 8.54 Gary K. Meyer: *Ethiopia, January 6, 2009.* Photograph, 2009. Gary K. Meyer.

More Composition: Gestalt Theory and Dominance

HOW IS DOMINANCE USEFUL?

Dominance grabs the eye and creates excitement. It can move the eye around the composition or hold the eye within because the eye is attracted to it. The subdominant element supports the dominant one through its contrast and by not being strong enough to hold the viewer's attention. The relationship is key: As long as the dominant and subdominant elements work together, they can be effective.

DOMINANT–SUBDOMINANT RELATIONSHIPS

Dominant–subdominant relationships can result from the following situations:

Lines in the Composition

An area can have dominance if all lines direct the eye toward the dominant area. Yoshitoshi Taiso's *Dragon King's Palace* in Figure 8.55 shows how this works. The warrior Watanabe no Tsuna commands our attention as the dominant object because he is large and placed in the

FIGURE 8.55 Yoshitoshi Taiso: *Dragon King's Palace*. Print, color woodcut, 11.1″ × 8.3″, 1880s. Library of Congress.

FIGURE 8.56 Cynthia Packard: *Eternal*. Oil and wax on board, 48″ × 60″, 2010. The blues dominate this painting because they have the largest area. Their contrast against the lower-value achromatic black areas, and against the almost complementary figure's color, adds to their strength. Cynthia Packard.

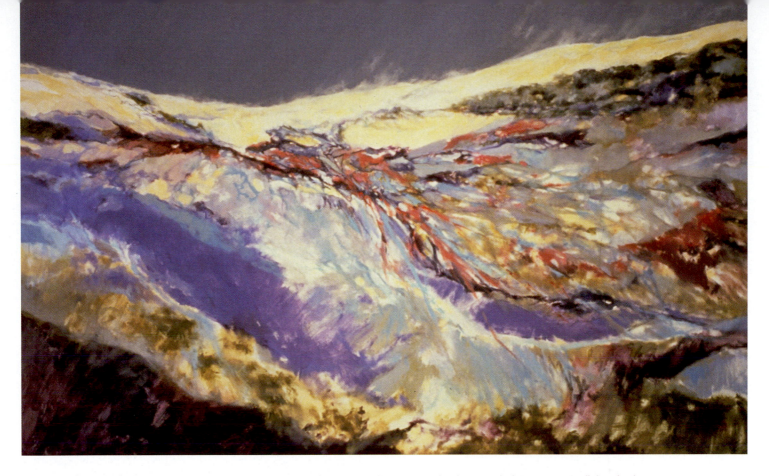

FIGURE 8.57 Catherine Kinkade: *Dunes*. Oil on canvas, 4.5' × 7', collection Connolly Insurance. Blue dominates by being present in all the other hues. Catherine Kinkade.

center. The red lines and the woman behind him are the subdominant elements; they support his dominance. They splay out from the center, the way his arrows, arms and feet, and even the folds of his skirt do, holding him in place as the center of attention.

Largest Area

A color—or a hue, type of value, or a specific intensity—can dominate the composition by taking up the most area, like the blues in Cynthia Packard's *Eternal* in Figure 8.56. Catherine Kinkade's *Dunes* in Figure 8.57 illustrates how blue can dominate by being present in hues mixed with blue, such as violet, green, and green–blue. Only small areas of white, yellow, and red do not include blue.

Strongest Quality

An area can dominate if it has great visual weight and a strong contrast with the rest of the composition. Whether or not it is the focal point, a color can dominate if it is stronger in intensity, value, or hue than all other colors in the composition. The orange shapes in Samantha Keely Smith's *Harbinger* in Figure 8.58 demand attention and dominate through intensity as well as complementary contrast with the blue background.

Dominance does not always mean being the focal point. Catherine Kinkade's *Monhegan Meadow* in Figure 8.59 is an interesting situation that illustrates this. The solid areas of color dominate the composition in terms of strength of color, largest area, and strongest quality. And yet what they actually do is lead the eye to the tiny houses at the horizon. This is most likely because the houses stand out as being different in shape and size from the rest of the composition, and more complex than the flat areas of color.

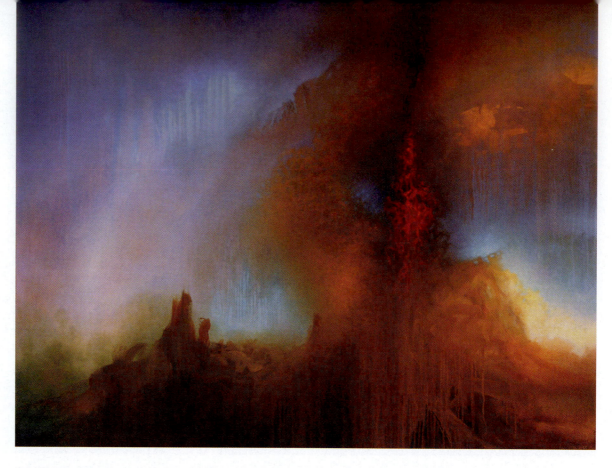

FIGURE 8.58 Samantha Keely Smith: *Harbinger.* Oil on canvas, 64″ × 78″, 2010. The orange dominates through its contrast with its blue complement. Samantha Keely Smith.

FIGURE 8.59 Catherine Kinkade: *Monhegan Meadow.* Pastel, 17″ × 21″. The solid colors dominate in area, but the houses are the focal point. Catherine Kinkade.

How different do the dominant and subdominant elements need to be to have dominance? The greater the difference between the visual weights of the dominant area and the opposing area, the greater the dominance. But as the dominant area increases, the opposing area becomes smaller and less important. The relationship is no longer effective at the point where the dominant object overpowers the subdominant one and they cannot contrast against each other.

Dominance also decreases as the two elements approach equal weight. At that point, they are codominant, a situation that can cause trouble for the designer. Having codominant areas in a composition can confuse the eye, prevent a natural path of continuity, and eliminate the focal point.

summary

The Gestalt principles of perception describe how we look at a composition as a whole, rather than as a combination of separate parts. It is our way of grouping together elements that we perceive as related, and this helps us understand what we are looking at.

The Gestalt principles affect how we see the composition, and the way we understand its message or artistic theme. If the design elements work against the principles, the viewer might completely miss the intended message.

quick ways . . .

Using the Gestalt principles of visual perception provides another way to evaluate your composition—in terms of how people perceive it in general. Here are the factors that you can use for a quick assessment:

1. Are there similar elements, dissimilar elements, or separate planes of elements? Are you effectively using dissimilarity to support your focal point or express your theme?

2. What lines or shapes are near each other? When the eye connects them together, do they help continuity? Do they keep the eye from moving through the composition?

3. Is there repetition? What is its effect on the composition? Does it help to focus the eye where you want it? Does it establish your mood of choice, or imply your message?

4. Does repetition establish a pattern of some type? Does the eye miss the details while focusing on the entire pattern?

5. Do the lines/shapes form a shape? Do they follow in good continuation? Does it help the continuity?

6. Where do you notice dominance? Would it be in hue, value, intensity, line, shape or area? What is subdominant? How do these factors affect your composition?

exercises

Parameters for Exercises

Remember these constants:

1. No recognizable objects are allowed.
2. All colors are to be flat and nongradient, with hard edges that don't fade away.
3. White is always considered a color, even if it is the background.
4. Only neatly cut and pasted papers are appropriate.
5. Balance and unity are *always* the singular goal of every composition.

1. ***Show similarity–repetition.*** Use repetitive colors in a composition to tell an artistic story or establish a theme. In your class critique, listen to your classmates' analysis of what story they actually understand before you reveal your objective.

2. ***Show similarity–dissimilarity.*** Create the focal point using a contrasting color in the midst of similarity. But be sure it doesn't upset the color balance in the image.

3. ***Show repetition–gradient changes.*** In this composition, use gradient changes in two elements of color or shape to create a logical and smooth visual path. Be sure all elements are in balance and there is just one focal point.

4. ***Show proximity–relative importance.*** Use five colors. The goal is to make the eye move through the composition in three stages. One color should represent the accent, which is the first place the viewer looks. The second color attracts the eye away from the accent, and sets it on the path to the third color, which should be the focal point. The other two can be supportive. You can relate their roles to an electrical appliance, where the first color is the on–off switch. The second switch is a primary adjustment, such as speed, and the third button could be akin to a computer "Enter" key.

5. ***Show good continuation.*** Create a composition with colors and shapes that lead the viewer on a smooth curvilinear path through the entire composition. Remember to delegate the areas that are directive and those that are supportive, so that they all facilitate the movement.

6. ***Create dominance and explore what creates the focal point.*** What makes a color dominate in a composition, but not overwhelm the others? Compose two images using five different *colors,* where one *hue* dominates, but be sure that the colors in the composition are balanced. Remember that you have many options for values and intensities in choosing your colors. Create dominance in one of these ways per image:

 • The dominant hue should be the focal point.
 • The dominant hue should be the strongest one in the image, but not the focal point.

7. ***Show closure.*** Create a balanced composition where shapes are suggested simply by placement of the lines of your shapes.

8. ***Show figure–ground.*** Using your choice of strategy, transpose figure and ground in your composition so that one could be the other.

Color Interactions—
Backgrounds, Borders, Outlines, and Transparency

FIGURE 9.1 Whitney Wood Bailey: *Extraordinary Geometries.* Oil and mixed media on canvas, 72" × 72", 2012.
Whitney Wood Bailey.

In many compositions, there are a few configurations that everybody recognizes specifically because of their locations: the background, borders, and outlines. These structures seem simple and basic, but they have such a great impact on the entire composition that it's impossible to underestimate their influence, and it's essential to choose their colors carefully.

These configurations are so familiar that even those outside the design industries know what they are. Naturally we know what backgrounds are! The figure–ground Gestalt principle states that we have a tendency to simplify a scene into two parts: The main object that we are looking at (the figure) and the background (or ground). And we know instinctively that borders and outlines surround shapes. Just as recognizable, although most of us have never analyzed why we know it, are transparency effects. Like the other three configurations, transparency is influenced by color location. It involves two colors placed near each other combining in an adjacent space to form a third color that appears to be a mixture of the two.

Color relationships determine how these structures affect the objects in the composition. As we learned in Chapter 3, the Law of Simultaneous Contrast causes colors to establish relationships with each other and make things happen. For example, complementary hues blue and orange scintillate and vibrate, and are useful for creating compositional tension. You can see how blue and orange look together in the Impressionist paintings by Claude Monet, who used them in many variations of intensity and hue to illustrate the effects of sunlight. In contrast, analogous hues like blue and green together calm the soul and suggest **atmospheric** or watery effects, depending on whether they are located above or below the objects. And the complementary hues of red and green are balanced and together support each other's strengths.

Keeping in mind the artistic message to be communicated to the viewer, the designer can choose the color relationships that can achieve it. In this chapter, we explore each structure and its color possibilities.

key terms

atmospheric
border
child color
interstitial
outline
parent color
partial border
permeable
transparency
visual field

Backgrounds

What effect does the background color have on the composition? It's obvious but still vitally true that the more space a color takes up in an image, the stronger its effects on the other colors and the more influence it peddles in setting the mood and artistic message. And no area takes up more space than the background (or ground), the area surrounding the figure A color with so much influence has to be a primary consideration when determining the nature of all color choices. That's why it's always a good idea to try out several possibilities for background color against the other colors in your composition, in order to select the one that contrasts most effectively with them.

Let's take a look at various possibilities for background colors and the effects they impose on the composition. With different choices, we will examine the changes that occur in the color relationships, the plane locations, and in continuity.

Whitney Wood Bailey's *Extraordinary Geometries* in Figure 9.1 illustrates the effect of background color against the figure color. The complex tiny slashes of ground hues optically combine to produce gray, the benevolent achromatic hue that preserves the intensities of the colorful curvilinear lines of the figures. This is because gray does not produce the color altering effects of black or white grounds.

BACKGROUND COLORS

To simplify things, we will limit our exploration to the effects of achromatic hues black, white, and gray, and primary hues red, blue, yellow. But remember that it is all influenced further by color relationships in your composition.

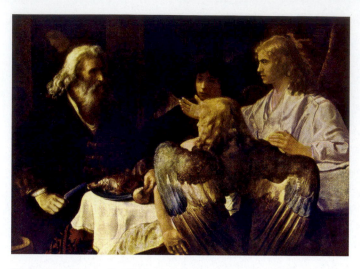

FIGURE 9.2 Rembrandt: *Abraham and the Angels.* Black highlights the other values. Oleg Golovnev/Shutterstock.com.

FIGURE 9.3 **The white background makes the red puzzle piece darker.** © masterofall686/Fotolia.

FIGURE 9.4 **Coca-Cola advertisement.** Red steals the show. © Peter Horree/Alamy.

Black

Against black, all other colors appear lighter. And in a composition, black visually separates itself from other hues because it alone is the lowest-value achromatic hue possible. True black (as opposed to a very low-value green, blue, or red) always looks like a species different from the chromatic hues. For this reason, it has great visual strength. Rembrandt's *Abraham and the Angels* in Figure 9.2 is a good example of black's separation, and the relative lightness of other colors when black is the background color. As we can see, he achieved great luminance and brightness through black's contrast with his other colors, a typical color relationship strategy for him.

White

White is extremely bright because it alone is the highest value possible. For this reason, it has a darkening effect on all other colors. By definition as an achromatic hue, it has no intensity at all, which increases the intensity of adjacent colors, even while making them darker. Even high-value colors look darker against white, like the red puzzle piece in Figure 9.3. Whitney Wood Bailey's *Extraordinary Geometries* in Figure 9.1 is an example of a white background. (Did you guess that?)

Red

As a background, red is a bully in the playground. Its power and intensity force other colors to be quieter. It steals the red from adjacent hues, and its tendency to push forward overwhelms the other colors. It's hard to stand out against red, but other colors have a chance to be somewhat visible on top of it if they contrast in value, or are complementary in hue.

The Coke ad in Figure 9.4 is a rare example of red as a background for an ad, a bold decision that often walks the thin line of visibility. Red draws attention to the ad—a noble cause—and keeps the energy high, but could easily prevent the text from being readable and the image from being understood. In Figure 9.4, white text is a good value and intensity contrast on the red ground, and the complementary contrast of the green bottle gives the image visual strength. The high value makes the face and hand contrast slightly, but not enough to stand out well because they are a tint of the same hue.

The photograph by Sarah Canfield in Figure 9.5 is a thought-provoking use of red as a background because the Queen's cape is also red. Since they are the same hue, neither stands out, allowing the face to become the focal point and creating a theatrical mood. Viewing the two types of red simultaneously heightens the hue differences: The cape has more yellow in it, and the background has more blue in it.

Blue

Blue is atmospheric in character, which means it has the quality of being infinite and intangible, surrounding an image the way the atmosphere exists above the earth. Since it does not seem to have a particular plane location, it usually recedes behind other colors. If it is the color with the most visual strength, it is possible for the blue to surge forward. But colors with any warmth in them can easily move to a plane in front of it.

In Sasha Nelson's photograph of St. Mary's Cathedral in Figure 9.6, the intense blue of the sky scintillates against the complementary orange turrets of the spooky Gothic architecture, seething and vibrating, yet not usurping the forward plane of

the orange building. A quieter, lower-intensity blue would not heighten the mood as well as this strong counterpoint to the orange.

Compare the behavior of the two different intensities of blue in Joel Schilling's two flying bird photographs in Figures 9.7a and b. Even with a great difference in value, the black form is hardly visible against the intense blue sky, but the four birds easily attract attention as the focal points against the less intense, higher value cloudy sky.

In Cynthia Packard's *Rhythm in Blues* in Figure 9.8, the blue ground recedes, although not by much, but it still pushes the tabletop objects forward. As a result, they become more prominent, even though they are low value and indistinct.

Yellow

Because of yellow's brightness and tendency to expand beyond its boundaries, it has energy and intensity. But it allows adjacent colors to come forward while it glows in the background, like the reds and blues in Alyce Gottesman's *Luminescence* in Figure 9.9.

Gray

The most balanced and generous of background colors, gray allows every simultaneously contrasting color to be itself. Not being a chromatic hue, it doesn't steal any hue from its neighbors; not having intensity, it enhances the intensity of adjacent colors. Gray makes a perfect background wall for art galleries, and a good mat for framing artwork. For example, Alyce Gottesman's *Water Swirl* in Figure 9.10 shows how the lower-intensity yellow gains in strength against the achromatic gray and black.

The gray background in Figure 9.11 provides an achromatic hue that contrasts with the orange and blue complements, allowing the upside-down figure of Lindsay to draw the eye. The gray steel walkway is just visible enough to lead the eye to her and let her steal the show with her derring-do.

FIGURE 9.5 **Sarah Canfield,** *Queen of Hearts*. Photograph, 2012. The face contrasts against the red cape and ground. Sarah Canfield.

FIGURE 9.6 **Sasha Nelson:** *St. Mary's Cathedral, Sydney, Australia*. Photograph, 2007. The blue sky is a spooky complement against the orange turrets. Sasha Nelson.

(a) (b)

FIGURE 9.7 **(a) Joel Schilling:** *Female Frigate Bird in Flight*. Photograph, 2009. Intense blue makes the bird hard to see. **(b) Joel Schilling:** *Blue Footed Boobies Diving*. Photograph, 2009. Higher value and lower intensity works better. Joel Schilling.

FIGURE 9.8 Cynthia Packard: *Rhythm in Blues.* Wax, tar and oil on board, 48″ × 72″, 2009.
A sophisticated use of hue, value and intensity—the blue is more intense but still makes the figures the focal point. Cynthia Packard.

COLOR RELATIONSHIPS

Changing the color of the background creates new color relationships, and a new artistic message. For example, an analogous relationship lends a more serene mood to a composition. Colors placed on a background similar to them in hue, value, or intensity are hard to see because of the lower contrast. As we have learned, this is the basis for camouflage, and we can see natural examples in Gary K. Meyer's photographs in Kenya. In Figure 9.12, the cheetah's coloring is of great value to him because it allows him to disappear in the brush, invisible to animals larger than himself as well as his prey. Although his spots look lovely, if you squint your eyes as you look at the photo, he completely disappears because of the similarity of his fur's hues and values to his background. Were he to swim in a blue body of water amid green bushes in another country, he would stand out like expensive jewelry.

On the other hand, a complementary relationship in hue, value, or intensity provides excitement and a more intensive dialogue between the colors. For example, the photograph of the lilac-breasted roller in Figure 9.13 demonstrates both complementary effects and camouflage. Camouflage makes it hard to see the head's variety of colors, because they are roughly the same colors and value as his low-intensity orange–brown and green background. Even the pink breast, while not the same hue as the ground, is similar enough in value that it

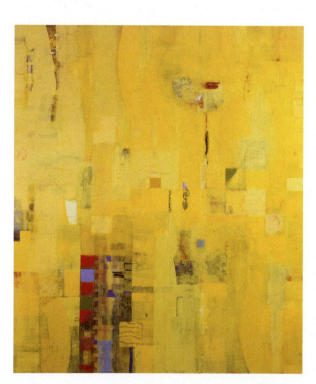

FIGURE 9.9 Alyce Gottesman: *Luminescence.* Oil on canvas, 48″ × 40″, 1999. Even with the intensity of the yellow, the reds and blues stand out. Alyce Gottesman.

FIGURE 9.10 Alyce Gottesman: *Water Swirl.* Small charcoal, ink, gouache on paper, 30.5″ × 20″, 2007. The gray increases the intensity of the yellow, and enhances the darkness of the black. Alyce Gottesman.

doesn't stand out, looking bluish or dirty by comparison. If we wanted the pink breast to appear more vibrant, we would have to photograph it against a complementary green ground, according to the law of simultaneous contrast. On the other hand, the belly's complementary fluorescent green–blue contrasts sharply against the low-intensity ground. Why is it such a color? Looking up at the sky, the answer would become clear because the hue of the flying bird's belly would disappear against it.

The pair of elephant photographs in Figures 9.14 and 9.15 is a lovely comparison of background values for the same subject. The elephant is neither victim nor prey, and doesn't need to blend in with her surroundings. This is apparent in the daytime photo, where the elephant's low value and achromatic contrast makes her visible compared to the high values of the grasses and sky. But at dusk, she is the same value as the ground, and practically impossible to discern.

PLANE LOCATIONS OF OBJECTS

Plane locations of objects can be made to move forward or backward in relation to different background colors, as we learned in Chapter 7. For example, a background color with red in it, or a color that is more intense relative to the object's colors, will move forward and by contrast it will make the other colors move to a plane farther back. On the other hand, a background of either blue or a relatively less intense color will force all the other colors to be in front of it.

CONTINUITY

Changing the background color changes the color contrasts in the image, and affects the visual path through the image. The focal point can suffer with such changes. The new

FIGURE 9.11 Hano: *Lindsay Hanging.* Photograph, Via Ferrata, Switzerland, 2010. Gray provides the perfect background hue to emphasize the complements orange and blue, as well as Lindsay's bravery in the high foggy Swiss Alps. Hano.

FIGURE 9.12 Gary K. Meyer: *Samburu National Park, Kenya.* Photograph, 2010. The cheetah disappears against his natural environment. Gary K. Meyer.

FIGURE 9.13 Gary K. Meyer: *Lilac-breasted roller, Lake Nakuru National Park, Kenya.* Photograph, 2010. The bird is a study in camouflage. His belly would make him disappear against the sky. A bigger bird above him wouldn't see him because the colors on his head are the same multi-colors, intensity and value as the grasses on the ground. Gary K. Meyer.

FIGURE 9.14 Gary K. Meyer: *Kenya Elephant, Amboseli National Park.* Photograph, 2010. The elephant stands out against high value surroundings. Gary K. Meyer.

simultaneous contrasts can compete with the focal point and obscure it. Or a different color can make a stronger contrast with another object and substitute it for the original focal point. A new focal point by definition would completely alter the path of continuity.

In Joel Schilling's butterfly photographs, the varying hues of the flower and leaf backgrounds allow us to see how different backgrounds can affect the focal point.

In Figure 9.16, because the violet has greater intensity than the butterfly, it competes as a focal point. Also, the yellow flowers flash as violet's complementary hue, and that combination holds our attention.

In Figure 9.17, the background's complexity of line and similarity in value to the butterfly forms a confusing contrast and competes with the butterfly.

In Figure 9.18, the value contrast of the very low-value leaves forms a better background for the butterfly. The yellow daisies behind it are a strong contrast, but they are not large enough to pull attention away from the focal point.

PULLING IT ALL TOGETHER

Let's look at a few choices for backgrounds in the following composition, using its colors as a point for comparison as well as plane location and focal point.

In Figure 9.19a and 9.19b, it's easy to see how the white background makes the colors darker compared to the black background. Not only does the black ground brighten the colors, it also provides a uniting base to visually hold the bars together, whereas the white makes them appear to be separate, almost unrelated, lines. The yellow lines are the focal point on the black ground, but have trouble holding onto this distinction on the white ground. In fact, it's not clear where the focal point is on the white ground.

The high intensity blue background in Figure 9.20b could be a solution if your intention were to express stress or high energy. The ground is so strong that it competes with the complementary orange bars for attention, vibrating against them. Still, it recedes more than the red grounds in Figure 9.21a and 9.21b. Because it is light, the intense blue darkens the other colors almost as much the white does, and more so than the low-value blue in Figure 9.20a does.

In Figure 9.21a and 9.21b, both of the red backgrounds remove red from the bars, and by so much that the bars appear to be different colors than they do on the black ground. The dark red bars appear to be blue–violet, and the thin orange bars have apparently become a warm yellow. The red background planes are pressed forward against all the bars, a testament to red's advancing behavior. The yellow stripes are the focal point for both red grounds by default, because it's hard to see any other color. That poor color contrast is the reason we can say that red is not the best choice for this background.

In contrast, the green background in Figure 9.21c influences the bars by making them redder, a predictable complementary effect, and the green supports the middle red stripes as the focal point.

FIGURE 9.15 Gary K. Meyer: *Kenya Amboseli National Park.* Photograph, 2010. The low values at dusk hide the elephant and emphasize the sun. Gary K. Meyer.

In conclusion, in terms of being the most beneficial contrasts for the colors of the bars, the green and the black are the most successful hues to use as the background. The lower-value blue is second best.

Let's look at a painting with complexity of line and color areas to help demonstrate the power of background colors. Liz Carney's *Self Portrait* in Figure 9.22 creates a very sophisticated balance through its colors and forms. The figure of the painter is almost centered, enough so that it is the center of attention, in spite of the busy forms throughout the painting. But then there is the daring addition of the red and orange painting in the background just behind the figure, daring because its intense hues should grab the spotlight away from the figure. Instead, they provide a value contrast that frames and sets off the high values of the painter's overalls and her low-value blue arm. The effect is stronger because of the complementary hue relationship. The low-value rectangles at the top form a partial border (partial borders are described in detail later in this chapter) that keeps the eye from moving beyond them. The contrast of their low-value illuminates the high-value colors of the wall, in turn making that area become a narrow border that surrounds and highlights the red painting and the figure. The rectangles, the red painting, and the wall help frame and keep the figure as the focal point.

FIGURE 9.16 Joel Schilling: *Butterfly No. 1.* Photograph, 2003. Which is a better background color for the white and black butterfly— 9.16, 9.17 or 9.18? Joel Schilling.

Borders

WHAT IS A BORDER?

A **border** is an area that is not part of the composition, but is added to it to fully surround the entire image and enhance it. It is a frame that appears to be a separate entity from the composition itself; we refer to them independently as "the composition" and "the border." But in reality, they are in the same **visual field**. In other

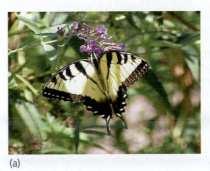

(a)

FIGURE 9.17 Joel Schilling: *Butterfly No. 2.* Photograph, 2003. Joel Schilling.

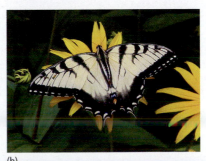

(b)

FIGURE 9.18 Joel Schilling: *Butterfly No. 3.* Photograph, 2003. Joel Schilling.

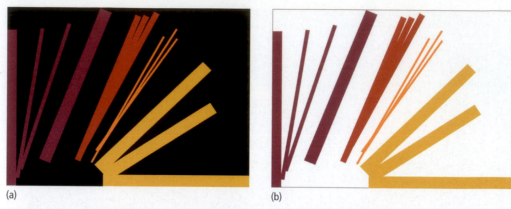

(a) (b)

FIGURE 9.19 (a) The black ground helps the lines connect with each other, and makes them more intense than on the white ground. (b) The white ground does not help the lines pull together as a unit, possibly because we interpret the white as "no color." They are so much darker on the white that they appear to be different colors from those on the black ground. Marcie Cooperman.

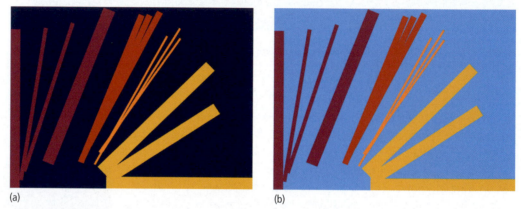

(a) (b)

FIGURE 9.20 (a) The orange bars stand out on the low value blue ground, but the low value reds disappear. (b) The high intensity blue ground vibrates against the orange bars, giving them dynamic energy. It comes forward slightly, but not as much as the red grounds. Marcie Cooperman.

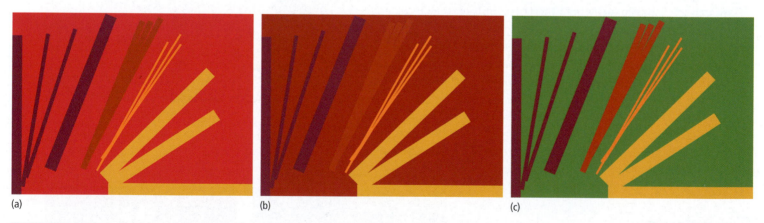

(a) (b) (c)

FIGURE 9.21 (a) The red background removes red from the bars and turns them greenish, a change that reduces their attractiveness. It also fights with them for attention. (b) The dark red doesn't come forward as much as the higher intensity red, but it has the same hue effects on the colors. The bars are hardly visible on this ground. (c) The complementary green ground doesn't come forward to fight the red in the bars, and in fact supports them by making them as red as possible. All of the hues are visible on this ground. Marcie Cooperman.

words, we see them simultaneously. So, although discrete elements, they are visually connected, and their colors need to be considered together.

A border can also be placed around just one area or an object within the composition. Inside the composition, we don't really notice them as separate borders; we see them as areas integrated into the picture itself.

FIGURE 9.22 Liz Carney: *Self Portrait at FAWC.* Oil on board, 9" × 12", 1995. All background colors are supporting the figure as the focal point. Liz Carney.

SHAPE AND SIZE OF A BORDER

Typically, an exterior border consists of long, thin rectangles that are parallel to its edges. But the shape itself doesn't determine whether it functions as a border. More important are the color contrasts and its location. Inside the composition, a border can also vary in terms of shape and size, although there are limits. If borders are too large, they appear to be backgrounds rather than borders. And borders small enough to completely surround objects are *outlines*, which are described later in this chapter.

PARTIAL BORDERS

We think of a border as an edge or enclosure that is placed on all four sides of an image. In reality, borders don't have to be all around a composition, or even on its edge. Elements of the right size and shape that are placed anywhere within the composition can create the effects of a border, called a **partial border**. They can be located on just three sides; they can be two borders facing each other in the middle of the image; or they can even consist of just one element. That's because the border effect is actually created by the shape and color contrasts that are set up.

FIGURE 9.23 Catherine Kinkade: *Winter Rocks Shan.* Pastel on sandboard, 30" × 24", 1982. Catherine Kinkade.

When a partial border has several elements, we see them all as related to each other. We learned in Chapter 8 that the eye produces closure when only parts of a shape are seen, and this perceptual process is how a partial border composed of several pieces functions as a whole border.

For example, Catherine Kinkade's *Winter Rocks Shan* in Figure 9.23 illustrates a partial border created by two high-value triangular elements placed at the top and bottom (the right side has no border), surrounding a triangle of lower value in the center of the image. They create a hue, value, and intensity contrast with the low-value blue water in between, and they focus the eye on that area. This is in spite of the fact that the entire center of the picture is shadowy and indistinct, almost a dare for the eye to try to focus on it.

Black functions well as a partial border because of its singularity in hue and value. Placed at the edge of a composition, a black area prevents the eye from escaping at that point, bouncing it back into the picture. If there are several strategically placed black areas, they bounce the eye back and forth between them, and keep it within the composition.

The two photographs by Sasha Nelson illustrate black's power as a partial border. *Remarkable Rocks* in Figure 9.24 keeps the eye focused on the strange, biscuit-like rocks framed by the concave black overhanging rock on top. *Bats Circling* in Figure 9.25 pulls the shadowed treetops into use as a partial border that surrounds the tiny bats, and the eye stays inside as it travels from one bat to the other.

FIGURE 9.24 Sasha Nelson: *Remarkable Rocks.* Photograph, Kangaroo Island, Australia, 2007. The partial border at the top pushes the eye down to the rocks in the middle. Sasha Nelson.

FIGURE 9.25 Sasha Nelson: *Bats Circling.* Photograph, Sydney, Australia, 2007. The barely-seen parts of trees surround and emphasize the bats. Sasha Nelson.

Look at Liz Carney's *Commercial Street* in Figure 9.26 for another example. The red line borders the entire left edge, pushing the eye back into the composition. Cover it up to see its effect disappear. Interestingly, the red is strong enough to balance the entire blue building and violet street.

FIGURE 9.26 Liz Carney: *Commercial Street.* Oil on board, 8″ × 10″, 1995. The red line on the left functions as a border because it bounces the eye back into the image. Liz Carney.

FUNCTIONS OF BORDERS

Because of its location and contrasts, a border has tremendous influence on the entire composition. In this section, we will discuss what borders do and we'll take a look at the color relationships they have with the other elements of the composition.

Borders Define Edges and Delineate Space

Rudolf Arnheim described a border as a way to delineate space by allowing us to perceive the edges of the image and separate the image from other areas.

In general terms, most people comprehend borders as they apply to real-life examples such as picture frames. The frame is meant to hold an image within its embrace, to surround the composition and protect it. It separates it from the wall, dividing each into visually different color areas. The frame is considered a necessity in properly finishing a painting or photograph, as a painting without a frame appears incomplete.

Arnheim postulated that without a frame, some pictures appear to go on forever. The border is like a window looking out onto that type of picture, giving the impression that it continues beyond the frame. That might be because the color spaces within the composition do not relate to the edges through shape, orientation of shapes, or color.

A border placed *within* the composition would delineate a particular interior space, making it stand apart by forming noticeable edges around it. It can help make an interior area become a focal point. Interior borders can also separate two areas, and yet belong to neither of the two. In *The View* in Figure 9.27, the horizontal and vertical borders set up a frame on the picture plane level, through which we see the images.

Borders Act as Barriers

A border creates a visual obstruction, keeping the eye from moving past it. A border forces the eye to stop at the edge of the area it surrounds, keeping the focus within. On the perimeter of the composition, a border keeps the eye from leaving the picture, and bounces attention

FIGURE 9.27 Marcie Cooperman: *The View.* Photograph, 2011. The window frames separate the view into six sections. Marcie Cooperman.

away from itself back toward the center of the image. This is one of the functions of a picture frame. Arnhein felt that the major role for the picture frame is to separate the picture from the wall. For this to happen, he said, it must have a strong color contrast with the picture.

Borders Influence Motion

A border color can lead the eye to connect with similar colors within because of the Gestalt *similarity* principle of perception (see Chapter 8). The eye moves from one area of this color to the other, setting up the path of continuity within the image. Changing the border color would make different colors in the composition pop up, altering the continuity.

For example, in Figure 9.28a and 9.28b, Sasha Nelson's *Snails on a Rock* has a blue border and a red border. The blue border connects the eye with the blue elements in the water, while the red border allows the red elements to pop up. Note that the blue border appears to be organic at the top, with concave parts that invite in some of the water image, making a more **permeable** border and enhancing the motion of the moving water.

In Julie Otto's *Cattails Marsh* in Figure 9.29a, the blue border connects to all the blue elements, which allows the complementary land to stand out in contrast. You can see the opposite effects in Figure 9.29b, where the border connects to the similarly colored reeds, and we notice the blue mountains in contrast to the complementary border.

A border in the shape of a circle reinforces the curvilinear motion within the image in a powerful way. In *The Power of the Center*, Arnheim suggests that the best type of composition within a circular frame would include objects placed in an implied curvilinear line, or placed at the three points of a pyramid. They would enhance the motion already set up by the border. As shown in Figure 9.30, Rafael painted his Madonna and child within a round picture plane. The curvilinear movement is enhanced by the curve of her red arm and the way the three heads crowd together.

(a) The blue border connects with the blue water, making it feel like part of the image.

(b) The red border contrasts against the blue water and makes the eye notice the red rocks.

FIGURE 9.28 Sasha Nelson: *Snails on a Rock. Photograph, 2007. Sasha Nelson.

(a) The blue border connects with the mountains and water, and we notice the brown land.

(b) This border contrasts against the blue mountains.

FIGURE 9.29 Julie Otto: *Cattails Marsh. Photograph, 2010. Julie Otto.

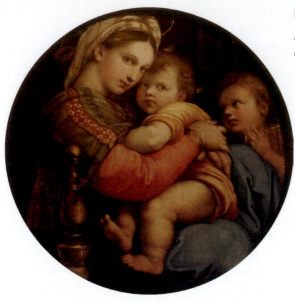

FIGURE 9.30 Raphael: *Madonna della Seggiola (Madonna of the Chair).* Oil on wood, diameter: 27.9", Ca. 1514. The circular border keeps the eye circling around the image. Michelle Grant, Dorling Kindersley

FIGURE 9.31 Pablo Picasso: *Imaginary Portrait No. 2.* MOCA Jacksonville / SuperStock.

Borders Provide a Contrast

A border is a simple thing, yet treated creatively it can work wonders for the composition. Through its simultaneous contrast—direct contrast for the adjacent colors and a lesser degree of contrast against the colors that are not right next to it—the border's colors can add a new level of complexity to the color relationships inside. It can accomplish three distinct objectives:

1. The border can stand apart from the image. A strong color or pattern contrast with the composition is an important factor in making a border stand apart. Complements or opposites in value or intensity would provide this type of hard-edged frame.

2. The border can be a more permeable boundary that enhances movement into and out of the composition, providing a connection between the two areas. To blend with the image and extend its boundaries, the border can include the same hue, value or intensity as the interior colors. To accept the flow of energy from the composition, the *shape* of the border also can be varied. Shapes that have a concave or organic interior edge allow a fluid movement between it and the composition. (To remind yourself of the type of energy emanating from concave shapes, see Chapter 5.)

3. A border can also create a three-dimensional contrast by setting up another plane. As we discussed in Chapter 7, color contrasts can move planes closer or farther away in space.

As an example, what does the border do in Figure 9.31, Pablo Picasso's *Imaginary Portrait No. 2*? It breaks up the image into separate quadrants. Because the edges of the red, white, and blue are uneven, and the border color is seen showing throughout the image, it is integrated somewhat into the composition. But if you cover up the exterior border, the quadrants pull together and the image appears more finished. Clearly, Picasso was interested in breaking up the surface of his paintings.

Michel Chevreul thought that frames destroy the perspective in paintings, and suggested it might be better not to use frames at all. He realized that they have a strong effect on the image through their contrast in color.

Analyzing the relationship between the colors in the composition and the frame around them, he came to some general conclusions. He said that a black frame is good, although, because of its status as the lowest possible value, it might reduce the strength of nearby browns. In general, he suggested tinting a white frame with the complement of the major hue in the image. And gray is good to use for a frame, especially when "the picture having a dominant color, we take a gray lightly shaded with the complementary of that color."[1] Because it is achromatic, gray doesn't reflect a complementary hue on adjacent hues as a chromatic hue would.

According to Chevreul, "Gilt frames accord perfectly with black engravings and lithographs, when we take the precaution of leaving a certain extent of white round the subject."[2] Otherwise, bright frames that detract from the art should not be used.

He noted that when searching for the correct color to use for a frame or border, it's important to take into account three things:

1. ***The value of the border*** and the effect it will have on the painting. His law of simultaneous contrast states that the border will make nearby values appear opposite to it. For an example, if the goal is to make the painting appear to be light, a dark border will work well.

2. **The hue of the border** and its complementary reflection on the hues in the painting. For example, a red border reflects its complement of green onto the nearby colors in the painting. If this produces an unpleasant effect, red is not the right hue to use .

3. **The intensity of the lighting situation** in which the painting will be viewed. Lower-intensity lighting doesn't allow high values and delicate color relationships to be seen, and very strong frame colors would further detract from them. Chevreul suggested that to avoid fatigue, the lighting should be as white and bright as possible, but distributed equally.

Inspired by Michel Chevreul, the Neo-Impressionist painter Georges Seurat thought about the proper color with which to frame his paintings. He insisted on white frames for many, although he did not tint them with the hue opposite to that in the painting. To reduce the contrasting effects of the frame color on many of his paintings, he painted borders using his dotting technique.

Outlines

Outlines are borders, too! **Outlines** are thin borders that surround a figure. Although outlines are secondary **interstitial** areas like borders, *secondary* doesn't imply a lack of influence in the composition. They actually do have a great effect on all the colors, on the planes, and on the movement in the composition. Actually, a composition with outlines throughout looks entirely different from a composition without outlines. Why is this true?

OUTLINES INTERRUPT THE SIMULTANEOUS CONTRAST BETWEEN FIGURE AND GROUND

Because they stand in between those two areas, it is the *outline* that is adjacent to the background and the *outline* that is adjacent to the figure. Therefore, all colors are seen relative to the outline color. The simultaneous contrast of the *outline color* against all its adjacent colors becomes primary, as illustrated in the painted bowling ball by Dodie Smith in Figure 9.32. Outlines prevent all colors from having strong directly contrasting effects on each other and can be used to visually separate colors that are not particularly harmonious. In a secondary way, because all colors in a composition are in the same visual field, they still have some effect on each other, although always mitigated by the outline color.

BORDERS AND OUTLINES DESTROY DEPTH AND FLATTEN FIGURES

Compositions with outlines around the objects make them appear to be flat. The outlines eliminate the 3-D effects in the whole composition, although inside the outline a figure can have 3-D techniques like blending and chiaroscuro. In Figure 9.33, the leaded glass lamp has delicate outlines around the dragonfly and through the wings, giving them a flat, nonrealistic appearance.

An uneven outline adds a raw quality of casualness, or naturalness, and accentuates the flatness. The thickness of outlines can have an effect on the composition, making them more intrusive on the design if they are wider and less noticeable if they are narrower. An outline can be so wide that it forms another color area, further intensifying its contrast against the colors of the objects. This effect is used extensively in stained glass, where the outlines can be made from black paint or the lead that surrounds each piece of glass.

OUTLINES "BELONG" TO THE FIGURE

Outlines are seen simultaneously with both figure and ground, but it is clear that their function is to hold in, or support, the figure. Since they appear attached to the figure, if the figure were to magically move, the outline would move with it. Comic strips are a good

FIGURE 9.32 Dodie Smith: Painted Bowling Ball. Marcie Cooperman.

example of outlines, where the figures "move" by changing position from one panel to the next. Paul Vanderberg's posters in Figures 9.34 and 9.35 illustrate the classic outlining we see in comics.

Because it belongs to the figure, the outline's color must have a strong but subservient relationship to it. If it has more visual strength than the figure, it will overwhelm it and take attention away from it. But if there is not enough contrast between them, the outline won't be visible. Paul Vanderberg's *New York Aquarium* poster illustrates hue and value differences in the outlines. The black outlines make the two fish in the foreground more prominent than the other fish and the other sea creatures who are attempting to hide. Their same-hue outlines make them softer than the black outlines in the Jones Beach poster.

OUTLINES PREPARE THE VIEWER FOR A STORY

FIGURE 9.33 Marcie Cooperman: *Dragonfly Lamp.* Photograph, 2011. Marcie Cooperman.

When all figures are outlined in an image, in our perception the outlines disappear. We don't consciously notice them. However, their effect is still there and we still perceive it subconsciously, because the image is clearly flat and nonrepresentative to us.

That is, it does not look like real-life, 3-D figures. This gives an image an identity other than realistic, and it's very useful for graphic novels and comic books. It opens the door for many types of emotional settings, depending on the colors: playful, sinister, mysterious, and more.

OUTLINES ACT AS THIN BORDERS

Outlines pull together the elements inside and help us see them as belonging together. In Chapter 8, we discussed the Gestalt principle of proximity, where elements that are placed near each other appear to be related. Outlines tell us that all elements inside are part of a family, and are meant to be viewed together. The outlines in Figure 9.36 surround each decorative area, isolating them into separate boxes of designs.

FIGURE 9.34 Paul Vanderberg, Pratt communications design student: *New York Aquarium*. Poster, 2010. Paul Vanderberg.

Transparency

We know transparency right away when we see it. Living in a world with colored glass and plastics, we know how they make the color of objects beneath them look different. And we are familiar enough with it to recognize transparency in a painting.

FIGURE 9.35 Paul Vanderberg, Pratt communications design student: *Jones Beach*. Poster, 2010. Paul Vanderberg.

FIGURE 9.36 Paris Pierce/Alamy: *Russian Border Design #3*. Photograph of fabric pattern, taken 1888. © PARIS PIERCE / Alamy.

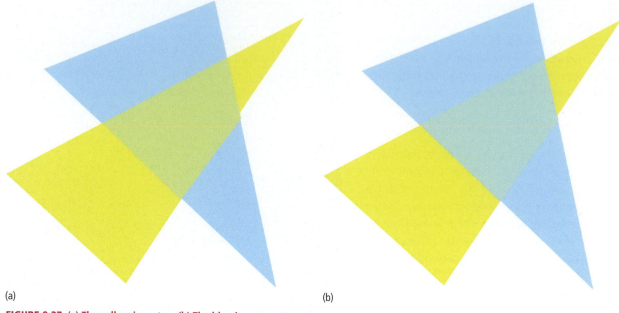

(a) (b)

FIGURE 9.37 (a) The yellow is on top. (b) The blue is on top. Marcie Cooperman.

FIGURE 9.38 Sonya Winner: *After Matisse.* © Sonya Winner www.sonyawinner.com.

But in a painting, **transparency** is an illusion formed by two colors that seem to overlap, their combination creating a third color. In reality, of course, nothing is overlapped; it's just three areas of color that fool us.

We call the first two colors the **parent colors**, and the color they form together is called the **child color**. The child color is some combination of the parent hues, values, and intensities. Just as real parents can produce a number of different looking offspring, in transparency, the child color can vary. The key determinant for its hue, value, and intensity is the question of which parent color lies on top. That color has a greater influence over the result.

For example, in Figure 9.37a the yellow parent appears to be on top because of the high value green child color. In Figure 9.37b, the blue appears to be on top because the child color is a greenish blue, only slightly higher in value than the blue parent.

Sonya Winner plays with transparency in her vivacious carpet, *After Matisse* in Figure 9.38. This irregularly shaped work of art appears to be transparent rectangles randomly tossed on the floor, with overlapping parent hues creating the correct child hues. Even in complex combinations of several parent hues, careful thought is given to which hues are combined and which are on top to produce the resulting values and hues. Texture and pile heights enhance the illusions.

Looking at Sasha Nelson's *Water Reflections* in Figure 9.39, without thinking about it we can understand that we are looking at a shallow stream of transparent water. But what is it that indicates this to us? It is the layer of transparent grass shadows

FIGURE 9.39 Sasha Nelson: *Water Reflections.* Photograph, 2008. The water is transparent and reflects shadows. Sasha Nelson.

FIGURE 9.40 Janos Korodi: *Stockholm-Soroksár.* Mixed media on wood, 64.5" × 78.7", 2004. This illustrates transparency of glass. Janos Korodi.

and high-value blue sky reflections over the layer of stream bed leaves and dirt. Likewise, the higher-value areas in Janos Korodi's painting in Figure 9.40 give the impression of the transparency of glass through which reflections of buildings and sky appear over a layer of a room's interior.

summary

Color location within the composition sets up important structural relationships with borders, backgrounds, and outlines. Although these arrangements with which we are so completely familiar seem like they would be less important than the composition they adjoin, their influence is huge. Backgrounds, borders, and outlines can make one color or another stand out. By enhancing various colors inside the image, they can change the way the compositional elements move the eye, and alter plane locations. And transparency effects can play with our sense of three dimensions on a two-dimensional surface. Use these effects to further the sophistication of your composition.

quick ways . . .

Background colors—What colors do you have in your background, and how do they affect the figures on them?

1. Is the contrast in hue, value and intensity good for your figures?
2. How does your background affect the locations of planes?
3. What does it do for continuity?

Borders—Look at your composition to find borders, partial borders and outlines that you might have missed. What areas function as borders or partial borders in your composition, because of the contrast in value, hue, or intensity?

1. What do these areas do for continuity? Do they keep the eye in a certain location or prevent it from going off the picture?

2. Do they delineate the space in any way?
3. Do they align with areas in the composition? How does that affect the continuity, figure/ground relationship, or locations of planes?

Transparency—Do you have areas where the hues suggest transparency or overlapping?

1. Is the child color a logical one in hue, value, and intensity, given the parent colors?
2. Which parent color seems to be on top? How does that affect the focal point?
3. What types of lines occur through transparency? How do they affect continuity?

exercises

Parameters for Exercises

There are many factors of color and color relationships in compositions, and all of them can affect the way the colors appear to the viewer. The best way for students to learn through their color exercises is to have simple objectives and fairly strict *rules* about the type of lines and colors to be used. We call those rules "parameters." With strong parameters allowing only a minimum of elements, it is easier to observe the direct relationships between colors, and to see the differences between the students' compositions. When lots of compositions hang together for a critique, it becomes clear which ones are successful in achieving the goals.

As students learn the objectives and build on their skills, they will become more adept at using color. They will gain the ability to tolerate more complications because they understand the ensuing interactions. Therefore, as we move through the chapters, the restrictions on composition size and the number of lines and colors will be gradually reduced. Larger compositions, more colors, and more types of lines will be allowed. However, certain ground rules will remain the same: Flat color and nonrepresentational shapes will remain constant parameters, and the goal of every assignment will be a balanced composition. Five specific parameters include:

1. No recognizable objects are allowed.
2. All colors are to be flat and nongradient, with hard edges that don't fade away.
3. White is always considered a color, even if it is the background.
4. Only neatly cut and pasted papers are appropriate.
5. Balance and unity are *always* the singular goal of every composition.

1. ***Create backgrounds:*** Create a 5″ × 7″ composition using a computer program such as Illustrator. Give one hue a large area, and use the complement for the background. Copy this for a second composition, but with an analogous hue for the background. Evaluate the differences and explain which one supports the hue better.

2. ***Create borders for paintings:*** What effect would borders of different colors have on your favorite famous paintings?

Find two paintings from different eras and surround each with a removable low-value border, a white border, and a border of your choice. Discuss the differences in your class critique.

3. **Create borders for photographs:** Check out hue possibilities for borders around a photograph. Choose an interesting photograph, and save it in a file in your computer. Choose three different colors, apply each of them as a 2″ border in Illustrator or another computer graphics program, and see how they affect the photo. What hues do they emphasize? How do they affect continuity? Which one is successful and why? Print them and discuss the results in your class critique.

4. **Design your borders:** Work with color and shape in designing your borders. Make a simple 5″ × 7″ composition using five colors. Figure out the physical structure of this situation: Create five different borders that fit precisely around the exterior edge of the composition, but that can be removed and replaced. Each one must accomplish *one* of the following goals:

 - This border should make movement flow into it and back out, returning to the picture it surrounds.

 - Make this one visually stand apart from the composition, contrasting greatly and providing a protective barrier for it.

 - This border should strengthen the intensity of the composition's colors.

 - This border should enhance the value of the composition's colors.

 - This border should be an organic shape on its inside edge, and it should completely alter the continuity of the composition—including a different focal point.

5. **Create outlines:** Explore what outlines can do for your composition. Create a 5″ × 6″ composition in your computer graphics program using no more than five colors. Make several versions of that composition, each with one of the following changes:

 - Use white or very high-value outlines around the objects.

 - Use black outlines.

 - Use outlines that vary in color for each object.

 - Use outlines that vary in width throughout the composition, with your choice of color.

 Compare all compositions with the original outline-free one in a class critique; discuss how they affect simultaneous contrast in the image.

6. **Evaluate transparent objects:** This exercise will help you train your eye in perceiving the exact colors of transparent materials and how they affect other colors seen through them. Look around at home and find two different transparent materials like colored bottles or plastic. Study each one to evaluate how its color influences an object placed underneath it. For each, paint a piece of paper in the color you see to try to match it.

7. **Create an illusion of transparency:** In this exercise, the goal is to use your imagination to create the illusion of transparency and explore the possibilities for child colors. Make two 6″ × 6″ compositions using the same two overlapping hues. In the first composition, the child color should indicate that one parent color appears to be on top. The child color in the second composition should indicate that the other parent color is on top. Bring them to class for a critique to evaluate your success: Are the child colors credible? Do they indicate that the correct parent color is on top?

Using Color to Communicate in the Design Industries

The Power of Color

Color is the key to success in the design industries. Color is what drives customers to your door. But the wrong color can keep customers from buying your product. How is it possible that the power of color is so strong?

It all adds up to this: Consumers have emotional reactions to color, and this moves them to create emotional attachments to a brand or product associated with that color.

Businesses send messages to their customers through the colors they use in their logos, ads, packaging, trade dress, and products. It is most amazing that customers interpret those colors and recognize that certain products are meant for them. The key is their emotional response; it's what drives sales of any product. But how do the businesses know which colors will produce that positive response on a large scale—within their entire target market?

In this chapter, we look at the meaning of color and how it is used to attract target markets. We trace how color trends arise and how businesses communicate with each other about color. Producing consistent color requires regularly measuring the amounts of primary hues that are used for each color in each product, and we will examine that process, as well as problems that can occur with color. Finally, we describe the "color management" process

FIGURE 10.1 The fabric on these Louis XV style chairs matches the wallpaper, as well as the paint colors. Hafizov.

that is necessary to help color move between the RGB system of the computer monitor, and the CMYK system of the many digital devices we use today.

COLOR EVOKES EMOTION

Colors are so important to us as consumers that we may decide not to buy a product just because we don't like the color. Or conversely, we may fall in love with a color and that may be enough to convince us to buy one brand over another, or spend more money than we had planned. We choose colors for the things we use because they make us feel something. They may soothe us or excite us, or just make us feel good.

Preference for colors depends to a great extent on the person doing the buying. Age and gender, as well as attitudes and lifestyle, dictate our choices. As we grow and mature, our tastes mature as well and the colors we choose usually become more sophisticated.

The culture in which we live also has a lot to do with colors that seem "normal" to us; normal is what we grew up with, what our friends and family choose, and what our neighbors and others in our area approve of. This is a powerful influence—it takes a strong character to choose colors for clothing and room decoration that do not seem normal. We keep in line because social approval is not something we want to risk losing. You know its power if you have ever gone to a party wearing something different from what everybody else is wearing. Even if nobody says something about it, you are aware that you look different.

We are especially particular about the colors of larger items that we don't replace often, such as furniture, kitchen counters and cabinets, and cars, because we will be living with them for a long time. Interior designers know that they need to understand their clients and their color likes and dislikes to create a comfortable, familiar space in which they can live happily.

We like to live with certain colors, but even more than that, we like our home goods to match each other so that we can use them together. For example, the chairs and walls in Figure 10.1 match each other exactly, and the paint colors blend perfectly as well. Sheets and towel colors should blend together like those in Figure 10.2 because they are visible in rooms adjacent to each other. And the carpets have to coordinate with the paint, curtains, and upholstery fabrics, that decorate the same space as in Figures 10.3 and 10.4.

key terms

color forecasting
color management system
color spaces
metamerism
spectrophotometer

FIGURE 10.2 The towels match the hues and low intensities of the sheets. Brian Goodman/Shutterstock.

FIGURE 10.3 Maryann Syrek, interior designer: Great-room. Low-intensity browns of several values provide a comfortable, low-key atmosphere. Maryann Syrek.

FIGURE 10.4 Maryann Syrek, interior designer: Dining room. Mostly neutral with a kick: blue and white harlequin tiles balance the warm woods and crown moldings. Maryann Syrek.

You can see the value of coordinating product colors by traveling to another country. The colors of their upholstery fabrics and clothing might look strange to you, simply because they are different from those in your home country. If, for example, you are searching for a particular type of yellow for your tablecloth to match your dishes, you might find that the yellows in the foreign country don't work because they are grayer or possibly more intense than you are used to.

You can bet that if coordinating colors is important to us as consumers, it's important to the manufacturers of these products, and they do their best to choose their product colors carefully to coordinate them with complementary products. In fact, color is the key product decision that they can make.

HOW MANUFACTURERS USE COLOR

What kinds of companies need to choose colors for their products? The answer may surprise you: *all* of them. Look at everything on your desk, in your kitchen, and in every store. Color is used for products as wide-ranging as bricks, kitchen cabinets, cleaning liquids, paper, toys, makeup, paint, cars, power tools, and fabrics. Food products like pasta, candy, and drinks come in colors, too. The bottles and containers that hold all of these products also have color. Even drug capsules and medications are not exempt; people identify the pills they have to take by their color.

Manufacturers of all these products are concerned with using the *right* colors, the ones that will make their products sell better, the ones that we consumers will fall in love with (Figure 10.5). Many manufacturers choose the colors for their product line only once, and that choice will stay the same for years to come. Changing the color later on will not be an option because the color becomes the way customers recognize the brand. The right choice is crucial.

Sudsorama™ The Soap Shop colors its soaps to reflect their natural origins and scents, but they must be careful to keep these low intensity colors delicious and non-muddy. Their Bamboo Charcoal soap colors give us an understanding of its organic oils and activated bamboo charcoal, scented in green clover and aloe. Sandalwood soap mimics sandalwood's traditional low intensity chocolate-y hue, with green for an organic fee.

Carla Horowitz of The Clay Cellar Pottery makes stoneware bowls and plates, products that will be used right next to food. She chooses her colors based on their simultaneous

FIGURE 10.5 Bamboo Charcoal soap uses its colors to illustrate its organic oils of coconut, palm, extra virgin olive, castor bean, along with chromium green and activated bamboo charcoal, scented in green clover and aloe while sandalwood soap mimics sandalwood's traditional low intensity red hue with green for an organic feel. Courtesy of The Soap Shop.

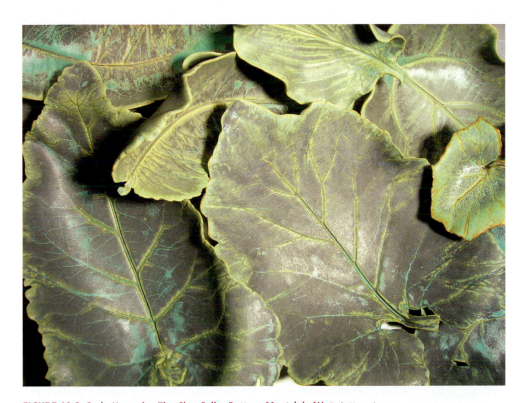

FIGURE 10.6 Carla Horowitz: The Clay Cellar Pottery, Montclair, NJ. Carla Horowitz.

FIGURE 10.7 The colors of the 1970s: Harvest gold, avocado and orange. iofoto/Shutterstock.

FIGURE 10.8 A bathroom outfitted in popular 1950s pink tile. © Wollwerth Imagery/Fotolia.

contrast with food colors, and often goes with gradient values of natural food colors or complementary relationships. Her green leaf plates in Figure 10.6 look natural supporting olives or breads.

Evidence of consumers' preference for particular hues has shown up in many industries for centuries. These color trends can be so strong that in retrospect we associate certain colors with specific time periods. For example, some color names will draw groans from those who remember owning the popular kitchen appliance and furniture colors of the 1970s: harvest gold and avocado green (Figure 10.7). That's because, from the vantage point of the new millennium they might be seen as ugly. And in 1950, pink and blue bathroom fixtures were all the rage (Figure 10.8).

In the United States, many buildings are still standing from the colonial era. Their brick, stone, and limestone frames have wooden windows and doors that regularly need to be

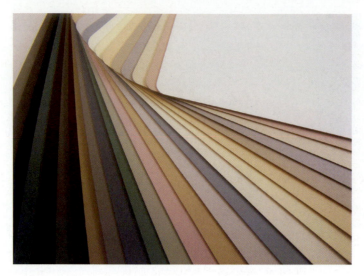

FIGURE 10.9 Fan deck of low intesity paint colors. © dwags/Fotolia.

FIGURE 10.10 Green 1996 Ford Explorer. Ford Motor Company.

painted and restored to their original appearance. The popular colors of the day included low-intensity versions of all hues, which complemented the natural building materials. You can see examples of these colors in the fan deck in Figure 10.9. The colors from this paint company blend well with colonial architecture.

Trends in specific hues can even spill into the car industry. For example, for several years from 1995 through the turn of the twenty-first century, the public was fascinated with green in all sorts of home furnishing products, and green was everywhere on the road as well. The 1996 Ford Explorer in Figure 10.10 is just one of the many hues of green demanded by car buyers at the time.

Many companies need to know which colors work well together, so that they can put together a color palette for their product lines. A color palette is a range of colors that are meant to look pretty together. Besides looking pretty, the palette provides color choices for consumers, and coordinates with complementary products that might be made by another company—but the colors need to stand out against the competition, too. Coordinating and yet standing out is a lot of responsibility for color. But it is vital to succeed; if consumers feel positively about the company's choices, they will like the company. It's that simple.

Manufacturers are not the only type of business with an interest in product colors. A business that offers a service must choose colors for its space that enhances its image and affects its customer in a positive manner. For example, restaurants often choose reds for their walls to excite the appetite and encourage an upbeat mood, like the restaurant in Figure 10.11. Diners entering the restaurant think the party has already started and anticipates a great meal—an expectation set by the lively atmosphere or red walls amid low lighting.

In contrast, a spa might rely on cool hues or low-intensity tints to calm nerves. Hospitals or schools might choose blue tints to create a peaceful atmosphere. For example, Changing Heads couture hair salon in Tappan, NY chose the color palette with just this goal in mind (Figure 10.12). The blue and green colors are intended to cool out the hair and skin tones of the clients while creating a sense of peace and serenity. Whereas, Massage Envy uses low intensity versions of the complementaries, violet and gold, to express wellness and to communicate the goal of reducing stress through massage (Figure 10.13).

Hotels also use color to express their character and style. For example, in Napa—the well-regarded wine country of California--the elegant accommodations at the Milliken Creek Inn and Spa use serene colors accented with an exotic flair to suggest sophistication plus a tranquil, intimate ambiance (Figure 10.14).

PANTONE COLOR MATCHING SYSTEM

Many companies in design industries, including product design, apparel, interior and graphic design, as well as printing houses, specify their colors by using Pantone color standards. Pantone is the best-known and most well-used color communication and quality control system. It produces fan decks of standardized color swatches, like the Formula Guide in Figure 10.15, in which each color is identified by a number that can be communicated and matched anywhere in the world. Pantone's Formula Guide features solid—or "spot"—colors, which are premixed by a printer and applied with a single pass of the press. Pantone solid colors can also be closely reproduced in CMYK—or "process"—printing methods, where the color is created by overlaying inks though multiple passes of the press; CMYK formulas for creating Pantone colors are provided in the PANTONE Color Bridge Guide, which also features color values for RBG (computer monitor) and html (web) Pantone color reproductions.

The best reason for using Pantone is the very fact of its global popularity. It is easier to communicate about colors, and reproduce them accurately, when every industry member is using a standard system. To highlight its reputation for accurate color, Pantone LLC moved into new territory by opening a boutique hotel in Brussels in 2010, where the décor is based on its saturated hues contrasted against white backgrounds. Each floor is highlighted by a specific color, paired with associated emotions, so that visitors can custom tailor their experience. Even the cocktails in the bar are named after Pantone colors, like Lemon Drop Pantone 12-0736.

COLOR TREND FORECASTERS

Fortunately for the marketing world, there are companies called *trendspotters* or *trend forecasters* that offer their **color forecasting** advice to businesses that sell to the public and need to know what colors they will want in future seasons. Trendspotters research the visual output from designers, artists and innovators, as well as social and cultural trends, and political movements. They look at how people are feeling as an ongoing process, judging where we will be in the near future. Then they translate these ideas and emotions into colors. The best and most effective trendspotters

FIGURE 10.11 The wall of the bar is painted tomato red.
onairda / Shutterstock.

FIGURE 10.12 The couture salon (left) and powder room (right) of Changing Heads Salon.

FIGURE 10.13 Massage Envy, Nanuet, NY.

can communicate the story with specific information about color ranges that businesses can use.

You can imagine how hard in can be to choose the best colors; the popular colors will not be the same from year to year, and popularity varies depending on the product. The type of color we would love for our car is probably not among those we want to look at in our curtains, or live with on the living room sofa. And we might have totally different ideas for our clothing, which change as one season passes into the next. Boredom and the need for newness spur us on to new color combinations from year to year.

Our preferences are altered as we go through our lives exposed to visual influences from colors and objects we see everywhere: in stores, in friends' homes, in magazines, on the Internet and on TV. But where do those visual influences come from? Somehow, new ideas are in the air through our associations with each other, and some artists, designers, and photographers catch it. They process what they see together with their personal viewpoints, and give it back to the world in the form of their creative output: paintings and sculptures, visuals in conventional and online magazines, videos for all of our electronic devices, and advertising images and photographs.

Also, a very small percentage of innovative consumers know what they want *now*, and it isn't what they see in the stores. They put together their own combinations of colors and clothing pieces, and it turns out that they are the leaders for the rest of us, helping to set the trends when they are "spotted" on the city streets, and trendspotters look to them for color direction. For example, the "Grunge" style of the early 1990s began on the streets of Seattle, worn by kids who dressed down in tattered jeans and plaid shirts.

FIGURE 10.14 Milliken Creek Inn & Spa room: Low values and warm colors. Photo courtesy of Milliken Creek Inn & Spa, Napa, CA.

FIGURE 10.15 The Pantone Formula Guide for coated paper. Photo Courtesy of Pantone.

Fashion and home goods companies need to know early in the design process what will be the color trends up to two years down the road. This is because the many raw materials used in the process need to be the proper colors. Clothing, for example, is made of fabric, thread, and possibly notions like buttons, zippers, and lace. But retail customers couldn't even say what they will be wanting in two years. That's why trendspotters are necessary to anticipate and communicate customers' needs to businesses.

Here is how the time schedule plays out in the fashion world. We see new spring fashions in the store in early spring. Fashion designers had sold those spring collections to retailers in October of the previous year. They had designed and made their garment samples during the previous six months, using fabrics in the proper colors. The fabric companies had shipped the fabrics to the designers one year ahead of when the garments would be in the stores. Those fabric companies had sold their goods to designers a few months before that, which means they had to know what colors to produce up to a year before. This places the color decisions two years ahead of the retail clothing sales.

Trend Union is a trendspotting company whose purpose is to search out the trends in color and texture, for use by fashion and beauty companies that need to plan their product lines. Trend Union creatively presents its findings by making trend books and videos for the industries that need them. It also offers its expertise by consulting with companies, gearing color and style trend information to its clients' products.

Promostyle is another trendspotting company that forecasts trends 18 to 24 months in advance of the sales date. To keep colors standardized, it translates them into Pantone hues. ESP Trendlab and the Doneger group also conduct trend research and consult with many industries as far in advance as they need.

Stylesight is an online search and retrieval system offering design professionals organized trend information in fashion, for all target markets. It is heavy on lush visuals with corresponding Pantone colors, which are especially useful for fashion industry members when they are planning their lines.

COLOR TRADE ASSOCIATIONS

The Color Marketing Group (CMG) is a nonprofit international organization whose purpose is to provide color trend direction for industrial companies in their search for the right colors to use for upcoming products. Working 18 months in advance, CMG offers online resources as well as conferences for industry members. CMG's slogan is "Color Sells, and the Right Colors Sell Better."

The Color Association of the United States (CAUS) is the oldest color trade association in the United States. It offers color trend information gleaned from social and political trends, and consults with companies to develop their strategies in using color to stand out among the competition. Stylists, manufacturers, merchandisers, and designers from many fields and from many countries utilize CMG's information in making color decisions.

The Inter-Society Color Council (ISCC) is a professional, nonprofit organization charged with several goals: working with "color problems arising in science, art, history and industry for the benefit of the public at large"; furthering color and color appearance education; and helping color scientists communicate with artists and designers who use color in computer programs and printing inks. ISCC focuses on the scientific aspects of color such as color research, color vision, and instruments that measure color; the psychology of color—how people perceive and use color; and on teaching the public how to use color more effectively.

Working 22 months ahead, the International Colour Authority (ICA) publishes color trend forecasts for furniture and textiles companies. To ensure accuracy, the ICA presents colors in the Pantone and the NCS standard color notations. It also offers an ICA Seal of Approval for some industry members' color ranges, which can then be used on advertising and promotional materials. This is important for companies that want to make sure their color offerings relate to those of others' in their industry.

Printsource is a trade show held three times a year, showing trends in colors and prints for paper goods and textiles for fashion and the home. At these shows, industry members such as fashion designers, retailers, and product developers can do business and attend seminars about color trends around the world. Printsource also offers research and advice on the changing color preferences for consumer products.

Businesses Use Color to Communicate

Marketers have three goals in choosing the colors of their products and packaging:

1. **To appeal to the target market.** All of us are part of a larger group of people called a *market segment,* who share several characteristics with us. We might share demographic qualities like age and gender, or we might share the type of lifestyle that we live. These characteristics cause those of us in that market segment to have similar likes and dislikes. This makes it easier for companies to know what we look for in our brand choices. Businesses that want to sell their brand of products to us can target our segment, thus identifying us as their *target market,* and then work on making things that appeal to us. We will notice and like certain colors, and those are the colors these businesses want to use for their packaging.

2. **To communicate the benefits that a brand can offer to the target market.** Based on our likes and dislikes, we buy products because we get certain *benefits* from them.

For example, they may solve a functional problem; they may help us gain social acceptance; they may make us feel good about ourselves; or just offer us a great experience. But we are impatient when we shop. We instinctively try to figure out if a particular brand will offer us the benefits we desire before we even commit to buying it and trying it. How do we do this? We make inferences and assumptions from the colors of the packaging. This behavior illustrates how imperative it is that the colors express the correct information to customers.

3. **To differentiate a brand from the competition.** Most of our purchasing decisions are made right in the store. There are so many competing brands vying for our attention that it would seem hard for us to make a choice. But we have ways of making it easier to choose. If we see colors that we recognize from one particular brand, we will pick it out right away from the clutter on the shelf. Colors that we like attract and hold our attention. Strong visuals like color can stand out and catch the eye before mere words ever could. Of course, since all marketers are trying to use color to stand out, each has to be very crafty in making its choice work.

APPEALING TO THE TARGET MARKET

Why does a particular color attract our attention? Why would we pick out one brand's package among the many that are displayed on a shelf? And why do some people want certain colors for products like their sofas or power tools, while others choose the opposite type of colors?

We like certain colors because they have meaning for us. The meaning is tied up with an emotional response that is informed by all that we are. When we see a color on a product, we imbue the brand itself with the meaning we associate with that color. For example, if a youthful male target market sees red as the proper color to indicate rebellion in a sports car, the red Ferrari zooming past them will embody rebellion. If Ford wants to convey that rebellious feeling to that target market, it needs to make its Mustangs red. A dark blue Mustang will not sell well with that target market because it doesn't mean rebellion to them. And a pink Mustang will just look feminine.

Colors evoke our emotional responses based on what we have learned culturally through behaviors and attitudes exhibited by our families, and by our friends and neighbors in our particular town and country, and of course through our own unique personalities. These attitudes and behaviors help us to understand colors that are acceptable to use, based on our age, stage of life (single or married, with children or empty nesters), and other demographic descriptors. We also look for certain colors depending on elements of our lifestyle, such as how active we are, how trendy we need to be, or how traditional we feel.

An important goal for manufacturers is to make the product appeal to a customer of a specific age or gender. Children, for example, are generally thought to respond to intense colors, so mostly all toys are primary and secondary hues. Turn on the TV to a show where everything in the set seems to be in those six colors and you know it is aimed at kids. It is intriguing that most toys seem to have many parts, each of a different color, as in the products in Figures 10.16, 10.17, and 10.18.

Lower intensities would be associated with a more mature and sophisticated consumer who is older. Men are courted with colors that could not be mistaken for products meant for women. Men's razors are offered in manly colors of silver, black, and the occasional safe blue, but women's razors come in delicate high-value pinks, blues, and greens.

Power tools are a signal imbued with brawn, and men recognize themselves as the target for companies that manufacture them. How do men know these tools are designed for them? Their masculine appeal most likely comes from the combination that every manufacturer uses in coloring the tools: black combined with one strong, intense hue. The exclusive use of a particular hue differentiates one brand from another. For example, the three major brands use primaries. Black and Decker uses a yellow–red, DeWalt

FIGURE 10.16 These shapes of primary and secondary hues fit together.

FIGURE 10.17 Intense colors for blocks for young children.

FIGURE 10.18 Stick-Lets from Kazakia Design LLC can hold twigs together to build a fort or teepee. Kazakia Design LLC.

FIGURE 10.19 Red power tool. Ruslan Semichev/Shutterstock.

FIGURE 10.20 Yellow power drill. Warren Millar/Shutterstock.

FIGURE 10.21 Green electric drill. © tuja66/ Fotolia.

uses a warm red–yellow, and Makita uses a green–blue. Examples of typical tool colors are shown in Figures 10.19, 10.20, and 10.21.

But some tool manufacturers realized that women would be more likely to buy tools from them if they came in women-friendly colors, colors that announce that these tools are for women only as in Figure 10.22. Men would not dare to be caught using them.

Athletic teams also use colors to rally the loyal fans, as we can see in Figure 10.23. Primary and secondary hues are the most popular—possibly for their visibility on the field.

COMMUNICATING THE PRODUCT'S BENEFITS

Color is the marketing tool that sends a message to consumers, instinctively, without even engaging their conscious attention. Product colors, logos, hangtags, ads, homepages, packaging and labels, all describe how buyers should feel about this product—is it sophisticated, young and kicky, functional, organic, or futuristic? The message of color is actually understood faster than words.

For example, UPS's brown is utilitarian, reminiscent of brown craft paper used to wrap parcels, suggesting that the company will work hard for the customer. Christian Louboutin's red soles stand out as fashionable and exclusive, meaning that the shoes will make the customer distinctive in a crowd. We will discuss both of these brands and their proprietary colors in more detail in the next section.

Breyer's ice cream is a good example of the use of color in packaging to convey benefits. Traditionally, dairy product packaging was mostly white to evoke freshness, and Breyer's used white as well. But in the 1980s, the design firm Gerstman & Meyers specified a black background. This created a sharp contrast in the package colors, and each ice-cream flavor looked delicious against the black. The color choice was backed up by market research on consumer preferences. Apparently freshness lost out to deliciousness for the ice-cream consumer. After implementing this color change, Breyer's became the leading national ice-cream brand in the United States. Bassett's ice cream (Figure 10.24) is dear to loyal Philadelphians, who know it is packaged in a fresh blue container that stands out among the competition.

Some companies create products that come in many colors, such as yarn and paints. They need a multicolor label to quickly communicate the message of color availability to the viewer.

FIGURE 10.22 A pink set of tools. © nielskliim/Fotolia.

FIGURE 10.23 Sports teams logos. © Ted Pink/Alamy.

FIGURE 10.24 Bassett's ice cream container. Courtesy of Bassett's Ice Cream Company.

FIGURE 10.25 Blue Heron Yarns label.
Marcie Cooperman.

For example, in Figure 10.25, the gradient hues and orange and blue complements of the Blue Heron Yarns logo convey the impression of the spectrum, and we are intrigued by its beauty.

But, what product benefit would green ketchup convey? Green seems totally wrong for a tomato product, making it the perfect color choice for Heinz EZ Squirt Blastin' Green ketchup, introduced for children in 2000 Most likely, the market thought that green represented childish mischief, reminiscent of Dr. Seuss's book *Green Eggs and Ham*. And, more to the point, the market approved. Sales proved that the green was the right choice.

Even flags use colors that are meant to convey their country's benefits to their citizens and the rest of the world. Before the nineteenth century, most national flags tended to be composed of hues chosen for their heritage, rather than having any particular meaning. But countries that have incorporated more recently have chosen colors for their flags with meanings that represent their national goals and origins, and these colors are placed in a more contemporary design. Ancient or new, the flags of most countries seem to be composed of a limited number of vibrant high-intensity hues.

For example, in Figure 10.26 the flags of Sweden, Canada, and Belgium are more traditional in their use of color. In Sweden, blue and yellow have been used on its flags since 1275. Canada's flag uses the colors of St. George's Cross, an English symbol of England's patron saint dating back to 1190 that might have been adopted from the flag of Genoa of 1096. Belgium's red, yellow, and black, dating from 1831, are based on the historical colors of one of its regions.

Among the newer flags, Portugal adopted a design for its flag in 1911, using a green and red field. The green represents the patriotic value of national hope, and the red symbolizes those who lost their lives for the nation.

In the flag of South Africa adopted in 1994, the red, white, and blue represent the early republics of the country; and the yellow, green, and black come from the flag of the African National Congress, the governing party. Green represents the land's fertility; yellow stands for its natural resources like platinum, manganese, and gold; and black represents the people.

The flag of Namibia was adopted in 1990, when it gained independence from South Africa. The blue represents Namibia's water resources and rain, the yellow sun symbolizes life and energy, green means plants, white represents peace and unity, and the red stands for Namibia's people and their valor and equality.

Contrary to popular belief, no associated meanings are legally defined for the United States flag. In 1782, however, Charles Thompson, Secretary of the Continental Congress, noted about the colors for the Great Seal of the United States, Figure 10.27, which we still

FIGURE 10.26 Flags of the world.

FIGURE 10.27 The Great Seal of the United States. Vladislav Gurfinkel/Shutterstock.

see on the back of the dollar bill: "White signifies purity and innocence, red, hardiness and valor, and blue … vigilance, perseverance and justice."[1]

DIFFERENTIATING A BRAND

How would you feel if someone you love gave you a box colored a certain high-value, greenish blue hue like the one in Figure 10.28? Could you guess what's inside? No problem! We all know that it would contain a lovely piece of jewelry from a certain Fifth Avenue shop we admire called Tiffany & Co.

It's no coincidence that we are familiar enough with that color to recognize the company that uses it: Tiffany worked hard to teach us that trick. Even if you aren't in the market for jewelry, you have probably noticed those ads enough times to become familiar with the color. In fact, the blue represents Tiffany so well that you don't even need to see the company name in that ad.

Tiffany even obtained a trademark for this color, called Tiffany Blue, prohibiting any businesses from using it on a product that could be confused with Tiffany's, so that the color would be exclusively associated with its own brand. The Pantone Matching System gives this color the number 1837, the year that Tiffany & Co. was founded, and it is unavailable to the public on its fan deck.

Tiffany & Co. is a perfect example of the successful use of *trade dress*, the practice of using colors for the product, packaging, uniforms, trucks, or logo of a product specifically to make it stand out from the competition and to convey an emotion connected with the brand. All companies, in every industry, need to communicate to their

FIGURE 10.28 Tiffany Blue box. pedrosala/Shutterstock.

FIGURE 10.29 Red soles make a fashion statement that appeals to those who crave social acceptance. Croisy/Shutterstock.

customers how they are different from and better than the competition. Visual elements such as trade dress go a long way in helping us understand what a brand is all about.

For example, think for a moment about shoes. It's amazing that we instantly recognize a certain brand walking by that has red soles. We are looking at an important marketing tool for Christian Louboutin, for which the company owns a patent. The red sole identifies the product immediately in the eyes of those in the know, including every style conscious woman (Figure 10.29).

UPS has succeeded by trademarking its brown, a color little used in industry, but it perfectly conveys its utilitarian and ubiquitous qualities. UPS colors its trucks and uniforms brown, and even calls itself "Brown" in its ads to further impress the color concept on the customer. Presumably, brown implies the cardboard boxes that are used for shipping, as well as their useful workhorse aspect. The brown can make the UPS brand appear to be indispensable for shipping. UPS's main competitor, FedEx, combats the low-intensity brown with a colorful array of hues with purple on a white ground, separately chosen for different operating units.

Many companies would love to emulate Tiffany's success in their logo or trade dress colors. But most choose popular and well-used primary or secondary hues, and that makes standing out in a crowd more difficult. Trademarking these colors for exclusive use is not possible, but it is for a unique color.

A company logo adds support to its colors by using a few letters as shorthand for the company's name, in an interesting design using compelling colors. The logo has many uses; it can be used as a letterhead on letters, placed in an ad, and on signs and billboards. The majority of logo colors seem to be red, blue, green, orange, and black. Yellow is used only in conjunction with other colors, usually red, because without a border of another color, yellow would be illegible. Lower intensities and higher values are not usually considered for logos.

Logo colors are chosen for the meanings they convey to us. Red, for example, has many admirers because of its tendency to attract attention in ads or packaging, especially when paired with yellow. Red indicates excitement and it's clear how that emotion would benefit the companies using it. We see red in Figure 10.30 in logos for Avis and McDonald's. Glowing and happy, sun-like yellow appears in the logos for McDonalds and Hertz. Budget's blue and orange has the strength of complementary contrast, as does the Gulf sign in Figure 10.31. The old gas station signs depend on red and orange to attract attention outside against blue sky and green trees. On the other hand, HP, Chase Bank, and Samsung use calm and dependable blue in their logos, a quality necessary for banks and electronic brands. Fresh, natural, organic-looking green is used by Whole Foods, Starbucks, and Animal Planet.

FIGURE 10.30 Company logos for McDonald's and car rental agencies: Avis, Hertz, and Budget. © Finnbarr Webster/Alamy and © Jeffrey Blackler/Alamy.

FIGURE 10.31 Old gas stations signs. © Michael Dwyer/Alamy.

Bright, hardworking orange signifies Home Depot. More on the meanings we associate with colors later in this chapter.

Measuring and Matching Color in Industry

It is a wonderful thing to have the ability to produce products in such a wide range of colors. But manufacturers have realized that a decision to make a product in a certain color incurs the responsibility to produce that color accurately for every succeeding product, every time. To a customer, such standardization demonstrates the quality and reliability of a product.

Producing accurate color in any type of material, whether liquid, powder or solid, is a painstaking process. As you can imagine, different materials and qualities of texture affect the way a color looks. Achieving the exact color takes skill and perseverance, as well as constant analysis.

The manufacturer needs to begin with a color system that includes a sample swatch of the desired color and the pigment or dye "recipe" for making it. The swatches are convenient for comparing possible choices for color, as well as for seeing how they differ in various light sources. The process of dyeing the material includes measuring the color and comparing it to the sample swatch, to make sure it is correct. The color of the finished product must be tested on a regular basis, to compare it to the sample and keep to consistent quality standards.

MEASURING COLOR WITH A SPECTROPHOTOMETER

Labs and production facilities use an instrument called a color measurement **spectrophotometer** to measure color in all sorts of materials, such as paper, paint, plastics, metals, liquids, and fabrics. The spectrophotometer does this by measuring light that is absorbed into a surface of a material. The light hitting the surface is made up of a combination of the wavelengths of three primary hues—red, green, and blue. The surface absorbs some of these wavelengths and reflects others. The wavelengths of light that are reflected and not absorbed determine the spectral hue of a color, and are known as the *spectral reflectance curve*. Two color samples with the same spectral reflectance curve are said to be a *spectral match*. Colors that are a spectral match have the same color in any light source.

Sometimes two colors that appeared to be the same are revealed to be different under another light source. Have you ever put on socks at home that you thought were the same color, but outside in daylight they were revealed to be different colors? Or two samples of paint that looked different to you in a store appeared to be the same in your home. This is called **metamerism**, and those pairs of colors are called a *metameric match*. This difference in their appearance happens because the colors are not a spectral match; that is, they do not have the same spectral reflectance curve.

Every light source combines with the color of the material and affects the color we see. For example, natural light is mostly white, as is halogen light. But fluorescent lights can have a pink or a blue cast, and incandescent lights have a yellow color. Different types of colorants and different materials that look the same under one light source look different under another, causing another type of metameric match. Businesses that put many types of materials together for their product, such as the interior of a car, need to work with metameric matches, making the colors look as similar as possible. Since they are not the same spectral hue, this requires careful observation, keeping the lighting source constant.

The product's material can affect the way the color looks during the measuring process. Transparent materials, for example, transmit light through the surface, and that lightens the color that we see. Translucent surfaces only partly transmit light and no light is transmitted at all through opaque surfaces, which could be of any material ranging from soft fabrics or rubber to hard materials like plastic or metal.

It is necessary to measure all of these types of materials carefully to eliminate color discrepancies. Translucent materials should have an opaque, uniformly colored backing behind them when they are measured. With liquids, the size of the vessel is important, because that changes the amount of light that passes through the container. The color would be darker in a large vessel than in a small vessel because less light can pass through. To measure accurately over time, the trick is to use the same-sized vessel every time. Also, liquids may have dirt or bubbles, which alter the color measurement. If that is the case, the color of the liquid must be measured at least three times, and the average used.

Powders also are sensitive to ambient light because light gets trapped between the particles. Using a thick enough sample helps make the substance more opaque, and measuring three separate portions from the same batch averages out the results.

Shiny surfaces like glass or plastic reflect light. This is known as *reflection haze*, and it can interfere with our perception of the material's color. But the spectrophotometer can compensate for errors that occur due to reflected light from a shiny surface.

Keeping the product color consistent requires testing the colored material on a regular basis, and using the same methods on the same instrument so that no inconsistencies or defects alter how the color is taken up.

USING DYES

Dyeing fabrics, wallcoverings, and carpeting is an art more than a science, which makes color matching difficult. Fabrics and yarns for fashion and interior design are dyed in batches of dye solution, which are called dye lots. So many factors must be contended with that prevent different dye lots from being identical, even though they are made from the same color formula. Humidity and temperature influence the results, as well as fabric differences. Even cotton from different crops takes up the dye differently. However, all fabrics from one dye lot look exactly the same.

There are slight inconsistencies in the dye lots of yarns used for knitting, too. But these dye lots are numbered, and manufacturers and consumers alike can utilize the dye lot numbers to identify the batches. Anyone who knits would tell you to buy all the yarn you need for a sweater at one time from one dye lot, so that you can be sure of even color. Some lower-grade knitting yarns are considered "no dye lot yarns" because the fibers are dyed before being spun into yarn, and they are not numbered.

Dye lots for wall coverings have numbers as well, but fabrics for fashion and interior design do not so it is impossible to distinguish batches for color matching.

Yarns for fabrics can be dyed at three different stages—the fibers can be dyed before they are spun into the yarn, after being spun, or after being woven into fabrics. Dyeing fibers before being spun has the advantage of consistent color because the dye saturates the core of the fiber. But it provides less flexibility to the manufacturer because a quantity of goods has to be committed to that particular color. This is not always practical because it is not easy to predict how much yardage will be needed for any particular season, or how long the

FIGURE 10.32 Colorful fabric at a market in Peru. Neale Cousland/Shutterstock.

color trend will last. Also, intricate patterns on fabrics require dyeing or printing them after they are woven.

Yarns that are dyed after being spun produce color that is more even in the resulting fabrics. This is important for jacquard weaves and tweeds like the one in Figure 10.32, where the weave of colors produces the design.

Color Management

Have you ever noticed that when you send something from your computer screen to the printer, the print doesn't match the colors on the screen? Or when a picture is scanned the image on the monitor has entirely different colors? There are very good reasons for this problem and it plagues all companies that work digitally: Printers, scanners, computer monitors, printing presses, digital cameras, and other digital devices do not all use the same primaries. Therefore, they do not produce the same *number* of colors, and some of the colors they produce look different.

The way color is displayed is *device dependent*—what you see depends on the device on which you are seeing it and the primaries it uses. Paintings use red–yellow–blue (RYB) as primaries, but computer monitors are a light-based system that uses red–blue–green (RGB) as primaries. Printers, scanners, and printing presses are pigment-based color systems, which use cyan–magenta–yellow (CMYK) inks as primary hues.

An RGB light-based system can produce many more hues than a CMYK system. This is because the blue in RGB can produce the darker hues, where the cyan in CMYK is too light

to do that. Consequently, black in CMYK (the "K") is used to help produce the low values. But mixing black with other colors reduces the intensity, resulting in two problems: (1) many printed hues are not the same as the corresponding RGB hues on the monitor, and (2) some hues cannot be produced by CMYK.

Complicating matters further is the fact that colors printed on a piece of paper cannot attain the glow of the luminous colors on the light-based monitor. Also, many papers have a slight yellow cast, further changing the colors. A pure white paper can help colors look brighter.

The way to solve the problem of coordinating the colors of a light based system with those of a pigment based color system is through color management. Every device has a *profile,* which is a description of its **color space**—all the colors it can produce—based on its system of primary hues. You could compare a profile to a language. Because devices such as scanners and printers, and monitors have different systems of primary hues, they have different profiles and it is as if they speak different languages. A **color management system** translates the light-based RGB profile of the computer monitor to the pigment-based CMYK profile of printing (compared in Figure 10.33). Color management can also include *calibration,* an adjustment of two devices to help them communicate with each other.

But the prevalence of the many types of digital devices we have today makes it easier to use a standard system for color management that doesn't depend on the profile of any particular device such as the *International Color Consortium (ICC) color management system.* It works because it is a standard that is used by most companies, and every device can be calibrated to it.

The ICC is a consortium of several businesses that was created with the goal of designing a universal color management system that could be used with any type of digital device. It achieved global prominence in 2005, when it was approved as an ISO international standard for computer graphics. (The ISO is the International Organization for Standards, which has defined and published 18,000 standards for many technical fields.)

The ICC system is based on the *CIE chromaticity diagram* (Figure 10.34), which plots the *gamut* (the range) of color that the human eye can see. The gamut includes over 1 million colors, more than the RGB and CMYK color spaces each include, although not all of these

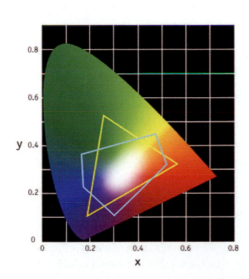

—— *A typical RGB color space*

—— *A typical CMYK color space*

FIGURE 10.33 In this screen shot, the colored area represents the CIE color space, which is the full gamut of the human eye. The RGB and CMYK color spaces overlap a small part of it. RGB produces some colors that are out of the gamut of CMYK, and vice versa. CIE.

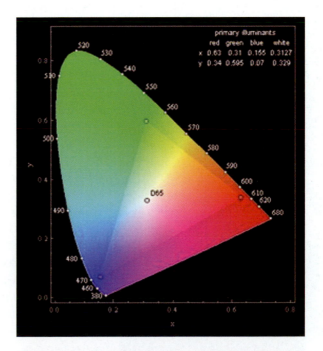

FIGURE 10.34 In this screen shot, the CIE color space chromaticity diagram, representing all the spectral hues plus the Line of Purples. The Line of Purples is the straight line at the bottom of the diagram, on which you can see nonspectral saturated purples and pinks, such as magenta and hot pink. Nonspectral hues are combinations of the hues red and violet, but not generated by the sun's light. CIE.

colors can be printed. In 1976, it was updated to the CIE Uniform Color Space, which plots the colors that can actually be printed. Along with the diagram, the ICC system includes an accurate formula of the primary hues, which is needed to make each color.

Graphic designers who outsource to another location to produce the printing job often use a chart that translates each RGB hue to the nearest corresponding CMYK hue. In that way the designer can be assured of the color that will be printed.

Using Color to Communicate

Color is one of the most directive and influential tools a designer can use in interior design, graphic design, advertisements, on packaging, and on products. Even unaccompanied by words, it can express ideas and communicate moods. Because we have such a primal emotional reaction to color, designers can manipulate it to create the response they are looking for. And the huge number of colors that can be used presents many choices for every possible quality of emotion and type of message. In this section, we examine the meaning of color universally and in various cultures, and take a peek at how artists and designers have used it to convey their ideas.

COLORS AND THEIR MEANINGS

How do we choose colors that will convey the design message we need to communicate? All hues have universal meanings that everyone can appreciate. But they also express culturally meaningful values that vary from culture to culture. Here is a brief list of some of the many meanings of hue, value, and intensity.

Hue

Red Red is energizing, subversive, and therefore appropriate for sports cars. It indicates fire, and it is universally recognized to signify STOP. A business *in the red* has to stop because it is losing money. Red is often associated with hunger, anger, passion, and vitality. To most of us, red is romantic and sexy, especially in *red-light districts*. In Asian societies, red symbolizes good luck, but writing with red ink brings bad luck. A *red-letter day* is auspicious, and to *paint the town red* means to have a hugely upbeat time. An Asian bride would wear a red wedding dress for luck and prosperity, but a Western bride wearing the same color might send an entirely different message about an excess of sexual relations.

Yellow Universally, yellow is the happy color of sunshine, spreading unbounded joy and light everywhere. But yellow is also associated with envy and jealousy, and other negative meanings like disease and cowardice. Warmer, darker yellows traditionally mean wealth and stature, and they make us think of gold coins. In Egypt, yellow is the color of mourning.

Blue Perfect for bedrooms and other places where we desire peace, blue makes us think of the blue sky or water. Blue is clean and masculine, carrying respect and tradition, wisdom, integrity, and stability, which are especially useful qualities for banks. *Blue laws* enforce conservative standards about alcohol sales. We use the words *true blue* to describe loyalty. *The blues* conveys sadness, but blue connotes peace and calm. A *blue-blood* is of noble descent, and a blue ribbon is the utmost accolade.

Green Green is universally fresh and natural, friendly and healthy, and represents living things. Green traffic lights direct us to go, and the Irish use green for good luck. But sometimes green has a negative meaning. In Western culture, one is *green with envy,* or green from seasickness. With the exception of red Martians, aliens and proper monsters are popularly considered to be a sickly green, like the Hulk in Figure 10.35.

FIGURE 10.35 Marvel's The Incredible Hulk. © ZUMA Press, Inc. / Alamy.

Orange Orange has red's energy, but less recklessness and more balance. Friendly and intense, it connotes warmth and joy.

Violet In the past violet was a color reserved for royal use only. As such, it has long been associated with ceremony, but also spirituality. But violet also has an offbeat connotation and exudes a feeling of creativity, and is especially outrageous for nail color (Figure 10.36). Even in language, its reputation is preserved; *Purple prose* refers to exaggerated statements.

White In Asian communities, white represents death and is the appropriate color to wear at a funeral. In Western cultures, white represents innocence and purity, perfect meanings to associate with bridal gowns. White implies cleanliness and we see it in doctors' and dentists' jackets. White is traditionally worn only in the summer, although in winter a slightly yellow *winter white* can be socially appropriate in natural materials like wool.

Black In America, black represents the darker elements of life, such as death. But black is prized for its ability to visually shrink the dimensions of an object, and women in New York City will never give up belief in the LBD (little black dress) as the ultimate in slimming and sexy apparel.

FIGURE 10.36 Butter London HRH nail polish.
Courtesy of Butter London.

Value

High values send a dose of light and happy cheerfulness, or they can suggest weakness or youth. Low values create mystery and suggest the unknown. They can look depressed, dirty, or fearful, too.

A composition with similar values feels vague, numb, soft, and quiet. However, contrasting values within a composition offer excitement. When values contrast, location in space can be suggested. High values and lower intensity conveys distance, while lower values and higher-intensity elements are closer to us. Or, in a tunnel, lower values show infinite depth and space while the lighter portions are out of the tunnel and in the light.

The achromatic hues and contrast of very low-value clouds in Gerhard Richter's *Sea Piece (Wave)* in Figure 10.37 illustrate a diabolical storm about to descend.

Intensity

High intensity is exciting and strong, while low intensities can have many meanings, depending on whether they are tints, tones, or shades and depending on the existing contrasts. Tints are benevolent and nonbelligerent, tones are depressing or unemotional, and shades are brooding and foreboding.

Seasonal Colors

In the Western world, as the seasons rotate, the colors we associate with them change as well. This affects clothing manufacturers because producing products in the wrong colors seasonally would mean being left with a load of unsold merchandise. The high-intensity floral patterns we associate with spring, for example, would look wrong to consumers in the fall, and the lower intensities of winter are too dull for spring.

Spring After putting up with the brutal winter weather, we are happy to see the colors of spring arrive. Bright hues of red, orange, yellow, violet, and pink engage our senses and signal a rebirth and freshness.

Summer Greens and intense versions of spring colors signal summer's warmth. Blues evoke water and water activities.

Fall Fall feels like a transitional time for those of us who live in a place with four seasons. The colors of fall echo the colors we see in the changing leaves: dark reds, oranges, and yellows, with the waning greens losing intensity and hue (Figure 10.38).

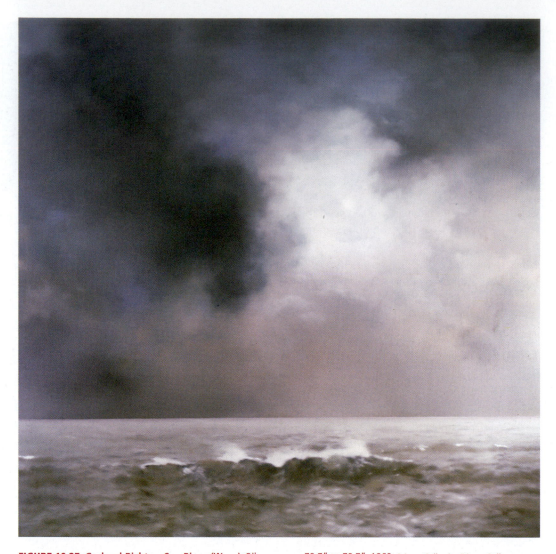

FIGURE 10.37 Gerhard Richter: *Sea Piece (Wave).* Oil on canvas, 78.7″ × 78.7″, 1969. Private Collection/Mayor Gallery, London/The Bridgeman Art Library.

FIGURE 10.38 Marcie Cooperman: *Red Maple.* Photograph, 2010. Marcie Cooperman.

FIGURE 10.39 Mim Nelson-Gilett: *Silent Landscape 6.* Photograph. Mim Nelson-Gilett.

Winter We associate winter with cold, bleak light, and the need for warm clothing and refuge from the weather. During the winter, rich, dark colors and muted grayed palettes seem appropriate, like those in Figure 10.39.

USING COLOR TO ACCOMPLISH ARTISTIC GOALS

Color used in the right combinations and quantities can accomplish many types of creative goals in 2-D compositions as well as 3-D environments or on products. In Chapter 3, we learned about color relationships and how artists such as van Gogh and Delacroix used complements to express emotions such as violence and terror. Matisse also thought about how to make color work for him. In *Still Life With a Seashell on Black Marble* in Figure 10.40, he combined black with yellow to create excitement and emphasize yellow's glowing attention-getting nature. The black separates each object, but the yellow helps draw the eye through the entire composition by uniting the pear and apples with the yellow bars on the top and bottom bars. The black background presents three types of contrasts: an achromatic contrast, a value contrast, and an intensity contrast. In Alyce Gottesman's *Sea Space* (Figure 10.41), the black background separates the figures in an outer space-like imagery and makes their colors more saturated by contrast.

Color and line are indispensable companions in illustrating emotions and influencing the artistic message in the composition. For example, horizontal lines, which indicate a lack of movement, could transmit a positive or a negative feeling, depending on the colors that are used. Horizontal vistas of sunlit fields, sparkling flat blue seas or dusky quiet streets give the impression of serenity and peaceful feelings. On the other hand, the same horizontal lines painted in lower values and more threatening hues can express deeper feelings of pain and loneliness.

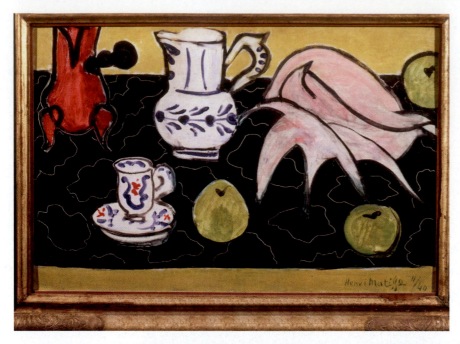

FIGURE 10.40 Matisse: *Still Life With a Seashell on Black Marble.* Oil on canvas, 20" × 25.5", 1940. Fine Art Images / age footstock.

John Rewald, who wrote extensively about the Post Impressionists, noted that Gauguin's writings compared specific moods to associated colors and color combinations, such as violet, blue and orange-yellow suggesting the fear of death. It's possible that for him the vibrancy and scintillation of the blue and orange complements connected with that heart-pounding concept.

Here is a short list of objectives for color usage:

- Make objects seem closer or farther away.
- Emphasize certain elements.
- Unite objects even though they are not adjacent or even near each other.
- Separate and delineate spaces in a room or areas in a composition.
- Create a focal point.
- Direct the eye along a viewing path.
- Make objects seem smaller or larger than they are.

FIGURE 10.41 Alyce Gottesman: *Sea Space.* Encaustic on wood, 25" × 30", 2005. Alyce Gottesman.

- Make the viewer feel emotions like excitement, happiness, or sadness.
- Communicate cultural meaning.
- Deliver messages like excitement or peacefulness; strength; simplicity; or femininity or masculinity.

USING COLOR TO EXPRESS QUANTITATIVE CONCEPTS

In graphs and charts, colors must pull their weight in expressing the quantitative concepts, and the right colors can make a difference between a chart that is easily understood and one that is confusing. For example, color can lead the eye to the main point of the chart, or help differentiate and contrast some informational elements. Bus or subway maps that an entire city will use need to communicate cheery helpfulness to many people with different ages and levels of comprehension. Complexity has to be reduced, a large amount of complicated information has to be simplified, text should be concise and readable, and pertinent information should be immediately visible. Last, but not least, all this information must be unified into a comprehensive, balanced whole.

Some guidelines in color usage can help. The hues must work together in harmony, and color intensity must render text readable. A lower number of colors can reduce complexity, and borders can help direct the eye. The ground color should not be stronger than the informative elements, and the most important information should be highlighted.

In the chart for *Population by Nativity* in Figure 10.42, orange vividly contrasts against the complementary blue, illustrating the differences in nativity, which is the main idea that needs to be set forth. The blended, high-intensity orange hues are made brighter by the black background, although the lower-value blues are somewhat less visible. The gradient hues of the bars make yearly changes easily comprehended.

In Figure 10.43, the "Big Apple" *Annual Report*, the red and green—complements contrast the difference in years. The hues stand out against a white ground, highlighting each yearly graph as well as the green timeline.

The chromatic ordering of label hues in the Mood Paint ad in Figure 10.44 communicates the large range of colors available for this fantasy line of paint.

FIGURE 10.42 Elizabeth Motolese, Pratt graduate communications design student: *Population by Nativity,* **2010.** This chart compares the number of foreign-born to native-born New York City residents from 1830 to 2000. Elizabeth Motolese.

FIGURE 10.43 Charlene Shih, Pratt graduate communications design student: *Annual Report—financial statement*, 2009. The apple shapes and colors symbolize changes in revenues for two different entities in the "Big Apple" within a two-year period. Charlene Shih.

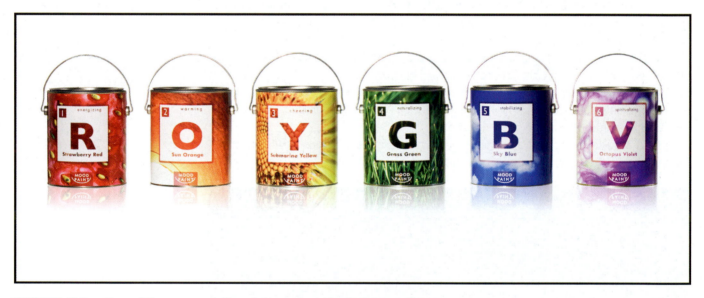

FIGURE 10.44 Ross Connard, Pratt communications design student: *Mood Paint Can Labels*, 2010. Ross Connard.

summary

Marketing and color are tightly bound. Every industry, whether creative or not, needs to appeal to a particular market by translating ideas into visual elements. It's easy to see how creative industries need to use color to produce products that stand out from the competition and convince their markets to buy them. Product design, electronic design, interior design, fashion design and architecture have products that depend on color and design to communicate to, and sell to, the right customers. And the managers of these companies are intensely interested in keeping up with whatever influential color trends are coming up next in our culture. They need to stay relevant, or be overcome by competition and fade away quickly in today's impatient society. The wrong colors just will not sell, but the right colors will fly off the shelves.

However, even non-creative businesses like banking, hospitals, technology, the legal field and pharmaceuticals have the very same goals: They, too, want to make their products attractive to the appropriate market. Even for them, a tangible product needs to have the right colors and design, and all marketing materials do too—they need to convey the essence of the product, and stress the need for the prospective buyer to take action.

This is how vital color is: Success means that the customer buys the product and the company prospers. It's that simple.

quick ways . . .

Is your composition sending the message you need? Does your viewer understand what you wish to convey? Check out your use of the colors, lines and shapes to evaluate your image. Your guiding light is this question: What do you wish to express? And it pays to have an impartial observer look at your image and give you an answer to this question as well.

1. Colors
 - What hues, values and intensities are you using? Are they strong or weak, peaceful and calm or exciting? Do they express sophistication or simplicity, age or youth? What emotions do they convey? What type of person do they attract?

2. Color relationships
 - How do they interact with each other and what message does that express? What planes are they all on and what message does that convey?

3. Lines
 - What types of energy and movement are expressed by your lines?

4. Continuity
 - How does it move the eye through the composition? Is your most important element the focal point? Are there too many distracting things to look at, or is the direction of movement clear?

5. Borders and outlines
 - Do you have borders or outlines that isolate or emphasize areas, direct continuity, or provide some other function? Do they work together with the other elements to give the same message?

6. Location in space
 - Where are the shapes located in space in relation to the picture plane? How does that affect what your image is saying?

exercises

Parameters for Exercises

There are many factors of color and color relationships in compositions, and all of them can affect the way the colors appear to the viewer. The best way for students to learn through their color exercises is to have simple objectives and fairly strict *rules* about the type of lines and colors to be used. We call those rules "parameters." With strong parameters allowing only a minimum of elements, it is easier to observe the direct relationships between colors, and to see the differences between the students' compositions. When lots of compositions hang together for a critique, it becomes clear which ones are successful in achieving the goals.

As students learn the objectives and build on their skills, they will become more adept at using color. They will gain the ability to tolerate more complications because they understand the ensuing interactions. Therefore, as we move through the chapters, the restrictions on composition size and the number of lines and colors will be gradually reduced. Larger compositions, more colors, and

more types of lines will be allowed. However, certain ground rules will remain the same: Flat color and nonrepresentational shapes will remain constant parameters, and the goal of every assignment will be a balanced composition. Five specific parameters include:

1. No recognizable objects are allowed.
2. All colors are to be flat and nongradient, with hard edges that don't fade away.
3. White is always considered a color, even if it is the background.
4. Only neatly cut and pasted papers are appropriate.
5. Balance and unity are *always* the singular goal of every composition.

Parameters for this chapter

These exercises will help you learn to use color to appeal to specific types of markets, and to express particular emotions and concepts. To keep your choices simple, the palette and compositional lines are limited. For each composition, use no more than two lines of composition, with a major and secondary compositional line. Do not use other types of lines. Some exercises have two parts, with opposite parameters for each, to help you perceive the difference between contrary artistic themes. Work with the same size parameters for each composition: Use a 9″ × 12″ horizontal layout, and **three** colors.

Objectives

The last exercise illustrates how the compositional lines can alter the message that colors send. They will help you learn how to unite the compositional lines with the colors to appeal to a market.

1. ***Use value and intensity to express weight:*** In this exercise, create two compositions using the same hues. For each hue, you may choose any value and intensity that you feel will accomplish the goal. The lines of composition should be only verticals and diagonals:

 * The first composition should express the concept of lightness in weight.
 * The second composition should express heavy weight.

2. ***Use color to express masculinity or femininity:*** Create two different compositions using your choice of three colors for each. Both images can use only horizontal and vertical lines of composition:

 * The first image should appeal to women, and should communicate a feminine message.
 * The second should have a masculine appeal.

3. ***Use colors to grab the eye of different age groups:*** Each of these compositions should be the exact same image, with only the colors different. For each, choose colors that you think will appeal to that market.

 * In the first composition, children should think that this one was made for them.
 * Teenage girls should stare lovingly at the second composition.
 * Young men between 18 and 34 years of age should enjoy this image in the third composition.
 * Mature adults should feel that the fourth composition speaks to them.

4. ***Use colors to express the idea of fun:*** What does "fun" look like? The size, distribution, and layout of your lines and your choice of colors should be the factors that convey that fun feeling. Make two different compositions that express fun in different ways, using only triangles and horizontal lines for both images.

5. ***Use values and intensities to make an image scary:*** Create two different compositions using the same hues, with your choice of values and intensities for each. Both can use circles only:

 * The first composition should create an environment of fear.
 * In the second composition, the images should suggest the quality of innocence and peace.

6. ***Use types of lines to change the message colors send:*** For each *pair* of compositions, use the same three colors with your choice of compositional lines:

 * In the first composition pair, one should express the idea of happiness, and the other, sadness.
 * In the second composition pair, one should appeal to men while the other should appear to be feminine.
 * In the third composition pair, one should convey the message that the image is new and exciting, with the other image conveying an image that is old and venerable.
 * In the fourth composition pair, one image should look like it can be used in the Arctic with the second used in the tropics.

Visual Sources of Inspiration for Composition and Color

FIGURE 11.1 Janos Korodi: *Axonomirror.* Acrylic and oil on linen, 52″ × 46″, 2010. Janos Korodi.

Using the World Around You for Inspiration

How does one come up with ideas for 2-D compositions? To many students who feel at a loss for inspiration, other people may seem much more creative in the idea department. As we look at art and design all around us, as well as advertisements and product packaging, we may see many two-dimensional compositions that are admirably creative, well balanced, and well constructed. And it's amazing how different they all are. How did these experts come up with those wonderful designs, and how can we ever get to that level of creativity?

Usually, wonderful, finished compositions don't pop up whole in somebody's head. Making art is a combination of really seeing what's in your environment, coming up with a beginning image or concept, using design techniques to alter it, and spending time refining and working out the design. It's not a situation of "some people have ideas and some don't"; you shouldn't come to the conclusion that you're just not a creative person. Anyone can work with the creativity process and use it to engender usable ideas.

BUILDING A DESIGN IDEA

How do we take something we see and build a design idea upon it? The process involves looking around you, finding lines, shapes, or colors, or a combination of those, and changing them in some way that allows you to utilize them for your design.

Amazingly, no idea is a bad idea as a place to begin. That means you can feel free to work with any type of element to produce a good composition. And there are unlimited varieties of shapes to be used as a source for either a representational or abstract design. If you need an abstract design, anything can be altered enough so that it is no longer a representational image. For any composition, you can choose just one method of alteration, or you can combine methods in endless variations.

You can use various "lenses" to look at your environment for inspiration. For example, use the color lens to analyze what colors are around you. Or evaluate the lines you can see, or the shapes. Chances are you don't usually stop to look at your surroundings this way, since it takes time and you are mostly passing it by on the way to another place or activity. In fact, most of us look at things to make sure they are not in our way, but we don't really see objects for themselves.

Colors

You can put on the "color lens" and see what is around you solely in terms of color, simultaneously noticing the hues, values, and intensities. As you wonder "What hue is that, really?" you might notice that shadows present as low-value colors rather than the achromatic black you originally supposed. Cement becomes a version of high-value and low-intensity red or yellow (brown), and tar streets are values of gray, not black. In the winter, barren hillsides that originally seemed to be dull noncolors begin to be revealed as delicate areas of red–brown, yellow–brown, and green–brown. Some people even prefer the winter landscape to the "garish" greens and blue sky of summer. This method of looking at the environment around you offers tremendous inspiration for using such low-intensity colors, which you may never have considered.

Learning to see is an intriguing process of concentration. It is beguiling to look closely at the waters of a river and try to determine what colors you really see. Hold up Pantone color swatches to compare to the water, and you might notice that the intensities are lower than you had thought. They are probably blue–gray or green–gray hues, rippling alongside slightly higher-intensity colors. The reflections of surrounding trees, boats, buildings, and sky are visible as unidentified colored areas.

Of course, the colors of the environment shift with the time of day and the weather, as the ambient light changes. This fact offered the Impressionist painter Claude Monet (1840–1926) enough subject matter and lighting situations to inspire a lifetime of paintings,

and it was diverse enough for him in the last two decades of his life to almost exclusively focus on his water lily pond.

Lines

Patterns suddenly emerge as you study tree branches and look deeper into bushes, and they change as you revolve around them. Diagonal lines of shadows on the ground connect to vertical building lines. Inside your home or office, a myriad of line choices can come from things like the window frames, fans, pens, or brushes.

Shapes

In nature, focusing on groups of leaves and their shadows reveals bushes and plants to be combinations of triangles and trapezoids. With your stored knowledge of shapes, you can see cars as ellipses, houses as rectangles and triangles. Small objects can be moved around on your desk to suggest a unified assemblage of shapes.

DECIDING ON THE TYPES OF VISUAL IMAGES TO USE

What kind of visual images can you use? It's always nice to start with something you like to look at. What types of images make you stop and look closely because you find them very appealing? What objects do you always like to see? Maybe you love cars, or always admire the architecture in your area. You might be that brave person who looks up instead of down when walking in New York City; up at the tops of buildings rather than down at cracks in the sidewalk. You might be into gardening, or you're fascinated by trains. All of those things have colors, lines, and shapes that can be useful for a design.

Here are some examples of subjects, and for each one, there are many possibilities for variations:

- **Flowers:** Look at large bouquets of them; or close-ups of the center of a flower; or at the shapes of the petals. Turn the flower around to look at them from different angles. Visit flower gardens and examine the dense structure of a complicated flower like a rose, or the simple, elegant lines of calla lilies. In Figure 11.2, *Chrysanthemums* illustrates numerous possibilities.

FIGURE 11.2 Suzanne DiStefano: *Chrysanthemums*. Photograph, 2009. Looking closely at any point in this photo, you can see many shapes that can form the basis of a fine composition. Suzanne DiStefano.

- **Grass:** Grass can be seen one blade at a time in close-up, or you can look at grass patterns from afar. Grass colors can be many varieties of green or brown, and don't forget the weeds, shadows, and bare patches.

- **Clouds and skies:** There are so many different types of cloud formations; look at the cloud colors and where they are located relative to each other. Watch some sunrises and sunsets and notice how the colors change as they reach their peak. Check out the colors in stormy skies. Notice the land beneath the sky: trees or buildings and their colors. Sometimes they are in silhouette.

- **Water:** Oceans, bays, streams, rivers, or lakes—all have similarities and differences. Water can reflect the trees and sky, or boats and houses. Wild waves or whitecaps on the ocean offer constantly changing shapes and colors; water's edge on the ocean offers foam and bubbles compared with the peacefulness of a lake's edge or a rippled bay. Water droplets on the window or rain dripping from trees, a waterfall or a cascade over rocks, or even a fountain can provide inspiring visual images.

- **Buildings:** Such variety can be found in architectural styles such as a farmhouse or contemporary or classical architecture. Other interesting visual images include the embellishments on Victorian houses, interesting doorways on city buildings and the tops of skyscrapers. Simple structures like barns and rundown shacks also offer shadows, lines, and textures such as limestone, stone, brick, or painted walls. Often the colors don't become apparent until you look closely at the building. The buildings on the pier in Figures 11.3 to 11.5 suggest many lines and colors, with various ways to look at the same building.

- **Natural materials:** Rocks can have highly developed striations and layers of color, especially granite and marble; small stones offer an all-over pattern; and large rocks piled up together relate to each other. Sand and dirt offer texture and lines; stones, branches, and dead leaves create wonderful line drawings and natural color variations. The decayed leaf in Figure 11.6 suggests organic shapes and colors.

- **Trees:** The overlapping leaves, and the shapes of the spaces between them, create interesting images. Look

FIGURE 11.3 Marcie Cooperman: Pier building on Hudson River, New York City. Photograph, 2009. The blue, green, and orange in this photograph would create the harmony of adjacent hues and complementary hues in a composition. The lines and shapes also offer interesting patterns. Marcie Cooperman.

(a) (b)

FIGURE 11.4 (a) A close-up of the pier building, which enables you to focus on the desired colors, or the composition and (b) A close-up of the lines of the building. It's the same building, but framed differently. This can be used as inspiration for lines in a composition. Marcie Cooperman.

(a) (b)

FIGURE 11.5 Marcie Cooperman: (a) Pier building on Hudson River, New York City and (b) A close-up of the building and sky reveals a primary hue triad, with lower-value red. Photographs, 2010. Marcie Cooperman.

FIGURE 11.6 Marcie Cooperman: *Desiccated Leaf.* Photograph, 2011. Marcie Cooperman.

FIGURE 11.7 Marcie Cooperman: *Triple-Petal Lily.* Photograph, 2011. Marcie Cooperman.

at bare tree branches silhouetted against the sky, the ends of bare branches or with new spring buds, and tree "skylines."

- *Plants and flowers:* Look at the way some of the leaves or petals twist and show their undersides. Trace their edges and shadows, or look at the veins on the leaves, or the shape of the entire plant.

- *Urban images:* In overcrowded areas, look at the shapes of dense signage; potholes and cracks in the cement; oil slicks on the street; railings and fences; building elements such as fire escapes, pipes, scaffolding, and metal grates; stonework; mismatched building structures; and trash containers. Look at the low-intensity blue and orange complements, and intricate lines of *Rusted Pipes on the Pier No. 1* and *No. 2* in Figures 11.8 and 11.9.

- *Things in your house:* Examine the shapes among the mess on your desk; perceptible shapes in your shag rug; lines and shapes formed by clothing in your closet; lines and angles from the stuff in your "junk drawer"; lines and shapes that come from things on your shelf or in your closet (staplers, paperclips, business cards, overlapping papers, lamps, textbooks, etc.).

FIGURE 11.8 Marcie Cooperman: *Rusted Pipes on the Pier, No.1.*
Photograph, 2009. Marcie Cooperman.

FIGURE 11.9 Marcie Cooperman: *Rusted Pipes on the Pier, No. 2.*
Photograph, 2009. Marcie Cooperman.

CHOOSING TECHNIQUES FOR MODIFYING YOUR IMAGES

Magnification

Magnifying your source material allows you to make use of the textures and colors you see in a way that disguises the source of the image. For example, petals (like in Figure 11.10) and leaves often have incredible variations in line and hue, as well as several colors in shapes distributed in random areas. When you magnify the leaf, you see these colors and patterns but no longer perceive that it is a leaf. Here is another example: Just one area of the branches of a bare tree can fill the page so that it is a design of nonrepresentational lines, angles, and diagonals, no longer distinctly a tree. Industrial or architectural elements like those in Figure 11.11 can also be magnified to fill the page. This type of close-up turns them into abstract sculpture, and because we don't see the sky or horizon, it eliminates a sense of place. Look at the all-over lacy veil of diagonal tree shadows layered over the cobblestones in Figure 11.12 for value and line inspiration.

Wide-Angle View

Pulling back from a scene for a wide-angle view allows the viewer to see more elements with less detail. For example, a bookcase with several shelves, and books on all of them, can suggest wonderful shapes to utilize in your composition. As another often-used example, a city skyline can form a sophisticated and varied design. Elements such as the metal window frames in glass and metal buildings, the rooflines and varying heights of the buildings, and the colors of the building materials can all add complexity to a composition. To change the balance in the composition, all of the elements can be altered in infinite ways. They can be lengthened or made wider, reduced in size, lightened or darkened, and some can even be eliminated at will.

Repetition

Selected shapes can be organized into a motif, and then repeated several times to form a pattern. Think about how you can develop endless variations of pattern. For example, you can play with various combinations of size or hue for the repetitions, or the colors can retain their hues, but change their values and

FIGURE 11.10 Suzanne DiStefano: *Hibiscus.* Photograph, 2007. A flower close-up allows you to see how the radial balance of the hibiscus can be used in a composition. Suzanne DiStefano.

intensities. Simple repetition of orange slices makes for an interesting pattern, as in *Fresh Oranges* in Figure 11.13. Modifying the colors or placing colors in different locations on the page can totally alter the depth of planes in your pattern. Or shapes can be repeated, but in different dimensions and colors for contrasts, like in Figure 11.15. We will explore pattern in depth in Chapter 13.

Rotation and Symmetrical Balance

Look at your image as a unit and imagine ways to place it on your paper to play with the balance of the elements. For example, rotating a particular image upside down changes it so that its appearance becomes less representative, and more of an abstract shape. Following that, the rotated image can be copied and placed around the picture in various ways to emphasize different details such as the shape of the image or the edges. When placed in a symmetrical pattern, we don't really see the similarities; the variations in height, width, and color become the highlights of the composition.

Rotation and Asymmetrical Balance

An image can be rotated and placed in an unstructured *organic* order so that the repetition does not form a pattern. The image can be repeated, forming shapes like swirls, diagonal and curvilinear lines, angles, and zigzags, among endlessly amusing possibilities.

Outside-in Point of View

Draw an organic or geometric shape, or a letter of the alphabet, and fill it with a combination of shapes, lines, and colors. The interior lines can relate to the picture plane of the external shape in many ways—by being parallel, perpendicular, or at some angle. They can be the same type of shape or the opposite, whether geometric or organic. The interior design can relate to the exterior in similarity, or by being opposite, whether in color or design.

FIGURE 11.11 Marcie Cooperman: *Iron Wall on the Pier, New York City.* Photograph, 2009. The large blocks march the eye around the center black hole, with the vertical lines helping to move things along, giving the movement a continuous circular flow. Marcie Cooperman.

FIGURE 11.12 Marcie Cooperman: *Cobblestones and Shadows, Greenwich Village, New York City.* Photograph, 2009. Marcie Cooperman.

FIGURE 11.13 Orange slices. © Roman Samokhin/Fotolia.

FIGURE 11.14 Photographer Chris Knorr. © Design Pics Inc. / Alamy.

FIGURE 11.15 Tama-iris. © ImageZoo / Alamy.

Alteration of Shape and Size

Representational elements can become abstract by altering their qualities of shape and size:

Use elements together and alter their traditional size proportional to each other. For example, window mullions can become a small screen on which to hang other shapes, or they could become a large frame around the whole composition, or around parts of the composition. Small shapes could be seen through long, oversized strands of grass.

Turn organic shapes into geometric shapes. For example, flowers can be simplified into their basic geometric shapes—for example, circle, cone, or barrel. Then they can be placed into an organic composition (Figure 11.14), or into a geometric organization (Figures 11.15) that keeps the size of the elements proportionally different. Objects can be drawn with lines, as in Figure 11.16.

Text as Decorative Element

Text can be shaped as organic elements such as leaves, fruit, or flowers or make up the design itself. The text in Figure 11.17 uses varying values of brown with orange.

Planes as a Jumping-Off Point

Think about Chapter 7, in which we discussed color relationships that can make planes seem to be closer to each other or farther away. Imagine the depth of space you would want to see in your composition, and choose the colors that will achieve that. The composition can be cut up into areas that have different spatial relationships.

Use of Color

After using any of the previously mentioned strategies, explore the elements of color and how they can transform your composition. Remember that different hues, values, and levels of intensity substantially alter the balance and the artistic message of a composition. Sometimes a hue change is all that is needed to make a composition work better. Changing the hues also modifies which planes come forward and which appear to go back into space, as well as the direction in which continuity flows.

FIGURE 11.16 Kirsty Pargeter, 2009. © Kirsty Pargeter/ Alamy.

FIGURE 11.17 Coffee cup made of words. © Skogas/ Fotolia.

Artists' Explanations of Inspiration

As diverse as these methods seem to be in using visual elements as inspiration for design, they are just the beginning. Artists use their unique sensibilities to draw on life for artistic influence in their own ways, and the methods and results are completely individual. Our experiences growing up and the way our brains are wired vary enough to change our interpretations of the same stimulus. Looking at a tree, one person might see the leaf colors, another might notice the overall tree shape but not the colors, still another might assign a personal message to it and completely miss the physical aspects. For that reason, it's interesting to hear how other creative people gain inspiration from the world around them. It might provide inspiration for your own work, or even help you move in a new direction.

Rather than using just one image, some artists take many photos of a particular subject matter in all its variety, and then use the composite to inform a composition. Sometimes that composition is completely abstract. For example, you might study clouds and skies, and make yourself an expert in the variety of possibilities, before using your own version as a structure for your picture. Perhaps just some of the information from the photos could make it into your picture, such as shapes, direction of energy through the composition, and colors.

Sometimes the ideas an artist puts together to come up with a design come from several sources. For example, it could be a combination of two images, or something the artist sees mixed with a concept he or she is thinking about. These two things could then be manipulated for the painting in any number of ways, using the techniques we discussed earlier.

The artist Pam Farrell is a licensed clinical social worker, in private practice as a psychotherapist. She helps clients heal from trauma and work through difficult life transitions. Water is Pam's creative visual image. She sees water in all its forms as emblematic of life itself, expressing such things as connections, the immutability of time, and the passage of time. Her concepts and her source images combine with her materials and color combinations to form the basis for her paintings.

She says (about Figure 11.18):

The title *All Things Flow*—for both the series and some of the paintings—is a reference to the ideas and thoughts of Heraclitus, the pre-Socratic philosopher, who is attributed with the idea that permanence is an illusion because all things are in flux. In an existential sense, through looking at water I was searching for a sense of continuousness, continuity, some hedge against an end. There is, of course, no such hedge. Looking to water flowing as a balm for my anxiety presented only momentary relief. Waterfalls, water flowing in a river, over a dam, coursing through a rocky brook. . . . Pretty as they are, I began to recognize the falseness, the illusion of permanence, and the impossibility of the sense of continuousness that I sought. The flowing water presented quite the opposite: water flowing is movement through time and space—a force as beyond our control as gravity is. I struggle with accepting this, and dare to think of the work as a way to "invite Mara to tea" (embrace the fear).

Some decisions emerge organically, intuitively in the moment. None of my painting process is planned, there are no sketches, and I am not working from photographs. While I may begin with a sense of the palette I want, the process involves multiple movements, gestures, implements, and new colors emerge as layers are built up or scraped back.[1]

Nina Baldwin is a painter who has used landscapes to inspire her abstract acrylic paintings. She found herself moved by the Rio Grande Gorge in New Mexico, at a particular time of day. Nina's explanation for her inspiration for the painting in Figure 11.19:

Rio Grande Gorge is a painting inspired by a trip my husband and I took one summer to the magnificent northern New Mexico area.

FIGURE 11.18 Pamela Farrell: *All Things Flow* (green). Oil on canvas, 36" × 36", 2010. Pamela Farrell.

In this painting I tried to capture the essence of nature's own architecture in the repetition of the beautiful strata of sedimentary rocks. The river surges far below cutting through the ancient earth. Petroglyphs dot the ruins. A beautiful New Mexico morning sky stains the earth in the shades of terra cotta, raspberry and gold.

As an artist I wanted to create a painting that would show nature's magnificence. The "Land of Enchantment" (New Mexico) has a spirit all its own. . . . I wished to portray the emotion I felt as I gazed over the rim into the deep canyon below . . . and then up to the horizon, filled with sunshine, seemingly going on forever, hopefully providing the sensation that the viewer could almost touch the sky.[2]

Richard Diebenkorn (1922–93) painted a series of 140 oil paintings over 25 years, each one called *Ocean Park,* numbered sequentially. The paintings' titles and washed-out blues and other hues suggest that their inspiration was the sea and the industrial urban landscape lining the coast in his Santa Monica neighborhood of Ocean Park. The artist recorded his visions in a totally abstract, nonobjective way that preserved the feeling of the location.

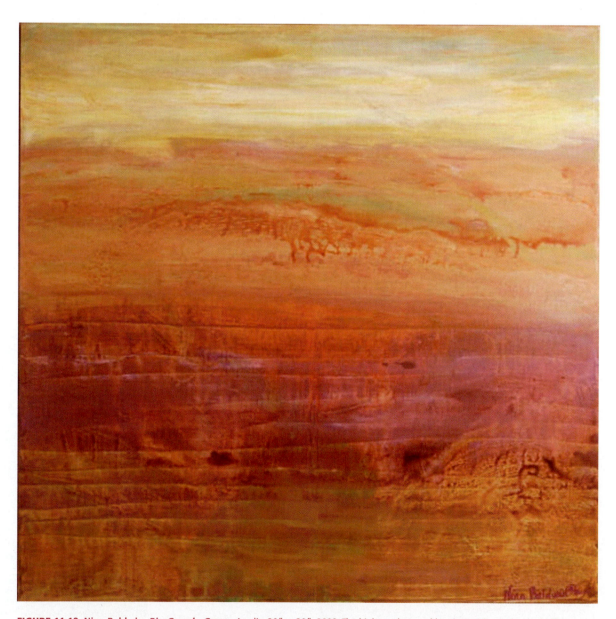

FIGURE 11.19 Nina Baldwin: *Rio Grande Gorge.* Acrylic, 30" × 30", 2008. The higher values and low intensities at the top indicate distance. Although this painting appears to be nonrepresentational, it was inspired by a landscape. Nina Baldwin.

Visual Inspirations Throughout History

Social and political events have often had a tremendous influence on color and design. A few times in the last century, environmental circumstances have motivated an entire culture in several countries to fall in love with one design style. The resulting art movement is so seductive that it leaves a permanent mark on the use of color, resonating even today. Following are a few that have had a lasting influence on art and design.

ART NOUVEAU (1890–1905)

Amazingly, the dehumanizing machines of the industrial revolution triggered one of the most beautiful and decorative trends to grace our cultural history. Rebellion against the machines sent artists to the natural curving forms of leaves and flowers for inspiration. Art Nouveau is easily recognized by its organic, flowing lines called whiplash lines, which seem to be the very opposite of the cold, hard machinery imposing itself on humanity.

Art Nouveau paintings are characterized by flat areas of color (Figures 11.20 through 11.22), which were influenced by the Japanese woodblock prints that became available during the late nineteenth century. The woodblocks' wide areas of unblended, flat color did not use chiaroscuro to indicate three dimensions. This had an important influence on

FIGURE 11.20 John Henry Dearle for Morris and Co.: *Golden Lily*. Wallpaper, 1897. The Stapleton Collection / Art Resource, NY.

FIGURE 11.21 Henri de Toulouse-Lautrec: *Jane Avril*. Lithograph in 4 colors, 51 1/8″ × 37 3/8″, 1893. Digital Image © 1893 Museum Associates / LACMA. Licensed by Art Resource, NY.

FIGURE 11.22 Alphonse Mucha: Ad for the "Job" cigarette papers, 1896. Scala/White Images/Art Resource, NY.

nineteenth-century artists: They realized that they did not have to follow the painting rules so stringently laid down by past generations! They did not have to faithfully copy life around them. They could create decorative images that were based on reality, but that did not look real.

The posters and prints from this period have outlines around and even through all the forms, like clothing and especially hair. This helps flatten the shapes and add to the simultaneous contrasts with the comparison of the colors against the black outlines.

The thought at the time was that art and design should meld, and that objects used in our daily lives should be as beautiful as paintings. Painters and sculptors had always been placed on a pedestal above commercial illustrators, designers, and craftsmen, but now the artistic skills of the latter trades were finally being recognized. Still, designers were able to use the evil forces of the machines to their advantage by mass-producing their work, which allowed a wider audience for their wares.

Art Nouveau spread its influence over many countries in Europe and America, and stays with us today in the numerous lovely artifacts from the period. You can see the effects of this style in Tiffany's jewel-toned glass lamps such as Figure 11.23; entire rooms with furniture and wallpaper like Ernesto Basile's *Interior—the hall of the Grand Hotel Villa Igiea* in Figure 11.24; and in lamps, combs, and brushes for the hair; jewelry; paintings, posters and advertisements; commercial art; and architecture. Antonio Gaudi's Modernisme architecture in Barcelona stands out as Art Nouveau architecture in its most curvaceous and unique form. Casa Mila in Figure 11.25 and Casa Batlló in Figure 11.26a and b, are famous examples of Gaudi's work—popular, as well as highly regarded, worldwide.

DADA (1916–22)

During World War I, there was an immense upheaval in many countries of Europe, when foundations of society seemed to be falling apart and all elements of life seemed bent on mutual destruction. An international group of antiwar artists, poets, and philosophers led by Marcel Janco (1895–1984), Tristan Tzara (1896–1963), and Francis Picabia (1879–1953) reacted by throwing out the now meaningless rules of the modern world and the accepted structure of art, and embracing the chaos all around them. Anarchy was the rule, and the point was to challenge even the concept of rules. They called their movement Dada because it sounded ridiculous. They created art that they said was not art; it was anti-art. Anti-art was not meant to be beautiful; it was meant to criticize the rule-bound structure that art had become. The iconic and ironic example of anti-art is Marcel Duchamp's *The Fountain* in Figure 11.27. The sense of anarchy during that period insinuated itself into art, poetry, theater, graphic design, and music as well as art manifestoes and multimedia exhibitions. You can get a sense of the anarchy that reigned during that time period in Hannah Hoch's *Cut With the Kitchen Knife Through the Last Weimar Beer-Belly Cultural Epoch in Germany*, shown in Figure 11.28. Dada is important because it set the stage for the Surrealism art movement later on, eventually opening the door for psychedelic art in the 1960s.

Marcel Duchamp: "Dada was an extreme protest against the physical side of painting. It was a metaphysical attitude. It was intimately and consciously involved with 'literature.' It was a sort of nihilism to which I am still very sympathetic. It was a way to get out of a state of mind—to avoid being influenced by one's immediate environment, or by the past: to get away from clichés—to get free."

FIGURE 11.23 Antique table lamp. © nicolebeskers/ Fotolia.

FIGURE 11.24 Ernesto Basile: *Interior—the hall of the Grand Hotel Villa Igiea,* Pallermo, Sicily, Italy. Art Nouveau furnishings and wall painting. © DeA Picture Library/Art Resource, NY.

FIGURE 11.25 Antoni Gaudi: Facade of Casa Mila, 1905–10, Barcelona, Spain. Paul Young/Departure Lounge, Dorling Kindersley.

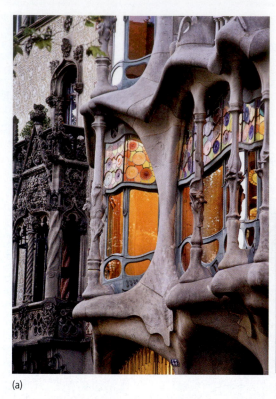

(a)

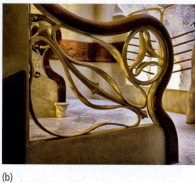

(b)

FIGURE 11.26 **Joel Schilling: Casa Batlló Window (a) and Batlló Staircase, Barcelona (b), Barcelona.** Photographs, October 2006. Joel Schilling.

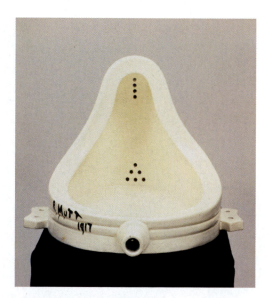

FIGURE 11.27 **Marcel Duchamp:** *The Fountain,* **1917.**
CNAC/MNAM/Dist. Réunion des Musées Nationaux/Art Resource, NY.

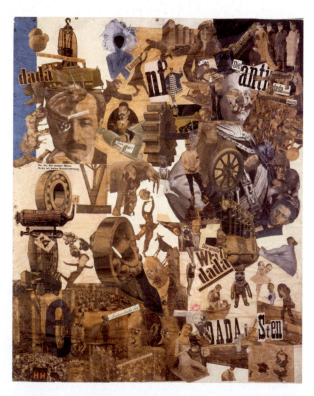

FIGURE 11.28 **Hannah Hoch:** *Cut With the Kitchen Knife Through the Last Weimar Beer-Belly Cultural Epoch in Germany.* Collage of pasted papers, 35 1/2″ × 56 1/2″, 1919. bpk, Berlin/Hannah Hoch/Art Resource, NY.

Marcel Janco: "We had lost confidence in our culture. Everything had to be demolished. We would begin again after the tabula rasa. At the Cabaret Voltaire we began by shocking common sense, public opinion, education, institutions, museums, good taste, in short, the whole prevailing order."

PSYCHEDELIA

In 1966, colorful flowery patterns appeared on men's clothing, women were seen wearing unorthodox hues together in one piece of clothing, and insanely clashing colors decorated upholstery fabrics and curtains. Patterns, stripes, and organic flowing shapes lived happily together and invaded designers' creative dreams. What had happened to transform the safe and secure, traditional 1950s into the carnival that symbolized life in the 1960s?

It began as a youth "counterculture" rebellion against the perceived apathy and mistakes of the older generation. Apathy translated into boring and colorless, and all were represented by "the gray flannel suit" of the 1950s "company man." But youth was different. Youth would rebel and usher the world into the new millennium of peace and love for all, the Age of Aquarius. And rebellion showed its face through such outlets as long hair, screaming color combinations, and outrageous clothing (Figure 11.29).

Not long afterward, events devolved into horrendous depths spurred by the Vietnam War and domestic civil rights abuses, as well as the triple assassinations of the young President John F. Kennedy on November 22, 1963, and Martin Luther King Jr. and Bobby Kennedy in 1968. This solidified the revolutionary efforts of most teenagers, including sit-ins and demonstrations amid the long hair and Nehru jackets. At the same time, certain psychedelic drugs became available, such as mushrooms, LSD, and marijuana that imposed their own visions of kaleidoscopic visual effects, cacophonous colors, and outrageous patterns on the users. With Dr. Timothy Leary telling his followers to "Turn on, tune in and drop out," the psychedelic experience was considered part of the revolution, fueled by visions presumably seen through the altered state of consciousness of psychedelic drugs. Colors and patterns moved in confluence with the music, which felt like the drug-induced experience. The influence of the drug experience completely infiltrated all areas of art, design, and music, and teenagers responded to the poster art of artists, such as the Australian artist Martin Sharp, Peter Max, Lee Conklin (Figure 11.30), and Wes Wilson. Creative record album covers illustrated a dream world one could escape to, and spoke to the young music buyers.

The main influence on the colors and designs of the psychedelic era was originally LSD and other psychedelic drugs. But the diffusion of the style into mainstream graphic design and advertising was so pervasive that one cannot say that it all stemmed from actual drug experiences. It had become the trend. Even the general public, including the older generations, approved of and wore clothing with colors and patterns thrown together in a way never seen before. With mainstream commercials imitating the drug experience, the hippie counterculture had become mainstream culture, ironically the very thing the hippies had fought against.

Using violent clashes of color without regard for relationships or simultaneous contrast, the dreamlike images in the posters related more to the psychedelic influence on design than the particular music groups or concert venue. In many posters, this resulted in a lack of readability and artistic message. But perhaps this was the point; after all, it *was* rebellion. And the drug experience wasn't known for following the rules.

FIGURE 11.29 Sixties Fashion 1960s clothing. © william87/Fotolia.

FIGURE 11.30 Lee Conklin, poster artist: Concert poster, *Canned Heat*, Oct. 3, 1968, Fillmore West. 14 3/16" × 21 1/8". The psychedelic colors of this poster seem to resemble a drug-induced vision. Lee Conklin: LeeConklin@MLode.com.

summary

After reading this chapter, you should have many ideas to use for your compositions. Knowing how to find color and design inspiration in the world around you frees your imagination. Everywhere you look there is source material, and it's clear that there are infinite ways to turn it into a fine, workable design that conveys your artistic message. Your increasing expertise will give you the confidence to take that seed of an idea and refine it to literally make anything work.

quick ways . . .

Allow your creativity to bloom: Go outside and find an interesting tree as a beginning for your visual explorations. No matter what season it is, summer or winter—leaves or no leaves—there is enough natural design in that tree to inspire you.

1. What colors do you see? What types of lines do you see? How about angles? What types of shapes are suggested by the massing of the branches?

2. Frame a section with your hands to isolate just one interesting area. Is it simple or complex? Is there a focal point? What type of composition is it? Do the branches or leaves direct the eye in a particular direction through the composition you have created?

3. Move your hands to frame the area immediately above this section, then the area below it. How does the composition change when the branches and leaves move to another location in your frame?

4. Can you simplify the composition by eliminating some branches or leaf areas? How would the composition change if you add a branch?

5. How can you alter the colors in your composition? How many hues could you use and what color relationships? How would the composition change by changing the hues, values or intensities? Can you change the mood by changing the intensities?

6. Now, use what you have learned in this chapter to change other elements of the tree in your composition, and it's easy to understand that this creative process really has no end.

exercises

Parameters for Exercises
Remember these constants:

1. No recognizable objects are allowed.
2. All colors are to be flat and nongradient, with hard edges that don't fade away.
3. White is always considered a color, even if it is the background.
4. Only neatly cut and pasted papers are appropriate.
5. Balance and unity are *always* the singular goal of every composition.

1. ***Research sources of inspiration:*** Choose a graphic designer whose work interests you. Write to him or her and ask questions about how the designer finds inspiration for his or her work. What images, objects, concepts, or subject matter influence the designer's work? How does the designer use the images he or she sees as inspiration for a 2-D composition? Why does the designer do his or her signature style of design?

2. ***Create urban images:*** Using urban sources, make line drawings for six 5″ × 7″ compositions. Walk around your city or town and search for shapes usable for a composition. They could be close-up corners of buildings, pipes or walls, supports for bridges or highways, and so on. Photograph or draw possibilities as you see them. Choose two of the best, and alter each of them three different ways to make six different compositions.

3. ***Use a tree as inspiration:*** Look at tree branches to find angles and branch intersections that you find interesting, and use them to develop your composition. Then decide on three different color combinations and make three versions of this composition. For the class critique: Hang up all three compositions adjacent to each other. Analyze each composition; state the difference in continuity and balance between the three, and also state what artistic message each one sends to the viewer.

4. ***Create a design with text:*** Make two versions of a composition using text as the center focus. Draw a large letter of your choice, and using your choice of lines, shapes, and colors, design the interior of the letter. In the second version, use the same letterform with different interior elements.

5. ***Use a flower for inspiration:*** Choose a complex flower, simplify it into its basic shapes, and use it as the basis for a 5″ × 7″ composition. Make a second composition, modifying the layout of the first.

6. ***Use objects from home for inspiration:*** Using objects in your home as your source material, draw a 5″ × 7″ composition that will be the basis for two compositions. Paint each one using a different set of five colors, so that each has a different artistic statement.

7. ***Use nature for inspiration:*** Take your Pantone color swatches outside to match it to colors you see in nature: rocks, sand, dirt, and leaves are all most likely lower in intensity than you would imagine.

Audio Sources of Inspiration for Composition and Color

FIGURE 12.1 Cynthia Packard: *Emma's World.* Oil on board, 36" × 48", 2010.
What type of music would suggest the colors and forms of this painting? Cynthia Packard.

key terms

beat (meter)

harmony

pitch

reverberation

rhythm

synaesthesia

tempo

theme

timbre

tone

The Visual Component of Sound

Sit back and listen to a piece of music you enjoy, close your eyes, and see if you can identify some corresponding visual images. Does it suggest colors? Shapes? Movement? Music is complicated and varied, with lots of contradictory sounds, even if just one instrument is playing. You can hear notes that are high and low, fast and slow, loud or soft, notes that are played alone or in tandem. Although it may be difficult to separate the sounds, concentrate on what images the notes let loose in your mind. They may remind you of colors or shapes, planes of colors, movements forward and backward or spiraling upward or from side-to-side.

In addition to hearing, music has long had associations with our other senses. It can inspire us to feel the beat physically, and to dance. It can relax us, create a peaceful environment, entice others to join in activity, create excitement or anticipation. Even in popular culture, we are familiar with the notion of connecting a visual image with an emotion and a piece of music. For example, a few simple notes played during a well-known movie warn us that a huge shark is nearby—guess which movie. And doorbells, rings from phones, text messages, and e-mails impel us to engage in an immediate response.

Music can also inspire us to create a painting or design. It is an intriguing idea to create a visual composition based on what we hear. Transferring a stimulus from one sense to another is almost like translating words into another language. There are words used to describe music that can also be used to describe visual compositions, and that is where the translation can begin: high, low, bright, intense, soft, harmony, vibrating, dark, light.

Starting off simply, just hearing a noise of a single pitch, such as a whistle, can you identify a color that would correspond to it? Since the whistle is high, most likely the color would be a high value, and possibly a yellow. Substitute a car horn, and you might feel that red represents a stronger sound because red is a stronger color. A siren, which changes pitch as it goes from low to high, might require several colors that blend into each other. The siren also might inspire lines with a movement that would hold those colors, such as curvilinear lines.

You can do this in reverse order by looking at a visual image. In Figure 12.1, we see middle and high values, whites and low intensities that seem to cover up intense reds, blues, yellows and other hues, broken lines and shapes, swirling curvilinear motions. What words would you use to describe the sensations you experience while looking at it? Does reading the title of the painting suggest a type of music? As you read this chapter, the answers will fall into place for you.

Music and Color Together

Music and art have long appeared to have a sensory connection, ever since Newton attempted to organize the spectral hues into seven hues that lined up with the seven notes of the musical scale. Artists, musicians, composers, writers, philosophers, and poets have likened painting to music, and some have thought that both influence the soul.

In the late nineteenth century, the connection was particularly seductive for those concerned with aesthetics. Many painters were influenced by the writings of Charles Baudelaire (1821–67), the poet and critic of painting and music, who thought it was obvious that sound suggested color. He said, "what would be really surprising is that sound could not suggest color, that colors could not give the idea of a melody, and that sound and color were unsuited to translate ideas."[1]

According to John Rewald in *Post-Impressionism from van Gogh to Gauguin,* Paul Gauguin said in the late nineteenth century that painting was entering a musical phase. Van Gogh said cryptically that painting should be more musical and less plastic, where plastic means changeable.

Paul Signac, the Neo-Impressionist painter, was struck by the kinship between music and art. In his diary, Signac wrote that he thought Eugene Delacroix's use of complementary hues to illustrate power was comparable to a composer handling the instruments for a symphony.

FIGURE 12.2 Paul Signac: *Opus 217. Against the Enamel of a Background Rhythmic with Beats and Angles, Tones and Colors, Portrait of M. Félix Fénéon in 1890.* Oil on canvas, 29″ × 36 1/2″, 1890. © Lebrecht Music and Arts Photo Library / Alamy.

From 1887 until 1893, Signac signed his paintings with an opus number, signaling an association of his work with musical compositions. For example, he illustrated rhythmic movement with spirals of color in his painting in Figure 12.2, *Opus 217. Against the Enamel of a Background Rhythmic with Beats and Angles, Tones and Colors, Portrait of M. Félix Fénéon in 1890.* From the title and the execution, *Opus 217* seems to be a literal, visual response to music as well as to M. Fénéon's personality.

Signac's *Opus 217* was a unique painting for that time period because, while it included a portrait, it was not just a direct observation of nature. In the late nineteenth century, paintings based on "mere" color and form simply were not done, and it would be 20 more years before Kandinsky introduced abstract painting to the world. Additionally, Signac unfortunately did not have support from his fellow artists for this style of painting. Camille Pissarro, Signac's mentor, felt that the rhythmic lines and forms of Signac's painting had no value. John Rewald said, "Pissarro pointed out that such obvious use of arabesques had no real decorative quality or any value from the point of view of artistic sensation. Signac must have agreed, for he did not persist in this vein of coldly reasoned compositions and endeavored instead to apply his new knowledge of the significance of linear directions to the observation of nature."[2] Colors for the sake of design would have to wait for two more decades. While still related to music, Signac's subsequent paintings once again became representations of nature and life.

Signac was influenced by illustration work he had done for a new publication by Charles Henry, called *The Chromatic Circle Giving all the Complementaries and Harmonies of Colors,* with an introduction on the general theory of dynamogeny or of contrast, rhythm, and measure. *Dynamogeny* means the production of nervous energy, where a source of energy causes something alongside it to move faster. Presumably, Signac's spiraling forms in *Opus 217* influenced each other to whirl faster.

For his part, Charles Henry, the writer, as well as a mathematician and psychoaesthetician, felt that physical movements, chords, and the sounds of certain instruments could be compared to various colors, and that music and art shared contrast and rhythm. He wrote in his book that paintings would be as rich as music if only the artists used complementary colors for their lines.

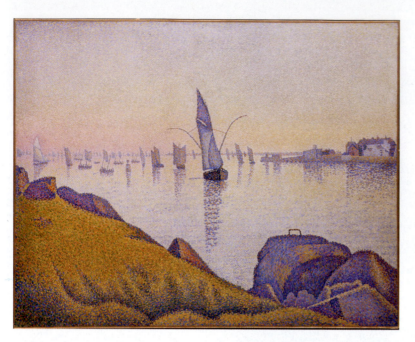

FIGURE 12.3 Paul Signac: *Evening Calm, Concarneau, Opus 220 (Allegro Maestoso).* Oil on canvas, 25 1/2" × 32", 1891. Image copyright © The Metropolitan Museum of Art. Image source: Art Resource, NY.

In 1891, Signac painted five seascapes that he called collectively *La Mer: Les Barques (Concarneau 1891);* they are the pictorial version of five themes of a symphony, each named for one movement characterized by the speed at which the notes are played. Figures 12.3 shows one of them.

During this time period, creative people were interested in something called **synaesthesia**, a "condition" in which a person hears a sound, but also sees it in color. Such a person would see colors when listening to music, or see numbers and letters as having specific colors. For example, as a child, the Russian American writer Vladimir Nabokov (1899–1977) thought that the colors of his alphabet blocks were wrong because he "saw" what colors each letter should "really" be. He reportedly told his mother that the number five was red. Another type of synaesthesia is seeing the months and years as a three-dimensional shape that has a location in space, such as a spiral that moves away from the viewer as time moves into the future. The location of the present date would be the vantage point from which the rest of the spiral is viewed. Those who have experienced synaesthesia feel it as normal and are surprised when learning that others do not necessarily share it. Sometimes drugs can induce a temporary synaesthetic experience where movement engenders vivid colors and patterns that change.

The late-nineteenth-century Russian composer Alexander Scriabin was particularly interested in producing sound and colors together for an audience, on the theory that when the correct color was perceived with the correct sound, "a powerful psychological resonator for the listener" would be created. To produce color and sound simultaneously, he had a "color organ" designed for him that displayed colors on a screen in response to chords that were played on it like a piano. Late in his career, he wrote a symphonic work called *Prometheus: The Poem of Fire, Opus 60* (1910), still performed today, that combined piano and orchestra with this color organ. Although Scriabin is said to have had synaesthesia because he associated chords with colors, it is also said that his theory was too orderly to be indicative of synaesthesia.

Wassily Kandinsky felt an affinity between his own artistic goals and Scriabin's desire to connect colors and emotions. Kandinsky connected painting with creating music, saying, "Color is the keyboard, the eyes are the harmonies, the soul is the piano with many strings. The artist is the hand that plays, touching one key or another, to cause vibrations in the soul."[3] He felt that paintings had the emotional power of a musical composition. His painting *Impression III (Concert)* in Figure 12.4 is not quite as abstract as it first appears. The large black object in the center is a grand piano with a pianist, with the audience to the left.

In 1910, Kandinsky wrote a booklet called *On the Spiritual in Art,* which discussed abstract art and the spirituality of color, as well as synaesthesia. It was a great impetus for his contemporary artists to start thinking about how color and music were connected.

In Germany in 1911, Kandinsky, with Marc and Gabriele Munter, organized the Blue Riders, a group of painters and musicians who felt that art and music had spiritual and symbolic associations. Their goal was the unification of art and music, and the promotion of modern art. The Blue Riders published an almanac containing 14 articles and 140 reproductions of artwork. They had two exhibitions before breaking up, disrupted by WWI in 1914.

The group included Arnold Schönberg, the composer. While listening to a concert of Schönberg's music in January of 1911, Kandinsky sketched the basis for his oil painting *Impression III (Concert)* in Figure 12.4. He felt a connection to the composer, as they had in common a distaste for organized structure, as well as the feeling that painting and music were spiritual.

Van Gogh said of Kandinsky: "The harmony of color tones in Kandinsky corresponds to that of musical sounds, and the psychological effect of color invests the object with a

symbolic character, or at least divests it of its solidity and naturalistic meaning. . . . Kandinsky's variations are harmonic and rhythmic rather than melodic, and his paintings are for the most part built on a primary chord of blue, red, and yellow, in various gradations and shades, and have been given a diagonal rhythm (street, road, woods)."[4] With these words, van Gogh was referring to how color symbolically relates to our emotions, and to our lives as a connected, universal whole.

The writer, Kenneth Burchett, says that Kandinsky associated timbre (the character of a sound) with the value of a color, and pitch with its hue. Color saturation was associated with volume.

Many people continue to feel that color and music are connected. Even as late as the 1980s, the Natural History Museum in New York City produced a popular laser light show timed to the beats of the music of Pink Floyd. And there are many computer music programs that have settings for light shows of corresponding colors for the computer monitor.

FIGURE 12.4 Wassily Kandinsky: *Impression III (Concert),* oil on canvas, 30 1/2″ × 39 5/16″, 1911. Fine Art Images/SuperStock.

MOVIES

Movies communicate their essence with visuals and sound. To imply emotions and feelings, set the mood, and tell a story, movies employ visual factors like lighting, photography, locations and stage settings, as well as music. Visual elements use hues, values, and intensities of color to create the moods the director is hoping to express. Although we are not necessarily aware of how it is done, while watching the movie we get the message and feel appropriate emotions. If any of those elements were not chosen wisely, we would be confused and would not receive the message. In that case, you would have to say that the movie was not a success, although most likely only an expert in that field could pick it apart, separate the elements, and analyze which ones were off.

Movie Soundtracks

Movie soundtracks are an invaluable way to communicate the theme of the movie, introduce characters, and set the stage for a scene. The combination of the score, the instruments, and the way they are played instantly sets up our expectations for the film and manipulates our emotions as we go for the ride.

Writing a soundtrack for a movie involves looking at concepts, colors, and physical elements and turning them into sound—the opposite of using music to inspire a visual design. Music can suggest thoughts, feelings, circumstances of life, and situations present and anticipated, its effects felt even before other elements in a movie become clear. For example, the movie *2001 A Space Odyssey* opens to the big booming sounds of kettledrums and horns playing Richard Strauss's *Also Sprach Zarathustra,* accompanying the image of the sun rising above the earth in deep space. The music captures perfectly the momentousness of this daily occurrence. John Williams' *Star Wars* soundtrack uses horns with the full orchestra to set the tone of majesty and vast spaces. And his soundtrack for *Jaws* was part of the reason for the movie's fear factor, with the main theme's simple repetition of two notes on a tuba, E and F, heralding the presence of the feared shark. More recently, Bruno Coulais's soundtrack for the 3-D movie *Coraline* plays with the combination of children's fantasy and danger by setting the sweet dulcet tones of the Children's Choir of Nice against the highly expressive Hungarian Symphony Orchestra, where the instruments and the way they are highlighted send a direct dose of mystery, dark night, creepy expectations, and fantasy's dark side down the viewer's spine. Danny Elfman's soundtrack for *Alice in Wonderland* is another example of the use of a choir and kettledrums to intimate dark mystery and fantasy, and deeply resonant storyline.

Contrasts in Movies

As in a 2-D composition, contrasts are an interesting way to illustrate the story in a movie. For example, perhaps because we know that bad things can happen on even the most beautiful day, the setting for a horror movie can be bright and cheery, providing an intriguing contrast to the disastrous events, but not taking away from the message of horror. In fact, the contrast can strengthen the horrific qualities. A fascinating example of this very combination of horrific image and peaceful sound is *Good Morning Vietnam,* which opens with the war visual of the terrible helicopter carpet bombings amid the essence of peace, the song "What a Wonderful World" by Louis Armstrong.

Time Element in Movies

A film has the advantage of using the element of time in a visual setting to mirror the fleeting changes of sound. As an example, in 1940, Walt Disney produced a movie called *Fantasia* that was ahead of its time. It used animation, moving colors, and images to illustrate the Philadelphia Orchestra directed by Leopold Stokowski, as it played Igor Stravinsky's *The Rite of Spring. The Rite of Spring* itself, written in 1913, had pushed the boundaries of music and offered new color relationships in sound, with rhythmic structures, timbres, and dissonant chords never before heard.

The Fourth Dimension: Time

When using music as an inspiration for visual design, should the composition illustrate an impression of the whole piece of music, or one moment in time? Sound travels through time, the fourth dimension. But a 2-D visual composition does not move through time, and therefore it may not seem like it could align closely enough with sound to illustrate it. While music may easily suggest colors and shapes to a designer, the question arises as to how to best express the changing nature of a song in a visual composition that has no mechanism for change. It seems like it would be necessary to have a huge number of 2-D compositions, each slightly different, each representing a particular musical moment succeeding the previous one.

Perhaps thinking that this was the only possibility, the first abstract artist, Wassily Kandinsky, wrote that it is not possible to illustrate sound with a visual composition because of the "successive" quality of sound. Subsequently the French artist Robert Delaunay, who read Kandinsky's writings, expressed the same opinion.

This is *literally* true. Faced with the complexity of trying to translate every successive moment of a musical piece into a visual composition, one is struck with the impression that there must be another way to do this. There actually are several ways.

CREATE AN OVERALL IMPRESSION

One way is to ignore the successive quality of music and gain an overall impression of the whole piece. The soul of a song, a very abstract notion, could be expressed in a single visual composition. To begin with, the song's essence might suggest the shape and dimensions of the picture plane, which would then influence the lines and shapes within, as well as the corresponding colors. Allowing for an artist's personality in playing the piece would give us many different interpretations.

EXPRESS A MOMENT IN TIME

Another possibility is to express just one part of a piece—a moment in time. Although of course still an abstract idea, this seems to be a more literal transformation of what you are hearing into its visual components, as you are describing exactly what you are hearing: the pitch at one moment, the tempo, the rhythm, etc. But even literal transformations give the artist lots of choices, and every artist could come up with a different personal visual response.

Try to imagine what instruments and notes during a musical moment could be conveyed by the colors in Janos Korodi's painting in Figure 12.5.

USE THE CONTINUITY PRINCIPLE

Another way to illustrate the changes in the music is to make the comparison between its changes over time and the continuity principle in a painting. For example, you might hear a song go from quiet to loud and abrupt, and that change could be expressed as the movement of energy in the composition. Taking advantage of the way we read many compositions from left to right, the time element could be expressed as lines or shapes that move the eye in that direction. Or a lilting, lyrical classical piece with a bit of repetition might make you think of curvy lines that spiral up and around to the beginning again. Its developing melodies could relate to sprouting shapes and lines in your composition. Its lightness in sound would require colors that reflect that quality, on a background that supports their bright qualities.

In Gary K. Meyer's photo of the Tsingy in Madagascar, Figure 12.6, the sinuous movement of the branches seems to illustrate the time element in music.

USE THE MUSICAL THEME

The musical theme is also appropriate to use as a source of inspiration for a visual composition. Occasionally, you might catch yourself singing a little tune that comes from a song or piece of music you have heard, whether it is classical, rock, or rhythm and blues. That tune would be known as the *theme*. It might be the reason you recognize the song when you hear it again. In pop music, it is also known as the *hook*, the melody that grabs you and makes you sing along to it until you give in and buy the album. We can be cynical about it and call it a marketing ploy, but the theme has existed since the dawn of music, and it is what directly connects us with music. This is what causes us to *feel* something when we listen to music, before our brains take over, and we analyze what we *think* we like about it.

IDENTIFY THE SOUNDSCAPE

We like certain songs because they have a sound that we enjoy, and sometimes we just can't identify what is it that we like about it. Songs have a particular *timbre* quality, meaning the particular sound that we hear and feel in our souls and associate with *that* song, by *that* singer. In *This is Your Brain on Music,* Daniel J. Levitin says, "Quite apart from the melody, the specific pitches and rhythms, some songs simply have an overall sound, a sonic color. It is similar to that quality that makes the plains of Kansas and Nebraska look one way, the coastal forests of northern California, Oregon, and Washington another, the mountains of Colorado and Utah yet another."[5] We could call it an auditory landscape, or a *soundscape*.

As an example, a piece of music might have an unspecific, amorphous landscape of sound that lends itself to being depicted by a visual landscape of flowing, blended colors. Or it might be full of jagged edges created by sharp highs and lows, which seem to be best represented by angles and diagonal lines.

For example, the rippling waves of grass in Sasha Nelson's *Grass Patterns* in Figure 12.7 seem to echo a smooth soundscape of quietly repetitive looping tones.

FIGURE 12.5 Janos Korodi: *Carpet-detail.* Oil on wood, 12" × 16", 2001. Janos Korodi.

FIGURE 12.6 Gary K. Meyer: *Madagascar Tsingy*. Photograph, 2011. Gary K. Meyer.

FIGURE 12.7 Sasha Nelson: *Grass Patterns.* Photograph, 2008. Sasha Nelson.

The soundscape is the reason we can identify whole eras of music. We know from the vantage point of decades later that songs from each era have a distinctive sound, which comes from the way they were recorded, the instruments, and the singing and playing styles used. We can identify a song from a particular era from its soundscape, even if we have never heard that particular song before. For example, think of the Big Band Era, with the large orchestra, the saxophones and the drums laying down the beat for the lively, danceable Swing music. Or think of 1950s rock and roll and how intimate and rebellious it is with its beat still influenced by Swing. Think how it differs from 1970s rock music, with its wildly variable rhythms, and noticeably separate and equally emphasized guitar, bass, drums, and singer.

The music scene today includes lots of genres, each with its own sonic color, and each of which can elicit different types of creative responses. For example, think of the sound of hard driving rock music (loudness, a heavy beat, strong contrasts, high and low pitches), as compared with the ambient sounds of New Age (smoothly linked notes, little change in how high or low the notes are, delicate tempo). Classical music has a structure more varied than the monotones of New Age. And the blues is yet another style that contains its own variations in characteristics.

But, even within one genre, different composers can compose music ranging from one extreme to the other in terms of sound quality, how fast the notes are played, how they link to

each other, how high or how low the notes are, and how much you want to tap your foot to the music. In fact, once you dissect music this way, you can see how even one composer can use those elements to compose many types of pieces, enough to support a lifetime of creativity.

RECOGNIZE YOUR EMOTIONAL RESPONSE

Besides the musical sounds themselves, your emotional response to the song is also a worthy basis for the visual composition. The way that piece of music makes you feel can suggest colors and lines. You might really love the theme, the beat, or the rhythm of a piece of music because it makes you feel a certain way that you enjoy and want to revel in. Maybe it makes you briefly recapture the essence of a moment from your childhood because you heard that song so long ago when you were young. Or maybe music helps you get through exercising, or it helps you work on creative projects, or do yoga or meditate. Some of us already know how to actually use music to engender certain emotions and make activities easier to do, and we know the secrets of how our own souls respond to certain pieces. This knowledge is actually the first step in using music as inspiration for your visual compositions. What emotional response would you feel while looking at Cynthia Packard's *Studio* in Figure 12.8, and what type of music would it suggest to you?

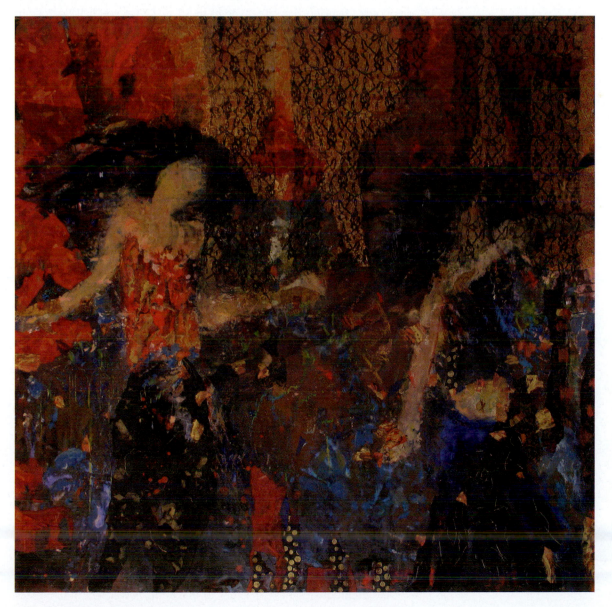

FIGURE 12.8 Cynthia Packard: *Studio.* Collage and paint, 60" × 60", 2010. Cynthia Packard.

Each of these methods is a viable way to simplify a composite sound and help produce a corresponding visual image. To translate sounds into a visual language, the artist is free to use whatever connections make creative sense.

Translating Music into Visual Compositions

LEARN TO HEAR THE MUSIC

Although you've heard music all your life, it's possible you have never isolated the musical elements, and analyzed how they sound. Even if you recognize some elements, such as the beat and the rhythm, you might not have taken the next step and discovered how to translate the sounds into their visual representation. But it's not that hard. Like chess, it's simple to do it and yet the possibilities can keep you occupied for years. Just as art is learning how to see, this process is about learning how to hear.

Here's how to analyze music to express it visually: Choose your music and listen to it. Decide how you wish to deal with the time issue as discussed earlier. Next, make a general plan for your composition, thinking about the type of music and what you have learned in the previous chapters. Then, if you are illustrating the sounds in a direct way, isolate the sound components and translate the information into your visual language. Follow through with your choices to refine the composition.

Choose Your Music

Begin by choosing a song or piece of music that is fairly simple. Decide on your method to illustrate the time issue—whether you will be illustrating one part of the song, the essence of the whole song, or your emotional response to it, and so forth.

Make a General Plan for the Composition

Your Emotional Response If you are using your own response to the music as the basis for your visual composition, think about these questions: When you listen to the music, does it resonate with you, and suggest a feeling, such as calmness, happiness, excitement, anticipation, or sadness? Does it remind you of another time and place? Is that a good feeling or bad feeling? Do you start moving to the music? Are you responding with lively dance moves, or slow and steady flowing movements? Get in touch with its effect on you to determine which emotion it describes or which feeling it evokes.

Sound Relationships If you have decided to isolate the sound components, consider these questions: How do they correspond with the elements of color and composition? What types of shapes or lines do they suggest? What type of sound relationships do you hear, and how would they compare to the relationships of color? Imagine the sound as images or movements through the air in front of you, and see what type of energy is suggested. For example, the swirling airy clouds in the blue sky in Figure 12.9 could illustrate the flowing high notes of classical violins.

Your Tools The elements of color and their relationships and the elements of composition are your tools for expressing your concepts and emotions. Painters and designers use *color relationships* in adjacent colors to make them move to various planes, visually demonstrating depth or closeness, in order to make the viewer feel the intimacy

FIGURE 12.9 Marcie Cooperman: *Eye in the Sky.* Photograph, 2010. Marcie Cooperman.

or expansiveness of a composition. Various types of *lines and angles* form the structure of the composition by suggesting types of energy. For example, consider the static characteristic of a horizontal composition, and the dynamic movement inherent in a diagonal composition.

Another concept—a dominant element—can be used to suggest power and strength. Other tools include the Gestalt principles of proximity (elements closer together are seen as belonging together) and similarity (elements that share visual characteristics are seen as belonging together). You can use these principles in your composition to suggest togetherness and joining with others, or use separateness to suggest the opposite: aloneness, loneliness, or individuality. *Blues, Movements II* in Figure 12.10, suggests that genre of music with the energy evoked by the lazy lines, very high values and stronger lower values settling heavily toward the bottom.

Isolate the Sound Components

Unless you are illustrating your emotional response to the music, the sound components can be directly related to the images you will create. Listen closely and isolate what you hear. Several components of music that form the structure of a musical composition were briefly referred

FIGURE 12.10 František Kupka: *Blues, Movements II,* oil, 1933. Private Collection, Paris, France / Peter Willi / The Bridgeman Art Library.

to earlier. These elements combine in myriad ways and form relationships of harmony and contrast to produce the particular composition we are listening to. Listening to any piece of music, one could imagine several ways to translate its components into visual elements, and the creative mind could continue to come up with more. However, using a visual language to translate each component can make it simpler.

The following components can establish a simple guide to a language that visually expresses sound.

Tone The note you hear is called a **tone**. Artists often think of the tone as a type of hue. What tones can you imagine hearing while looking at the orange and blue lines of *Dream Palm Tree in Hawaii* in Figure 12.11? Are they low or high, or a mixture?

Timbre **Timbre** is the sound quality of a note, related to the type of vibrations produced by the instrument; it is the difference in sound between instruments. Timbre is the reason each of us has a different voice, and the reason our voices sound different when we have a cold, or if we just woke up, or are tired. Two singers who sing the same song can produce a completely different piece of art. For example, look up the Beatles' version of "With a Little Help From My Friends" and then listen to Joe Cocker's version, and you can hear the difference in timbre between their voices. Music history is full of artists who "cover" another artist's song, putting their own stamp on it. Their personal timbre is enough to change your emotional reaction to the song, and require completely different colors and lines. In a visual composition, timbre is more than hue; it is all three elements of color combined—hue, value, and intensity. Together they form the visual weight of a color that describes the timbre of a particular tone or sound.

In Figure 12.12, the medium- and high-intensity blue water could have an entirely different timbre than the intense red cranberries. The combination of the two in *Cranberry Harvest* could make you think of a strong instrument contrasting against a smooth, high background like a saxophone amid guitars.

FIGURE 12.11 Marcie Cooperman: *Dream Palm Tree in Hawaii.* Photograph, 2006. Marcie Cooperman.

Tempo **Tempo** is how fast or slow the notes are played. The energy in a song arises from the tempo. The tempo can relate to things that change in your visual composition, such as the following:

1. The slope of a diagonal line, where steeper lines represent faster notes

2. Gradation of changes in value or intensity

3. Gradation of changes in sizes of adjacent elements

You can use color combinations to reproduce the tempo you hear in your song. Recall color relationships from Chapter 3, and from Chapter 5 the types of energy associated with hue combinations such as complements or adjacent hues: potential, dynamic, static, and passive. What type of energy do you feel in your song?

Rhythm **Rhythm** refers to how the beat sounds over time; repetition of some notes over time; how the sounds link to each other (abruptly, or smoothly, etc.). In a visual composition, regular changes in shapes and colors could illustrate rhythm. An underlying repeating musical rhythm could be shown by the background of your composition, while you could illustrate individual notes by painting separate elements that exist on a plane in front. A continuous repetitive rhythm could be represented by Julie Otto's *Ansonia Staircase* in Figure 12.13.

Pitch **Pitch** refers to how high or how low the notes are. Pitch could relate to the value of a color, or it could direct the locations of various lines in your picture, determining whether they should be higher or lower. A high note, light sounds, delicate tones, all correspond to the top of the composition, and low notes would be at the bottom. Pitch could also determine the size of shapes and lines, where smaller and slimmer is equated with high pitch and larger is equated with low pitch. A song has several levels of pitch, but sometimes one song can have mostly higher or lower pitch. Different levels of pitch occurring at one time in a song can produce a sensation of layers of sound. Turn on your favorite music and answer this question: What are the layers of sounds continuing throughout the piece you are listening to?

FIGURE 12.12 Catherine Kinkade: *Cranberry Harvest*. Oil on canvas, 72″ × 48″, collection Jamieson Insurance. Catherine Kinkade.

What would be a corresponding pitch for Sasha Nelson's *Anacapa* in Figure 12.14? How does it compare to the pitch that would be suggested by Joel Schilling's *Irish Sea* in Figure 12.15? These images are so similar, because they both involve water, mountains and sky. Yet, there are differences, enough to change the pitch. They have to do with the dark clouds and their watery reflections in *Upper Lake Sunset, Ireland*, which might lower the pitch; and the birds, the sunset, and the overhead view of the rocky islands in *Anacapa*, which contributes to a higher pitch.

Beat or Meter The background pulse that makes you want to tap your foot is the **beat** or **meter**—the particular order in which tones are grouped together. We have learned about the beat in music by growing up with music all around us. Even if a regular beat isn't emphasized or is not really there in a song, we can hear the deviation from it (known in music as *syncopation*) because we know what it should be.

FIGURE 12.13 Julie Otto: *Ansonia Staircase.* Photograph, 2010. Julie Otto.

We can sense a similarity between pulses of sound and dashes on a page, which would be a direct representation of it. But you could repeat any type of line or shape, or color, depending on the quality of the beat. Intense colors and strong value contrasts seem to do the best job of representing a strong beat. Look at *The Shadows Underneath* in Figure 12.16 and see if you can imagine staccato beats that follow the pattern of the shadows and railings.

Theme A **theme** is a melody or a complete musical phrase or expression that you want to sing along with. It forms the structure of the musical composition. You might have chosen this element to guide you in your visual composition. Listening to your musical selection, is there a particular sound or combination of sounds that stands out as the most important part of the song?

The artistic message of your visual composition would be conveyed by the theme; it is the

FIGURE 12.14 Sasha Nelson: *Anacapa.* Photograph, 2007. Sasha Nelson.

FIGURE 12.15 Joel Schilling: *Upper Lake Sunset, Ireland.* Photograph, 2010. Joel Schilling.

FIGURE 12.16 Marcie Cooperman: *The Shadows Underneath.* Photograph, 2010. Repetitions of line can suggest repetitions of a beat. Marcie Cooperman.

point of your composition, the main idea. To create a theme, imagine a pattern combining lines and shapes and colors that translates the musical theme and demonstrates what you need to say.

In your song, does the theme repeat a few times, or do several brief themes repeat? How the theme repetitions are linked together is also important in creating the character of the song. It could range from an abrupt change to a sliding connection. Refer to Chapter 5 to refresh your memory of the various elements of continuity to choose from in illustrating the musical energy you hear.

Figure 12.17 is an unusual tree with strange mythical proportions that seems to depict movement and dance. What type of music can you seem to hear when you look at it?

FIGURE 12.17 Gary K. Meyer: *Madagascar Baobab Tree.* **Photograph, 2011.** Gary K. Meyer.

FIGURE 12.18 **Gianni Dova:** *Spacial.* Mixed media on Masonite, 24″ × 31.8″, 1952. The Israel Museum, Jerusalem, Israel / Vera & Arturo Schwarz Collection of Dada and Surrealist Art / The Bridgeman Art Library.

Harmony A combination of notes we hear that sound pleasing, whether played together or concurrently, produces **harmonies** that can elicit different feelings. The magic of music, and the difference between songs, comes from how the notes relate to each other. For example, certain combinations of notes feel happy and cheerful, and certain notes together feel sad or lonely. Translating sound into visual components, the pitches and tones of the music would suggest the particular colors. Those colors together can describe the harmony that we hear.

In Figure 12.18, the analogous colors might produce a harmony of high sustained notes. The way the strange image floats seems to support this idea, but its peculiarity could not fail to influence your visual response.

Reverberation **Reverberation** is the echo of a sound you are listening to. If you are listening in a small closed space, the echo would sound bright and immediate; but if you are in a wide open space, the echo would be a quiet faraway hint of sound.

We can discuss music in a recording in terms of reverberation. The sounds in a song can seem to come from different locations, whether closer to you or farther back, and they correspondingly make the audio space seem bigger or smaller. In your visual composition, shapes and colors can be located in planes that correspond to the depth you hear. The deeper or lower the note, the farther back the plane. Very low notes, such as a tuba, bass, or cello, appear to be on the plane farthest back. Quiet sounds that seem nearby are located in planes closer to the viewer. The total depth is conveyed by the contrast of the sound locations in the music. More intimate music would describe a smaller total distance in your picture between the foremost plane and the one farthest back. Big, booming compositions with drums or many instruments would seem to require depth in the visual composition.

The painting in Figure 12.19 seems to reverberate like a boundless landscape because of the great depth in planes suggested by the contrasting colors.

FIGURE 12.19 Abstract painting. Happy person/Shutterstock.

FIGURE 12.20 Marcie Cooperman: *Night Sky.* Gouache, 12" × 16", 2009. Marcie Cooperman.

USE THE ELEMENTS OF COLOR TO EXPRESS EMOTIONS

Elements of color such as hues, values, and intensities can be used to express emotions and create atmosphere:

Hues: Remember what we learned in Chapter 10, as we discussed the various hues and the meanings we get from them.

Low values: Values can be used to express sadness, intense and dark moments, quiet and thoughtful passages, heaviness, or scariness. *Night Sky* in Figure 12.20 might suggest one of these feelings to you.

Low intensity: This can imply quietude, peace, somber feelings, a static situation, or oppressive uncertainty. In *Yellow Fish* (Figure 12.21), the stillness of the water is expressed in the low-intensity rocks and reflections of light on them.

High values: High values can be used to illustrate peacefulness or happiness, calm, childhood themes, or softness, all of which can be inferred from Figure 12.22.

High intensity: High intensity implies strength, forcefulness, loudness, and surprise. Intense colors can be used to illustrate a loud sound, a note long held, or an unforeseen change in the music.

WORK BACKWARD: USE VISUAL IMAGES TO SUGGEST TYPES OF MUSIC

To build up our repertoire of responses to music, we can work backward by looking at images, analyzing the colors and compositions, and seeing what type of music they suggest. Bear in mind that any conclusions are not limited to the ones drawn here, as we must take into account the creativity of the artist in imagining the musical response. As an exercise, working backward always helps, as it feels like a puzzle that gives the answer before the question.

Sunsets are known for their luminous and fluorescent reds and oranges, which suggest a certain amount of energy. Figures 12.23 through 12.25 are three photographs of sunsets using similar hues but in very different quantities. The lines and shapes are also different. Each sunset varies enough to cause a different emotional reaction. What is your response to these photographs?

Ethiopia in Figure 12.23 has the greatest quantity of orange, contrasted against a minimal amount of low intensity blues that are middle and low value. It burns and is energetic, yet the horizontal composition keeps the movement contained and the energy stays potential. As a musical response, a consistent but noticeable beat contrasted against a smooth theme can be imagined.

Namibia in Figure 12.24 again contrasts the orange–reds against blue, but this time much more blue and it is of a higher intensity. This would cause scintillation were it not for the softer high value of most of the orange, which renders it calm. However, the reaching arm of the clouds expresses uplifting and curving energy, grounded by the horizontal base of clouds and black hill silhouettes. This would suggest low notes of a base or cello, with lilting circular melodies from a guitar or possibly a flute.

FIGURE 12.21 Marcie Cooperman: *Yellow Fish.* Oil on canvas, 18″ × 18″, 2009. Marcie Cooperman.

FIGURE 12.22 Alyce Gottesman: *Untitled Blue.* Encaustic and oil on wood, 30″ × 22″, 2003. Alyce Gottesman.

Sunset in Ventnor in Figure 12.25 shares the warm orange of sunsets, but it is contrasted against a greater quantity of very low-intensity blues that are middle and very low values. The low intensity decreases the scintillation of these complements, thus dampening movement, especially at the bottom. The mostly horizontal composition contains horizontal curvilinear clouds that float, but nonetheless are heavy because of their low value and shape. In corresponding music, one can imagine low pitches and ponderous melodies, but with a rich depth as expressed by the complementary contrast. And yet there is also an uplifting slightly floating quality. This photo has the most peaceful energy of the three because of the static horizontal lines, low values, and less intense warm colors.

FIGURE 12.23 Gary K. Meyer: *Ethiopia, December 29, 2008.* Photograph. Gary K. Meyer.

Audio Sources of Inspiration for Composition and Color

FIGURE 12.24 Gary K. Meyer: *Namibia, May 22, 2009.* Photograph. Gary K. Meyer.

FIGURE 12.25 Marcie Cooperman: *Sunset in Ventnor.* Photograph, 2010. Marcie Cooperman.

summary

Sound and color are firmly linked in movies, television, art, websites, video, and commercials. They work together to tell us how to respond according to the director's conception. We know subconsciously that light happy music gets us ready to laugh, peaceful birdsong relaxes us, and the ever-present exultant hero music must accompany action themes. If contrast is an important theme, even a normal child's room can appear ominous with scary music underlying it, and conversely even violence like the Three Stooges movies will make the audience laugh along with the funny noises. You might remember how the repetition of two notes kept us from going in the ocean one summer, after experiencing Jaws.

Unity is as important here as it is in 2-D compositions; all elements need to work together to express the theme or message. How do colors express any particular emotion expressed by music? Tone, timbre and the other elements of sound are directly associated with hues, values and intensities that can imply emotions or messages. By using a precise language that our culture has set up over the generations, an audience knows how to infer the meanings of color and sound and respond emotionally to them.

quick ways . . .

Allow your creativity to bloom: Lie back on your sofa, listen to your favorite music, close your eyes and imagine the lines and colors you would use to express it in a composition.

- What colors do the sounds suggest? Are they high notes suggesting yellows, or low notes suggesting violet or dark colors? Are they clear high intensity notes, or hazy or soft sounds, suggesting low intensities? Are they deep booming notes, suggesting low values or high-pitched notes, suggesting high values?

- How are the notes connected to each other? Are they continuous (long lines), or staccato (broken sounds)? Are the notes in a straight line (geometric shapes), or do they curve around (curvilinear lines?)

- Are there any big changes that suggest a visual jump—a bridge or a hole?

- What is the general theme of the song?

- What type of tempo do you hear? Is it fast (diagonal lines) or slow (horizontal lines?)

- Is the music soft (high values, low intensities) or loud (intense primary and secondary hues?)

- Is it close to you and intimate (tints, thin lines, little distance between planes), or deep and far away (low values, large shapes and great distance between shapes?)

exercises

Parameters for Exercises

There are many factors of color and color relationships in compositions, and all of them can affect the way the colors appear to the viewer. The best way for students to learn through their color exercises is to have simple objectives and fairly strict *rules* about the type of lines and colors to be used. We call those rules "parameters." With strong parameters allowing only a minimum of elements, it is easier to observe the direct relationships between colors, and to see the differences between the students' compositions. When lots of compositions hang together for a critique, it becomes clear which ones are successful in achieving the goals.

As students learn the objectives and build on their skills, they will become more adept at using color. They will gain the ability to tolerate more complications because they understand the ensuing interactions. Therefore, as we move through the chapters, the restrictions on composition size and the number of lines and colors will be gradually reduced. Larger compositions, more colors, and more types of lines will be allowed. However, certain ground rules will remain the same: Flat color and nonrepresentational shapes will remain constant parameters, and the goal of every assignment will be a balanced composition. Five specific parameters include:

1. No recognizable objects are allowed.
2. All colors are to be flat and nongradient, with hard edges that don't fade away.
3. White is always considered a color, even if it is the background.

4. Only neatly cut and pasted papers are appropriate.

5. Balance and unity are *always* the singular goal of every composition.

1. ***Translate an instrument into visual marks:*** Create a very small composition of 4″ × 6″ for each of the following unique sounds. Your composition should answer the following questions: How would you translate the sounds into visual elements? What images seem to correspond to each sound?

 - "Walking" baseline—staccato steps
 - Thin, clear violin—continuous, high, floating notes
 - Bass drum
 - Clash of cymbals

2. ***Work backward:*** Find a photograph that appeals to you, and bring it to class with a piece of music that communicates the same feeling.

3. ***Listen to a piece of music to hear the theme:*** Use that as your basis for this 8″ × 10″ composition, using only five colors, and translate the theme into a visual image.

4. ***Pick a moment in time:*** Use the same piece of music as in exercise 3, but this time pick a moment in time to illustrate in your 8″ × 10″ composition.

5. ***Illustrate change in a song:*** Find a song that has a major change in it. In this small, 5″ × 7″ composition, use continuity to illustrate that change.

6. ***Compare music genres:*** Choose three genres with which you are familiar. What colors and lines or shapes occur to you as you listen to music from each? Make a simple composition to illustrate each of the three, and compare them in a critique with your class members.

7. ***Pull it all together:*** Choose a piece of music, choose your desired approach, and create a visual composition that best represents it for you. Ask your classmates for their reactions to your composition, and see if you were successful in transmitting your emotions to them. Be prepared to explain your inspiration and logic, and to understand why; they might not have received the message.

Pattern and Texture

Pattern

As you may recall from Chapter 8, according to the Gestalt principles of visual perception, elements that are near each other or share visual characteristics are seen as belonging together. This state of belonging together is actually the basis for puzzles, patterns and many games.

FIGURE 13.1 **Dodie Smith,** *Guitar.* Dodie Smith.

key terms

affine transformation
fractal
linear transformation
mosaic
pattern
reflection
repetition with alternation
rhythm
rotation
scale
self-similarity
sequence
tessellation (tiling)
texture
translation

For example, we love card games like Rummy that involve putting together patterns of numbers and Concentration where we have to find pairs of similar cards. And we adore jigsaw puzzles where each piece fits perfectly against another with a uniquely opposite shape.

Patterns have been in our lives for the entire recorded history of humans. Long ago, many subcultures began using the principles of order to add design to their lives. Patterns were born when people began constructing intricate designs based on interlocking shapes and repetition of colors and forms. These patterns are part of the visual group memories and shared universal understanding within a particular culture. They are passed down through the generations, continuing to be created by members of the subculture, and conveying meaning and emotion to succeeding generations.

All around us, we see and build patterns that are a part of our own culture, without our even being much aware of it. For example, because of the unique shape of bricks, they are placed together in a specific and limited number of ways, creating what we readily recognize as a brick wall. We form infinite types of patterns in our bathrooms, kitchens, and outdoor walkways with tiles of many different shapes. Figure 13.1 shows a colorful guitar by Dodie Smith that combines over two dozen patterns! Chances are, you are taken with the color contrasts and notice only five or six of the patterns. See how many you can identify with the knowledge that all of the shapes have patterns in them. Figure 13.2 shows the pattern established in a train station by the iron ceiling structural support. Knit sweaters like the one in Figure 13.3 combine different types of stitches to form patterns of lines, holes, knots, and shapes. And woven fabrics and leathers, windows on skyscrapers, and bicycle wheels create patterns we see every day.

Natural elements show us patterns of infinite arrangements, like snowflakes, ferns, and frost patterns. Joel Schilling's tulips and daisies in Figure 13.4 form a pattern that is "evenly uneven." The placement of the individual flowers is not exactly the same for each, but because we see the repetition of colors and the alternation of the white with the red, we can see the pattern. Sasha Nelson's photograph *Frost Flowers* in Figure 13.5 demonstrates the amazing flower-like patterns that frost can assume in the right conditions of temperature and humidity.

FIGURE 13.2 Joel Schilling: *Lisbon Train Station.*
Photograph, 2009. Joel Schilling.

FIGURE 13.3 Marcie Cooperman: *Knit Stitches.*
Photograph, sweater design by Marcie Cooperman, 2011.
Marcie Cooperman.

FIGURE 13.4 Joel Schilling: *Red and White.*
Photograph, 2007. Joel Schilling.

FIGURE 13.5 Sasha Nelson: *Frost Flowers.*
Photograph, 2007. Sasha Nelson.

Some patterns we can see from very far away: From an airplane window we might notice the sinuous movement of rivers and streams, or rocky or watery coastlines. Mountains and hills with roads through them become flat lines and shapes that exist irrespective of their height. All of these are patterns and structures are based on a limited number of specific rules.

Let's take a look at the rules for how patterns are formed, see how color affects patterns, and learn about the array of possibilities for new patterns you can create on your own.

WHAT IS A PATTERN?

A **pattern** is an arrangement of shapes, lines and colors that repeat in a predictable manner. Patterns are created using three processes: **repetition with alternation, sequence** and **rhythm**. The most basic patterns are made from a simple, unmodified repetition of a shape and two colors—for example, checkerboards and stripes. But even those simple patterns can become much more complex through the use of color.

For example, the checkerboard pattern is the basis for the painting in Figure 13.6, but the repetitions within them reduce the intensity of the black against white. The rigidity of the repeating squares is further mitigated by the circle repetitions and looseness of the painting technique.

FIGURE 13.6 Mixed Media Background Painting. OneSmallSquare/Shutterstock.

Repetition and Alternation

Repetition is the primary requirement in creating patterns. However, repetition alone cannot do the trick. Repeating just one element would result in a composition of just one color, and not a pattern. At least two colors have to *alternate* and contrast against each other. The pattern can range from a simple alternation of those two elements to a more complex repetition of a *sequence* of elements (sequence is discussed next).

What can be repeated? Some or all of the following can be repeated at the same time in a pattern: colors, hues, values, intensities, shapes, types of lines, or size of elements.

We can thank the Gestalt principles of perception for our ability to perceive the repetition that makes up the whole pattern, and not really notice each individual element. Otherwise, we could be overwhelmed by the details and then we wouldn't see the pattern.

In a pattern, the repetition is the message. It tells us that the characteristics of the colors and shapes being repeated are interesting and worthy of our gaze, and we see them more clearly because they are repeated. Remember that in Chapter 8, we discussed repetition in relation to the Gestalt principles of perception, and how we utilize repetition to tell us what is important. We need it because it helps us understand the point, the message of the image.

Once we notice that a particular set of colors and shapes is repeated, we *expect* it to continue through the entire pattern. In a way, we have learned something—we learned what to expect. Because patterns set up this expectation, any element that differs from the repetition is noticed immediately. It stands out and becomes the focal point, which is extremely useful for tasks such as sending an artistic message, or spotlighting a shape or word. Sasha Nelson's *Window Dressings* in Figure 13.7

FIGURE 13.7 Sasha Nelson: *Window Dressings,* **2008.** Sasha Nelson.

FIGURE 13.8 Greek Pattern. © Alexey/Fotolia.

demonstrates how the hue differences stand out in a rigorous block pattern, where all the lines and most of the colors are the same. Although the chromatic hues are low intensity, they catch the eye amidst the even lower-intensity window frames.

Although repetition is the basis for creating patterns, the rules can be stretched to accept elements that are similar but not identical. As long as the important structural elements are similar enough, we will accept them as patterns.

Sequence

Patterns can be a simple repetition of just two elements, or the more complicated arrangement we call a sequence. A **sequence** is a discrete arrangement of shapes, lines, and colors in a determined order, forming a unit. The entire unit can be repeated infinitely to form the pattern. We utilize sequences every day, in many activities. Sequences form patterns in music, for example, and the particular type of sequence identifies it as part of a specific genre. The master of repetition of sequences, for example, is J. S. Bach, where the repetitions set up our expectations and allow for the changes that occur on top of that. Knitting is another example of a sequence, where a sequence of stiches forms a pattern. And when three or more people take turns playing a game, they are operating in sequence. Figure 13.8 shows us several Greek sequences used in classic design. Simple repetitions that form sequences make up the fundamental design in Dodie Smith's tricycle in Figure 13.9, using strong color contrasts of complementary violet and yellow, red, and a mesmerizing black and white front wheel. In Figure 13.10 we see an incredibly complex pattern in the Lisbon piazza. Can you identify where the pattern repeats?

Sometimes two sequences repeat together as a unit, and the two together become one sequence. For example, Joel Schilling's *Windows, New York City* in Figure 13.11 shows several sequences of similar windows in a building. The two lower floors show one sequence of two windows that is repeated. The third floor has its own sequence of two windows in red brick, then two surrounded by a narrow band of limestone. The two floors above those have a different sequence of two red brick windows, then two completely surrounded as a unit by limestone. Yet another two sequences appear on the next two floors.

Rhythm

Rhythm refers to the harmony and movement that a pattern generates through the regular recurrence of its contrasts. High values change to low; intense colors contrast against dull colors; complex lines abut simple line; and these changes occur repeatedly, forming the pattern's unique push and pull.

You may be wondering: How are repetition and rhythm different from each other? The answer is: Rhythm is more than simple repetition. It is the *esthetic result* of all the repetitions in a pattern. The interaction of the colors and lines creates *emphasis* and *rest* within each sequence, or between each sequence. Rhythm is the harmony or discord we feel, the emotions—surprise, excitement, or peace—stemming from the rise and fall of those elements.

Rhythm is the breathing of the composition, the heartbeat. We can compare the rhythm in a visual pattern to rhythm in music, established by the repeated changes in tone and beat. For example, listening to dance music might make you get into a groove as you respond to the entire arrangement, dancing along with it and aligning your heart with the bass notes. Or you could be in the mood for Bach's partitas and sonatas for violin, and your spirit can soar as you float upward on the silvery curving notes.

FIGURE 13.9 Dodie Smith, hand-painted tricyle. Dodie Smith.

FIGURE 13.10 Joel Schilling: *Lisbon plaza.* Photograph, 2009. Joel Schilling.

FIGURE 13.11 Joel Schilling: *Windows, New York City.* Photograph, 2001. Joel Schilling.

Repetition frees us to hear what's different. We become accustomed to the rhythmic pattern, and we know what comes next. By establishing "the way it is," it forms an underlying groundwork for novel sounds—the excitement of a stronger drum beat, the sweetness of a lilting higher note, even a sudden stop. They resonate and grab our attention because they contrast with the established pattern.

Rhythm in musical and visual compositions is bound by the law of simultaneous contrast. We hear the thinness of high notes because of their contrast with the fullness of the lower notes. In visual compositions, rhythm emanates from our perception of the colors relative to neighboring colors. In a pattern, the stronger colors give more energy and lead the eye, while the ones with less relative visual strength act as support. Strong colors show emphasis, and high or very low values allow the eye to rest. Hues with red come forward and impose themselves on the cooler blue hues that recede. Read Chapters 5 and 7 again to refresh your knowledge of these facts.

The changes that define the sequence create the rhythm when the sequence is repeated. It is established by the differences between the hues, values, and intensities, and the way that they move from one to the next. Is it a gradient change, or a sudden alternation between two contrasts? Are the contrasts far apart, or only slightly different? What type of line links them? Gradient changes can be illustrated with curves, while straight lines link various elements with a sharp and direct connection. As an example, in the promotional poster for the Lloyd Express in Figure 13.12, the knifelike hulls of the big ships set up a sharp, sawtooth rhythm, made more intense by the strong contrasts of the high-intensity primary hues and the white text. *Lisbon Fenestration* in Figure 13.13 shows a softer linkage. It too has verticals, but the curvilinear arches and circles make the transitions smoother.

Figure 13.14 shows three sets of stripes that all use the same colors in a sequence that is somewhat similar. The rhythm in each is completely different because of the different widths of the stripes. In Figure 13.14a, the wide blue stripe effectively separates the red

FIGURE 13.12 Shipping Companies: Norddeutscher Lloyd (Bremen)— "Norddeutscher LLoyd Bremen/Express liner Bremen." Cover of an advertising brochure, ca.1930. bpk, Berlin/Art Resource, NY.

FIGURE 13.13 Joel Schilling: *Lisbon Fenestration.* Photograph, 2009. Joel Schilling.

FIGURE 13.14 Marcie Cooperman: The rhythm created by these sequences varies depending on the width of the stripes. Marcie Cooperman.

and yellow into a strong unit, creating a blue rest stop. In Figure 13.14b, the blue merely indicates where the repeat begins, its presence going almost unnoticed, creating a strong but rolling, unbroken type of rhythm. In Figure 13.14c, the blue areas follow the Gestalt principle of closure and seem to unite, creating a blue background, while the red bars with a yellow edge stand out on top like horn blasts, and look almost three-dimensional.

What creates the rhythm in a musical piece, and how can we translate it to a visual pattern?

Music	Pattern
Phrasing, or grouping of notes	The sequence of lines and colors that is repeated
Repetition of highs and lows	Repetition of high and low values or intensities
Abrupt starts and stops	Complementary hues; obstructive lines
Gradual runs up a scale	Gradient changes in hue or value
Emphasis of notes	Colors with visual weight
Rest between notes	Colors with relatively less visual weight

Another source of rhythm can be found in our patterns of speech, which is influenced by where we live. Depending on that location, at certain points in words and in sentences, the tone can go up or down either sharply or gradually. Also, phrasing emanates from the emphasis given to words of importance, and the manner in which unimportant words are strung together. Another characteristic of our rhythmic patterns of speech could be stops in the middle, or at the end, of certain words.

If you repeat an English word or a phrase, you can hear the rhythm peculiar to the emphasis we give to certain syllables, as indicated by how the tone goes up.

In the following examples, the capitals indicate the emphasis on certain syllables:

CO-lor … com-po-SI-tion … ir-re-SIS-ta-ble

How can we illustrate this type of sound in a visual composition? Visual patterns can illustrate patterns of speech using elements such as hue, line, or value. Take a look at the visual speech analysis of the North Carolina speaker in Figure 13.15. Read the words as you look at the dots below them, and try to modulate your voice like his, going up when the dots go up and down when they go down. The colored blocks below that line graph indicate his emphasis on parts of words: As red is visually stronger, it would show more emphasis, and hues adjacent to red show less and less as they move toward green. Underneath the colored bars, the bar chart shows the same relationships in value and size, where black represents the strongest sounds.

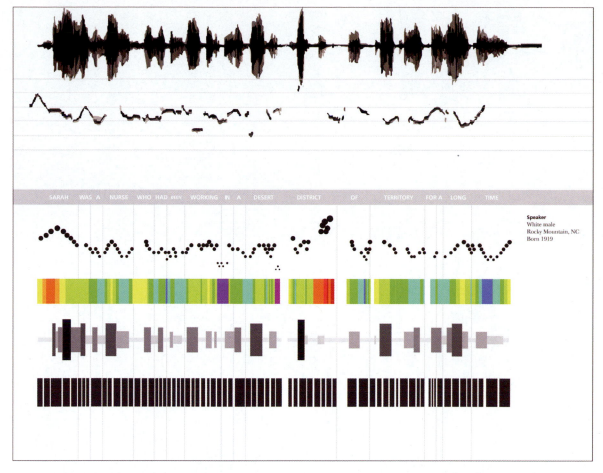

SARAH WAS A NURSE WHO HAD BEEN WORKING IN A DESERT DISTRICT OF TERRITORY FOR A LONG TIME

Speaker
White male
Rocky Mountain, NC
Born 1919

FIGURE 13.15 Liz Motolesem, Pratt Communications Design student, Visual Speech Analysis: *North Carolina Speaker,* **2010.**
Elizabeth Motolese.

CREATING A PATTERN

Linear Transformation

To create a pattern, a sequence can be modified in several ways. On a two-dimensional surface we call any of these modifications a **linear transformation**. The simplest and most primary action most often used is repetition. Beyond simple repetition, however, the original sequence can be modified, moved around, and arranged using several different techniques. They can create patterns so far afield from simple repetition, you might not even recognize them as patterns. Using these actions together and combining them in different ways creates the different types of patterns we see around us, both in natural elements and those made by people.

Let's take a look at these linear transformations: translation, reflection, self-similarity or scale, and rotation.

Translation Translation is a repetition that is formed by simply moving the entire shape a specific distance away in a specified direction. We say such a shape was *translated*. A *linear* pattern can be formed by translating a shape in just one direction—in a line, and a 2-D pattern can be formed by translating this shape in two directions, such as vertically and horizontally. This 2-D translation can occur an infinite amount of times to construct a pattern of any size. Translating an element infinitely to produce such a pattern creates *translational symmetry*.

Figure and ground are two separate and identifiable elements in this type of pattern. The design elements repeat at a constant distance from each other, and the gaps between

FIGURE 13.16 Janos Korodi: *Persian Silk*. Oil on canvas, 55" × 55", 2000. Janos Korodi.

them would clearly be considered the background. Strong color contrasts that enhance figure and ground distinction make more successful translations. When used in a linear direction, translational patterns are handy for borders in textiles, in books, or on walls. Janos Korodi's *Persian Silk* in Figure 13.16 illustrates patterns formed by translation.

The profiles in Figure 13.17 appear to be created through translation but, after studying them, it is clear that they are not exactly the same shape. Their apparent similarity in orientation draws them together and makes the one that is facing the other way look slightly different. But it's hardly visible. Because the hues are repeated, and the values and intensities are on almost the same level, that head doesn't contrast against the others.

Translation is a technique commonly used in wallpaper today. Figure 13.18 illustrates the type of repetition we see in many wallpaper patterns, with a slightly altered simple translation: every other row is moved up by half a pattern length.

Reflection A form of symmetry, **reflection** refers to the mirror image of a shape across a central axis. You might have made this kind of pattern when you were young, by folding a piece of paper in half, applying paint on one side, and pressing the other side of the fold against it. As an example in nature, each flower in *Pink Rhododendron* in Figure 13.19 shows a pattern with symmetrical reflection.

FIGURE 13.17 John Newcomb, *Checkerboard People*, 1984. John Newcomb / SuperStock.

FIGURE 13.18 Damask seamless pattern wallpaper. Pavel K.

FIGURE 13.19 Joel Schilling: *Pink Rhododendron.* Photograph, 2007. Joel Schilling.

Self-Similarity You can **scale** a shape by enlarging it or making it smaller, but the key is keeping the *proportion* of all sides and angles unchanged. In **self-similar** patterns, the object is similar to a smaller part of itself. Lining up the shapes in gradient order is one way to produce the pattern. The reduction in size is an important factor in patterns with self-similarity; that's because if the object didn't change size, it would be a *translation*.

The pattern in *Imagine*, the Central Park Strawberry Fields memorial to John Lennon in Figure 13.20, shows scaling of a hexagon. Each line is also actually an axis for reflectional symmetry. Notice that there is no background in this pattern, because each area that appears to be the background is actually used as half of another hexagon.

FIGURE 13.20 *Imagine.* Strawberry Fields memorial to John Lennon in Central Park, New York, inaugurated Oct. 9, 1985. The geometric pattern is a reproduction of a mosaic in Pompeii. Dorling Kindersley.

Fractals **Fractals** are fascinating examples of a self-similar structure, but a structure without easily definable shapes, too irregular to be described as Euclidean geometric shapes. Fractals include many parts that are at different scales, and all of those parts have the self-similar structure of the whole. The earliest fractals were derived from mathematical formulas. Examples are the *Koch snowflake*, similar to Figure 13.21 constructed, in 1904 by Helge von Koch, and the classic *Julia set* in derived in 1918 by the French mathematician Gaston Julia (1893–1978). Examples of natural fractals include frost crystals, mountain ranges with their foothills, clouds and coastlines, and vegetables like cauliflower and broccoli and the *Romanesco Broccoli* in Figure 13.22.

Affine transformation A fern is a type of fractal called an **affine transformation**. Look closely at the leaves of the fern in Figure 13.23. Each long stem has many short stems, each of which has leaves of the same shape, size, and distribution as the long stem. In this way, the frond is a replica of the whole, but on a smaller scale. The leaves are rotated, scaled down in size, and then translated next to the previous one. And on each frond, you can see the same pattern of stems and fronds on an even smaller scale. The cedar frond in Figure 13.24 is similar.

FIGURE 13.21 An early fractal derived from a mathematical formula.

FIGURE 13.22 Fractals: *Romanesco Broccoli.* © Rob Walls / Alamy.

FIGURE 13.23 Marcie Cooperman: *Ferns.* Photograph, 2011. Marcie Cooperman.

FIGURE 13.24 Marcie Cooperman: *Cedar Fronds.* Photograph, 2011. Marcie Cooperman.

FIGURE 13.25 *Ely Cathedral Lantern Tower.* © rad100/ Fotolia.

FIGURE 13.26 Joel Schilling: *Blue and White Tiles from Sintra.* Photograph, 2009. Joel Schilling.

Rotation Turning the shape around clockwise or counterclockwise to use it in another orientation in the pattern is referred to as **rotation**. Rotation doesn't work with shapes that have equal-length sides (like squares) or circular symmetry because when rotated they remain exactly the same. Sometimes new shapes are created that totally obscure the original sequence, when all the pieces are put together. For example, the star pattern in the *Lantern Tower* in Figure 13.25 was formed by rotating the sequence of lines and colors eight times, and placing them around a center point in a circular orientation. We see this in snowflakes as well.

Figure 13.26 shows a tile wall pattern with several linear transformations. Each tile is actually exactly the same, with reflection symmetry across a diagonal axis, a vertical axis, and a horizontal axis for each tile. Beneath the white tiles is a distinct blue background. Each tile was rotated one-quarter turn to produce a sequence of four in a square, and this sequence was translated in two dimensions—horizontally and vertically—to produce the pattern.

FIGURE 13.27 *Honeycomb.* © Lilya/Fotolia.

PATTERNS WITH NO BACKGROUND

Tessellation or Tiling

Tessellation, also known as **tiling**, is a type of pattern where figure and ground are one; no area appears to be the background. Take another look at all the patterns we have seen so far. Can you pick out the ones with a distinct separation of figure and ground?

Why is there no background in a tiling? Small regular polygons fit together like a jigsaw puzzle, eliminating areas in between. All shapes have a continuous and uninterrupted outline and no shape overlaps another. Tiling can be repeated in all directions, covering a surface of infinite dimensions.

A crucial effect occurs because of this continuous outline: No shape takes the foreground by means of overlaps. Only color has an impact on which areas move forward and which recede. Color behaviors influence the location of the planes. Colors with great visual strength, such as red or intense colors, would advance, and colors with blue in them would

FIGURE 13.28 John Henshall: *The Alhambra,* Granada, Andalucia, Spain. © John Henshall / Alamy.

tend to recede. But since color is relative, the color relationships in the pattern would also be instrumental in determining which areas advance or recede.

A natural example of a tiling is the honeycomb. Study the honeycomb in Figure 13.27, and you might notice something interesting about it. Although obviously not engineered by human hands according to a mathematical formula, it is nonetheless composed of perfectly identical hexagons, with no gaps between them. The size of the openings never varies.

If the shapes of a pattern fit together tightly but they are not regular polygons, the pattern is not technically a tessellation; it is called a **mosaic**. M. C. Escher is an artist famous for his intriguing mosaics using birds, fish, and other animals. They are quite inventive in the way they transform from one animal into another. Escher was inspired by a visit to the Alhambra palace and fortress complex in Granada, Andalusia, where he saw the ancient tessellations that had been laid out by the Moors in the fourteenth century. Figure 13.28 shows a tessellation on the lower portion of the wall. The borders above it are not tessellations, since figure and ground are clear.

The rules for tessellations allow the use of rotation, but not translation or scale. They don't use scale because the tessellation structure is based on the shapes being a constant size, and scale refers to changing the size. They don't use translation because tessellation means fitting together with no gaps, and translation by definition refers to moving the sequence a little bit away from the preceding one—causing a gap.

Beyond cultural meaning or artistic expression, mathematicians have long been intrigued by the mathematical possibilities for tessellations. Several types have been discovered, and they vary depending on the types of figures used and the types of patterns they produce. For example, in the 1970s, Roger Penrose discovered a specific type of tessellation now called Penrose tiling, in which a finite number of specific shapes cover the plane with no gaps or overlaps, using these rules: The pattern uses Euclidean geometric shapes that are rotated and reflected symmetrically. They produce a pattern that is random and never repeats itself, a situation that we call *aperiodic*.

At the World Science Festival Street Fair, an annual festival held in New York City since 2008, participants learn how they can tessellate a surface with pattern pieces using only two different shapes called kites and darts, as originally conceived by Roger Penrose.

Op art patterns are a form of tessellation in black and white, using the lines and shapes to produce vibrations and even make it seem like there are other colors. Op art hit its heyday in the psychedelic late 1960s, and found its way to paintings, posters, clothing and fabrics. Refer back to Bridget Riley's *Hesitate* in Figure 2.38 in Chapter 2 to see how such a pattern can vibrate.

A tessellation called Bargello, known as a flame stitch, has long been popular for needlepoint patterns and is used in many color combinations to upholster footstools and chairs. The zigzag pattern in Figure 13.29 illustrates the typical Bargello pattern.

FIGURE 13.29 Marcie Cooperman: Bargello pattern for petit point. Marcie Cooperman.

FIGURE 13.30 Palace of the Columns, Mitla, an ancient Mixtec site, Oaxaca, Mexico. © gioppi/Fotolia.

CREATING TRADITIONAL PATTERNS

Most cultures have traditional patterns that have been used in decorating buildings, fabrics, jewelry, walls, bowls, and floors. For example, the Mixtec lived in Oaxaca, Mexico, over 2,000 years ago and many ruins left by this civilization have been uncovered. The stonework is decorated with precise mosaics (Figure 13.30). Can you identify which techniques they used to create these patterns?

Decoration is an integral element in Islamic art. There are three types of Islamic patterns, each of which uses a different type of figure:

1. **Geometric** tilings are generated from the triangle, the circle, and the square or quadrilateral. Rotation produces complicated shapes such as a star pattern made of squares and triangles, and more. Figure 13.31 shows geometric tilings in the interior of the Nurullabai Palace in Uzbekistan.

2. **Vegetal** patterns used flowers and plants to form the designs, as in the door in Figure 13.32.

3. **Calligraphy,** which is a decorative form of writing, has for centuries been used for many tile patterns in the Arab world. Figure 13.33 shows a calligraphic design on a glazed tile panel from the fourteenth century in Fez, Morocco, on the Bou Inania Madrasa, a fourteenth-century school and congregational center.

FIGURE 13.31 Ivan Vdovin: Interior of the Nurullabai Palace, built in the 1910s, Khiva, Uzbekistan, 2009. © Ivan Vdovin / Alamy.

Texture

WHAT IS TEXTURE?

Texture refers to the surface quality of an object, or the way its surface would feel. We often think of texture as something rough or with a "nap," which means the fuzzy part of a fabric with raised fibers, such as Meret Openheim's disturbing cup, spoon, and saucer of fur in Figure 13.34. But every object has a tactile quality, even very smooth metallic objects.

In the real world, we can touch things and understand their tactile nature. But of course we can't touch the objects in photographs or books because there is only the smooth texture of the photographic paper. The colors, lines, and values can, however, successfully suggest how the objects might feel if they were actually there. The same is true for a visual composition, where the colors and lines can suggest this tactile experience and create the illusion that the surface is actually three-dimensional. The question is: How would you do that in a visual composition?

Many of the same factors we use to create patterns can be used to create texture. Repetition is probably the most vital element, as it is with patterns. Also, transformations like rotation, scale, and translation can be used to make a texture. The major factor, however, is not to place the shapes evenly; it's more like *evenly uneven*. Texture gets its realism from random but mostly fairly evenly dispersed lines, shapes, and colors with the occasional outsized or contrasting element allowed, as in Figure 13.35.

Value is the most influential element of color in creating texture, and value contrasts are most important in defining the type of texture of an object. Even if the textures represented in the figures in this section were created in black and white as opposed to chromatic hues, they would still communicate what they are.

FIGURE 13.32 Moroccan door. © Bizroug/Fotolia.

FIGURE 13.33 Calligraphy in stone. © Xavier Allard/Fotolia.

FIGURE 13.34 Meret Oppenheim: Fur-covered cup, saucer, and spoon, cup 4 3/8" in diameter; saucer 9 3/8" in diameter; spoon 8" long, overall height 2 7/8", 1936. This famous fur-covered cup was disturbing because it had the "wrong" texture for a cup. Digital Image © The Museum of Modern Art/Licensed by SCALA / Art Resource, NY.

FIGURE 13.35 William Watters: *Nuts in Turkey.* Photograph, 2009. William Watters.

FIGURE 13.36 *Empty Structure,* Jorge Oteiza in Donostia. © poliki/Fotolia.

FIGURE 13.37 Marcie Cooperman: *Hudson River Water Texture.* Photograph, 2010. Marcie Cooperman.

FIGURE 13.38 Joel Schilling: *Winter Fading.* Photograph, 2011. Joel Schilling.

Shiny and smooth objects reflect light, and the best way to illustrate this is to have strong value contrasts. For example, in Figure 13.36 the bronze statue by Jorge Oteiza demonstrates its metal surface through higher-value contrasts.

Water reflects the light of the sky, and value changes illustrate the reflections above watery depths. In Figure 13.37, the texture of the water is illustrated by the many highlights scalloped above the slightly lower values, the peaks and troughs showing the constant movements of the currents. Value is so important in creating a water-like texture that the hue and intensity are almost not important.

Rougher surfaces don't reflect as much light, and consequently, the values are closer together. For example, the desiccated leaf by Joel Schilling in Figure 13.38 has the highest value (white) with light gray. The lowest-value gray and black are only on the center vein.

The handbags in Figure 13.39 show off their variations in texture. Clockwise from bottom: silk, velvet, and feathers, leather, yarns of cotton and various other fibers.

Joel Schilling's *Formed by Lava* in shows its rough, natural texture more through the differences in value than through the unusual color changes.

In Figure 13.41, the texture of these discs is clearly fabric because there are no reflections. The patterns are created through processes that you can now identify from what you have learned in this chapter.

FIGURE 13.39 Marcie Cooperman: *Texture.* Photograph, 2011. Marcie Cooperman.

FIGURE 13.40 Joel Schilling: *Formed by Lava, Galapagos Islands, Ecuador,* *2009.* Joel Schilling.

FIGURE 13.41 Gary K. Meyer: *Ethiopia.* Photograph, 2009. Gary K. Meyer.

Pattern and Texture

summary

Patterns are among the most complex types of compositions. All the color interactions and relationships, and human perception processes that we have discussed in the previous chapters exist together in patterns. Every one of those factors adds to the rhythm of a pattern and the message it communicates to the viewer. For example, as we discussed in Chapter 8, the location of similar elements and the proximity of colors to each other determine phrasing—the grouping of the areas of color and line. Based on how colors influence planes, which we discussed in Chapter 7, the colors determine where there is emphasis or rest in the pattern. As we read in Chapters 3 and 4, color relationships and the types of compositional lines establish harmony and set the mood. And as we discussed in Chapter 5, the lines and shapes in the composition lend their brand of energy and direction, and determine how quickly and how smoothly the eye moves through the entire pattern.

Value proves once again to be the most influential element of color, capable of creating textures and determining the rhythmic movements in a pattern depending on how much area each value has in relation to the others.

As you gain expertise with these components of color usage, you will delight in making your patterns express the artistic concepts you wish to convey just by manipulating the colors. They are your tools, and now you understand how to use them in combination with shape and line to accomplish all of your two-dimensional compositional goals.

quick ways . . .

Look around you, and you'll see patterns everywhere, both in the natural world and the manufactured. It's good practice to really study them and figure out how the patterns were made. Try to identify at least one of each of the following types of patterns:

- Was this pattern made through repetition of a shape that was merely moved a short distance away on one direction? (translation) Was it moved in two directions—laterally as well as vertically?

- Does one type of shape have alternating colors? (alternation)

- Do you see the mirror image of the shape across a central axis? (reflection)

- Is the object similar to a smaller part of itself? (affine transformation)

- Is a shape rotated and used in a second orientation in the pattern? (rotation)

- Do you see no background at all, where figure and ground are one? (tessellation)

exercises

Parameters for Exercises

There are many factors of color and color relationships in compositions, and all of them can affect the way the colors appear to the viewer. The best way for students to learn through their color exercises is to have simple objectives and fairly strict *rules* about the type of lines and colors to be used. We call those rules "parameters." With strong parameters allowing only a minimum of elements, it is easier to observe the direct relationships between colors, and to see the differences between the students' compositions. When lots of compositions hang together for a critique, it becomes clear which ones are successful in achieving the goals.

As students learn the objectives and build on their skills, they will become more adept at using color. They will gain the ability to tolerate more complications because they understand the ensuing interactions. Therefore, as we move through the chapters, the restrictions on composition size and the number of lines and colors will be gradually reduced. Larger compositions, more colors, and more types of lines will be allowed. However, certain ground rules will remain the same: Flat color and nonrepresentational shapes will remain constant parameters, and the goal of every assignment will be a balanced composition. Five specific parameters include:

1. No recognizable objects are allowed.
2. All colors are to be flat and nongradient, with hard edges that don't fade away.
3. White is always considered a color, even if it is the background.
4. Only neatly cut and pasted papers are appropriate.
5. Balance and unity are *always* the singular goal of every composition.

1. Create sequence and rhythm:

 Explore the color possibilities in creating several sequences of stripes. Each sequence is a 1″ × 2″ composition using five colors, with all stripes running vertically from top to bottom. First place each sequence alone on a foamcore backing, to isolate it. Then, on another 6″ × 6″ foamcore, repeat the sequence three times across and six times down to see the effect of repetition.

 Create the following different sequences to illustrate different types of rhythms. In a critique, be prepared to describe to your class the rhythm established by each type of sequence:

 - Sequence 1: Use strong contrasts for this one.
 - Sequence 2: Use a gradient progression of one of the elements (the hue, the value, or the intensity) of your colors.
 - Sequence 3: Make a dramatic change in the middle of your sequence.
 - Sequence 4: Use all low-intensity colors, including achromatic hues.

2. Design a shape to translate:

 Design a shape to be translated when used to form a pattern. Using two colors, one for the figure and one for the ground, make a 6″ × 6″ pattern.

3. Design a shape to scale and rotate:

 Design a shape to be used for a simple self-similar composition. Use a two-step process to figure out a composition with your choice of shape:

 - First image: Scale and repeat this shape five times, and place the shapes in a row in size order.
 - Second image: Using rotation, connect the set of five scaled shapes together in your choice of design.

4. Design a shape to rotate with unequal sides:

 Using four colors, design a shape that does not have equal sides, so that when rotated the orientation is different. Create a 6″ × 6″ composition with a pattern you design by rotating the shape in some way.

5. Draw a tessellation:

 Explore how color changes plane locations. Draw a tessellation of two shapes that fit together with no gaps. Make an 8″ x 8″ composition using a color of your choice for each shape. Make a second composition with one shape's color changed. In your class critique, be prepared to analyze the plane locations that result due to their colors.

6. Replicate textures:

 Make three 3″ × 3″ compositions to replicate found textures. Find objects that have textures that vary considerably. Choose one with a smooth shiny surface, one with a soft nubby surface, and one with a rough surface. Examine them to determine what the difference is between them. Can you identify the size and extent of the value differences? For each composition, replicate these three different textures, paying close attention to value differences.

7. Use texture as the basic shapes for a pattern:

 For this 5″ × 7″ composition, create a tessellation using rectangles of the three textures you created in exercise 6.

8. Differentiate pattern from texture:

 - In an 8″ × 8″ composition, make a pattern that has a figure–ground distinction by using the techniques of repetition, translation, scale, and rotation.
 - In this 8″ × 8″ composition, turn the pattern into a texture by changing the elements through the use of scaling and rotation and by randomizing the elements. In your class critique, identify how you applied each technique to the original shape to make the pattern. Then identify how you used these techniques to create the texture.

9. Create water texture:

 Study a river or stream and try to match a color you see in it with paint. Create three variations of water textures using different hues, and evaluate whether they appear to represent water:

 - First image: Make the hues of this texture true to what you observed.
 - Second image: Make the hues for this one slightly more intense.
 - Third image: For this image, use hues that are totally not water-like.

10. Use your new-found knowledge:

 What techniques were used to create the patterns in the woven bowls shown in Figure 13.41, *Ethiopia*?

Chapter 1

1 Francis MacDonald Cornford (translator with a running commentary), *Plato's Cosmology: The Timaeus of Plato* (First published in Great Britain 1937 by Kegan Paul, Trench, Trubner & Co. Ltd.; reprinted 1948, 1952, 1956, and 1966 by Routledge & Kegan Paul Ltd. Broadway House; printed in Great Britain by Compton Printing Ltd., London & Aylesbury, *"single homogeneous body,"* p. 153).

2 Ibid.

3 James S. Ackerman, *Distance Points: Essays in Theory and Renaissance Art and Architecture* (Boston: Massachusetts Institute of Technology, 1991); FROM Leonardo da Vinci, *The Notebooks of Leonardo Da Vinci*, Vol. 1, compiled and edited from the original manuscripts by Jean Paul Richter (London: Dover Publications, 1883, 1970), paragraph 306, from MS. G, fol. 153v (an unabridged edition of the work first published in London in 1883 by Sampson Low, Marston, Searle & Rivington, with the title *The Literary Works of Leonardo da Vinci*. Mineola, NY.)

4 Roy Osbourne, *Lights and Pigments: Color Principles for Artists* (UK: John Murray Publishers, 1980), 19.

5 Isaac Newton, *Opticks* (London, 1704; numerous subsequent editions; New York: Dover Publications, 1952).

6 Ibid.

7 Ogden N. Rood, *Students' Text-Book of Color; or Modern Chromatics with Applications to Art and Industry* (New York: D. Appleton, 1903); *"a more or less pure white, but under no circumstances anything approaching green"* p. 125.

8 Ibid., 295.

9 Ibid., 295–296.

10 "Applications Note," *Insight on Color*, Vol. 13, No. 2. http://www.hunterlab.com/appnotes/an02_01.pdf. Accessed June 14, 2012, Hunter lab, 2008.

Chapter 2

1 Jehan Georges Vibert Percy Young, *The Science of Painting* (London: Percy Young, 1892), 49.

Chapter 3

1 Michel E. Chevreul, *The Principles of Harmony and Contrast of Colors* (New York: Reinhold Publishing, 1967), 11.

2 H. Anna Suh (Ed.), *Van Gogh's Letters: The Mind of the Artist in Paintings, Drawings, and Words*; Letter 533 to Theo van Gogh, Arles, September 8, 1888, (New York: Black Dog & Leventhal Publishers, 2006), 224.

3 Rudolf Arnheim, *Art and Visual Perception: A Psychology of the Creative Eye*, Fiftieth Anniversary Printing (Berkeley and Los Angeles, CA: University of California Press, 1974, by the Regents of the University of California, USA), 360. *"Since the eye spontaneously seeks out and links complementary colors, they are often used to establish connections in a painting between areas that lie at some distance from each other."*

4 Ogden N. Rood, *Students' Text-Book of Color; or Modern Chromatics with Applications to Art and Industry* (New York: D. Appleton, 1903); *"The object of painting is the production, by the use of color, of more or less perfect representations of natural objects." "The painter is to a considerable extent restricted in the choice of his tints; he must mainly use the pale unsaturated colors of nature, and must often employ color-combinations that would be rejected by the decorator:"* p. 306; *"not too opposite . . . hurtful contrast . . .offending:"* p. 297; *"forsake its childlike independence"* p. 307.

5 Kenneth Burchett, *A Bibliographical History of the Study and Use of Color from Aristotle to Kandinsky* (Lewiston, NY: The Edward Mellon Press, 2005), 80.

6 John Gage, *Colour and Culture, Practice and Meaning from Antiquity to Abstraction* (Berkeley and Los Angeles, CA: University of California Press; published by arrangement with Thames and Hudson Ltd., London, 1993), 229.

Chapter 5

1 *New York Times*, "Topics of the Times: Innocence as an Art Critic," March 1, 1913, p. 14.

2 Rudolf Arnheim, *The Power of the Center: A Study of Composition in the Visual Arts* (rev. ed.), (Berkeley and Los Angeles, CA: University of California Press, 1982; London: Regents of the University of California, 1982), 237.

Chapter 6

1 Rudolf Arnheim, *The Power of the Center: A Study of Composition in the Visual Arts* (rev. ed.), (Berkeley and Los Angeles, CA: University of California Press, 1982; London: Regents of the University of California, 1982), *"the dynamic state in which the forces constituting a visual configuration compensate for one another. The mutual neutralization of directed tensions produces an effect of immobility at the balancing center."* p. 237; *"acts as the balancing center for the entire composition,"* p. 92.

2 Ibid., *"marks the line along which a composition most easily breaks into two halves,"* p. 87.

3 Vincent van Gogh, Arles, September 3, 1888; letter 531 to Theo van Gogh http://www.vggallery.com/letters/combined.htm, (David Brooks).

4 Rudolf Arnheim, *Art and Visual Perception: A Psychology of the Creative Eye, Fiftieth Anniversary Printing* (Berkeley and Los Angeles, CA: University of California Press, 1974, by the Regents of the University of California, USA), 360. *"In a balanced composition, all factors such as shape, direction and location are mutually determined in such a way that no change seems possible, and the whole assumes the character of 'necessity' in all its parts. An unbalanced composition looks accidental, transitory and therefore invalid. Its elements show a tendency to change shape or place in order to reach a state that better accords with the total structure."* p. 20.

Chapter 7

1 Rudolf Arnheim, *The Power of the Center: A Study of Composition in the Visual Arts* (rev. ed.), (Berkeley and Los Angeles, CA: University of California Press, 1982; London: Regents of the University of California, 1982), 238.

2 Wendy Steiner, *Venus in Exile: The Rejection of Beauty in Twentieth Century Art* (First published in 2001 by The Free Press, a division of NY: Simon & Schuster, 2001; University of Chicago Press edition 2002, USA), 62.

3 Kenneth Clement Lindsay and Peter Vergo, *Wassily Kandinsky: Complete Writings on Art* (Edited by 1st Da Capo Press; originally published: Boston: G. K. Hall, 1982), 370.

4 Will Grohmann, *Wassily Kandinsky: Life and Work* (New York: Harry N. Abrams, 1958), 183.

Chapter 8

1 Willis D. Ellis, *A Source Book of Gestalt Psychology* (London: First published in 1938 by Kegan Paul, Trench, Trubner & Co., Ltd., 1938; reprinted in 1999, 2000, 2001 by Routledge, Great Britain), 2.

2 Ibid., *"additions to an incomplete object (e.g. the segment of a curve)"* . . . *"carries on the principle logically demanded by the original,"* p. 325.

Chapter 9

1 Michel E. Chevreul, *The Principles of Harmony and Contrast of Colors* (New York: Reinhold Publishing, 1967), 232.

2 Ibid.

Chapter 10

1 Michael Corcoran, *For Which It Stands: An Anecdotal Biography of the American Flag* (New York: Simon & Schuster, 2002).

Chapter 12

1 Margaret Ruth Miner, *Between Music and Letters: Baudelaire's "Richard Wagner Et Tannhäuser À Paris,"* Athens, GA: University of Georgia Press, 1995), 48.

2 John Rewald, *Post-Impressionism from Gauguin to Matisse* (New York: Museum of Modern Art, 1956), 126.

3 Will Grohmann, *Wassily Kandinsky: Life and Work* (New York: Harry N. Abrams, 1958), 88.

4 Ibid., p. 88.

5 Daniel J. Levitin, *This Is Your Brain on Music: The Science of a Human Obsession* (New York: Penguin Group, 2007).

A

Abstract—Nonrepresentational art; art with no object.

Accent—The area of a composition that attracts attention first; it has a strong contrast against the rest of the composition.

Achromatic hues—The hues that have no chroma, are not mixtures of chromatic hues, and are not in the spectrum. Black, white, and gray are the achromatic hues.

Additive hue system—The colors we obtain when mixing together different wavelengths of light.

Adjacent hues—Hues that are next to each other on the color circle, such as yellow and orange.

After-image—When we stare at a hue for a few seconds and then look away, fatigue and an inability of the cones to adjust causes the eye to see the after-image—a ghostly complement of the hue; also known as "successive contrast."

Analogous hues—Hues that are near each other on the color circle, and that share at least one primary hue. For example: Red and violet, which share red.

Asymmetry—Inequality of shapes, colors, and lines on either side of a center line or point; also a counterbalance situation in another location, using the elements of composition.

Atmospheric—A quality of a color that makes it seem to have depth, like the sky.

B

Balance—The organization of a composition (the arrangement of the colors, lines, and shapes) on either side of the center line.

Background—The area behind the object in a composition; the ground or field.

Barriers—Design elements, such as low value colors, that form a barrier preventing the eye from moving past them. They may surround a focal point or be aligned with the edge of the composition.

Breathing room—The empty space that can surround an object in a composition and allow it to remain unobstructed and easy to see. Some elements need a substantial amount of breathing room around them, or else they seem crushed, cramped, or overwhelmingly large for the area.

Brilliance—The intensity chroma or saturation of a color; a measure of grayness versus the chroma of a color. Grayness is created by adding gray, black, white or the complement to a color.

Brightness—The lightness or darkness of a color. A light color has brightness.

Broken Hues—Also known as "intermediary hues," they have been mixed with gray, black, or white; two complementary hues can also make a broken hue.

C

Calibration—An adjustment of two color-producing devices to help them communicate with each other and produce the same color. For example: A printer and a monitor can be calibrated.

Camouflage—A decoration on objects to make them blend in with the background.

Chiaroscuro—A technique in art that uses variations of highlights and shadows to achieve a three-dimensional effect.

Child color—In transparency, the child color is created from the two parent colors that are mixed together.

Chroma—The intensity or brilliance of a color; chroma is the opposite of grayness.

Chromatic hues—Chromatic hues include the spectral hues and their mixtures. If these hues are mixed with achromatic hues, they still are chromatic hues. Only black, white, and gray are not chromatic hues, because they have no chroma.

Closure—The Gestalt principle of perception whereby we perceive a whole shape even when it is missing some edges.

Color—The result of a combination of a hue, a value, and a level of intensity.

Color circle—An illustration of all spectral hues, placed in a circle, with the longest wave hue (red) meeting the shortest wave hue (violet).

Color space—All the colors that a color-producing device (such as a monitor or a printer) can make.

Color management system—In software, a way of translating the light-based RGB profile of the computer monitor to the pigment-based CMYK profile of printing.

Color relationship—Color relationships are defined by their distance from each other on the color circle. For example: Color relationships include complements and triads.

Complement—The hue opposite another hue on the color circle. For example: Red is the complement of green.

Composition (two-dimensional)—The arrangement of colors, lines, and shapes on a two-dimensional surface that are intended to be a work of design.

Concave—A curve shaped like part of the interior of a circle.

Cones—Photoreceptors in our retinas that allow us to see color. There are three different types of cones, each of which can absorb one of the three primary hues of light.

Contrast—The effect that one color, line, or shape has on another due to their differences. Their placement near each other would allow comparison and intensify their particular properties.

Continuity—The visual path, or the eye's process of moving through the composition.

Convex—A curve shaped like part of the exterior of a circle.

Curvilinear—The curvy quality of lines or shapes.

D

Differentiation—Making a product stand out from the competition in some way, either because of its physical appearance, or through the benefits that it offers to the customer.

Direction—The orientation of a line or shape in a composition. The direction can be horizontal, vertical, or diagonal.

Dominant—The element that has the greatest influence on a composition is said to be "dominant." Dominance can exist in color, line, shape, or size of area. The second most influential element would be called "subdominant," "secondary," or "subordinate."

Dye lot—A batch of dye solution, associated with its color; each batch varies from other batches because of atmospheric differences or qualities of the dye itself.

Dynamic—Energy in a composition that makes the shapes and lines appear to have energy or to be moving.

E

Elements of color—Hue, value, and intensity are the three factors or elements that make up a color.

Elements of composition—Color, line, and shape are the three factors that are used to form a composition.

Energy—The visual movement in a composition. Energy could be tension, dynamic energy, static energy, or passive energy.

Extraneous object—An element in a composition that prevents it from being balanced and needs to be removed to achieve balance.

F

Field—The background, or ground, of a two-dimensional image; the area surrounding the object.

Figure—The object of a composition; not the background.

Fluting—An illusion in a value chart where each gray appears to change value slightly at the borders of its two neighboring values. Fluting, also known as "Mach Bands," illustrates how the value of any color makes an adjacent one as different from it as possible.

Focal point—The area of a composition that creates an attraction for the eye, keeping the eye focused on it.

Forecasting—In reference to forecasting color, this refers to trend-spotting companies that determine the colors that will be popular a couple of years in the future. Manufacturers rely on this information to help guide them with their color choices.

Form—A shape that appears to be three-dimensional in a two-dimensional composition; a volume.

G

Gamut of color—The range of colors, such as those that the eye can see, or those that can be produced by a color-producing device.

Gestalt principles of perception—As identified by psychologist Max Wertheimer, the way we organize objects that we see to help us determine their importance, based on factors such as their similarity or proximity.

Goethe's proportions—Goethe proposed the concept that pairs of complements are best used together in specific proportions. For example: Green and red should each have 50 percent of the area.

Gradient—Several values of one hue that are lined up in sequence from lightest to darkest. Gradient can also refer to shapes or lines placed in size order.

Ground—The background of a two-dimensional image, placed behind the object.

H

Harmony—Colors that are pleasing together are said to be in harmony with each other.

Hue—The color name, such as red, blue, green, and yellow, based on the length of the light wave.

I

Illuminated—An area brightened up or lit by light from another source; also the decoration on a manuscript.

Implied curvilinear—A curvy movement indicated by the placement of a series of shapes on a curve in a composition. It is *implied* because no curvy line is actually drawn.

Interference phenomenon of light—The obstruction of a ray of light by another medium, such as oil, that causes a different hue to appear; also known as "iridescence." We see interference colors in oil slicks, butterfly wings, bird feathers, and the inside of oyster shells.

Intensity—The saturation, chroma, brilliance, or strength of a color as compared to gray. A high intensity color has no gray in it. Low intensity colors have more grayness, and are created by adding gray, black, white, or the complement to a color.

Interstitial—A narrow area that is in-between two shapes.

Iridescence—The interplay of rainbow-like hues that arises from interference of light waves by another medium such as oil or bird feathers. Objects that produce iridescence include opals, butterfly wings, peacock feathers, the mother-of-pearl that we see inside oyster shells, and oil slicks.

L

Line of composition—The major orientation of the lines in a composition; the type of line in the composition that has the most influence over the mood and artistic message. There is often a secondary line of composition with slightly less influence.

Linear perspective—Lines and forms on a two-dimensional surface that give the illusion of distance.

Local color—The color ascribed to an object irrespective of the lighting situation. We don't really know if every object has its own local color, since we see the color relative to the lighting situation.

Luminous—Radiating or reflecting light. Appearing to be the source of light.

Luster—The gleam of reflected light that we see on fabrics such as silk or leather. Within the category of luster are the qualities of luminosity and iridescence.

M

Metamerism—A pair of colors that are different under one light source but appear to be the same under another type of light source. They are a metameric match. This difference in their appearance happens because the colors are not a spectral match; that is, they do not have the same spectral reflectance curve.

Metameric match—Two samples of colors, as in paint, that look different under different light sources.

Meter—In music, meter is the beat; the background pulse that you feel that makes you want to tap your foot.

Middle gray—The value we call "middle gray" appears to be the point halfway between black and white.

Monochromatic—Having one hue.

N

Negative space—The background surrounding the lines and forms in a two-dimensional composition.

O

Object—The figure in a representational composition; the opposite of the background.

Opaque—A surface that transmits no light through it, made of materials ranging from soft fabrics or rubber to hard materials like plastic or metal.

Organic—A word that describes lines or shapes that are curvy and do not follow the shape of a recognizable geometric form; lines or shapes with no sharp edges.

Orientation—The direction in which a line or shape leads.

P

Parent color—In an illustration of transparency, the parent color is one of the two that are mixed together to produce a "child" color.

Passive energy—Acceptance of, or a nonmoving obstruction to, nearby elements. Curves are examples of passive reaction to the adjacent elements.

Pattern—A predictable arrangement of lines and shapes using repetition and other techniques.

Perception—The way the human brain shapes our understanding of what we see.

Picture plane—The flat surface—the paper or canvas—of the two-dimensional composition. It is a vertical plane. The top, bottom, and side edges of the composition define the limits of the picture plane, and we say they are on the "picture plane level."

Pigment—Coloring matter in the form of insoluble powder that is mixed with an aqueous or oil base to make paint.

Pitch—In music, how high or how low the notes are.

Positive space—The objects in a composition.

Primary hues—These hues cannot be attained by mixing other colors. Red, yellow, and blue are the three pigment primary hues; red, blue, and green are the three primary hues in light.

Profile—A description of the color space of a printing or viewing device; a list of all the colors it can produce based on its system of primary hues. Because devices such as scanners, printers, and monitors have different systems of primary hues, they have different profiles.

Proximity—In the same area.

R

Radial balance—Balance that is achieved by elements that start in the center and move out along a radius, like the spokes of a wheel.

Refraction—Light waves that are bent and split up into their component parts when passing through a medium such as the lens of a prism. We call those component parts the "seven spectral hues."

Relationship of hues—Several relationships exist as a result of the distance the hues are from each other on the color circle, for example, complements.

Representational art—Art that looks like real-life objects.

Reverberation—A quality of sound that makes it seem to come from different locations, making the audio space bigger or smaller.

Rhythm—In music, how the beat sounds over time; how the sounds link to each other.

Rods—Photoreceptors in our retinas that allow us to see light and dark.

S

Saturation—The intensity, brilliance, or strength of a color as compared to gray. A saturated color has no gray in it.

Scintillation—Two colors in the same visual space that seem to vibrate against each other.

Secondary hues—Green, orange, and violet are the secondary hues. Each is obtained by mixing two primary hues together.

Secondary line of composition—The secondary line of composition has slightly less influence than the major line of composition.

Shade—A hue mixed with black.

Sidebars—Minor areas of interest that occur when visually obstructive colors, shapes, or borders break up the surface of the composition into sections.

Simultaneous contrast—The effect that two colors have on each other when they are in the same visual space. All colors are perceived relative to the surrounding colors.

Spectral hues—The seven hues that can be refracted from the white light of the sun (ROYGBIV).

Space—An open area of background in a two-dimensional composition.

Spectral reflectance curve—The wavelengths of light that are reflected by a color and not absorbed into it. It determines the spectral hue of the color.

Spectrophotometer—An instrument that measures the wavelengths of light that are absorbed into a surface of a material to determine its color.

Split complements—The two hues adjacent to the complement of a hue. For example: The complement of violet is yellow, but the split complements are red—yellow and green—yellow.

Stability—A shape that feels steady and unwavering.

Static—A nonmoving type of energy in a composition.

Stepping-stones—Elements with a graduating relationship that move the eye from one point to the next to help continuity within the composition.

Subordinate—The element that is secondary to the main element in its influence in the composition. It is also known as "subdominant" or "secondary."

Subtractive system—The system of mixing pigments to obtain color.

Symmetry—Equality of parts on either side of a center line or point when the shapes and their sizes and locations are a mirror image of each other.

Synaesthesia—A "condition" in which a person experiences one sense through another sense, such as seeing a sound in color as well as hearing it.

T

Temperature of color—A word used to describe whether a hue has red mixed in it, or blue mixed in it. Those with red in them are considered warm; those with blue in them are considered cool.

Tempo—How fast or slow musical notes are played.

Tension—Potential energy, where colors and shapes scintillate or vibrate against each other. Tension is the feeling that something is about to move.

Tension—Potential energy; the feeling that something is about to move.

Tertiary hues—These hues are the ones between the primary and secondary hues on the color circle.

Theme—A melody; a complete musical phrase or expression.

Timbre—The sound quality of a note, related to the type of vibrations produced by the instrument; it is the difference in sound between various instruments.

Tint—A hue mixed with white.

Tone—A hue mixed with gray.

Triad—Three hues equidistant from each other on a color circle, such as the primary hues red, yellow, and blue, or the secondary hues green, violet, and orange.

Transparent—A clear surface that transmits light through it.

Translucent—A partially occluded surface that transmits diffused light through it.

U

Unity—A composition has unity when all the elements work together toward a common artistic goal.

V

Value—The lightness or darkness of a color. Black is the darkest of all colors, and therefore the lowest value possible. White is the highest value possible.

Value scale—A range of achromatic values lined up in order from white to black.

Vector—An imaginary and invisible line, created by shapes in a composition, that determines the direction in which the eye moves.

Visible light spectrum—The electromagnetic waves from the light of the sun that are visible to us; we see them as color.

Visual weight—A color's strength and ability to stand out relative to the other colors are due to a combination of elements: the color's size, location, color, and shape. Visual weight lends an object power and strength, and the ability to attract enough attention to be the focal point.

Volume—A three-dimensional shape; a form.

W

Wavelength—An electromagnetic wave with a particular wavelength identifies each spectral hue.

Ackerman, James S. *Distance Points: Essays in Theory and Renaissance Art and Architecture.* Boston: Massachusetts Institute of Technology, 1991; From Leonardo da Vinci, *The Notebooks of Leonardo Da Vinci*, Volume 1, compiled and edited from the original manuscripts by Jean Paul Richter. London: Dover Publications, 1883, 1970, paragraph 306, from MS. G, fol. 153v (an unabridged edition of the work first published in London in 1883 by Sampson Low, Marston, Searle & Rivington, with the title *The Literary Works of Leonardo da Vinci*. Mineola, NY.)

Albers, Josef. *The Interaction of Color.* New Haven, CT: Yale University Press, 1975, (hardcover, 1st ed.).

Arnheim, Rudolf, and Alan Lee. A *Critical Account of Some of Josef Albers' Concepts of Color.* (re: Alan Lee). 15, No. 2, p. 174 (1982). From: Rudolf Arnheim Bibliography of Articles, Reviews, Commentaries and Letters Published in Leonardo On-Line (International Society for the Arts, Sciences and Technology), 1968-2000; *Compiled July 1997 by Patrick Lambelet*; Updated 4 September 2003 (no citations 2001-2003). http://www.leonardo.info/index.html

Arnheim, Rudolf. *Art and Visual Perception: A Psychology of the Creative Eye.* Los Angeles, CA: University of California Press, 1974.

———. *The Power of the Center: A Study of Composition in the Visual Arts* (rev. ed.). Berkeley and Los Angeles, CA: University of California Press, 1982; London: Regents of the University of California, 1982.

———. *Visual Thinking.* Los Angeles, CA: University of California Press, 1969.

Art of Islam, Language and Meaning. Titus Burckhardt Commemorative Edition. Bloomington, IN: World Wisdom, 2009.

Backhaus, Werner, and Reinhold Kliegel and John Simon Werner. *Color Vision: Perspectives from Different Disciplines.* New York: Walter de Gruyter & Co., 1998.

Birren, Faber. *Principles of Color.* New York: Van Nostrand Reinhold Co., 1969.

Brownell, F. G. "Coats of Arms and Flags in Namibia." *Archives News.* Eight articles from April to December 1990.

———. *National and Provincial Symbols and Flora and Fauna Emblems of the Republic of South Africa.* Melville: C. van Rensburg Publications, 1993.

Buckberrough, Sherry. *Robert Delauney: The Discovery of Simultaneity.* Ann Arbor, MI: University of Michigan Research Press, 1982.

Burchett, Kenneth E. *A Bibliographical History of the Study and Use of Color from Aristotle to Kandinsky.* Lewiston, NY: The Edwin Mellen Press, 2005. (ISBN 0773460411).

Chevreul, Michel E. *The Principles of Harmony and Contrast of Colors.* New York: Reinhold Publishing Co., 1967.

Chipp, Herschel Browning. *Theories of Modern Art.* Los Angeles, CA: University of California Press, 1967.

Corcoran, Michael. *For Which It Stands: An Anecdotal Biography of the American Flag.* New York: Simon & Schuster, 2002.

Dewey, David. *The Watercolor Book: Materials and Techniques for Today's Artists.* New York: Crown Publishing Group, 2000.

Ellis, Willis D. *A Source Book of Gestalt Psychology.* London: First published in 1938 by Kegan Paul, Trench, Trubner & Co., Ltd.; reprinted in 1999, 2000, 2001 by Routledge, Great Britain.

Flam, Jack. *Richard Diebenkorn: Ocean Park.* New York: Rizzoli/Gagosian Gallery Publications; 1992.

Gage, John. *Colour and Culture, Practice and Meaning from Antiquity to Abstraction.* Berkeley and Los Angeles, CA: University of California Press, by arrangement with Thames and Hudson Ltd., London, 1993.

———. *Color and Meaning: Art, Science and Symbolism.* Berkeley and Los Angeles, CA: University of California Press, by arrangement with Thames and Hudson Ltd., London, 1999.

———. *Color in Art.* London: Thames & Hudson, 2006. (ISBN-10: 0500203946).

Garan, Augusto. *Color Harmonies.* Chicago: University of Chicago Press, 1993.

Grohmann, Will. *Wassily Kandinsky: Life and Work.* New York: Harry N. Abrams, 1958.

Guggenheim Foundation. *Kandinsky: On the Spiritual in Art.* New York: Solomon R. Guggenheim Foundation, for the Museum of Nonobjective Painting, 1946.

Hunt, R. W. G. *Measuring Color* (3rd ed.). United Kingdom: John Wiley and Sons, 2001. (ISBN-10: 0863433871).

Itten, Johannes, and Faber Birren (Ed.). *Elements of Color.* USA: John Wiley and Sons, 1970.

Jacobson, Egbert. *Basic Color: An Interpretation of the Ostwald Color System.* Chicago: P. Theobald, 1948.

Janco, Marcel. *Dada at Two Speeds.* Lucy R. Lippard, editor and translator. *Dadas on Art.* Englewood Cliffs, NJ: Prentice Hall, 1971.

Kandinsky, Wassily. *Point and Line to Plane.* Translation by Howard Dearstyne; edited by Hilla Rebay. Mineola, NY: Dover Publications, 1979.

———. *The Art of Spiritual Harmony.* New York, NY: Cosimo Books, 2007.

Levitin, Daniel J. *This Is Your Brain on Music: The Science of a Human Obsession.* New York: Penguin Group, 2007.

Lidwell, William, and Jill Butler and Christina Holden. *Universal Principles of Design.* Beverly, MA: Rockport Publishers, 2003. (ISBN-10: 1592530079).

Lindsay, Kenneth Clement, and Peter Vergo. *Wassily Kandinsky: Complete Writings on Art.* Edited by First Da Capo Press; originally published: Boston: G. K. Hall, 1982. National Society for the Arts, Sciences and Technology's & Co., reprinted with plates originally omitted from *Sounds* publication.

Maurer, Naomi Margolis. *The Pursuit of Spiritual Wisdom: The Thought and Art of Vincent van Gogh and Paul Gauguin.* USA: Associated University Presses, 1999. (ISBN: 0-8386-3749-3).

Meyers, Herbert M., and Richard Gerstman. *Branding at the Digital Age.* New York: Palgrave, division of St. Martin's Press, 2001. (ISBN: 0-333-94769-X).

Miner, Margaret, and Charles Baudelaire. *Resonant Gaps Between Baudelaire and Wagner.* Athens, GA: University of Georgia Press, 1995.

Miner, Margaret. *Richard Wagner et "Tannhäuser" à Paris.* Athens, GA: University of Georgia Press, 1995.

Munsell, Albert H. *A Color Notation by Albert H. Munsell: An Illustrated System Defining All Colors and Their Relations by Measured Scales of Hue, Value and Chroma*, (14th ed.). Baltimore, MD: Munsell Color, 1981. (A division of Macbeth, Kollmorgen Corp., Copyright 1946 by Munsell Color Co., Inc.).

Newton, Isaac. *Opticks.* London, 1704; numerous subsequent editions; New York: Dover Publications, 1952.

New York Times, "Topics of the Times; Innocence as an Art Critic," March 1, 1913, p. 14.

Nielson, Karla J. *Interior Textiles: Fabrics, Applications and Historical Styles.* USA: John Wiley & Sons, 2007.

Osbourne, Roy. *Lights and Pigments: Colour Principles for Artists*, New York: Harper & Row, 1980.

Ostwald, Wilhelm, and Faber Birren (Ed.). *The Color Primer.* New York: Van Nostrand Reinhold Co., 1969.

Plato. *Plato's Cosmology: The Timaeus of Plato.* Francis Mac-Donald Cornford, translator with a running commentary. First published in Great Britain 1937 by Kegan Paul, Trench, Trubner & Co. Ltd.; reprinted 1948, 1952, 1956, and 1966 by Routledge & Kegan Paul Ltd. Broadway House; printed in Great Britain by Compton Printing Ltd., London & Aylesbury.

Pollan, Michael. *The Omnivore's Dilemma: A Natural History of Four Meals*, New York: Penguin, 2006.

Poore, Henry Rankin. *Pictorial Composition (Composition in Art).* Mineola, NY: Dover Publications, 1976. (ISBN-10: 0486233588).

Ratliff, Floyd. *Paul Signac and Color in Neo-Impressionism.* NY: Rockefeller University Press, 1992. (ISBN-10: 0874700507).

Rewald, John. *Post-Impressionism: From Van Gogh to Gauguin.* New York: Museum of Modern Art, 1962.

———. *The History of Impressionism.* New York: Museum of Modern Art, 1946.

Roger, Julia Ellen. *The Shell Book* (for information, not pictures). General Books LLC, 2009. (ISBN-10: 0217130895).

Rood, Ogden N. *Modern Chromatics.* (Preface, Introduction, and Commentary Notes by Faber Birren.) New York: Van Nostrand Reinhold, 1973.

———. *Students' Text-Book of Color; or Modern Chromatics with Applications to Art and Industry.* New York: D. Appleton and Company, 1903.

Ruskin, J. *Modern Painters: Of General Principles and of Truth* (volume 1). London: Smith, Elder and Co., 1843.

Sacks, Richard. *The Traditional Phrase in Homer: Two Studies in Form, Meaning and Interpretation.* Copyright by the Trustees of Columbia University in The City of New York, 1987. Printed in the Netherlands by E. J. Brill.

Steiner, Wendy. *Venus in Exile: The Rejection of Beauty in Twentieth Century Art.* First published in 2001 by The Free Press, a division of NY: Simon & Schuster, Inc.; University of Chicago Press edition, 2002.

Suh, H. Anna (Ed.). *Van Gogh's Letters: The Mind of the Artist in Paintings, Drawings, and Words.* New York: Black Dog & Leventhal Publishers, 2006.

Tammet, Daniel. *Embracing the Wide Sky: A Tour Across the Horizons of the Mind.* New York: Free Press, 2009. A division of Simon & Schuster, NY 2009.

Taylor, J. Scott. *A Short Account of the Ostwald Color System.* London: Winsor & Newton Limited, 1934.

van Gogh, Vincent. *Letters to Theo van Gogh.* Written September 8–10, 1888, in Arles. Translated by Johanna van Gogh-Bonger; Robert Harrison (Ed.), published in *The Complete Letters of Vincent van Gogh.* Boston: Bulfinch, 1991, numbers 533, 534, W07.

Vibert, Jehan Georges, and Percy Young. *The Science of Painting.* London: Percy Young, 1892.

Ward, Geoffrey C. and Burns, Ken. *The War: An Intimate History, 1941–1945*, New York: Knopf, 2007.

Westfall, R. S. "The Development of Newton's Theory of Color." *ISIS 53*, 1962, pp. 339–358.

White, Jan B. *Color for Impact: How Color Can Get Your Message Across or Get in the Way* (paperback). Berkeley, CA: Strathmoor Press, 1997. (ISBN-10: 0962489190).

Znamierowski, Alfred. *Flags of the World: An Illustrated Guide to Contemporary Flags* (hardcover, 1st ed.). Dayton, OH: Lorenz Books, 2000. (ISBN: 1842153374).

Websites

Adobe technical guides—The Munsell Color System: http://dba.med.sc.edu/price/irf/Adobe_tg/models/munsell.html

Adobe technical systems: Color management systems http://dba.med.sc.edu/price/irf/Adobe_tg/manage/main.html

Ancient Greek painting: www.mlahanas.de/Greeks/LX/Zographia.html accessed June 2012.

Article: "McDonald's Happy Meal Toy Safety Facts," McDonald's Corporation, accessed July 19, 2008, http://www.mcdonalds.com/corp/about/factsheets.html

Classics in the History of Psychology: An internet resource developed by Christopher D. Green, York University, Toronto, Ontario; Max Wertheimer: Laws of Organization in Perceptual Forms (1923): http://psy.ed.asu.edu/~classics/Wertheimer/Forms/forms.htm

Color management systems – Adobe technical systems: http://dba.med.sc.edu/price/irf/Adobe_tg/manage/main.html

Color Marketing Group: www.colormarketing.org/

Comenas, Gary: www.warholstars.org/abstractexpressionism/artists/duchamp/marcelduchamp.html garycom@blueyonder.co.uk

Cooper Union: www.cooper.edu/classes/art/hta321/99spring/Rebecca.html accessed June 2012.

Helenica: Ancient Greek painting www.mlahanas.de/Greeks/LX/Zographia.html accessed June 2012.

Helenica: Homer www.mlahanas.de/Greeks/Live/Writer/Homer.htm accessed June 2012.

Homer information: www.mlahanas.de/Greeks/Live/Writer/Homer.htm accessed June 2012.

HSV and RGB color spaces: www.grxuan.org/english/ICME07-IDENTIFYING%20COMPUTER%20GRAPHICS.pdf

Hunter Lab "Applications Note," *Insight on Color*, 13, No. 2. Hunter L, a, b Versus CIE 1976 L*a*b*.

www.hunterlab.com/appnotes/an02_01.pdf accessed June 14, 2012, Hunter lab, 2008.

Inter-Society Color Council (ISCC): www.iscc.org/pdf/brochure.pdf

JISC Digital media: www.jiscdigitalmedia.ac.uk/stillimages/advice/colour-management-in-practice

Kubovy, M. and M. van den Berg, 2008. "The Whole Is Equal to the Sum of Its Parts: A Probabilistic Model of Grouping by Proximity and Similarity in Regular Patterns." *Psychological Review*, 115, 131–154. http://people.virginia.edu/~mk9y/mySite/papers/KubovyVanDenBerg2008.pdf

Kurland, Philip B. and Lerner, Ralph, eds. *The Founders' Constitution* (Chicago: University of Chicago Press, 1987), accessed February 28, 2010, http://press-pubs.uchicago.edu/founders/

MacEvoy, Bruce. "Color Vision: Colormaking Attributes." 2005. www.handprint.com/HP/WCL/color3.html

National Roofing Contractors Association – Color retention problems in roofing materials: http://docserver.nrca.net/pdfs/technical/1814.pdf

NASA National Aeronautics and Space Administration: http://missionscience.nasa.gov/ems/12_gammarays.html accessed June 24, 2012 (Chapter 2).

Nineteenth Century Art Worldwide: *Symphonic Seas, Oceans of Liberty: Paul Signac's La Mer: Les Barques (Concarneau)* by Robyn Roslak.

www.19thc-artworldwide.org/index.php/component/content/article/64-spring05article/302-symphonic-seas-oceans-of-liberty-paul-signacs-la-mer-les-barques-concarneau

Pantone LLC: www.pantone.com/pages/Pantone/Pantone.aspx?pg=20757&ca=4

Philadelphia Museum of Art: www.philamuseum.org/collections/permanent/51449.html

Roque, Georges. "Chevreul and Impressionism: A Reappraisal." *The Art Bulletin*, 78, No. 1 (Mar., 1996), pp. 27–39. Published by: College Art Association. www.jstor.org/stable/3046155

Thornton, William A. *How Strong Metamerism Disturbs Color Spaces*. New York: John Wiley & Sons, 1998: http://aris.ss.uci.edu/~kjameson/Metamerism.pdf (University of CA, Irvine)

Wertheimer, Max "Laws of Organization in Perceptual Forms" (1923): http://psy.ed.asu.edu/~classics/Wertheimer/Forms/forms.htm

Color Trend Organizations and Their Websites:

ESP Trendlab www.esptrendlab.com/

Promostyl www.promostyl.com/anglais/trendoffice/trendoffice.php

Printsource: www.printsourcenewyork.com/the_future_cafe.html

The Color Association of the United States www.colorassociation.com/

The Doneger Group www.doneger.com/web/231.htm

The International Colour Authority (ICA) www.internationalcolourauthority.org/

Trend Union http://trendunion.com/

K

Kandinsky, Wassily, 99, 149–150, 151*f*, 157, 257, 258–259, 259*f*, 260
Karasikov, Shiri Cohen, 173, 173*f*
Kennedy, Bobby, 253
Kennedy, John F., 253
King, Martin Luther Jr., 253
Kinkade, Catherine, 62*f*, 87*f*, 97, 98*f*, 102, 103*f*, 140*f*, 161*f*, 162*f*, 187, 187*f*, 188*f*, 200, 200*f*, 267*f*
Knorr, Chris, 246*f*
Koch, Helge von, 286
Korodi, Janos, 28, 31, 31*f*, 57, 57*f*, 68*f*, 69*f*, 74*f*, 107, 107*f*, 108, 108*f*, 143, 144*f*, 152*f*, 155*f*, 170, 172*f*, 209, 209*f*, 261, 261*f*, 284, 284*f*
Kupka, František, 265*f*

L

Le Blon, Jacques, 7
Leary, Timothy, 253
Léger, Fernand, 180, 184*f*
Lennon, John, 286, 287*f*
Levitin, Daniel J., 261

M

Matisse, Henri, 149, 151*f*, 233
Max, Peter, 253
Meyer, Gary K., 26, 39, 60, 60*f*, 72, 74*f*, 80*f*, 92*f*, 102, 102*f*, 104, 112*f*, 113, 113*f*, 121, 122*f*, 138, 140, 141, 142*f*, 150, 152*f*, 157, 159, 161*f*, 174*f*, 180, 182, 183*f*, 184, 185*f*, 194, 195*f*, 196*f*, 197*f*, 261, 262*f*, 270*f*, 273*f*, 274*f*, 291*f*
Millet, Jean-François, 121, 121*f*
Miró, Joan, 169, 170*f*
Monet, Claude, 148, 149*f*, 191, 240–241
Motolese, Liz, 283*f*
Munsell, Albert, 9–10, 10*f*, 20, 53
Münter, Gabriele, 258
Münter, Marc, 258

N

Nabakov, Vladimir, 258
Nelson, Sasha, 59, 59*f*, 63, 64*f*, 162, 192, 193*f*, 200, 201*f*, 203*f*, 208–209, 261, 262*f*, 267, 278, 278*f*, 279–280
Nelson-Gillett, Mim, 233*f*
Newcomb, John, 285*f*
Newton, Isaac, 5–6, 7, 51

O

Oppenheim, Meret, 289, 290*f*
Ostwald, Wilhelm, 8–9, 52, 54
Oteiza, Jorge, 290, 290*f*
Otto, Julie, 203*f*, 268*f*

P

Packard, Cynthia, 18, 18*f*, 27, 29, 29*f*, 43, 44, 45*f*, 72, 72*f*, 76*f*, 79*f*, 128*f*, 133*f*, 135, 136*f*, 152, 154*f*, 186*f*, 193, 194*f*, 263, 263*f*
Pargeter, Kirsty, 246*f*
Penrose, Roger, 288
Picabia, Francis, 250
Picasso, Pablo, 149, 151*f*, 153, 204, 204*f*
Pires, Andrea, 153, 155*f*
Pissarro, Camille, 257
Plato, 2
Pliny the Elder, 2
Polygnotus of Thasos, 2
Price, Michael, 137*f*

R

Raphael, 204*f*
Rembrandt, 4, 192, 192*f*
Rewald, John, 234, 256, 257
Richter, Gerhard, 231, 232*f*
Riley, Bridget, 28*f*, 288
Rood, Ogden, 9, 53
Rubens, Peter Paul, 4
Rubin, Edgar, 177
Runge, Philipp Otto, 7

S

Samuel Owen Gallery, 156*f*
Schilling, Joel, 12*f*, 34*f*, 60, 61*f*, 63*f*, 65, 66*f*, 67*f*, 94*f*, 108, 109*f*, 111*f*, 112*f*, 127, 127*f*, 131*f*, 147*f*, 177*f*, 179*f*, 193*f*, 197*f*, 252*f*, 269*f*, 278, 278*f*, 280, 281*f*, 282*f*, 285*f*, 287*f*, 290, 290*f*, 291*f*
Schönberg, Arnold, 258
Scriabin, Alexander, 258
Seurat, Georges, 149, 152, 153*f*
Sharp, Martin, 253
Shih, Charlene, 236*f*
Signac, Paul, 149, 256–258, 257*f*, 258*f*
Sissman, Liron, 19, 20, 20*f*, 41, 71*f*, 73*f*, 109, 110*f*
Smith, Dodie, 205, 206*f*, 277*f*, 278, 280, 280*f*
Smith, Samantha Keely, 81, 162, 163*f*, 187, 188*f*
Steen, Hovickszoon, 137, 137*f*
Stokowski, Leopold, 260
Strauss, Richard, 259
Stravinsky, Igor, 260
Svalbonas, Krista, 120, 120*f*, 170, 171*f*
Syrek, Maryann, 213*f*, 214*f*

T

Taiso, Yoshitoshi, 186, 186*f*
Thagard, Paul, 184*f*
Thompson, Charles, 223–224
Toulous-Lautrec, Henri de, 72, 76*f*, 249*f*

Turner, JMW, 126, 126*f*
Tzara, Tristan, 250

V

Valliela, Ivan, 73
van Eyck, Jan, 4, 5*f*
Van Gogh, Vincent, 43, 122, 123*f*, 132–133, 134*f*, 149, 151*f*,
 233, 258–259
Vanderberg, Paul, 206, 207*f*
Vdovin, Ivan, 289*f*
Velazquez, Diego, 4

Vermeer, Jan, 4, 4*f*
Vibert, J.G., 19
von Helmholtz, Hermann, 9

W

Watters, William, 290*f*
Wertheimer, Max, 166, 178
Williams, John, 259*f*
Wilson, Wes, 154, 156*f*, 253
Winner, Sonya, 208, 208*f*

Jet Boats in the Lake, Queenstown, NZ (Cooperman), 67f
Jones Beach poster (Vanderberg), 207f

K

Kenya, 2010 (Meyer), 174f
Kenya Amboseli National Park (Meyer), 197f
Kenya Elephant (Meyer), 196f
KISS method, 105
Knit Stitches (Cooperman), 278f
Knossos throne room, 3, 4f
Koch snowflake, 286, 286f

L

LAB (CIELAB color measurement), 9
Lacuna 3 (Farrell), 134, 135f
Lacuna 7 (Farrell), 134, 135f
La Mer: Les Barques (Signac), 258
Lantern Tower, 287, 287f
Lapis lazuli, 3, 3f
Lava Beach, Hana, Hawaii (Cooperman), 72, 75f
Law of simultaneous contrast, 24, 35–38
 borders/background/transparency and, 191
 Chevreul and, 35
 complements and, 41–42
 explained, 176
 hue and, 36–37
 intensity and, 38
 value and, 37, 38
Laws of nature, balancing composition with, 101
The Letter (Jan Vermeer), 4, 4f
Liberty on the Barricades (Delacroix), 132f
Light
 as additive color system, 15
 da Vinci on, 4
Light-based color system, 228–229
Light bulbs, types of, 16
Light colors, visual weight and, 101
Lighting
 color changes and, 240–241
 color perception influenced by, 16
 effect on color, 4–5
 local color and, 12–13
Light value, 21
Light waves, 13
Lilac-breasted roller, Lake Nakuru National Park (Meyer), 196f
Lilies Not looking at Each Other (Cooperman), 88f
The Lily Garden Speaks (Cooperman), 89f
Lindsay Hanging (Hano), 195f
Linear transformations, 283–287
 reflection, 284
 rotation, 287
 self-similarity, 285–286
 translation, 283–284

Lines
 artistic message and, 233
 changing perception of an image, 168
 continuity and, 106
 curvilinear, 93
 design idea and, 241
 diagonal, 92
 distance between, 93–95
 dominance and, 186–187
 function of, 106
 horizontal, 92
 implied curvilinear, 93
 producing energy, 91
 relating to the picture plane, 157
 vertical, 91–92
Lines of composition, 57–77
 curvilinear, 67
 diagonal, 65
 dominant, 57–58
 energy through, 61–62
 evaluating, 59–60
 horizontal, 62–63
 multiple, in one image, 67–73
 secondary, 58
 vertical, 63
Lisbon Fenestration (Schilling), 281, 282f
Lisbon plaza (Schilling), 281f
Lisbon Train Station (Schilling), 278f
Little Sahara, Kangaroo Island, Australia (Cooperman), 92, 93f
Lloyd Express promotional poster, 281, 281f
Local color, 5, 9, 12–13
Location, influences on, 158–162
Logo colors, 223f, 225–226, 226f
Lotus (Cooperman), 130f
Low-intensity colors, 27, 272
Low values, emotions expressed through, 272
Low values, meaning of, 231
The Lucca Madonna (Van Eyck), 4, 5f
Luminescence (Gottesman), 193, 194f
Luminosity, 9

M

Mach Brands, 24
Madagascar Baobab Tree (Meyer), 270f
Madagascar onions (Meyer), 113, 113f
Madagascar Tsingy (Meyer), 261, 262f
Madonna of the Chair (Raphael), 204f
Magenta, 20f
Magnification, 244
Makita tools, 222
Manarola From the Sea (Schilling), 34f
Manufacturers. See Businesses
Massage Envy, 216, 218f

Outside-in point of view, 245
Overlapping, 158–159
Overweight (balancing problem), 142

P

Painted Bowling Ball (Smith), 206*f*
Palace of the Columns, 288*f*
Palouse, Washington, June 11, 2009 (Meyer), 112*f*, 159, 180, 182*f*
Palouse, Washington, June 13, 2009 (Meyer), 161*f*
PANTONE Color Bridge Guide, 217
Pantone Formula Guide, 217, 219*f*
Pantone Matching System, 217, 224
Papyrus, 2, 2*f*
Parent color, 208
Partial border, 199–201
Passive energy, 84, 88
Path of continuity, moving elementing altering, 119
Patterns
 creating traditional, 289
 defined, 279
 examples, 278–279
 Islamic, 289
 with no background, 287–288
 overview, 277–278
 reflection and, 284
 rotation and, 287
 self-similarity and, 285–286
 tessellation, 287–288
 through linear transformations, 283–287
 through repetition, 173–174
 through repetition with alternation, 279–280
 through rhythm, 280–282
 through sequence, 280
 translation and, 283–284
Penrose tiling, 288
Perception. *See* Color perception; Gestalt theory of principles
 of perception
Perceptual space, 148
Permeable border, 203, 204
Persian Bay (Korodi), 69*f*
Persian Silk (Korodi), 284*f*
Philadelphia 1969 was Not a Very Good Year (Cooperman), 155*f*
Photoreceptors, 15–16
Picture plane, 155, 157–158
Picture plane level, 155
Pier 54 Pipes (Cooperman), 77*f*
Pier building on Hudson River, New York City (Cooperman), 243*f*
Pigment-based color system, 228–229
Pigments
 mixing together, 9
 as subtractive color system, 14
 used during Renaissance, 3–4

Pine Barrens (Kinkade), 102, 103*f*
Pink Rhododendron (Schilling), 284, 285*f*
Pitch, 266–267
Plane locations of objects, background color and, 195
Planes, 157–158
 chiaroscuro and, 159
 color and, 160–162
 defined, 155
 as jumping-off point, 246
 overlapping and, 158–159
 picture, 155, 157–158
Plants, as visual image type, 243
The Poem of Fire, Opus 60 (Scriabin), 258
Polygons, 89
Population by Nativity (Motolese), 235, 235*f*
Positive space
 figure as, 148
 transposition of, 153–154
Potential energy, 82
The Power of One (Sissman), 109, 110*f*
The Power of the Center (Arnheim), 202
Power tools, appealing to target market and, 221–222, 222*f*
Pragnanz (order), 167–169
Primary colors, 2, 15
Primary hues, 17, 17*f*
 as background color, 192–193
 complementary, 43–44
 triad, 40, 41*f*
The Principals of Harmony and Contrast of Colors (Chevreul), 8, 35
Principles of perception. *See* Gestalt theory of principles of
 perception
Printsource, 220
Prisms, 5, 6*f*
Promostyle, 219
Proportions for complements, 45–47
Proximity, Gestalt principle of, 175–177, 207
Psychedelia, 253
Psychological perception, 16
Purple, 231
Pyramid
 balance and, 130
 line of composition, 60

Q

Quantitative concepts, color used to express, 235–236
Quantum Patchwork (Ganz), 161, 161*f*
Queensborough Bridge, NYC (Ahmed), 130*f*, 143, 143*f*
Queens, NY (Ahmed), 27, 77*f*

R

Radial balance, 130
RBG system, 229–230
Rebirth (Sissman), 41, 41*f*

hue names and, 18
 relationship with tones and tints, 39–40
 Runge on, 7
 value and, 22
The Shadows Underneath (Cooperman), 269f
Shape(s)
 alteration of, 246
 of a border, 199
 close to each other, 160
 continuity and, 106
 created by using repeated elements, 174
 design idea and, 241
 distance between, 93–99
 function of, 106
 grouping elements to create illusion of, 177
 line of composition, 57
 producing energy, 89–90
 relating to the picture plane, 157
 right distance apart from eachother, 141
The Shelter of Tangled Wings (Smith), 162, 163f
Sidebars, 107–108
Sight
 color comprehension and, 16
 lighting influencing, 16
 psychological perception and, 16
 rods and cones influencing, 15–16
Silent Landscape (Nelson-Gilett), 233f
Similarity principle of perception, 169–175
 borders and, 202
 proximity and, 175
 repetition of similar elements, 170–171
 repetition strategies, 171, 173–175
Simultaneous contrast. *See* Law of simultaneous contrast
Size
 alteration of, 246
 of borders, 199
Skies, as visual image type, 242
Sky Pink Over Deep Red Hills (Gottesman), 185f
Snails on a Rock (Nelson), 202, 203f
Soap colors, 214, 215f
Sound. *See also* Music
 color associated with, 256–259
 connection of music and color, 256–260
 movies and, 259
 visual component of, 256
Soundscape, 261–263
Soundtracks, movie, 259
Sources of inspiration. *See* Music; Visual sources of inspiration
South Georgia (Meyer), 92f
Space. *See* Visual space
Space (Korodi), 170, 172f
Spacedeconstruction (Korodi), 68f
A Space Odyssey (film), 259
Spaces No. 1 (Korodi), 74f

Spaces No. 5 (Korodi), 57, 57f
Spacial (Dova), 271f
Spectral hues
 in color circle, 20
 color relationships and, 39
 defined, 17
 electromagnetic waves, 13–14
 intensity, 27
 Newton on, 6
Spectral Jars (Karasikova), 173, 173f
Spectral match, 226
Spectral reflectance curve, 226
Spectrophotometer, 226–227
Split complements, 40, 49
Sports team logos, 222, 223f
Spring, colors of, 231
Square of Tensions, 99
The Starry Night (Van Gogh), 132, 134f
Star Wars (film), 259
Static energy, 83–84
Steamfitter (Hine), 179, 182f
Stepping-stones, 108
Still Home (Cooperman), 160f
Still Life With a Seashell on Black Marble (Matisse), 233, 234f
St. Mary's Cathedral, Sydney, Australia (Nelson), 193f
Stockholm-Soroksár (Korodi), 209f
Strawberry Fields memorial, 285, 286f
Studio (Packard), 263, 263f
Studio Montclair (Cooperman), 155f
Study for Composition VII (Kandinsky), 151f
Stylesight, 220
Subdominant, 181, 183, 186
Subordinate area, 183
Subtractive color system, 14, 15f
"Successive contrast," 47
Sudsorama™ The Soap Shop, 214
Summer, colors of, 231
A Sunday Afternoon on the Isle of La Grande Jatte (Seurat), 149
Sunlight, Newton's prism experiment and, 5–6
Sunset (Korodi), 172f
Sunset in Ventnor (Cooperman), 272, 274f
Sunset on the Daintree River, Blue Mountains, Australia (Cooperman), 63
Sunset Over the Hudson From Cold Spring, NY (Cooperman), 99, 100f
Surrounding colors
 color perception influenced by, 34–35
 influencing color perception, 13
Survival Hug, Grand Canyon-Arizona (Drever), 124, 124f
Susan's Brook II (Kinkade), 62f
Susan's Brook-Winter (Kinkade), 98f
Symmetrical balance, 126–128, 245
Symmetry
 reflection, 284
 repetition and, 171